THE PROSTHETIC IMPULSE

THE PROSTHETIC IMPULSE

FROM A POSTHUMAN PRESENT TO A BIOCULTURAL FUTURE

Edited by Marquard Smith and Joanne Morra

The MIT Press Cambridge, Massachusetts London, England

© 2006 Massachusetts Institute of Technology

MIT Press books may be purchased at special quantity discounts for business or sales promotional use. For information, please e-mail <special_sales@mitpress.mit.edu> or write to Special Sales Department, The MIT Press, 5 Cambridge Center, Cambridge, MA 02142.

This book was set in Bembo by Graphic Composition, Inc., and was printed and bound in the United States.

Library of Congress Cataloging-in-Publication Data

The prosthetic impulse : from a posthuman present to a biocultural future / edited by
 Marquard Smith and Joanne Morra
 p. cm.
 Includes bibliographical references and index.
 ISBN 0-262-19530-5 (hc : alk. paper)
 1. Body, Human—Social aspects. 2. Body, Human—Technological innovations. 3. Prosthesis—Technological innovations. 4. Medical innovations. I. Smith, Marquard. II. Morra, Joanne.
 GN298.P76 2006
 306.4—dc22

 2005041684

10 9 8 7 6 5 4 3 2 1

CONTENTS

ACKNOWLEDGMENTS

We extend our deepest thanks to the contributors to *The Prosthetic Impulse: From a Posthuman Present to a Biocultural Future* for their enthusiasm, generosity, humor, and commitment to this project. This book has been a long time in coming, so we are grateful for their stamina and their considered, provocative, and enduring thoughts. It's been a pleasure. Thanks also to Boris Belay, Steve Connor, Joanna Delorme at Galilée, Kate Hayles, Friedrich Kittler, Jean-Luc Nancy, Katherine Ott, Norris Pope at Stanford University Press, Vivian Rehberg, Avital Ronell, Jeffrey Shaw, Sandy Stone, Rosemarie Garland Thomson, and Ben Watson. Thanks to the excellent advice from our anonymous referees, and finally to Roger Conover and Lisa Reeve, and Deborah Cantor-Adams, Susan Clark, and Emily Gutheinz for their faith in this project and their encouragement from beginning to end.

THE PROSTHETIC IMPULSE

INTRODUCTION Marquard Smith and
Joanne Morra

*With every tool man is perfecting his own organs, whether motor or sensory, or is
removing the limits to their functioning. . . . Man has, as it were, become a kind of
prosthetic God. When he puts on all his auxiliary organs, he is truly magnificent; but
these organs have not grown on to him, and they still give him trouble at times. . . .
Future ages will bring with them new and probably unimaginable great advances in this
field of civilization and will increase man's likeness to God still more. But in the
interests of our investigations, we will not forget that present-day man does not feel
happy in his Godlike character.*
 —*Sigmund Freud,* Civilization and Its Discontents[1]

*The prosthesis is not a mere extension of the human body; it is the constitution of this
body* qua *"human."*
 —*Bernard Steigler,* Technics and Time[2]

The rich diversity of specially commissioned essays in *The Prosthetic Impulse: From
a Posthuman Present to a Biocultural Future* engage, in one way or another, with the
figure of "prosthesis." Originally from the Greek, the word *prosthesis* entered the
English language in around 1553 and was initially used, as David Wills informs us
in his landmark book *Prosthesis,* in its grammatical sense, as "the addition of a syl-
lable to the beginning of a word."[3] It wasn't until 1704, Wills goes on to say, that

a medical sense of *prosthesis* was employed to mean a "replacement of a missing part of the body with an artificial one."[4] Already from these earliest instances in the discourses of grammar and of medicine, *prosthesis* offers itself up as an "addition" or a "replacement," and it is usually this dual meaning that persists to this day. It underpins considerations of prosthesis in the medical profession, in the spheres of mechanical engineering and design innovation, in the visual arts, and across the academic humanities and beyond. Pointing to an addition, a replacement, and also an extension, an augmentation, and an enhancement, prosthesis has become a staple in the armory of metaphors or tropes that are utilized by intellectuals, scholars, students, and practitioners who are concerned with interactions *in general* between the body and technology in modernity as they figure a conception of prosthetic lives in our posthuman times.

And yet . . .

To a perhaps worrying extent, "the prosthetic" has taken on a life of its own. Following closely on the heels of the appeal of the cyborg in the late 1980s and 1990s—which was prompted in large part by the success of Donna Haraway's 1985 essay "The Cyborg Manifesto: Science, Technology, and Socialist Feminism in the 1980's," as well as by developments in the cultural studies of science and technology, science fiction cinema and literature, transplant technology, artificial intelligence, virtual reality, postmodern warfare, and so on—"the prosthetic" has similarly begun to assume an epic status that is out of proportion with its abilities to fulfill our ambitions for it.[5] Often it is conjured up as an instance of "metaphorical opportunism," a phrase used by David T. Mitchell and Sharon L. Snyder in the introduction to their edited collection *The Body and Physical Difference: Discourses of Disability* to characterize the ways in which thinkers like Jean Baudrillard and Paul Virilio but also N. Katherine Hayles, Avital Ronell, and Haraway herself "deploy disabled bodies as proof of our fascination with 'cyborglike' prosthetic enhancement."[6] But this portrayal is by no means restricted to just the prosthetically enhanced "disabled body." In fact, so dominant has the trope of prosthesis become that Sarah S. Jain has dubbed our obsession with its capabilities "the prosthetic imagination."[7] For Jain, this is no more or less than a marker of our cultural condition's desire to disavow the fact of prosthesis and instead indulge in flights of fantasy to utilize prosthesis as "a tempting theoretical gadget with which to examine the porous places of bodies and tools."[8]

In part, then, we hope that *The Prosthetic Impulse* adds credence to these voices of caution and to similar recent correctives by others who are working on prosthesis from within anthropology and material-culture studies (such as Steven L. Kurzman and Katherine Ott) by further interrogating the metaphorical opportunism of "the prosthetic imagination" and, in so doing, reassert the phenomenological, material, and embodied nature of "the prosthetic impulse."[9] At the same time, we are wary of dismissing out of hand the metaphorical potential of the aforementioned flights of fancy of prosthesis since they set in motion imaginative speculations, analyses, and interpretations. Because the authors gathered here are alert to both the phenomenological and speculative aspects of prosthesis, in attending to the complex historical and conceptual confluence of modernity, technology, and "the human," the texts in this collection negotiate and critically interrogate both the material *and* the metaphorical possibilities of prosthesis.

The Prosthetic Impulse is by necessity concerned with how the material and metaphorical figurations of prosthesis initiate considerations of the historical and conceptual edges between "the human" and the posthuman, the organic and the machinic, the evolutionary and the postevolutionary, and flesh and its accompanying technologies. (Certainly we are not simply tracking a transformation or metamorphosis from one to the other.) Concentrating on how these edges figure prosthesis in its historical and conceptual materiality *and* in its metaphorics is to begin to acknowledge how (since at least the classical era and certainly explicitly theorized with the advent of modernity) "the human" has been understood as technologized, thereby revealing to us the *promise* of the "posthuman" that is already found in the human and the humanization of technology itself. "The prosthetic impulse" specifies *this delicate dialectical situation in which we find ourselves* and with which this volume deals. The essays herein thus work toward a dialectical materialism and a dialectical *im*materialism where identity, embodiment, consciousness, perception, and memory have been and are lived out inelegantly in an age of science, technology, and information.

———

What is "the prosthetic impulse" of which we speak?

To begin, there are two possible answers to this question. One is more conventional, the other less so. The more conventional answer is that the discourse of the humanities and elsewhere has proposed—sometimes explicitly, sometimes implicitly—that our modern Western culture has a "prosthetic impulse."[10] In recent years, some fascinating writings have sought to define as well as reply to this prosthetic condition with political and ethical debates that cut across history, philosophy, the history and philosophy of science, critical theory, the medical humanities, literature, new media, material culture, and the visual arts, as well as the grey areas between them. At their best, these writings have attended to, debated, and struggled with the points at which modernity has brought the modern subject and technology (in its broadest sense) into contact with one another and to what ends.[11]

In general, these productive writings have both responded to and shaped our knowledge and curiosity about "the prosthetic impulse." In the context of this literature, this impulse is composed of any encounter—material, figural, or metaphorical—that facilitates or contests our chances of making (human) contact with a modern world that is ever more mediated and determined by communication technologies, biomedicine, and information. Such encounters, in this expansive literature, do not simply examine the ways in which the body is extended or enhanced by prosthetic technologies but also explore the ways that the body and technology come into contact with one another and are integrated, fused, reciprocal, and parasitic. This understanding of prosthesis might include discussions of contact with old or new communication technologies—from the telegraph, the automated typing machine, and the telephone to the mouse, the computer screen, and video conferencing; from air conditioning to virtual environments; from practices of dissection to laparoscopic surgery and unmanned space travel; from ghosts in the machine to the sentience of "living" technology; from cyborgian organisms to the *Visible Human Project*;[12] from biomedicine and nanotechnology to the postorganic; from robotics and genetics to hacker culture; from electronic lighting to telematic networks; from teledildonics to military hardware; from closed-circuit television and digital censoring to policing one's own practices and pleasures; from pacemakers to artificial wombs; from glasses, telescopes, microscopes, and the camera obscura to more recent ocular prosthesis such as virtual-reality gaming and other immersive technologies; from reports of the

world's first face transplant to the news that Microsoft has been awarded U.S. Patent 6,754,472, which bears the title "Method and apparatus for transmitting power and data using the human body" and which will grant the company exclusive rights to the body's ability to act as a computer network.[13]

Of course, one could also say that "the prosthetic impulse" is enacted, dare one say created, in the spheres of culture, literature, the visual arts, and our everyday practices where there are no shortages of instances of such prosthetic contact. In the history of science fiction and horror cinema, for example, *Frankenstein* and *Metropolis* gave way to *Blade Runner* and *The Terminator,* which in turn have led to *Tetsuo:The Iron Man, Pi, Crash, Gattaca, A.I.: Artificial Intelligence,* and *I, Robot.* Philip K. Dick, William Gibson, and Japanese comic book artists continue to define cyberesthetics. In visual art practice, the mutable and obsolete flesh of Orlan and Stelarc is eulogized, and attention is lavished on new media arts and the sonic arts. Similarly, the histories of reconstructive, esthetic, and cosmetic surgery are being chronicled. The popularization of modern primitivist adornment and technopaganism offers a now almost banal notoriety to the body arts of tattooing, piercing, and scarification. Specialist dating agencies, publications, and e-magazines—such as *Amp Life, Real Crip Sex,* and Amputee.online.com—are plentiful. And the catwalk has had its first couture (from the Latin *consuere,* "to stitch together") model, double amputee Aimee Mullins, who modeled for Alexander McQueen's 1999 London spring collection and appears in the most recent installation of American artist Matthew Barney's *Cremaster* film cycle (1994–2002).

Such are the ways in which academics and creative practitioners have initiated, grasped, and commented on "the prosthetic impulse" in our contemporary cultural condition. We know this is familiar, there is nothing too surprising about the ubiquity of such body-technology contact. This is, after all, the more conventional answer to our question, "What is 'the prosthetic impulse'?"

————

The less conventional answer to the question of "What is 'the prosthetic impulse?'" is given throughout this collection. *The Prosthetic Impulse* is not first and foremost concerned with our hopes that encounters with technology—and the knowledge and practices that emanate from such contact—will lead us to self-extension into

a technoculture. If anything, quite the opposite. This volume is not over-invested in perpetuating the exhilaration of an earlier moment in the cultural considerations of prosthesis, a moment best exemplified in Jean Baudrillard's frenzied warning of technology's infectiousness:

> *The point when prostheses are introduced at a deeper level, when they are so completely internalized that they infiltrate the anonymous and the micro molecular core of the body, when they impose themselves upon the body itself as the body's "original" model, burning out all subsequent symbolic circuits in such a way that every body is now nothing but an invariant reproduction of the prosthesis: this point means the end of the body, the end of its history, the end of its vicissitudes. It means that the individual is now nothing but a cancerous metastasis of his basic formula.*[14]

The overexcited fear that is induced by such a theorization of encounters with cybernetic prostheses, by the indulgent and dystopian panic of contagion, and by the rhetoric of high postmodernism is a position from which the authors in this volume take a step back. They are not concerned with such fatality, such inevitable futurity. We have learned that the body, its histories, and its mutability have not become fixed by technology. There is no fear of technology's invasion and infiltration of the body, as outlined by Baudrillard. These scholars in *The Prosthetic Impulse* are not simply interested in the ways in which human beings are *enhanced* by the augmentation of human intelligence and capabilities by prosthetic technologies. Nor are they simply contributing to the unremitting escalation of the pile of scholarly literature that is introducing us, yet again, to cyberculture, to technoculture, to our virtual futures. Although the texts are informed by these general concerns that arise around the confluence of the human, of technology, and of cultural transformation, the contributors to this volume are specifically fascinated by *where the edges lie,* as Allucquère Rosanne Stone has asked, *between* the person and communication prostheses.[15] Where does one stop and the other begin?

Accordingly, the texts herein attend to the ways that prostheses, both material and metaphorical, have the potential to form an integral part of certain speculations on the corporeal surface, the psyche, and the interior and exterior limits of the body and to the ways that these efforts to renegotiate discourses on "the human" might attend to the edges between these material and immaterial

surfaces and limits. They do so by negotiating the dialectical process wherein these very limits and edges—emerging as they do from particular histories, bodies, objects, and practices—enact or voice such a challenge. Yet these writings also do more than this. Against a more evolutionary understanding of the gradual infiltration of the body by prosthesis, there is a common consensus among the authors gathered here that the point of prosthetic contact—and the dialectic of the edges in such contact—is also a part of a process that recognizes exactly how "the prosthetic" is an integral or "interconstitutive" part of the "human." This is the more particular, less conventional answer to the question "What is the prosthetic impulse?" and is the crux of this volume.

This puts us on our way toward showing how Sigmund Freud's and Bernard Steigler's words at the beginning of this chapter and our response to them identify ways in which "the prosthetic impulse" reveals that the promise of "posthuman" thought can already be found in the human. Here we take our lead on the posthuman from one of its clearest, recent articulations in N. Catherine Hayles's *How We Became Posthuman,* in which she writes: "The posthuman subject is an amalgam, a collection of heterogenous components, a material-informational entity whose boundaries undergo continuous construction and reconstruction."[16] In Hayles's consideration, she declares that "the posthuman view thinks of the body as the original prosthesis we all learn to manipulate, so that extending or replacing the body with other prostheses becomes a continuation of a process that began before we were born."[17] This is consistent with Steigler's assertion in *Technics and Time,* the second epigraph to this chapter: "The prosthesis is not a mere extension of the human body; it is the constitution of this body *qua* 'human.'"

———————

The essays in *The Prosthetic Impulse* take an eclectic approach to this understanding of prosthesis, born as it is from the particularity of specific histories, bodies, objects, and practices. They draw on historical and theoretical methodologies from gender studies and philosophy, literary criticism and visual culture, psychoanalysis and deconstruction, critical race studies, cybertheory, and phenomenology. Through these means, they attend to the dialectic and edges between metaphor and materiality, figuration and literality, inside and outside, internalization and

externalization: quite simply, they work in between the points of contact linking bodies and technologies to configure them differently.

Part 1, "Carnality: Between Phenomenology and the Biocultural," is grounded in a dialectic between prosthetic embodiment—as phenomenological, psychic, and material—and the historical, cultural, scientific, neurological, biomedical, and figural discourses that constitute this embodiment as such. In particular, by playing out the fraught dialectic between the material and metaphorical implications of prosthesis, the essays in this part interrogate bodies, sexual lure, eroticism, genetics, neural networks, mimesis, and the esthetic to stretch the limits and limitations of current debates on that ultimate prosthetic God, "the posthuman." Concentrating on the organic body, a body that is determined not by evolution so much as by way of a nonteleological phenomenology, these essays outline a rendering of the body, the human form as flesh, whose very materiality constitutes it as always and already prosthetic.

Vivian Sobchack's essay "A Leg to Stand On: Prosthetics, Metaphor, and Materiality" begins this interrogation in earnest by drawing our attention to the recent technofetishistic or technoanimistic embrace of the prosthetic as a particularly sated metaphor in critical discourses on technoculture and the posthuman. In offering a critical response to this "metaphorical displacement of the prosthetic," Sobchack forces our attention toward the metaphorical *and* the material mechanisms of both language and the embodied phenomenological experience of lived bodies that by necessity underpin any figuration of the prosthetic. Picking up on the question of technofetishism, Marquard Smith's "The Vulnerable Articulate: James Gillingham, Aimee Mullins, and Matthew Barney" asks about the kinds of erotic fantasies that are being played out across medical, commercial, and later avant-garde images of the body of the female amputee in our Western visual culture. In so doing, he suggests that as opportunistic as such fantasy is, because this "perversity" is itself structured by prostheses it has something to tell us, quite unexpectedly, about the intimacy and vulnerability of body-machine unions. In pursuing the notion of sexual perversity from another angle, Alphonso Lingis's "The Physiology of Art" outlines a (nonteleological) evolution of artistic compulsion, a compulsion that is found in humans, other mammals, and in fauna, and drives them to adorn and display themselves as a manifestation of their desire to create their body as art. In seeking to reveal how this compulsion dis-

closes how beauty and infirmity are themselves prosthetic from the beginning, he focuses on the erotic potential of apotemnophilia, a fixation on self-amputation.

Also confronting the question of "evolution" head on, in "Stumped by Genes: *Lingua Gataca,* DNA, and Prosthesis" Lennard J. Davis contributes to the emerging discourse of "biocultures" by exploring how a reconceptualization of genetics—in which the gene itself "acts as a kind of prosthetic *en abime,* an endlessly deferred location" or as "a virtual prosthetic"—demands an attention to the fixing and unfixing of race. Gary Genosko's "The Bug's Body: A Disappearing Act" also plugs into the biocultural by way of the history of insects in military research and science fiction to consider how the bug as a "machinic principle of interactivity" haunts cyberculture. He goes on to suggest how it has come to do so via the (assimilationist) technique of biomimesis—a combination of machine and insect body that challenges the distinction between an organism and its environment.

In "On the Subject of Neural and Sensory Prostheses," Lisa Cartwright and Brian Goldfarb draw out and mobilize the confluence of the prosthetic, the neural, and the networked to propose an "interconstitutive" bond. By focusing on foregrounding "neural prosthesis," they play out how the interweaving of the fictional, the technical, and the autobiographical can enact a profound conceptual shift, conceiving of "the intersubjective unit body and technology as an intrasubjective entity."

Finally, in exploring the intersections between disability and queerness in military culture, David Serlin's "Disability, Masculinity, and the Prosthetics of War, 1945 to 2005" explores how the "dynamic potential of queer practices" and "expressions of queerness" within this nationalistic culture offers a homoerotic continuum rather than a heterosexist demarcation between nonnormative bodies, ablebodiness, and masculinity.

Part II, "Assembling: Internalization. Externalization," considers the technological qualities and peculiarities of prosthesis. This part uses prosthesis as a way of interrogating the notion that an isomorphic relationship exists between the subject's internal world and its external projection. This is ultimately a question of mimesis and its technologies. By recognizing the work that prostheses undertake, both literally and metaphorically, part 2 brings together, unpacks, and reassembles this question. First, this section posits the mimetic relationship as dialectical: the internal and external form a reciprocal, mediated, and inflected

relationship with one another. Second, the relationship is constituted by gaps and fissures. Together these approaches enable the essays in this part to consider the linguistic, ontological, visual, and epistemological issues posed by prostheses within the framework of social and technological production, raising questions around the ways in which film, photography, artificial intelligence, drawing, and literature—representation itself—can be situated within the framework of a prosthetic discourse.

Beginning this part, Elizabeth Grosz's essay "Naked" concerns itself with the *mediated* nature of our nakedness as visual representation. She asks how the body is augmented through its representation, the extent to which such mediation is determined by the primacy of vision, and the consequent overattention to sexual spectacle and sexual viewing. In so doing, she goes on to rethink notions of the gaze, voyeurism, and exhibitionism to propose a new typology of looking. Lev Manovich's "Visual Technologies as Cognitive Prostheses: A Short History of the Externalization of the Mind" tracks how over the last century and a half visual technologies—from photography and film to contemporary experiments in computer-image systems, cognitive psychology, and neuroscience—invent or fabricate models through which it becomes possible to "externalize the functions of consciousness." The far-reaching implications of this trajectory, proposes Manovich, are that this very desire to objectify the psyche—to imagine or visualize the mind itself—gave birth to modern imaging technologies such as photography, cinema, and virtual reality. Raiford Guins and Omayra Zaragoza Cruz are also intent on excavating this process of externalization, albeit very differently, and to this end in "Prosthetists at 33⅓" they engage with sound technologies and black urban culture. They show how Marshall McLuhan's pronouncement on the phonograph as "an extension and amplification of the voice" was misjudged from the beginning and instead turn to practices of "turntablism"—a prosthetic media technology environment that places a recognition of racialization at the center of debates in acoustic culture.

Similarly caught up in questions of externalization, this time in relation to the externalization of memory, in "Techneology or the Discourse of Speed" David Wills turns to the writings of French philosopher Bernard Stiegler. In picking away at this monumental body of work and its blindspots, Wills charts the uncanny effects of technology, the "prosthetizing effect" in which the human is defined as

technological in a way that will have profound implications for our understanding of time and speed, language, the image, and the politics of new media. Finally, concerned with the ways in which the prosthetic has been theorized in relation to writing, specifically as a means of understanding the corporeal and psychic construction of subjectivity, Joanne Morra's "Drawing Machine: Working through the Materiality of Rauschenberg's Dante and Derrida's Freud" tracks the role of the graphic within the philosopher's thoughts on the analyst's writing machines. Unlike Derrida's interest in the a priori of writing, Morra examines the ways in which a work of art and its production—specifically, Robert Rauschenberg's transfer *Drawings for Dante's Inferno*—can reveal the elision that substantiates this priority and thereby can recuperate the visual, drawn element of the graphic.

———

In the end, then, *The Prosthetic Impulse* explores how the figure of "prosthesis"— born as it is from the discourse of grammar and medicine as an "addition" and a "replacement"—has always been more complex and nuanced than it is presented in "the prosthetic imagination" as an extension or augmentation or enhancement of the human in investigations of the posthuman. For "prosthesis" is material as well as metaphorical, literal as well as figural, and (as we have begun to suggest) is these things together from the beginning. As such "the prosthetic impulse" needs to be considered in these diverse and convergent ways because ultimately this is *the delicate dialectical situation in which we find ourselves.*

Freud did have a sense of this, as is intimated in this chapter's opening epigraph from *Civilization and Its Discontents*. His words certainly suggest a possible future in which the magnificence of humans as prosthetic gods is tempered by the ill-fitting and troublesome nature of their auxiliary organs. To anticipate the future through the figure of the human and its enhancement is for Freud to imagine something glorious, inadequate, and imperfect. But Freud gets us only so far. *The Prosthetic Impulse* is interested in something altogether more minor and all the more marvelous because of it—the prospect that the body and prosthesis are already of one another in specific ways that are lived out and experienced through material as well as metaphorical considerations that are embodied in and theorized directly out of particular histories, bodies, objects, and practices.

This volume, then, sits awkwardly between Freud's conception of a future possibility and Stiegler's conception of a future anterior. This is what *The Prosthetic Impulse: From a Posthuman Present to a Biocultural Future* attempts to do. It is just a matter of pondering where the inelegant edges lie—and living them most wonderfully.

Notes

1. Sigmund Freud, *The Standard Edition of the Complete Psychological Works of Sigmund Freud,* Vol. 21, *Civilization and Its Discontents,* trans. James Strachey (London: Hogarth Press, 1953-1974), 101.

2. Bernard Stiegler, *Technics and Time,* Vol. 1, *The Fault of Epimetheus,* trans. Richard Beardsworth and George Collins (Stanford: Stanford University Press, 1998), 152-153.

3. David Wills, *Prosthesis* (Stanford: University of Stanford Press, 1995), 218.

4. Ibid.

5. It is worth remembering that Haraway's "Manifesto" was avowedly ironic, which many enthusiasts of the cyborg seem to have forgotten or ignored. See Donna Haraway, "A Manifesto for Cyborgs: Science, Technology, and Socialist Feminism in the 1980's," *Socialist Review* 80 (1985): 65-108.

6. David T. Mitchell and Sharon L. Snyder, eds., *The Body and Physical Difference: Discourses of Disability* (Ann Arbor: University of Michigan Press, 1997), 8. Mitchell and Snyder rightly make it clear in their text that Hayles, Ronell, and Haraway do much besides this.

7. Sarah S. Jain, "The Prosthetic Imagination: Enabling and Disabling the Prosthesis Trope," *Science, Technology, and Human Values* 24, no. 1 (1999): 31-54.

8. Ibid., 49.

9. Steven L. Kurzman, "An Anthology of the Prosthesis Field" (1996), "Cultural Attitudes toward Prostheses: An Anthropological Approach" (1997), "Performing Able-Bodiedness: Amputees and Prosthesis in the USA" (1996), all retrieved from <http://www2.ucsd.edu/people/kurzman/index.htm/>; Steven L. Kurzman, "Presence and Prosthesis: A Response to Nelson and Wright," *Cultural Anthropology* 16, no. 3 (2001): 374-387; Katherine Ott, David Serlin, and Stephen Mihm, eds., *Artificial Parts, Practical Lives: Modern Histories of Prosthesis* (New York: New York University Press, 2002). Peter Lunenfeld has similarly referred to "science-fictionalized" discourse as "vapor theory of ruminations unsupported by material underpinnings.";

see Lunenfeld, "Theorizing in Real Time: Hyperaesthetics for the Techno-culture," *Afterimage* 23, no. 4 (1996): 16–18.

10. This collection is concerned with prosthesis in modern Western cultures. We are aware of the limits of this focus. Much has been written on prosthesis in non-Western cultures from within anthropology and material-culture studies. References to these writings—in particular Kurzman, Nelson, and Srinivasan—can be found in the following note.

11. While there are scores of books and articles on Modernity and technology, by no means all of them refer to or invoke the matter of prosthesis in particular. For the more interesting ones that do, along with others that do not necessarily mention prosthesis directly, see, for example, Tim Armstrong, *Modernism, Technology and the Body: A Cultural Study* (Cambridge: Cambridge University Press, 1998); Gabriel Brahm, Jr. and Mark Driscoll, eds., *Prosthetic Territories: Politics and Hypertechnologies* (Boulder, CO: Westview Press, 1995); Lisa Cartwright, *Screening the Body: Tracing Medicine's Visual Culture* (London: University of Minnesota Press, 1995); Howard Caygill, "Stelarc and the Chimera: Kant's Critique of Prosthetic Judgment," *Art Journal* (Spring 1997), 46–51; Mark Dery, ed., "Flame Wars: The Discourse of Cyberspace," *South Atlantic Quarterly* 92, no. 4 (1993); Helen Deutsch and Felicity Nussbaum, eds., *Defects: Engineering the Modern Body* (Ann Arbor: University of Michigan Press, 2000); Sander L. Gilman, *Making the Body Beautiful: A Cultural History of Aesthetic Surgery* (Princeton: Princeton University Press, 2000); Elizabeth Haiken, *Venus Envy: A History of Cosmetic Surgery* (Baltimore: Johns Hopkins University Press, 1997); Haraway, "A Manifesto for Cyborgs"; N. Katherine Hayles, *How We Became Posthuman* (Chicago: University of Chicago Press, 1999); Jain, "The Prosthetic Imagination"; Kurzman, "Presence and Prosthesis"; Alison Landsberg, "Prosthetic Memory: *Total Recall* and *Blade Runner*," *Body and Society* 1, nos. 3–4 (1995): 175–189; Drew Leder, *The Absent Body* (Chicago: University of Chicago Press, 1990); Akira Mizuta Lippit, *Electronic Animal* (Minneapolis: University of Minnesota Press, 2000); Peter Lunenfeld, ed., *The Digital Dialectic* (Cambridge: MIT Press, 1999); Celia Lury, *Prosthetic Culture* (London: Routledge, 1998); Lev Manovich, *The Language of New Media* (Cambridge: MIT Press, 2001); Mitchell and Snyder, *The Body and Physical Difference;* David T. Mitchell and Sharon L. Snyder, *Narrative Prosthesis: Disability and the Dependence of Discourse* (Ann Arbor: University of Michigan Press, 2000); Diane M. Nelson, "Desire and the Prosthetics of Supervision: A Case of Maquiladora Flexibility," *Cultural Anthropology* 16, no. 3 (2001): 354–373; Diane M. Nelson, "Phantom Limbs and Invisible Hands: Bodies, Prosthetics, and Late Capitalist Identifications," *Cultural Anthropology* 16, no. 3 (2001): 303–313; Diane M. Nelson, "Stumped Identities: Body Image, Bodies Politic, and the *Mujer Maya* as Prosthetic," *Cultural Anthropology* 16, no. 3 (2001): 314–353; Ott, Serlin, and Mihm, *Artificial Parts, Practical Lives;* Sadie Plant,

Zeros + Ones (London: Fourth Estate, 1998); R. L. Rutsky, *High Techne* (Minneapolis: University of Minnesota Press, 1999); Jeffrey Sconce, *Haunted Media* (Durham, NC: Duke University Press, 2000); Mark Seltzer, *Bodies and Machines* (London: Routledge, 1992); Richard A. Sherman, *Phantom Pain* (New York: Plenum Press, 1996); Vivian Sobchack, "Beating the Meat/Surviving the Text, or How to Get out of This Century Alive," in Mike Featherstone and Roger Burrows, eds., *Cyberspace/Cyberbodies/Cyberpunk: Cultures of Technological Embodiment* (London: Sage, 1995), 205–214; Vivian Sobchack, "Is Any Body Home? Embodied Imagination and Visible Evictions," in Hamid Naficy, ed., *Home, Exile, Homeland: Film, Media, and the Politics of Place* (New York: Routledge, 1999), 45–61; Raman Srinivasan, "Technology Sits Cross-legged: Developing the Jaipur Foot Prosthesis," in Ott, Serlin, and Mihm, *Artificial Parts, Practical Lives,* 327–347; Stiegler, *Technics and Time; Technema: Journal of Philosophy, and Technology;* Rosemarie Garland Thomson, *Extraordinary Bodies: Figuring Physical Disability in American Culture and Literature* (New York: Columbia University Press, 1997); Mark Wigley, "Prosthetic Theory: The Disciplining of Architecture," *Assemblage* 15 (1991): 7–29; David Wills, "Preambles: Disability as Prosthesis," in Laurence Simmons and Heather Worth, eds., *Derrida Downunder* (Palmerston North, NZ: Dunmore Press, 2001), 35–52; Wills, *Prosthesis;* David Wills, "Re: Mourning," *Tekhnema: Journal of Philosophy and Technology* 4 (1998): 8–25; Robert Rawdon Wilson, "Cyber(body)parts: Prosthetic Consciousness," *Body and Society* 1, nos. 3–4 (1995): 242; Gaby Wood, *Living Dolls* (London: Faber and Faber, 2002).

12. Lisa Cartwright, Constance Penley, and Paula A. Treichler, *The Visible Woman: Imaging Technologies, Science, and Gender* (New York: New York University Press, 1998). See also Lisa Cartwright, "The Visible Man: The Male Criminal Subject as Biomedical Norm," in Jennifer Terry and Melodie Calvert, eds., *Processed Lives: Gender and Technology in Everyday Life* (London: Routledge, 1997), 124–137.

13. David Adam, "Computerising the Body: Microsoft Wins Patent to Exploit Network Potential of Skin," *The Guardian,* July 6, 2004, 3; David Concar, "The Boldest Cut," *New Scientist,* May 29, 2004, 32–37.

14. Jean Baudrillard, *The Transparency of Evil,* trans. James Benedict (London: Verso, 1993), 119.

15. Allucquère Rosanne Stone, *The War of Desire and Technology at the Close of the Mechanical Age* (Cambridge: MIT Press, 1995), 5.

16. Hayles, *How We Became Posthuman,* 3.

17. Hayles, *How We Became Posthuman,* 3.

PART I

CARNALITY: BETWEEN PHENOMENOLOGY
AND THE BIOCULTURAL

A LEG TO STAND ON: PROSTHETICS, METAPHOR, AND MATERIALITY[1]

Vivian Sobchack

Matter has been given infinite fertility, inexhaustible vitality, and at the same time, a seductive power of temptation which invites us to create as well.
 —*Bruno Schulz,* The Street of Crocodiles[2]

It is this submission which is offered as a sacrifice to the glamorous singularity of an inhuman condition.
 —*Roland Barthes, "The Jet-Man," in* Mythologies[3]

Let me begin with the fact that I have a prosthetic left leg—and thus a certain investment in and curiosity about the ways in which "the prosthetic" has been embraced and recreated by contemporary scholars trying to make sense (and theory) out of our increasingly technologized lives. When I put my leg on in the morning, knowing that I am the one who will give it literal (if exhaustible) vitality even as it gives me literal support, I don't find it nearly as seductive a matter—or generalized an idea—as do some of my academic colleagues. And walking around during the day, going to teach a class or to shop at the supermarket, neither do I feel like Barthes's "reified hero," the "Jet-Man"—a mythological "semi-object" whose prosthetically enhanced flesh has sacrificially submitted itself to "the glamorous singularity of an inhuman condition." Not only do I see myself as fully human (if hardly singular or glamorous), but I also know intimately my prosthetic leg's essential inertia and lack of motivating volition. Indeed, for all the weight

that I place on it, it does not run my life. And thus, as I engage a variety of recent work in the humanities and arts, I am both startled and amused at the extraordinary moves made of and by "the prosthetic" of late—particularly since my prosthetic leg can barely stand on its own and certainly will never go out dancing without me.

Particularly, shall we say, "well equipped" to do so, I want both to critique and redress this metaphorical (and, dare I say, ethical) displacement of the prosthetic through a return to its premises in lived-body experience. However, this return will not be direct—but rather by way of what might be called a "tropological phenomenology."[4] In *The Rule of Metaphor: Multi-disciplinary Studies of the Creation of Meaning in Language,* Paul Ricoeur writes: "If there is a point in our experience where living expression states living existence, it is where our movement up the entropic slope of language encounters the movement by which we come back this side of the distinctions between actuality, action, production, motion."[5] Thus, in what follows, I pay as much attention to language as I do to lived bodies. This is because there are both an *oppositional tension* and a *dynamic connection* between *the* prosthetic as a tropological figure and *my* prosthetic as a material but also a phenomenologically lived artifact—the *the* and the *my* here indicating differences both of kind and degree between generalization and specificity, figure and ground, esthetics and pragmatics, alienation and incorporation, subjectivity and objectivity, and between (as Helen Deutsch and Felicity Nussbaum put it) "a cultural trope and a material condition that indelibly affect[s] people's lives."[6] Thus, it is not my aim to privilege here autobiographical experience as somehow "more authentic" than "less authentic" discursive experience. Experience of any kind requires both bodies and language for its expression, and both autobiographical and discursive experiences are real in that they both have material causes and consequences. It is also not my aim here to hobble flights of scholarly or artistic imagination and deny them the freedom of mobility that I have come to dearly cherish. In this regard (although I return to my own prosthetic leg—as well as to the prosthetic legs of an extraordinary woman who has made both the metaphorical and the material dance to her own choreography—later in this chapter), such an anecdotal move is not meant to overvalue the "secret" knowledge that is possessed and revealed by the cultural other who has a real prosthetic. Rather, it is meant to ground and expand the tropological premises of "the prosthetic" as it

informs the aesthetic and ethical imagination of the humanities and arts. Perhaps a more embodied "sense-ability" of the prosthetic by cultural critics and artists will lead to a greater apprehension of "response-ability" in its discursive use.

1

Sometime, fairly recently, after "the cyborg" became somewhat tired and tiresome from academic overuse, we started to hear and read about "the prosthetic"—less as a specific material replacement of a missing limb or body part than as a sexy, new metaphor that, whether noun or (more frequently) adjective, has become tropological currency for describing a vague and shifting constellation of relationships among bodies, technologies, and subjectivities. In an important essay called "The Prosthetic Imagination: Enabling and Disabling the Prosthetic Trope" that investigates the scholarly uses and abuses of the prosthetic, Sarah S. Jain writes: "As a trope that has flourished in a recent and varied literature concerned with interrogating human-technology interfaces, 'technology as prosthesis' attempts to describe the joining of materials, naturalizations, excorporations, and semiotic transfer that also go far beyond the medical definition of 'replacement of a missing part.'"[7]

We have, for example, "prosthetic consciousness" ("a reflexive awareness of supplementation")[8] and "prosthetic memory" (the public extroversions of photography and cinema that cast doubt on the privilege of interiority that once constructed individual subjectivity and identity).[9] Then there is the "prosthetic aesthetic," which "extends our thinking on the relationship between aesthetics, the body, and technology as an a priori prosthetic one."[10] We have also "prosthetic territories," described as "where technology and humanity fuse;"[11] "prosthetic devices," such as "autobiographical objects," that are "an addition, a trace, and a replacement for the intangible aspects of desire, identification, and social relations;"[12] and "prosthetic processes," such as "contemporary aging," that point to a "postmodern state [that] is clearly a prosthetic creature cobbled together out of various organic and cybernetic sub-units."[13] And then there is a recent issue of *Cultural Anthropology* that produces what might be called the "prosthetic subaltern" in two essays, respectively entitled "Stumped Identities: Body Image, Bodies Politic, and the *Mujer Maya* as Prosthetic" and "Desire and the Prosthetics of

Supervision: A Case of Maquiladora Flexibility."[14] Indeed, as Diane M. Nelson (author of the first essay) points out in her introduction to the issue's focus on prosthesis and cultural analysis:

The prosthetic metaphor is drawn from recent work in cyborg anthropology, feminist studies of science, philosophy, political economy, disability studies, and neurophysiology. . . . [P]rosthetics mediate a whole series of those binaries we know we need to think beyond, but which still tend to ground our politics and our theory (self/other, body/technology, actor/ground, first world/third world, normal/disabled, global/local, male/female, West/East, public/private).[15]

This is a tall order for a metaphor to fill. Furthermore, somehow, somewhere, in all this far-reaching and interdisciplinary cultural work (and with the exception of disability studies), the literal and material ground of the metaphor has been largely forgotten, if not disavowed. That is, the primary context in which "the prosthetic" functions literally rather than figuratively has been left behind—as has the experience and agency of those who, like myself, actually use prostheses without feeling "posthuman" and who, moreover, are often startled to read about all the hidden powers that their prostheses apparently exercise both in the world and in the imaginations of cultural theorists. Indeed, most of the scholars who embrace the prosthetic metaphor far too quickly mobilize their fascination with artificial and "posthuman" extensions of "the body" in the service of a rhetoric (and, in some cases, a poetics) that is always located *elsewhere*—displacing and generalizing the prosthetic before exploring it first on its own quite extraordinarily complex, literal (and logical) ground. As Jain points out in her critique, "So many authors use it as an introductory point—a general premise underpinning their work about the ways in which technoscience and bodies interact," and thus the "metaphors of prosthetic extension are presented as if they were equivalent in some way, from typewriters to automobiles, hearing aids to silicone implants. . . . Both the prosthesis and the body are generalized in a form that denies how bodies can and do 'take up' technologies of all kinds."[16]

There is, then, a certain scandal to this metaphorical displacement and generalization—not because my (or anyone else's) literal and specific experiences of prosthesis are sacrosanct or because the metaphor obliterates the political atroc-

ities of mass amputations by land mines in Cambodia or by civil war in Sierra Leone.[17] Rather, the scandal of the metaphor is that it has become a fetishized and "unfleshed-out" catchword that functions vaguely as the ungrounded and "floating signifier" for a broad and variegated critical discourse on technoculture that includes little of these prosthetic realities. That is, the metaphor (and imagination) is too often less expansive than it is reductive, and its figuration is less complex and dynamic in aspect and function than the object and relations from whence it was—dare I say—amputated. As Steven L. Kurzman (himself an amputee) summarizes in the aforementioned special issue of *Cultural Anthropology:*

Rather than develop a metaphor based on ethnographic material about artificial limbs or other prosthetic devices (e.g., breast implants, dental implants, joint implants, and so on), [scholars] develop a theoretical model to explain a problem arising out of a completely different topic and then retroactively define it in the world of amputation and artificial limbs. . . . Prosthesis simultaneously occupies the space of artificial limbs, metaphor, and discursive framework. The metaphor becomes unsituated and an instance of totalizing theory, managing to be both everywhere and nowhere simultaneously.[18]

In this regard, it is useful to think more specifically, if briefly, about the *function* of metaphor. To be fair to all of us who use metaphor (and who doesn't?), we must acknowledge that metaphor is, by tropological nature, a *displacement:* a nominative term is displaced from its mundane (hence literal, nonfigural) context and placed elsewhere to illuminate some other context through its *refiguration.* That is, by highlighting certain relations of structural or functional resemblance that might not be noticed without the transportation of a foreign object into an otherwise naturalized scene, an analogy is constituted. However, as Paul Ricoeur notes (quoting Pierre Fontanier), metaphor "does not . . . refer to objects"; rather, "it consists '*in presenting one idea under the sign of another that is more striking or better known.*'"[19] Thus, primarily based on the relation of *ideas* rather than *objects* and on structural and functional resemblances rather than physical similarities, metaphorical usage does not owe any necessary allegiance to the literal object—such as a prosthesis—that generated it. Nonetheless, it does owe necessary allegiance to a "common opinion" about the object and context that needs to acknowledge the resemblance sufficiently to "get" the analogy. As Ricoeur sums up: "resemblance

is principally a relationship between ideas, between generally held beliefs." Thus, not only does analogy operate between ideas of structure and function rather than between objects as such, but the "idea itself is to be understood not 'from the point of view of the object seen by the spirit' but 'from the point of view of the spirit that sees.'"[20]

It is not surprising, then, that the "spirited" individuals who use prostheses in the most literal (rather than literary) sense have some major problems with the prosthetic metaphor as it is seen (and used) by those whose point of view is positioned in some theoretical rather than practiced—and practical—space. In this regard (and following the work done by Jain), Kurzman emphasizes not only the short shrift given to actually substantiating the theoretical use of the metaphor (that is, justifying the analogy through careful comparison and contrast of specific structures and functions) but also two major and consequential reversals and reductions that have attended its current theoretical usage and that do not correspond to the common opinion of most of us who actually use prostheses.

First, despite the metaphor's emergence from an apparent and critical interrogation that is meant to disrupt the traditional notion of the body as whole, unlike Donna Haraway's nonhierarchical and hybrid cyborg the metaphor of the prosthetic and its technological interface with the body is predicated on a naturalized sense of the body's previous and privileged "wholeness."[21] Furthermore, this corporeal wholeness tends to be constituted in purely *objective* and *visible* terms: body "parts" are seen (from an "observer's" point of view) as missing or limited, and some "thing" other (or some "other" thing) is substituted or added on to take their place. This predication (and point of view) elides the phenomenological— and quite different—structural, functional, and aesthetic terms of those who successfully *incorporate* and *subjectively live* the prosthetic and sense themselves neither as lacking something nor as walking around with some "thing" that is added on to their bodies. Rather, in most situations, the prosthetic as lived in use is usually *transparent;* that is, it is as "absent" (to use Drew Leder's term) as is the rest of our body when we're focused outward to the world and successfully engaged in the various projects of our daily life.[22] Ideally incorporated not "into" or "on" but "as" the subject, the prosthetic becomes an object only when a mechanical or social problem pushes it obtrusively into the foreground of the user's consciousness—much in the manner in which a blister on a heel takes on an objective

presence that is something other even though the body's own bodily fluid and stretched skin constitute it. Thus, the existence or use of a prosthetic does not determine whether a user feels that his or her body is disrupted. Indeed, in common use, as Kurzman writes, "Artificial limbs do not *disrupt* amputees' bodies, but rather reinforce our publicly perceived normalcy and humanity. . . . [A]rtificial limbs and prostheses only disrupt . . . what is commonly considered to be the naturally whole and abled Body."[23]

Second, Kurzman points to the way in which the theoretical use of the prosthetic metaphor tends to transfer *agency* (albeit not subjectivity, as with the cyborg) from human actors to human artifacts. Paradoxically, this transfer of agency indicates a certain technofetishism on the part of the theorist—however closeted and often antithetical to the overt critique of certain aspects of technoculture for which the metaphor was mobilized. As an effect of the prosthetic's amputation and displacement from its mundane context, the animate and volitional human beings who use prosthetic technology disappear into the background—passive, if not completely invisible—and the prosthetic is seen to have a will and life of its own. Thus we move from technofetishism to *technoanimism*. For example, Landsberg, in "Prosthetic Memory," cites a Thomas Alva Edison film, made as early as 1908, called *The Thieving Hand,* in which an armless beggar is provided with a prosthetic arm that once belonged to a thief and, against his will—but not the arm's—starts stealing.[24] A similar agency is cinematically granted to the prosthetic arm belonging to the crazed German nuclear scientist in *Dr. Strangelove or: How I Learned to Stop Worrying and Love the Bomb* (directed by Stanley Kubrick, 1964). In terms of body parts, more arms and hands (which in fantasy often slip and slide between the severed limb and the prosthetic) have been granted agency by the cinema than legs. Perhaps, and I speculate, this is because, having an opposable thumb, a hand has essentially a broad and dramatic range of acting skills.)[25]

According to this seductive (and culturally recurrent) fantasy of the uncanny and willful life of limbs and objects, my prosthetic leg can go dancing without me and also can "will" me to join it in what, in effect, is a nightmarish *danse macabre.* And in the context of both technofetishism and technoanimism, I cannot help but recall my beloved *The Red Shoes* (directed by Michael Powell and Emeric Pressburger, 1948). Antedating both my own encounter with a prosthetic leg and our current culture of "high technophilia" (which might regard shoes as a fetish

but certainly not a technology), the film, based on a Hans Christian Andersen story, concerns a young ballerina who gets her big break in a ballet about a woman who longs for a pair of red slippers that, when she finally gets to put them on, force her to dance until she dies from exhaustion. Such transfers of human agency to our technologies allow our artifacts to come back with a vengeance. Thus, in amused response to reading a theoretical essay on the prosthetic that was rife with technoanimism, Kurzman imagines his "modest collection of below-knee prosthetic legs" (kept in a box in his basement) developing "a collective consciousness of oppression" when they realize that he had "been using them to complete [his] identity" and "march[ing] upstairs to have a word with [him] about it."[26]

In effect, the current metaphorical displacement of the prosthetic into other contexts (because of its analogical usefulness in pointing out certain vaguely specified structural and functional resemblances between ideas) also—and mistakenly—displaces agency from human to artifact and operates, as Kurzman puts it, as a "silencing dynamic of *disavowal*." Contemporary scholars (and many artists as well) are unwitting technophiles who, despite their critiques of global technoculture, too often "represent prosthesis and phantom limbs as agents, and amputees are present only as stumps and phantoms, which metonymically embody our lack of presence and subjectivity. Amputees . . . become 'the ground': the invisible, silent basis of the metaphor."[27]

Kurzman's use of the term *metonymy* here seems to me critical to our understanding of the negative reaction that many prosthetic users have to the current "prosthetic imagination" and also of the specific figural differences and consequent relational meanings and functions that "the prosthetic" discursively serves. Metonymy is a figural operation that is quite different in function, effect, and meaning from metaphor (even as it is often imprecisely subsumed by it). It is even more significantly quite different from *synecdoche,* with which it appears almost—and problematically—symmetrical. These differences often discursively slip and slide into each other in ways that are confusing, but they also form the expressive and dynamic ground of the varying, confused, and ambivalent ways in which prostheses are seen in their relation to the human beings who use them.

In this regard, Ricoeur (again glossing Fontanier) is particularly helpful. He differentiates the figural operations of the three species of tropes—metaphor, metonymy, and synecdoche—by their respective relations of *resemblance,* relations

of *correspondence* (or *correlation*), and relations of *connection* and goes on to explore these relations and their consequences in detail. Earlier I pointed out that predicated on relations of resemblance, metaphor operates to construct an analogy, presenting "one idea under the sign of another," primarily through highlighting similarities between the structural or functional aspects of objects rather than between the literal objects as such. Hence the prosthetic as a metaphor easily—and often—takes on adjectival form, characterizing and qualifying other nouns rather than serving a noun function itself: "prosthetic memory," "prosthetic territories," and so forth. Unlike metaphor, however, metonymy and synecdoche *do* primarily refer to objects—albeit quite differently. Constructing relations of correspondence or correlation, metonymy "brings together two objects each of which constitutes 'an absolutely separate whole.' This is why metonymy divides up in turn according to the relationships that satisfy the general condition of correspondence—cause to effect, instrument to purpose, container to content, thing to its location, sign to signification, physical to moral, model to thing."[28] In relation to the prosthetic, this variety of relationships plays out across the relevant literature as well as in the culture at large. For example, as Kurzman notes, the way in which agency is transferred from the amputee to the prosthetic is clearly metonymic in character; the cause-and-effect relation between two "absolutely separate wholes"—a human and an artifact—is exaggerated and becomes not an ensemble but the seemingly complete transference of force or influence from one species of object or event to another.

Synecdoche, unlike metonymy, constructs relations of connection through which "two objects *form an ensemble, a physical or metaphysical whole, the existence or idea of one being included in the existence or idea of the other.*'" This relationship of connection, Ricoeur writes, like metonymy, also divides up into a variety of subordinate but constitutive relations—"relations of part to whole, material to thing, of one to many, of species to genus, of abstract to concrete, of species to individual."[29] Particularly important to an understanding of tropes and to the troubled—and troubling—figural usage of the prosthetic is that, however symmetrical the functions of metonymy and synecdoche may appear, metonymic correspondence and synecdochic connection are radically different and "designate two relationships as distinct as *exclusion* ('absolutely separate whole') and *inclusion* ('included in . . .')."[30] In relation to Jain and Kurzman's critiques—and to

the perceptual and discursive conflict between "the point of view of the object seen by the spirit" and "the point of view of the spirit that sees"—the metonymic discourse of scholars (who describe the prosthetic *objectively* as an absolutely different species from the body) is exclusionary and is at odds with the synecdochic discourse of amputees (who describe their prosthetic *subjectively* as of the same species as the body that has incorporated and therefore included it). Thus, significant figural movement occurs from metonymy to synecdoche—from *the* prosthetic viewed abstractly to *my* prosthetic leaning up against the wall near my bed in the morning to *my* leg, which works with the other one and enables me to walk. And here it is worth pausing to note how the notion of my "other" leg functions in the previous sentence: that is, my "real" leg suddenly becomes the "other." But this is a false—and hence justly confusing—opposition, as well as a telling reversal of figure and ground. My "real" leg and my "prosthetic" leg are not usually lived as two absolutely different and separate things since they function as an ensemble and are each a part of my body participating in the whole movement that gets me from here to there. Thus, they are *organically* related in practice (if not in material) and are, to a great degree, *reversible* each with the other (my leg can stand in a part-to-whole synecdochic relationship with my body and vice versa). To refer back to Ricoeur and Fontanier, as I live them subjectively (and ambiguously), my two objective legs "*form an ensemble, a physical [and] metaphysical whole, the existence [and] idea of one being included in the existence [and] idea of the other.*"

Regarding the tropological tendency to see the prosthetic (and sometimes to live it) in metonymic relation to the body, the inclusiveness of synecdochic connection is not always as complete in existence as it is utopian in desire. Robert Rawdon Wilson writes: "Any consideration of prostheses has to take into account their potential failure and, even, the conditions under which they might go wrong or turn against their users. The consciousness of machines always includes . . . a dimension of fear. There is also fear's most intimate radical, an element of potential disappointment: the prosthesis may not work, or may work inadequately, or may entail unwanted consequences."[31] Although I really never feel as though my prosthetic leg possesses the agency or subjectivity to "turn against" me, I admit that it does have the capacity to become opaque, to turn into a hermeneutic object that I have to pay attention to and interpret and do something about (other than transparently walk with it). That is, my leg is transformed metonymically at

times to another (inhuman) species of thing—the prosthetic resisting its formerly organic function in an ensemble of action directed elsewhere. In these moments, it becomes an absolute other. This can happen suddenly—as when I lose a certain amount of suction in the socket that holds my leg in place, and I feel (quite literally) a bit detached from the leg and have to press the valve on its side to recreate a vacuum. Or as is more often the case, it can happen gradually—as when over a long and hot day of walking, a combination of sweat and the pressure of the edge of the socket begins to chafe my flesh and, if I don't "do" something about it, causes an abrasion.

Like the turns and effects of language in use, my experience—and view—of my leg (and of the rest of my body) is not only *dynamic* and *situated* but also *ambiguous* and *graded*. Whether and to what degree I live (and describe) my prosthetic metaphorically, metonymically, or synecdochically is dependent on the nature of my engagements with others (how do they see it, avoid it, or talk about it abstractly, or can I keep pace with them?), with my environment (when I'm in unfamiliar territory, the question is always "How far can I walk on it?"), with my mood (how physically attractive or frumpy do I feel overall, and what part of myself will I single out for praise or blame?), and my project (how do I write about "my leg" or "it" within the context of cultural studies?). In sum, Jain, Kurzman, and I question two major aspects of the tropology of the prosthetic. First, it is vague, if not inaccurate, as a metaphor that is meant to foreground the similarity of its structures and functions with various other ideas and institutional practices. Second, it has an objectifying and often stultifying tendency to privilege and essentialize metonymic and oppositional relations that separate body and prosthetic, thus neglecting or disavowing both the synecdochic relations that posit the cooperation and connective union of body and prosthetic in world-directed tasks and also the complex and dynamic ambiguity of all these possible existential and tropological relations as they are situated and lived.

2

I now focus, as earlier promised, on a few specific prosthetic legs—first my own rather mundane one and then the much more flamboyant ones of double below-the-knee (BK) amputee Aimee Mullins, a successful model and record-breaking

paralympian sprinter, who has subsequently gone on to celebrity as a motivational speaker, a writer, one of *People* magazine's "Fifty Most Beautiful People" in 1999, and the leading lady of *Cremaster 3* (2002), the latest in artist Matthew Barney's series of art-house films filled with "impressive prosthetics and special effects."[32] This move to the specific and material does not leave the realm of tropology but, rather, animates it—and the human-technology interface—with the complexity, ambiguity, and desire that are revealed both in "discourse" and by "real bodies" that are living both real and imaginative lives.

Here I want to stay grounded in (rather than displaced from) the materially, historically, and culturally situated premises of "the prosthetic"—even as the prosthetic also engages an experiential and discursive realm that is larger than that of its merely literal materiality, situation, and logic. As becomes particularly evident—and dramatic—in the case of Aimee Mullins's legs, such grounding of the prosthetic does not disavow figuration (which, in any case, cannot be avoided). Rather, metaphor, metonymy, and synecdoche are put in the service of illuminating the nature and experience of our prostheses instead of the prosthetic serving to illuminate something else (and elsewhere). Furthermore, even in my own mundane instance, focusing on the specificity of the prosthetic in its primary context functions also to highlight the contingent and uncanny play of its (and my) tropological and existential possibilities. That is, the prosthetic's many inconsistencies in use and its elements that are theoretically paradoxical yet creatively functional not only account for the fascination it holds for others but also open up imagination and analysis to an expanded range of action and description.

Beginning with my own situation, I want to take the general and vague trope of "technology as prosthesis" that Jain and Kurzman criticize and *reverse* it— turning it back and regrounding it in its mundane context where, like my prosthetic leg, it stands objectively in common opinion as the general and vague trope of "prosthesis as technology." This reversal neither rejects the supposed purpose of the initial metaphor (which according to Jain's description, "attempts to describe the joining of materials, naturalizations, excorporations, and semiotic transfer that also go[es] far beyond the medical definition of 'replacement of a missing part'") nor does away with figuration. Rather, viewing the prosthesis as technology allows me to stake out (and stand) my ground in the *materiality* of the prosthetic and

its incorporation—and in the process to playfully reconnect such figurative descriptions as "standing one's ground" with their quite literal "underpinnings."

In the summer of 1993, as the result of a recurrent soft-tissue cancer in my thigh, my left leg—after three operations, literally as well as metaphorically, "a drag"—was amputated high above the knee. For six months or so, while my flesh was still healing and I was engaged in strenuous preliminary rehabilitation, I got about using crutches (and here we might wonder not only how but also if crutches "hold up" in today's high-tech prosthetic imagination). Finally, however, my body was ready to go through the arduous plaster casting, fiberglass molding, and microfitting of a prosthetic leg so that I could begin to learn to walk again—a fairly lengthy and complex process that imbricated both intensive mechanical adjustment and physical practice. There were all sorts of physical things that I had to learn to do consciously in quick sequence or, worse, simultaneously: kick the prosthetic leg forward to ground the heel, tighten my butt, pull my residual limb back into the socket, weight the prosthetic leg to lock the knee, take a step with my "own" leg and unweight the prosthetic leg as I did so, tighten my stomach and pull up tall to kick the prosthetic forward, and begin again. This nonetheless took a great deal less time than I feared it would, given my middle-age, general physical clumsiness, and almost willful lack of intimacy with my own body. Although it took much longer for me to develop a smoothly cadenced gait, I was functionally walking in a little over a month.

A prosthetic leg has many components and involves dynamic mechanical and physical processes, as well as a descriptive vocabulary all its own. As an above-the-knee (AK) amputee, I have had four successive sockets that were molded of fiberglass and "thermo-flex" plastic to conform, over time, to the changing shape of my stump. The first socket was secured to my body tenuously through a combination of suspension belt and multilayered cotton "socks" of different thickness, which were added or subtracted depending on my fluid retention, the weather, and my slowly changing shape. Several sockets replaced that first one, and they were secured snugly through suction. Now I put the leg on by pulling my flesh into the socket with a "pulling sock" and then screw a valve into a threaded plastic hole embedded in the fiberglass, depressing it so that all the air escapes and my stump and the socket mold themselves each to the other. I have also had three different

metal knee mechanisms that are made out of aluminum and titanium, all of which were attached to a small wooden block that was bonded to the socket. The first was a mechanical knee with an interior safety "brake" that could be set to freeze at a certain angle to stabilize me in "midfall" inflexion; the second, a double-axis hydraulic knee that I didn't like because its reaction time seemed to lag behind my increasingly accomplished and fluid movements; and the third, my current single-axis hydraulic knee whose extension and inflexion move transparently (at least most of the time) in isomorphic concert with my own bodily rhythms.

Over time, two different lightweight metal leg rods (replacing my tibia and fibula) have run from the knee mechanism down into the foot—the first a dull silvery aluminum rather like the stuff of my crutches and the second a glowing chartreuse green titanium that I sometimes think a shame to hide. (Before the cosmetic cover was added, I remember an eleven-year-old boy coming over to me to admire it and crow, "Cool. . . . Terminator!") Ultimately, these metal rods, like the rest of the leg and thigh, were covered with foam that my prosthetist sculpted and shaped to complement, albeit not exactly match, my fleshy leg. (The prosthetic thigh is a bit thinner than my real thigh since it's not as malleable as flesh is in relation to clothing.) And then I've also had two feet although I've only needed one at a time—both of hard rubber composition with an interior spring that allows me to "roll over" and shift my weight from heel to ball even without an ankle joint, both the same model Seattle Foot. (Prosthetics often have place names like the Oklahoma Socket, the Boston Elbow, the Utah Arm.) Given my replacement and accumulation over time of all these prosthetic parts, I now have a complete spare leg in the depths of my closet behind some winter coats that I have no need for in California, and somewhere in the trunk of my car, there's an extra socket (put there and never taken out after I got a new lighter-weight one). Finally, along with the crutches that I use in the early morning before I shower or when I wake up late at night to get a drink of water or go to the bathroom, I have about six or seven metal, plastic, and wooden canes. Because my remaining femur is extremely short—little more than two inches in length—I need the cane for stability. It basically counters the slight torquing and consequent "wobble" of the pliable mass of flesh within my socket and thus helps ground my walk (but, again, we might ask if canes count in today's prosthetic imagination).

I've paid as much as $79.95 for the best of my canes (they can run into hundreds of dollars when they have silver handles shaped as the heads of hunting dogs to disguise physical need as aristocratic attitude), but I really do not know precisely how many thousands of dollars my prosthetic legs cost. Since I am one of a fortunate few who belong to a health maintenance organization (HMO) that covers such expenses and sends me no bills, I have been spared contemplation of the enormous and quality-of-life-threatening sums of money spent on producing, purchasing, and maintaining my prostheses.[33] Nonetheless, my research tells me that my full (and rather ordinary) AK leg probably cost no less than $10,000 to $15,000, since a top-of-the-line carbon fiber BK prosthesis used for sports competition (with a special flexible foot that its inventor calls the Cheetah) costs at least $20,000 per leg. Should I wish it (which I don't), I could request that my HMO approve the purchase and fitting of Otto Bock's latest C-leg—whose microprocessors, strain gauges, angle detectors, hydraulics, and electronic valves "recreate the stability and step of a normal leg" and that, as the *New York Times* reports, was a "lifesaver" for Curtis Grimsley who used the leg "to walk down from the 70th floor of the World Trade Center on September 11th."[34] On the other hand (or leg?), the HMO might refuse me—because the C-leg costs $40,000 to $50,000 and also because I'm a woman of a certain age who is generally perceived as not needing to be so "well equipped" as someone who is younger (and male).

Indeed, like the movement that it enables, prosthetic technology is highly dynamic and always literally incorporating (in both the bodily and business sense) the newest materials and technology available. Nonetheless, as Dr. Richard A. Sherman notes in a booklet written for amputees: "Just like any other machine, [prostheses] get out of whack and break with time and use. They need to be kept up properly and tuned up. The newer devices have computers, muscle tension and motion sensors, computer-controlled joints, tiny motors, etc. You can expect them to give you and your prosthetist more problems and have more 'down time' than relatively simple mechanical prostheses."[35] As it is, I have to see my prosthetist at least once a year: the mechanisms need checking and cleaning, and my cosmetic foam cover always needs some repair or "fluffing up."

I hope, by now, that you—the reader—have been technologized and quantified into a stupor by a very narrow and "objective" register of meaning—this

bland (or at least straight-faced) enumeration, detailing, and pricing of my pros-
thetic parts (whether on my body or in the closet) meant to ground and lend some
"unsexy" material weight to a contemporary prosthetic imagination that privi-
leges (and, like the eleven-year-old boy quoted above, is too often thrilled by) the
exotic (indeed, perhaps erotic) *idea* rather than the mundane *reality* of my intimate
relations with high technology. (Hence my wonderment about the prosthetic sta-
tus of my low-tech crutches or canes.) Missing here (albeit suggested) is a de-
scription of the variety of phenomenological, social, and institutional relations
that I engage that have been partially transformed by my prosthetic. My con-
sciousness, for example, has been altered at times by a heightened awareness of
such things as the availability of "handicapped" access and parking and also of the
way in which city streets, although still the same objective size, have subjectively
expanded in space and contracted in time so that crossing the street before the
traffic light changes now creates a heightened sense of peril and anxiety that I
never felt before my amputation.

Missing, too, is the way in which learning to walk and incorporate a pros-
thetic leg has made me more—not less—intimate with the operation and power
of my body: I now know where my muscles are and am physically more present
to myself. I also enjoy what for me (previously a really bookish person) always
seems my newfound physical strength, and I have discovered my center of grav-
ity (which, in turn, has transformed my entire comportment in ways that include
but also exceed my objective physical bearing). And, then, too, there are the en-
counters I've had with others that my prosthetic leg enabled—for example, a sup-
port group I attended at the request of my prosthetist (who had just started it and
wanted to show me off in my short skirt and one-inch heels as a success story).
There I met the most extraordinary individuals who might not otherwise have
crossed my path: an older quadriplegic man who for years had been locked away
by his parents and now, with some assistance, was living on his own for the first
time; a whining, self-pitying woman who had lost one of her legs BK to diabetic
gangrene and obviously "got off" on being in a position to tearfully order her hus-
band to respond to her beck and call; a furious young woman, just graduated from
college, whose legs were crushed in a car accident and whose boyfriend had just
broken up with her but who went on (still furious), with two AK prosthetics, to
become a Special Olympics athlete. And, of course, there was my prosthetist—

who knows my aging body and my ageless will perhaps more intimately and approvingly than has any other man in my life.

My objective description of the prosthetic as technology also doesn't begin to touch on the great pride that I've felt in my physical accomplishments or the great delight that I take both in the way my prosthetic leg can pass as real and the desire I have to show it off. This paradoxical delight and desire have led to a strangely unself-conscious and exuberant exhibitionism that always catches me by surprise. As Kurzman points out: "In a social context, artificial limbs are ideally invisible in order to facilitate mimicry of nonamputees and passing as able-bodied," yet many "amputees are proud of their ability to walk well and pass, and often disclose because one's ability to pass is most remarkable when people are aware of it. . . . Prostheses do become visible, but often under amputees' terms of pass and trespass."[36] Indeed, I often find myself revealing as a marvel what the prosthetic leg is cosmetically supposed to hide (that I have a prosthetic leg), and even more often, I tend to talk about—and demonstrate—the coordinated and amazing process of walking that we all don't normally think about but that the prosthetic leg is able to foreground and dramatize both to myself and for others.

These paradoxical desires and delights become particularly dramatic in relation to Aimee Mullins—both her legs and their "figuration" (discursive and literal). Consider, for example, the following passages from an article on Mullins by Amy Goldwasser that appeared in 1998 in an issue of I.D.: The International Design Magazine:

Men devote themselves to Aimee Mullins' legs. Two men, in particular, have made it their business to know every millimeter of the expanse that runs from Mullins' knees down to her heels. One of these men can tell you precisely how many foot-pounds of torque she stores and releases with every running stride. The other can speak authoritatively about the spacing of hair follicles on her shins and the width of her Achilles tendons. Then there is a third man, who is a glass-blower. "He wants to make glass legs for me. Isn't that amazing?" Mullins says, genuinely awed by the poetic offer. "He said, 'Cinderella had a glass slipper, I could give you glass legs.'"

In a modern literal twist to the old tale, it's not the beautiful heroine's hand but her legs that have inspired such courtly attention. And the kingdom at stake spans fewer than four feet, the lower-leg prosthetics, left and right, that Aimee Mullins wears. Mullins,

22, was born without fibula bones in her shins. Both of her legs were amputated below the knee at age one, a decision her parents made when doctors told them that otherwise she'd be confined to a wheelchair. On what Mullins refers to as her "sprinting legs," she is an elite athlete who holds world class records in her class in the 100- and 200-meter dash and long jump. On her "pretty legs," she is the only amputee in the country who looks magazine-model ideal in miniskirt and strappy sandals. If design can be seen as the quest for human solutions, then the challenge of creating legs to meet Mullins' bio-mechanical and beauty needs is an irresistible one to engineer and artist alike.[37]

What we have here is certainly the "high technology" of practical prosthetics. However, even more apparent—and to jaw-dropping degree—is the particular and contemporary "technological high" that comes from imagining and in Aimee's case from realizing prosthetics tropologically. For example, Van Phillips, who designed Mullins's "sprinting legs," said in 1998 of the Sprint-Flex III foot that is the legs' most prominent component: "I like to call it the Cheetah Foot because if you look at the hindquarters of the cheetah, the fastest animal there is, it's basically a C-shape."[38] And then there is Mullins's own description of her "pretty legs": "They're absolutely gorgeous. Very long, delicate, slim legs. Like a Barbie's. Literally, that's exactly how it is." Even though Barbie dolls are anatomically impossible (the breasts too big and the legs too slim to support the torso), Mullins finds "the doll ideal is liberating rather than limiting"; her "cosmetic prostheses make her a leggy 5'8" and she has an arch that demands two-inch heels."[39] And this "liberation" is experienced not only by Mullins alone but also by Bob Watts, the prosthetist who materialized her desire for "Barbie legs." He tells us, "These are sort of my fantasy legs. With a single amputee, it's easier to get an artificial leg to look like the sound leg. But when you're making two legs, it's twice as much work. But there's twice as much freedom, because there's also no reason why you can't make them absolutely identical and ideal. Aimee offered me an opportunity to produce the perfect female leg."[40]

The mind boggles—at the complicit male and female gender fantasies that literally are materialized here and at the complex and paradoxical desires that are uncannily articulated through and by the prosthetic. Cheetah legs? On the one hand (or is it leg?), this materialization is all about the desire for the superhuman power and prowess that are afforded by highly specialized technology. On the

other, its highly specialized technological enhancement of human motion and speed in sprinting paradoxically foregrounds the human costs of such technologically achieved and focused animal power. Thus, what is gained on one side is lost on the other. Mullins finds sprinting easy, and she finds that "it's standing still that's hard." As the article points out, "One limitation of legs that move like the fastest animal on earth: the fastest animal on earth is more stable than Mullins when not in motion." Thus, in photo shoots featuring her as an athlete, Mullins tells Goldwasser: "The photographer has to hold me and kind of prop me in position before I fall over."[41]

And then there are those fabulous glass legs. Unrealized in 1998, they formed the basis for a grandiose Cinderella story in which a romantic prince looks for an ideal woman with just the right legs (or lack of them) so that he can outdo previous narrative heroes and their glass slippers with something more and bigger. But the prince here is also a prosthetist—revealing both his and the imagined prosthetic's confused substrate of desire and fear. That is, the very physical and social transparency that prosthetists wish to achieve and amputees wish to experience with their artificial legs entails in such an extreme figuration slippage—in the esthetics of transparency, delicacy, and thus femininity and also latent awareness of the awful fragility of glass.

Except for the glass legs, the tropes that are articulated here discursively ("Cheetah foot" and "Barbie legs") are also materialized *literally*—but materially realized as legs, they maintain their figurative status as tropes nonetheless. That is, like language used figuratively, they are literally "bent out of shape" both in context and material form. Furthermore, as realized figures, they literalize both male and female gender fantasies and confuse such categories as human and animal or animate and inanimate in precisely the ironic way that Donna Haraway's cyborg was originally meant to do. This confusion is embraced quite matter-of-factly by Mullins, who, recalling a technology and design conference she attended, tells us:

The offers I got after speaking . . . were from animatronics designers and aerospace engineers who are building lightweight but strong materials, and artisans—like the guy who works for Disney and creates the skin for the dinosaurs so that it doesn't rip when their necks move. . . . These ideas need to be applied to prosthetics. . . . With all this new technology, why can't you design a leg that looks—and acts—like a leg? I want to be at

the forefront of these possibilities. The guy designing the next generation of theme parks. The engineers. The glass-blower. I want everyone to come to me with their ideas.[42]

Aimee Mullins—at least in this article in 1998—is entirely sincere but hardly naïve. However ironically paradoxical and politically incorrect, for Mullins's practical purposes the prosthetic fantasies articulated here are all potentially liberating. Indeed, Aimee Mullins's "Cheetah legs" have allowed her to set world sprinting records and her "Barbie legs" have allowed her a successful career as a fashion model.[43]

3

There is something truly uncanny about the literalization of desire—whether prosthetic or discursive. We find it utterly strange when figures of speech and writing suddenly take material form, yet at the same time, we find this strangeness utterly familiar because we wished such existential substantiations through the transubstantiations of thought and language. Thus, it was both uncannily strange and familiarly "right on" when, quite by accident and within two weeks' time, I suddenly encountered both Barbie and Aimee Mullins in two extraordinarily suggestive prosthetic scenarios—both discursive and both very real. Here we find prosthetic figuration literally and materially realized and the literal and material prosthetic reversed on itself reflexively to become figurally the trope of a trope. First, listening to the radio, I learned that Ruth Handler, Barbie's creator, had died. The news obituary recounted how, after achieving corporate success at Mattel Toys, she was ousted from its leadership for "covering over" the company's "losses." Then, a survivor of breast cancer, she went on to establish a successful company that manufactured "prosthetic breasts." Impossibly breasted Barbie on those unsupportable legs, cosmetically "covering over losses," a hidden mastectomy, prosthetic breasts: this admixture and this further reversal of the literal and figurative, the projective and the introjective, reflexively refer back to earlier figurations and make metaphor, metonymy, and synecdoche seem, by comparison, figurally straightforward.

And, then, a week later, I read that Aimee Mullins had finally gotten her glass legs—and more. Browsing through a current issue of *The New Yorker,* I came

across a short piece on the New York art-house opening of artist Matthew Bar-ney's latest addition to his epic *Cremaster* film cycle. Suddenly, there was Aimee:

Hardly less daring was the gown worn to the premiere by the movie's leading lady, Aimee Mullins: a beige, floor-length number with a deeply plunging backline skimming buttocks that could star in "StairMaster 3." Mullins, who is a double amputee, plays a number of roles in the film, including one in which she wears a backless dress over a pair of translucent high-heeled legs, and another in which she is changed into a cheetah woman, stalking her prey—Barney, in a pink tartan kilt and pink feathered busby— on hind legs that end not in human feet but in feline paws.[44]

This literalized figuration goes far beyond the narrower compass and func-tion of the usual prosthetic imagination—whether that of the cultural theorist or that of a prosthetic user like me. Indeed, I can barely keep pace with Aimee Mullins's legs here. Figuratively, they won't stand still: the "glass legs" (made, how-ever, of clear polyethylene) are now literalized to function figurally in a movie, and the "Cheetah legs" (the literal prosthetic Cheetah foot) are now figurally extended to incorporate and transform the whole woman. And, further, there is leading lady Mullins offscreen at the premiere "teetering slightly" in strappy sandals because, she explains to the reporter, "these legs have, like, Barbie feet, and the heels of the shoes are an inch too short."[45] Indeed, in Barney's film, she also has legs fitted with shoes that slice potatoes and, as a giant's wife, "legs cast out of dirt and a big brass toe," and another set of transparent legs "ending in man-of-war tentacles."[46] Again, we are far beyond simple irony here, far beyond metaphor, metonymy, and synec-doche. Indeed, we are both discursively and "really" in the tropological realm of *metalepsis*—the "trope of a trope." This is not simply repetition at a metalevel. Rather, as Harold Bloom (glossing tropes and the "psychic defenses" that inform them in his *A Map of Misreading*) writes:

We can define metalepsis as . . . the metonymic substitution of a word for a word al-ready figurative. More broadly, a metalepsis or transumption is a scheme, frequently al-lusive, that refers . . . back to any previous figurative scheme. The related defenses are clearly introjection, the incorporation of an object or instinct so as to overcome it, and projection, the outward attribution of prohibited instincts or objects onto an other.[47]

Here, with Aimee Mullins's legs (both onscreen and off), we have both—and simultaneously—incorporation and projection, an overcoming and a resistance, an unstoppable "difference" that is not about negation but about the alterity of "becoming." Aimee Mullins's legs in all their variety challenge simple figuration and fixity. Here the literal and the figural do not stand on oppositional ground, and the real and the discursive together dance to Aimee Mullins's tune—and choreography.

As for me, despite my awe and admiration for Mullins and the complexity of her life and projects, I have no desire to keep pace with her. I tend to locate my difference and variety elsewhere than my legs and just want to get on with things both mundane and extraordinary. Indeed, I remember long ago attending that first meeting of the support group at which my prosthetist proudly showed a video of amputees (without Cheetah legs) racing in the Special Olympics. As I sat there, I watched the people around me—and knew that all they wanted, as I did, was to be able to walk at work, to the store, and maybe on a treadmill at the gym. In sum, I've no desire for the "latest" in either literal or figural body parts. All I want is a leg to stand on, a limb I can go out on—so I can get about my world with a minimum of prosthetic thought.

Notes

1. The vernacular expression "a leg to stand on" is also used by phenomenological neurologist Oliver Sacks as the title for a book that deals with a topic somewhat related to the present one—Sacks's experience with a neurologically damaged leg. See Oliver Sacks, *A Leg to Stand On* (New York: Simon and Schuster, 1984). A similar version of this chapter also appears in Vivian Sobchack, *Carnal Thoughts: Embodiment and Moving Image Culture* (Berkeley: University of California Press, 2004).

2. Bruno Schulz, *The Street of Crocodiles,* trans. Celina Wieniewska (London: Penguin, 1963), 59.

3. Roland Barthes, "The Jet-Man," in *Mythologies,* trans. Annette Lavers (New York: Hill and Wang, 1957), 72-73.

4. It is worth noting here that *trope* has a philosophical definition as well as a rhetorical one: a trope is a figural use of language, but it is also an argument advanced by a skeptic. In this regard, a tropological phenomenology would take into account both senses of the word and would proceed in its "thick description" both fully aware

and productively suspicious that lived-body experience is always also being imagina-
tively "figured" as it is literally being "figured out."

5. Paul Ricoeur, *The Rule of Metaphor: Multi-disciplinary Studies of the Creation of Meaning in Language,* trans. Robert Czerny, Kathleen McLaughlin, and John Costello (Toronto: University of Toronto Press, 1977), 309.

6. Helen Deutsch and Felicity Nussbaum, "Introduction," in Helen Deutsch and Felicity Nussbaum, eds., *Defects: Engineering the Modern Body* (Ann Arbor: University of Michigan Press, 2000), 1–2.

7. Sarah S. Jain, "The Prosthetic Imagination: Enabling and Disabling the Prosthetic Trope," *Science, Technology, and Human Values* 24, no. 1 (1999): 32.

8. Robert Rawdon Wilson, "Cyber(body)parts: Prosthetic Consciousness," *Body and Society* 1, nos. 3–4 (1995): 242.

9. Alison Landsberg, "Prosthetic Memory: *Total Recall* and *Blade Runner,*" *Body and Society* 1, nos. 3–4 (1995): 175–189.

10. Joanne Morra and Marquard Smith, eds., "Introduction," in *The Prosthetic Aesthetic* (special issue), *New Formations* 46 (2002): 5.

11. See the back-cover copy of Gabriel Brahm, Jr., and Mark Driscoll, eds., *Prosthetic Territories: Politics and Hypertechnologies* (Boulder, CO: Westview Press, 1995).

12. Jennifer A. Gonzalez, "Autotopographies," in Brahm and Driscoll, *Prosthetic Territories,* 134.

13. Chris Hables Gray and Steven Mentor, "The Cyborg Body Politic and the New World Order," in Brahm and Driscoll, *Prosthetic Territories,* 244–245.

14. Diane M. Nelson, "Stumped Identities: Body Image, Bodies Politic, and the *Mujer Maya* as Prosthetic," *Cultural Anthropology* 16, no. 3 (2001): 314–353; Melissa W. Wright, "Desire and the Prosthetics of Supervision: A Case of Maquiladora Flexibility," *Cultural Anthropology* 16, no. 3 (2001): 354–373.

15. Diane M. Nelson, "Phantom Limbs and Invisible Hands: Bodies, Prosthetics, and Late Capitalist Identifications," *Cultural Anthropology* 16, no. 3 (2001), 303–313.

16. Jain, "The Prosthetic Imagination," 33, 39.

17. For a moving and specific discussion of mass amputations in Sierra Leone as a political counter to the slogan "The future is in your hands," see George Packer, "The Children of Freetown," *The New Yorker,* January 13, 2003, 50–61.

18. Steven L. Kurzman, "Presence and Prosthesis: A Response to Nelson and Wright," *Cultural Anthropology* 16, no. 3 (2001): 374–387.

19. Ricoeur, *The Rule of Metaphor,* 57. Ricoeur is quoting from Pierre Fontanier, *Les Figures du discours* (Paris: Flammarion, 1968 [1830]), 99.

20. Ricoeur, *The Rule of Metaphor,* 57–58, interior quotation is from Fontanier, *Les Figures du discours,* 41.

21. Donna Haraway, "Manifesto for Cyborgs: Science, Technology, and Socialist Feminism in the 1980s," *Socialist Review* 80 (1985): 65–107.

22. Drew Leder, *The Absent Body* (Chicago: University of Chicago Press, 1990).

23. Kurzman, "Presence and Prosthesis," 380–381.

24. Landsberg, "Prosthetic Memory," 175.

25. Freud himself possessed an oral prosthetic. In "The Uncanny," he writes of phantasies of "dismembered limbs, a severed head, a hand cut off at the wrist . . . feet which dance by themselves," these chilling and *unheimlich* because "they prove capable of independent activity." See Sigmund Freud, "The Uncanny," in *The Pelican Freud Library,* Vol. 14, *Art and Literature,* trans. James Strachey (Harmondsworth, UK: Penguin Books, 1985), 366.

26. Kurzman, "Presence and Prosthesis," 380.

27. Ibid., 383. In this regard, I note that I have a small etching on my wall at home called *Break a Leg* that was given to me by a close friend. Referring to a theatrical phrase perversely meaning "Good luck," the etching shows an onstage chorus line of disembodied legs and is, for me, a delightful figuration of my own early preoccupation with my prosthetic and the general fantasy of the transference of agency—through metonymy—from subjects to objects.

28. Ricoeur, *The Rule of Metaphor,* 56 (interior quotation is from Fontanier, *Les Figures du discours,* 79).

29. Ibid. (interior quotation is from Fontanier, *Les Figures du discours,* 87).

30. Ibid. (interior quotation is from Fontanier, *Les Figures du discours,* 87).

31. Wilson, "Cyber(body)parts," 242.

32. Rebecca Mead, "Opening Night: An Art-House Epic," *The New Yorker,* May 13, 2002, 35.

33. Kurzman, in "Presence and Prosthesis," also discusses these issues—considering, in particular, how the materials and design of his leg are "based on the same military technology which has blown the limbs off so many other young men," how he has benefited from "the post–Cold War explosion of increasingly engineered sports equipment and prostheses," and how the man who built his leg "struggles to hold onto his small business in a field rapidly becoming vertically integrated and corporatized" (382).

34. Ian Austen, "A Leg with a Mind of Its Own," *New York Times,* January 3, 2002, D1.

35. Richard A. Sherman, *Phantom Pain* (New York: Plenum, 1996), 231.

36. Kurzman, "Presence and Prosthesis," 379.

37. Amy Goldwasser, "Wonder Woman," *I.D.: The International Design Magazine,* May 1998, 48.

38. Ibid.

39. Ibid., 49.

40. Ibid.

41. Ibid.

42. Ibid., 51.

43. It is worth noting that, as a model, Mullins does not always use her "Barbie legs" or opt for "passing." See, e.g., a fashion advertisement for haute couture clothing, photographed by Nick Knight, that appeared in *The Guardian,* August 29, 1998. Mullins, purposefully doll-like in her seated pose, is revealed with two distinctly "mannequin-like" lower legs, the knee joints apparent, their condition rather worn, adding to Mullins's abandoned doll-like appearance.

44. Mead, "Opening Night," 35.

45. Ibid.

46. Nancy Spector, "Aimee Mullins," in *Matthew Barney: The Cremaster Cycle* (New York: Guggenheim Museum, 2003), n.p.

47. Harold Bloom, *A Map of Misreading* (Oxford: Oxford University Press, 1975), 74. Unfortunately, although I think it well worth doing, there is not room enough here to take "the prosthetic" as figure through all the tropes and attendant psychic defenses that Bloom lays out in a resonant—and relevant—argument and diagram (69–74, 84).

THE VULNERABLE ARTICULATE: JAMES GILLINGHAM, AIMEE MULLINS, AND MATTHEW BARNEY[1]

Marquard Smith

Prosthetics, Aesthetics, Erotics

This essay circles around a particular question: what kinds of erotic fantasies are being played out across medical, commercial, and avant-garde images of the body of the female amputee in Western visual culture? In attending to this question, my aim is to consider how and why these images articulate *the subject of prosthesis* in academic discourse with regards to what Vivian Sobchack has called "a tropological currency for describing a vague and shifting constellation of relationships between bodies, technologies, and subjectivities."[2] Although these images that point toward the confluence of prosthetics, esthetics, and erotics are often problematic in the extreme and the arguments that fasten themselves to and emanate from them are similarly somewhat awkward, it is my hope that asking this question will make certain previously unthinkable possibilities available.

Flirting with Technofetishism[3]

I have of late been flirting with technofetishism. By *technofetishism,* I refer simply to that well-known and widespread series of cultural practices acted out by academics, writers, artists, and others who fetishize technology in their writings and art making—both within the confines of their intellectual communities and in everyday life. From the start, I'm happy to acknowledge that technofetishism is a practice of a "perverse" kind.[4] Fetishes always are in the West, seeing as how, since at least the late nineteenth-century's epistemological explosion of perversions the

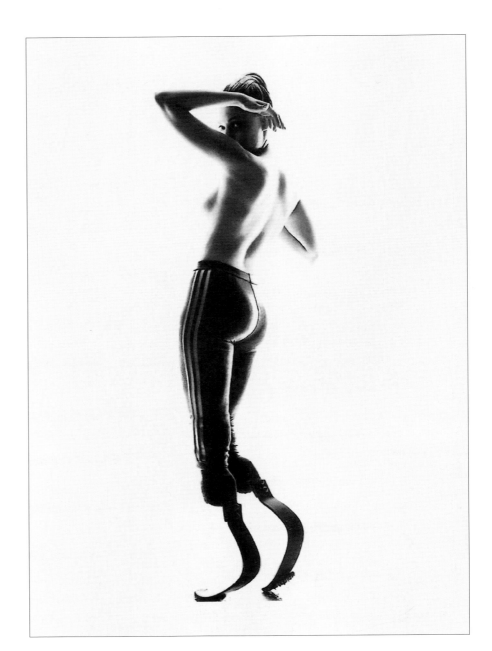

Figure 3.1: Aimee Mullins

Figure 3.2: from James
Gillingham of Chard, ca. 1915.
Reproduced with the permission
of the Science Museum/Science &
Society Plc Lib.

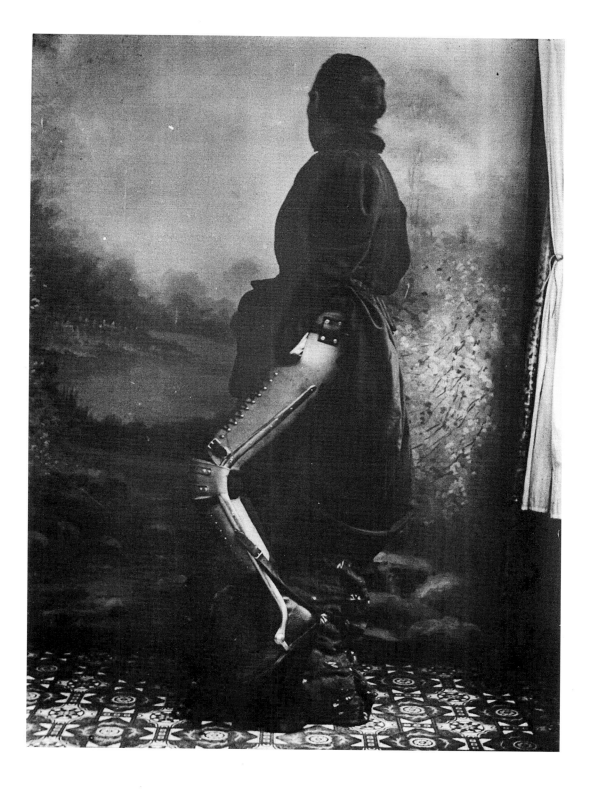

presence of fetishistic practices and objects marks the distinction between the "normal" and the "abnormal," the normative and the pathological, the well hinged and the unhinged, the "straight" and the "perverse." We will remember that for Michel Foucault in volume 1 of *The History of Sexuality,* fetishism was the "master perversion."[5]

This essay is well disposed toward perverse, fetishistic practices and objects in general. But it is wary of the notion of technofetishism, a pernicious notion whose cause for concern is its dangerously implicit metaphorical opportunism. Which is to say that philosophers of technology are prone to take advantage of metaphorical opportunities that are made available by thinking and writing about technology and about the technologization of being. They tend to indulge in a metaphorical poetics of technologization at the expense of the more mundane reality of material lives that are lived through technology and the body *as it is experienced* through the technology that it must employ—to the extent, for instance, that the figure of the disabled body has for them become a living, shining embodiment of posthuman existence in prosthetic times.[6] Even so, perhaps because of this, this essay must become intimate with technofetishism to gauge its impact on the constellation of bodies, technologies, and subjectivities—without ever losing sight of its potential dangers or my complicity with it.

Maintaining this fraught dialectic—between material and metaphorical, literal and figural, flesh and poetics—is the most productive way of engaging with the central concerns of this essay, the "constellation . . . of bodies, technologies, and subjectivities" in all of their real and phantasmatic, grounded and *un*grounded possibilities. Maintaining this dialectic becomes so pressing because it is only in attending to the literal, material, and fleshy nature of things *and* by flirting with technofetishism as a practice that involves an estheticization, a poeticization, and a metaphorization of "the prosthetic"—as what Sobchack calls an "unfleshed" out catchword—that one can make use of such possibilities without becoming unduly sympathetic towards the very things one admonishes.

To this end, the following speculations are staged in three parts. Part 1 considers the role that "passing" plays in the discourse of prosthesis and the way that the challenge that the amputee faces in trying to "pass" for something that they are not turns on questions of visibility and invisibility. To demonstrate this, I draw

on photographs from the early twentieth century that both follow a precedent set in medical imagery in the nineteenth century and, in pursuing commercial ends offer us ways to take in the intermittent oscillation between the visible and the invisible that engenders a fetishistic eroticization of the female amputees represented in the images. Part 2 deals with recent commercial fashion photographs of the American double amputee Aimee Mullins and with the press and media celebration around these images. It points out how her "becoming visible" as an eroticized Cyborgian sex kitten, while significant for the public presence of differently abled bodies in our visual culture takes place at the expense of her identity as an amputee, in fact requires the very negation of her figural condition as an amputee. Part 3 focuses on Aimee Mullins in a more recent fine-art context—the final episode of American artist-filmmaker Matthew Barney's five-part *Cremaster* cycle—to consider how she is drawn on here to both reaffirm the mechanisms and the fantasies of technofetishism and at the same time to offer some other nicely surprising possibilities.

Overall, then, I look to account for how these three historically distinct yet conceptually linked visual renderings of the confluences of bodies, technologies, and subjectivities as they are spun through the prism of prosthetics, esthetics, and erotics makes it possible for us to begin to articulate something neglected and thus worthy of note in the etymology of perversion. This is to say that an etymology of perversion makes it possible to acknowledge, open up, and seek to separate the more obvious perverse practices of technofetishism as practices of an erotic kind from a far more fascinating thread of the genealogy of perversion (that is already apparent in Havelock Ellis's sexology, Max Nordau's studies in degeneration, and Sigmund Freud's psychoanalysis) in which the matter of sexuality is but one part of perversion's desire to in fact mimic a "turning away" from such sexuality.[7]

The reason to insist upon the prospect of this separation—between the feat of perverting itself and perversions of a sexual kind—is founded on the need to preserve the promise of the former and to be wary of the sleight of hand of the latter (that is, to be wary of perversion's fetishizing in general, its fetishizing of technology in particular, its technofetishism, its ability to make things disappear, its imperative to loss). To put it another way, my endeavor here is to trace and rub up against the points of articulation between fetishistic practices, fetishistic objects,

and perversion itself. To do so is to question some of the ways that—following the three primary models of fetishism, the anthropological, the Marxian, and the Freudian—the matter of fetishism and its supplementary nature turn on or hint at a disavowal, a displacement, a replacement of or a compensation for *something else,* a substitute or surrogate for *other things,* now lost, that are magical, mysterious, horrific. So although I am deeply suspicious of fetishism's role in the patterning of human sexuality and subjectivity, what interests me is the prospect of the perverting (but nonsexualizing) thread of the etymology of this genealogy of perversion in which it becomes possible to begin to understand the implications of how (as Emily Apter has put it so succinctly) fetishism necessitates "inanimate or non-human objects, [and] living part[s] of the body [that are] treated as dead or partial objects substituted for the whole" and how "these inanimate, non-human, or partial objects are surinvested [or overvalued] to the exclusion of all other targets of desire." [emphasis mine][8] To put it more simply, what fascinates me is a decision to "turn away" from perverse and fetishistic practices as being exclusively sexual and to turn toward fetishistic objects (including the possibility of animat*ed* and animat*ing* objects as replacing our phantasmatic desire for the human body as a totalized union and instead lead us into a malignant, which is to say enduring investment in things that are not wholly human. For Apter, following Jacques Lacan, a body is thus "composed of prosthetic parts . . . rather than [being] at risk of . . . loss."

I believe, then, that certain discourses on prosthesis have something provocative to tell us about the nature of fetishistic practices and fetishistic objects—especially given the *supplementary* nature of these fetishistic objects, that, for Freud at any rate, are only ever body parts or inanimate objects substituted inappropriately for the sexual object proper, ultimately taking its place and thereby encouraging us further to abandon this so called "proper" sexual aim. Since this is in essence the definition of perversion, so by extension the discourse on prosthesis also has the chance to tell us something unexpected about perversion—the very pathology that *spawns* fetishistic practices. For me, something in the material and metaphorical articulations of the body and its prosthetic technologies is mirrored in the historical, theoretical, and morphological structures that we see unfolding in questions of fetishism and perversion and, as a consequence, questions of the emergence of sexuality and eroticism.

Part 1. Passing: Commercial Photography and "Evidence of a New Invisibility"

I really cannot tell you what my friends thought of your work, I believe there was only one word and that was "marvellous," and when I had the leg on and began to walk about, I don't think they fully realised it was me, after walking with a crutch all these years.

I must tell you I had a good deal of practice while at home, I had a mile walk two days after I left you and I did not feel any inconvenience after and on Sunday I had the leg on nearly all day, and I only had the backache a little. [emphasis mine]

This letter dated July 19, 1907, is one of a number of such patient testimonies that can be found in the Osteogenesis Collection at the Science Museum, London. It is attached to an archive of photographs of products that were manufactured by James Gillingham of Chard, a maker of artificial limbs since around 1866. These testimonies and images draw attention to the fact that at the heart of the modern discourse of prosthesis is the realization that the joining together of bodies and machines is not just a manufacturing process or even just an art and a craft. An ethic is in play here that seeks to answer a challenge of presentation and utility— how an item of prosthetic technology is fashioned industrially and also how this piece of machinery is experienced too. At stake, then, is how a particular prosthesis is sculpted and utilized, how it looks and how it works, and how its esthetic success and its practical success affect the ontology of its wearer—the body's experience of itself. These are matters of esthetics, ergonomics, and sentience.

Most interesting for my purposes is the quality of *in*visibility that circles around the presence of the prosthesis in the late nineteenth and early twentieth centuries. As the patient says, *when they put on their leg and began to walk about, they didn't think their friends fully realized who they were.* Like an uncanny inversion of the phenomenon of the spectral phantom limb, which is experienced by many amputees, here the identity of the patient has been disguised by the prosthetic device and at the same time has transformed the patient into someone else by its material existence. This is a perfect instance of the history of the development of prosthetic technology as it stands and falls on its ability to play hide-and-seek with the truth. This is simultaneously a humanitarian success story and a story of

inevitable failure. One story is about curative therapeutics, a pragmatic episteme of how medicine and technology come together with a shared compassion for the integrity of the human being to begin a process of reparation to turn the *disabled* into the *able*-bodied. Another story is about an ever more frantic effort to seek to conceal missing body parts, loss itself, by replacing them with artificial substitutes or surrogates, to replicate or imitate that lost object—an irreconcilable quest to make the human body whole again, a will to verisimilitude that in the end simply draws attention to its own inability to approximate the real.[9]

In this patient testimony, then, success and failure turn on the edge between invisibility and visibility. Success is gauged in terms of invisibility—in terms of *not* being able to see the prosthetic device or its consequences. Given this, it is ironic that the success story of prosthesis is legitimated by its adherence to the truth of reparation when it is in fact determined by *hiding* the truth, making *invisible* the body's "disability" and the very thing that makes it "able-bodied" again. This sleight of hand allows prosthetic wearers to carry out a so-called normal life while they are safe in the knowledge that the rest of the world is unaware of their disability. But of course, the point is that as effective as evidence of this new invisibility might be in principle and *from a distance,* much like aesthetic surgery, so it is for prosthetic technology. In practice our eyes can be deceiving. Once you get closer, intimate, there is always a small scar tucked away behind the ear or under the breast or, in the case of prosthetic technology, a slightly irregular gait, or as the letter indicates, a little bit of backache suffered by the patient that evokes a memory, sometimes visible sometimes invisible, that is both a reminder of success and an admission of the failure to hide this truth.

This discourse of prosthesis—as one of invisibility and visibility, success and failure, reparation and imitation, deceit and display—can be located in debates about aesthetic and cosmetic surgery especially toward the end of the nineteenth century (although its genealogy goes back much further than this) and in particular within the deeply ideological subject of "passing." While passing has been discussed recently by Judith Butler and Judith Halberstam in relation to questions of gender identity, performativity, and queer sexual practices, it is a topic that has also been revitalized by Sander L. Gilman in his cultural history of aesthetic surgery.[10] In *Making the Body Beautiful: A Cultural History of Aesthetic Surgery,* Gilman explores passing—an esthetic and as I have already suggested ideological

undertaking that emerged directly out of the racialization of nineteenth-century culture—as a challenge by which individuals seek to pass for something that they are not. This passing has historically assumed a variety of forms as individuals employ all kinds of esthetic and medical deceits to become something other than what they are. This is a question of not just masquerading but rather actually *becoming* something other than what we are—looking to pass *as* or pass *from,* say, being a man to being a woman or vice versa, from being straight to being gay or vice versa, from being black to being white or vice versa, and so on. (One can see why theorists of gender subversion such as Butler and Halberstam would find this trope so productive.) Through this operation of passing, the individual passes from one category to another, for the most part moving in a not unexpected direction—from a category of exclusion to a community of inclusion, from being an abject pariah to an object of desire, from being anomalous to being something else more enviable.[11] And while it must be kept in mind that passing is inherently conservative—because, as Gilman reminds us, unlike reconstructive surgery it is premised on a purely physical metamorphosis in which signs of physical difference (so-called pathological signs) are camouflaged through modification—the *consequences* are nonetheless very real.[12] As Gilman makes clear, such acts of "passing" do have a profound effect on the correlation between an individual's desire to overcome their physical stigmatisation and their psychological unhappiness or, to put it differently, the *visible* efforts at redesign will have a direct impact on an individual's *invisible* interior emotional architecture.

Much like Gilman's account of aesthetic surgery in which "techniques must constantly evolve so as to perfect the illusion that the boundary between the patient and the group [that they wish to join] never existed,"[13] developments in prosthetic technology as I have already indicated are *in principle* committed to the same evolutionary imperative—working seamlessly in such a way as to make themselves invisible. Similar to the narrative that takes place in the discourse of aesthetic surgery,[14] an account of the development of prosthetic technology is caught up in ideological concerns that are similar to those embedded in "passing" and thus might be characterized, as does Gilman for aesthetic surgery, as "evidence of a new invisibility."[15]

Given the importance of this evidence of the new invisibility—that the truth and success of the discourse of prosthesis are premised on hiding the presence

following pages:
Figures 3.3 and 3.4: from James Gillingham of Chard, ca. 1915. Reproduced with the permission of the Science Museum/Science & Society Plc Lib.

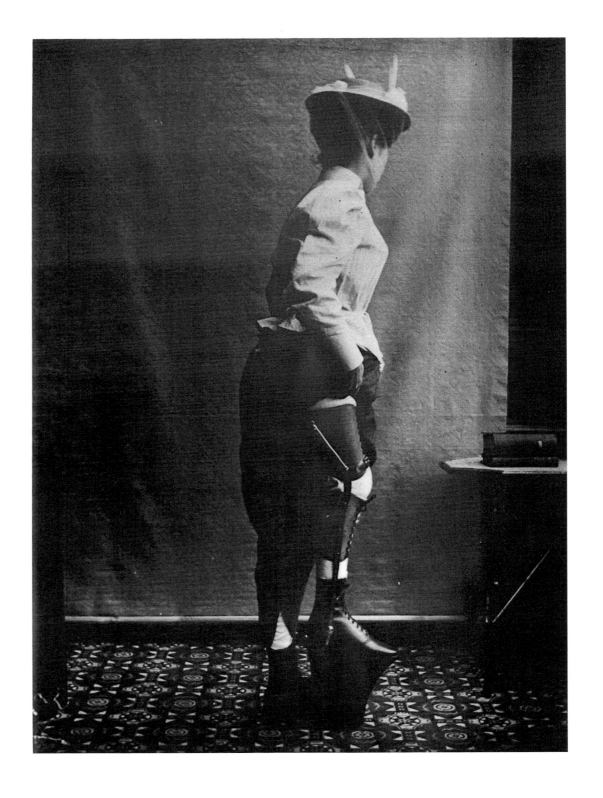

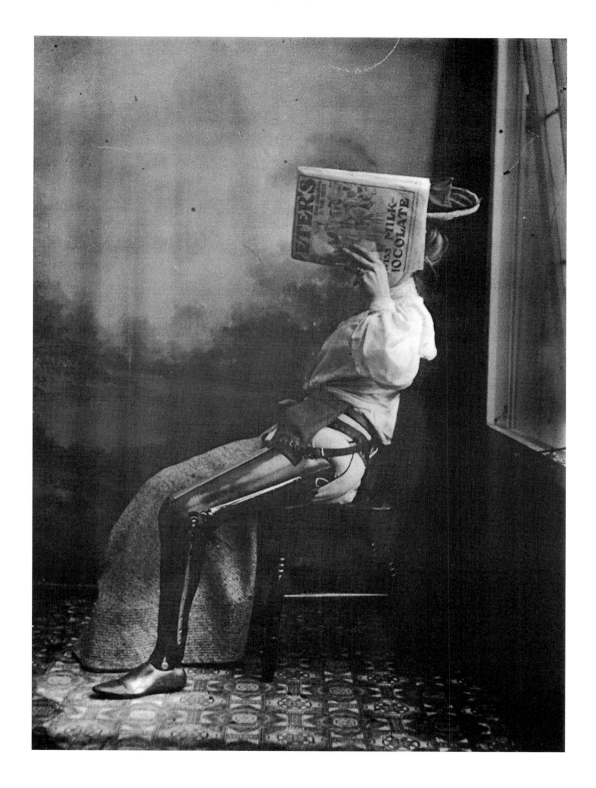

of the amputee's disability (their physical otherness) and that visibility makes failure all too evident—it is ironic that these photographs of female amputees produced by James Gillingham do the opposite. They *reveal* their prosthetic devices to show the virtuosity of their maker, the triumph of the technology itself, the possibility of their machinic articulations, and the impact that they will have on the user, the purchaser. Let us not forget that these photographs are serving a commercial purpose. Because of this, the wearer, the patient, the model is obliged to display (at the expense of their refusal to disclose) the technology in a way that draws attention to the very disability that the technology has been developed to disguise. Male amputees are often presented utilizing their prosthetic limbs as model examples of the enhancing potential of human-machine synergy and are shown fully integrated in the world of both work and leisure activities. But letters in the archives of the Science Museum and elsewhere from female amputees emphasize a need for continued disguise and a pleasure in such disguise—a pleasure in modestly and discreetly being able to pass for something other than dis-abled, in this case to be able to pass for being able-bodied.[16]

This is why the *exposure* of James Gillingham's patients in his catalogues is particularly troubling. In playing this game of hide and seek, the models, the photographer, the photographs themselves, the people using the ads to select prosthetic machinery for themselves, and we viewers as competent interpreters of images are obviously aware of this pivot between invisibility and visibility, hiding and revealing, concealment and revelation, and the assault to modesty that this exposure entails. This play between concealing and disclosure, secrets and their confession, also of course lies at the heart of debates in the discourse of fetishism, and it is writ large here, literally, in the complex way in which the revealing of the fetishistic substitute (the artificial limb) acts as both a desire to overcome loss and an exposure of that very loss itself. It is no wonder, then, that a consequent sexualization of the figure of the female amputee ensues. It is also worthwhile pointing out that because these photographs are images of female amputees displaying the manufacturer's wares for commercial purposes, this display, this exhibition, is a dual seduction that is at once commercial and erotic. Viewers need to keep in mind that these images are ads, the purpose of which is to sell Gillingham's products. But at the same time, the interior setting, the studio, the lighting, the painted backdrops, the props, the drapery, the staged quality of the images, and the carefully posed

figures of the women themselves certainly imply that an effort has been made to employ the accoutrements of portraiture (as commercial imperatives themselves maybe) to both humanize and individualize. Perhaps these very aspects of portraiture, coupled with the "theatricized or narritivized tableaux," further eroticize.[17] Some of these women have been invited to lift up their shirts, others to remove their overgarments so that a potential customer might see more precisely the quality of the products crafted by Gillingham. In giving in to the request to disrobe, the amputees assist in the selling of the callipers, body supports with underarm stirrups, leather bodices, corsetry, and artificial limbs that are Gillingham's specialty. In so doing, they expose their arms, the napes of their neck, the tops of their thighs, the shadow effected by the point at which the tops of their thighs and buttocks meet, revealing skin that has been trussed up by the confines of straps, (garter) belts, and buckles. Skin is squeezed and molded by the bondaged tautness of its restricted lacing, the back-straightening contraptions have a sadistic edge, and the hints of undergarment betray a less than prudent photographer who is inviting our voyeuristic gaze. With a twist of the hips, the women turn away from the camera to obscure their faces, to remain anonymous and disguised, to keep their modesty intact and their identity a secret. By averting their gazes, they also endeavor to frustrate the attention that we might lavish on them, which could, in turn, distract our eye from more properly consumerist desires.

Part 2. "Be a 'Creature Unlike Any Other'": Fashion, Fashion Photography, and Aimee's "Pretty Legs"[18]

This fetishistic dialectic between invisibility and visibility, concealing and revealing, denial and disclosure, loss and enhancement seems to be thrashed out somewhat differently in the instance of Aimee Mullins, who is committed in a variety of ways to "passing" *as* disabled—although I'm going to suggest that this isn't necessarily what ends up happening. Mullins is an American double-amputee paralympian athlete who appeared provocatively in a Nick Knight photo shoot for a 1998 issue of the fashion magazine *Dazed and Confused* guest edited by fashion designer Alexander McQueen; who adorned the catwalk, Barbie doll-like, on a revolving pedestal in McQueen's 1999 spring-summer collection in London; and who sprinted through the desert landscape of a television advertisement for the

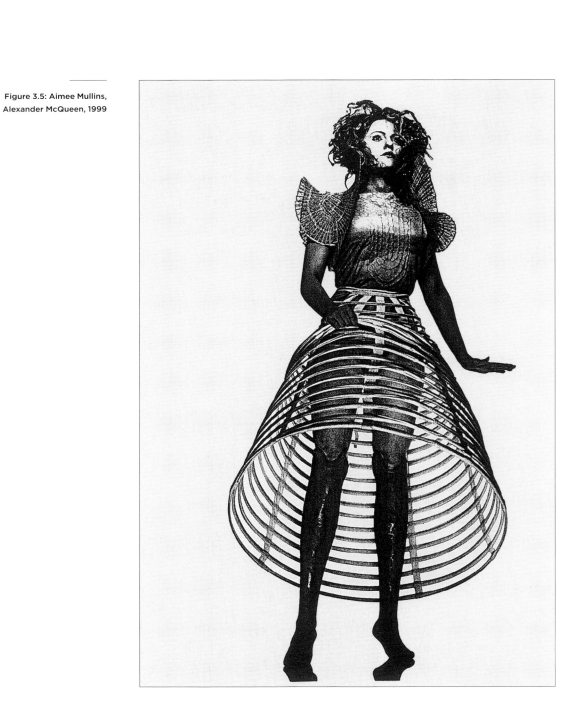

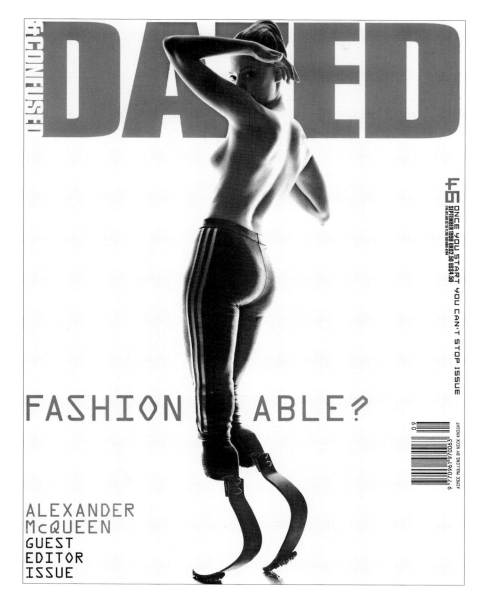

Figure 3.6: Aimee Mullins, *Dazed and Confused*, 1998

British Internet service provider Freeserve in 2000 on her carbon-graphite Chee-tah legs designed by Van Phillips. Aimee Mullins is featured in American artist-filmmaker Matthew Barney's film *Cremaster 3* (2002) which I consider in part 3.

As might be expected, the tabloid newspapers, popular magazines, and se-rious news sources responded to these images by concentrating on Aimee Mullins as the figure of the quintessential Cyborgian sex kitten rather than as an amputee. Every image and every discussion drew attention to the arrangement of her body and its supplementary parts, but although her status as an amputee was a signifi-cant autobiographical detail (certainly during TV chats with Oprah), it was never played up as an aesthetic, erotic, or ergonomic fact in and of itself.[19] Instead, these conversations sought to maintain her seamless presentation—the ultimate victory of technology over deficiency. What mattered was that the seams were overlooked, the joins did not show, even when they were impossible to ignore. Unlike James Gillingham's images of amputees—images that sought the comfort of the "new invisibility" and yet exposed their subjects as amputees for commercial and erotic rewards—Aimee Mullins *was not allowed* to be an amputee or disabled. More pre-cisely, her disability was simply seen as another perfect example of posthuman progress, a simple celebration of the human spirit's victory over adversity—or for those in complete denial, a wonderful sleight of hand that we might come to be-lieve in our age of computer-generated images.

To be less dramatic, it isn't strictly true that she *wasn't allowed* to be disabled. Her image became commercially and aesthetically palatable because of the ways in which the power of the human spirit was celebrated over the fact of her disabil-ity, that she refused to be a victim of her disability and was proud to show us that this was the case. She was honored specifically for this defiance. Interestingly, then, her image becomes a visible illustration of the recent eroticization of disability because she is sexualized as an *able*-bodied woman, one who just happens to be an amputee. That is to say, she is not really eroticized because she is an amputee. At best, her status as an amputee must be acknowledged and disavowed simulta-neously—and her prosthetic legs, more than just a substitute for her missing limbs, allow us to argue her back into existence as a cyborg, a prosthetic body, a figure of supraerotic fantasy.[20]

Mullins is wholly complicit with this game. Although she is a staunch cam-paigner for the rights and choices of people with disabilities, she is in wholehearted

narcissistic collusion with her own objectification and eroticization. So, while she is adamant that she wants to "challenge prevailing attitudes toward beauty" and wants "to be seen as beautiful because of [her] disability, not in spite of it," she is also aware of and complies with the more obvious forms of conventional feminine desire and admits that she is prone to vanity (although she happily shares this vanity, she confirms, with "billions of other women"). It is well documented that Mullins has always been determined to have legs that are designed for the sake of appearance as well as function and practicality, since conforming to such stereotypes is not so much debilitating, as it is aspirational and liberating. And she is prone to wear short shirts and high heels to show off her long, delicate, Barbie-like legs—it is well worth remarking that what she calls her "pretty legs," a longed-for alternative to the composite of plastic and wood legs with a foam coating that she wore in the past, whose toes she paints assiduously, have little blue veins around the heel of the feet, and that these feet remain permanently arched since these pretty legs are designed specifically to be worn with two-inch heels, *and simply don't function without them*. (It has also been noted that if she stops moving, she has to lean or be leaned against vertical surfaces for stability. This nuisance, the point where movement and animation give way to graceless immobility, has a key role to play in what becomes crucial about Mullins's place in artist-filmmaker Matthew Barney's *Cremaster 3*.)

So while these images of Mullins contribute to an important increase in the visibility of the differently abled bodies of amputees, in the fashion and the advertising industries they raise, turn, and fail on the collusion of visibility itself. If her presence does offer mild surprise (or what people call shock value), it still does little more than pay lip service to the affirmative politics of disability identity, and that, in the end, perhaps from the beginning, being up front on the fashion runways and in fashion magazines seems to make little difference to her fetishization or her complicity with—or implication in—her own enfreakment.[21] Ultimately, her differently abled body does not challenge any esthetic conventions of beauty or offer (as some working in Disability Studies would have it) potentially disruptive possibilities in and of itself.

If anything, quite the opposite is the case. My feeling, unfortunately, is that these images simply feed our culture's fascination with spectacles of difference, even if they do so in new ways. While they no longer hide the fact of disability or

seek to overcome such lack by exposing such deficiency from the beginning, and while this means that they no longer hide the (sometimes metaphorical, sometimes metonymic) sexual fetish or the meaning of the sexual fetish, her image here has neither the power to disturb (in a way that castration anxiety might be expected to disturb), nor does she make available an autonomous power to produce an eroticism that goes beyond her own fetishization. Much like the earlier commercial photographs from James Gillingham's catalogues, the figure of Aimee Mullins here on fashion runways, in magazine photo shoots, or in advertisements seems to have made no difference to the will to fetishize female amputees or to her own implication in such fetishization. It is just another example of what Kobena Mercer (in the context of his discussion of Robert Mapplethorpe's photographs) has called "sexual fetishism dovetail[ing] with commodity fetishism to inflate the valorization of print texture in art photography as much as in fashion photography."[22]

Part 3. Matthew Barney's Aimee Mullins: Intimacy, between Me and the Ground There Was Nothing

Aimee Mullins appears very differently in *Cremaster 3* (2002), the final installment of American artist-filmmaker Matthew Barney's five-part *The Cremaster Cycle* (begun in 1994 with *Cremaster 4*). In *Cremaster 3,* Mullins is no longer the generic if individualized figure of sexual athleticism, the cyborgian sex kitten, or the eroticized amputee. Well, she is still all of these things, and explicitly so, but she is also somehow more. This may have something to do with the numerous guises that she slips into in Barney's *Cremaster 3* the fictional parts that she takes on. These include the character of Oonagh, the wife of the Irish giant Fionn Mac-Cumhail; the role of Moll to Matthew Barney's Entered Apprentice; a unnamed woman sitting in a white room in the Cloud Club bar cutting potatoes with a device attached to the sole of her prosthetic legs; a figure known as Entered Novitiate, who quickly morphs into a cheetah divinity, languid one moment and fierce the next; and finally, at the end of *Cremaster 3,* a dying, bleeding, blindfolded Madonna with a noose around her neck (which may or may not indicate sexual asphyxiation) who is sitting astride a flexiglass sled tethered to five lambs and wearing clear prosthetic legs that end in man-of-war tentacles. (And I shall return to this final image in a moment.)

To engage with these current incarnations of Aimee Mullins and to distinguish them from her earlier phantasmatic, fetishized, and narcissistic manifestations, it is worthwhile focusing on the line of reasoning proposed by Nancy Spector, the curator of the Matthew Barney exhibition that toured the Museum Ludwig, Cologne; the Museum of Modern Art of the City of Paris; and the Solomon R. Guggenheim Museum, New York. As the first and as far as I can tell the only person so far to discuss, to any great extent, Mullins in the context of Barney's artwork, Spector gives us a way into the figures of Aimee Mullins in her extended catalogue essay "Only the Perverse Fantasy Can Still Save Us."[23] For Spector, the whole of Barney's five-part *Cremaster* cycle has developed as a project that is, as she says, "a self-enclosed aesthetic system" in which the body "with its psychic drives and physical thresholds—symbolizes the potential of sheer creative force." For Spector, Barney's "perverse imagination" takes us on a journey—a rite of passage through his physical, psychological, and geographical landscape of "digestion, repression, and morphing," a landscape that emerges from and is carved out of the psychosexual and the libidinal and is for her narcissistic, anally sadistic, and, at one and the same time, a masturbatory machine—much like Marcel Duchamp's *The Bride Stripped Bare by Her Bachelors, Even* (1934), to which she refers.[24] Never not meticulous, Barney's *Cremaster* cycle has for Spector "an attention to detail that can only be described as fetishistic,"[25] while overall its "creative potential of perversion pervades [its] very genetic code."[26] It is clear that for Spector to be in Matthew Barney's *Cremaster* cycle is to be enveloped in the perverse and fetishistic folds of psychoanalysis.

There is much to debate and much to disagree with in Spector's catalogue essay as well as in the exhibition itself. Nonetheless, for my purposes, the most straightforward way to engage with the roles of Aimee Mullins in *Cremaster 3* is to pit Spector's essay with and against another part of her catalogue, a section entitled "Personal Perspectives" in which a number of the individuals involved in Barney's *Cremaster* cycle—including Gabe Bartalos, the prosthetic makeup and special effects expert;[27] Norman Mailer, a protagonist in *Cremaster 2;* Richard Serra, a character in *Cremaster 3;* Ursula Andress, a star of *Cremaster 5;* and Aimee Mullins herself—are given a chance to speak about the pleasures of working on it.

Having already appeared in a number of early scenes in various guises, Mullins's central performance is at the heart of *Cremaster 3* in a section of the film

entitled "The Order," which "rehearses the secret initiation rites of the Masonic fraternity."[28] This section is made up of five scenes or degrees, as they are called in the film, and each scene reveals Matthew Barney's character (a modification of his earlier incarnation, the Entered Apprentice, as a cross between Odysseus, Lara Croft, and Donkey Kong) facing a challenge. This challenge is played out as a semicomedic journey in which he scales the interior walls of the Guggenheim Museum, encountering combative obstacles as he progresses first up and then down the interior levels of the building's spiraling architecture. Each of the five degrees of "The Order" is representative of one of the five episodes of the *Cremaster* cycle. Aimee Mullins comes into view in the third degree of "The Order" and thus personifies the third episode of the *Cremaster* cycle, *Cremaster 3* itself. She is a personification of the very film in which she acts, of which she is a part, and is thus for Spector the "narcissistic center of the cycle." Positioning Mullins in this way licenses Spector to claim that Mullins—as a character known as Entered Novitiate, a "couture model dressed in white gown with crystal legs" (although I have always felt that her outfit is more naughty nurse's uniform that couture)— will mutate into "a hybrid Egyptian warrior whose lower body is that of a cheetah." For Spector, in this key role at the center of *Cremaster 3* Mullins "is, in essence, the Apprentice's [that is, Barney's] alter ego." Thus when Mullins and Barney confront one another face to face, Spector says that he is "facing himself in all his guises." She continues:

Looking into the mirror of his own soul, he is transformed into an apparition of his female element. They embrace each other with the FIVE Points of Fellowship in a moment of exquisite oneness, and the model whispers the divine words Maha byn[29] *into his ear. But she then abruptly transmutes into the cheetah and attacks. An intense struggle ensues, which continues intermittently throughout the Order, until the Apprentice uses the stonemason's tools to slay the hybrid creature; with a blow to the plumb of her temple, she drops to one knee; hit with the level in the other, she drops to both knees; and struck in the forehead with the maul, she falls dead. Having ceremonially killed off his own reflection, the Apprentice achieves the level of Master Mason.*[30]

At the end of *Cremaster 3,* we are given a final image of Aimee Mullins, presented to us by Nancy Spector thus:

Figure 3.8: Matthew Barney,
Cremaster 3, 2002, production
still, photo: Chris Winget, © 2002
Matthew Barney

*The final image of the Order shows Mullins seated on a sleigh drawn by five baby
lambs. She is dressed in the costume of the First Degree Masonic initiate. Blindfolded,
she wears a noose around her neck. Blood spills from her temple and forehead, where she
had endured the fatal wounds of the Mason's tools.*[31]

I am less concerned than Spector is with Mullins as the narcissistic center of the
cycle—as the Apprentice's/Barney's alter ego, the mirror of his soul, his feminine
element, another wise, dead woman whose passing confirms the ascension of
Barney's character to greatness. What interests me more is what Mullins has to say
about this final scene in her "Personal Perspectives" section of Spector's cata-
logue. Mullins is well versed in the acknowledged and regulative symbolism of
the *Cremaster* cycle. But while she is all too aware, confirming Spector's analysis,
that her character is "essentially a reflection of Matthew's character,"[32] she also
gives two alternative insights—political and personal—into this specific scene,
neither of which is readily available in either Spector's text or Barney's *Cremaster
3*. The political insight is that when Barney "first told [her] about the Entered
Novitiate character dressed as a candidate with the Masonic First Degree—with
the left pant leg and right sleeve rolled up, the left breast exposed, blindfolded and
wearing a noose—[she] thought, 'I can't do that,' [She] remember[s] thinking
how many disability-rights activists were going to be calling [her] outraged."[33]
The personal insight is even more telling:

*The clear legs ending in man-of-war tentacles worn by the Entered Novitiate [in this final
scene] evolved as a compromise. Originally Matthew had wanted me to do that scene with-
out prosthetics. He saw this as a way to express the Masonic theory that you have to lose
your lower self in order to reach a higher level. I guess the literal representation of that
would have been for me to sit on the sled without any limbs below the knee, but that
would have been difficult for me because it's very, very intimate. We had a long dialogue
about what we could do instead, and Matthew came up with the idea of making the legs
appear like jellyfish tentacles because they're not a human form and they're clear. It worked
for me because I don't feel so bare where there's something between me and the ground.*[34]

I'm certainly not accusing Barney of being an amputee devotee. His desire
to strip Mullins of her prosthetic legs so that he can make some spurious symbolic

point is an act that on first viewing strikes me as far more disingenuous and boor-ish than that. In a sense, stripping her of her literal legs so that she can be seen to rise to a higher level replicates some of the most careless and ill-thought-through philosophies of disembodied technofetishism in which discussions of *post*human-ism are really little more than celebrations of *de*humanization. This is what I ear-lier referred to as metaphorical opportunism. But if we put Barney's Masonic foolishness to one side and listen carefully to what Mullins has to say, something quite surprising emerges. Hearing her say that to be without prosthetic limbs is to be exposed, to be laid bare, and that these prosthetic limbs are an emotional crutch as well as a corporeal support is not surprising. But learning that they are *a guard against intimacy* is unexpected. Or, rather, she tells us that it would have been too, too intimate to have appeared in *Cremaster 3* without wearing some kind of prosthetic machinery, even if the prosthetic takes the nonhuman anthro-pomorphic form of the tentacles of a large coelenterate hydrozoan and ever if it would not permit her to stand by herself, let alone to walk on her own. Anything, as long as there is something to stop her feeling the bareness between her self and the ground, to make sure that there is something, even if it is impossibly shaky and unstable, and makes you all the more vulnerable.

Although unrealized, in hoping to have Aimee Mullins appear without her legs, her cheetah legs, her pretty legs, or even her man-of-war legs, Barney pro-vides us with the chance to make out something very intimate—*too* intimate—about the subject of prosthesis. And if you watch Mullins, you realize that there are in fact numerous moments of awkwardness throughout *Cremaster 3* in which we see her staggering around the set with her transparent legs, wobbly on her feet, walking backward unsteadily, often on the brink of toppling over, holding onto the balustrade of the Guggenheim Museum for support, always trying to keep her balance on the oblique angle of the museum's runway.

These uncomfortable movements, along with the far too intimate image of Mullins without her prosthetic legs, are redolent with a vulnerability that is not a ready part of the discourse of prosthesis with its overwhelming imperatives of rehabilitation, empowering, and resolute unshakability. And yet here we have many scenes in which Mullins is truly perverse, but in a properly etymological sense of that word. She "twists" and "turns the wrong way"—which is to say away from her figuration as a perverse erotic fetishistic object and toward an almost desperate celebration of the relative failure of movement wherein her prosthetic legs are not

a *metaphor* of lack but a *metonymy* of movement, a substitute for nothing, for the space between her self and the ground, that otherwise unbridgeable gap between immobility and touching the ground, undoubtedly an incitement to movement.[35]

————

In this essay, I have tried to say something about the tensions and contradictions between stillness and movement—between the stillness of photographic stills and the movement of moving-image culture. Many of the questions that make up a provocative engagement with the discourse of prosthesis lie in the variegated gaps *between* stillness and movement—in the hinge between the inanimate and the animate, the so called disabled body that is rendered somewhat inoperative and the ways in which that body is jump-started into all kinds of mobile modifications, however unstable some of these experiences might be. This is very much the position that Aimee Mullins is found in Matthew Barney's *Cremaster 3*. So while I am all too aware of some of the naïve assumptions I am making about differently-abled bodies in our visual culture, I am more acutely aware that it is necessary to be attentive to the danger that the stillness of images can cause to bodies already often either rendered immobile or overly technologized by metaphorical opportunism. For it is this stillness, such an integral part of the fixity of the process of stereotyping, eroticizing, and objectifying that has played such a destructive part in the history of disability and in the discourse of fetishism. It seems to me, at least in a provisional way, that fetishism—the practice of making an object a fixture, a mark of the recognition of disavowal, an inflexible substitute, a replacement for other things that have moved on for one reason or another—might be affected by the moving part of moving-image culture. At the same time, the discourse of *prosthesis* might wish to focus on the grey area between the inanimate and the animate, on the brink of articulation, which is precisely where we can best attend to the point of convergence between the metaphorization of the prosthetic body *and* its materiality—its moving flesh as well as its wood, plastic, leather, metal, and hydraulic systems, because it is well worth remembering that the prostheticization of the human body does not mean a necessary material displacement of that body.[36]

While attending to this hinge between stillness and movement, between inanimate and animate, and to its effect on our understanding of both the material and metaphorical prosthetic body, I planned to move backward and forward across

the question with which I began this chapter: what kinds of erotic fantasies are being played out across medical, commercial, and avant-garde images of the body of the female amputee in Western visual culture? In so doing, I did my best to keep two ideas in mind. The first idea was a need to attend to how three domains of visual imagery—medical/commercial photography, fashion photography, and moving-image culture—over the period of almost a hundred years offer almost identical instances of technofetishism. Having said that, I hope I have also begun to draw out some of the ways that these three instances of metaphorical opportunism are trying, intentionally or otherwise, to propose an alternative to such technofetishism, even if more often than not they fail to deliver in the end. (It is hard to envisage thinking fetishism through the movements of metonymy rather than through its structuring metaphorical dynamics.) The second idea was to consider how the discourse of prosthesis—in its facility to articulate the confluence of bodies, technologies, and subjectivities—draws attention both to the role that perversion and fetishism play in the eroticization of visual imagery, and some of the reasons why this might be so, and to the ways that we might be able to begin to think about perversion and fetishism, perverse practices and fetishistic objects, in ways that are resoundingly not sexual at all. Which is to say, in the end I hope to have intimated that the discourse of prosthesis in fact makes it possible for us to begin to speak of fetishism and perversion in a way that is stripped of sexuality and eroticism, that exists beyond an economy of lack, and that instead, endures in other kinds of productive practices, if one can imagine such a thing.

Notes

1. The word *articulate,* as used here, means "having joints" rather than "speaking fluently and coherently." Earlier versions of this essay were presented at the Courtauld Institute of Art in October 2002 at the invitation of Caroline Arscott and Gavin Parkinson and at the Twenty-ninth Association of Art Historians Annual Conference, "ARTiculations," held at UCL/Birkbeck College, London, April 10–13, 2003, at the invitation of John Wood, Aura Satz, and Helen Weston. Thanks to them for the invitations and to participants for the many interesting questions thrown from the floor during both events. Thanks also to Tim Boon and Craig Brierly at the Science Museum, London, and special thanks to Jean-Baptiste Decavèle, Vivian Rehberg, and of course Joanne Morra.

2. See Vivian Sobchack, "A Leg to Stand On: Prosthetics, Metaphor, and Materiality," chapter 2 in this volume. For a background to the kinds of discussions developed in my essay, see also Jacques Derrida, passim; David T. Mitchell and Sharon L. Snyder, *Narrative Prosthesis: Disability and the Dependencies of Discourse* (Ann Arbor: University of Michigan Press, 2000); Katherine Ott, David Serlin, and Stephen Mihm, eds., *Artificial Parts, Practical Lives: Modern Histories of Prosthetics* (New York: New York University Press, 2002); Marquard Smith, "The Uncertainty of Placing: Prosthetic Bodies, Sculptural Design, and Unhomely Dwelling in Marc Quinn, James Gillingham, and Sigmund Freud," *New Formations* 46 (2002): 85–102; Marquard Smith and Joanne Morra, *The Prosthetic Aesthetic,* themed issue of *New Formations,* 46 (2002); Allucquère Roseanne Stone, *The War of Desire and Technology at the Close of the Mechanical Age* (Cambridge: MIT Press, 1995); David Wills, *Prosthesis* (Stanford: Stanford University Press, 1995).

3. This essay is in certain ways a kind of flirtatious "thinking through"—an effort to be curious, skeptical, and hesitant; to display a certain lack of commitment to certain ideas and thereby sustain their speculative promise; to avoid making categorical judgments. Here I follow Adam Phillips's book *On Flirtation,* in which he notes, following George Simmel's essay "Flirtation," that "every conclusive decision brings flirtation to an end." See Adam Phillips, *On Flirtation* (London: Faber and Faber, 1994), xxi.

4. See Sigmund Freud, *Three Essays on the Theory of Sexuality* (Harmondsworth, UK: Penguin Books, 1977). For Freud, perversions are largely "nonproductive" sexual practices that *deviate* from goal-directed sexual practices. Instances include extended foreplay and deferred coitus. The nineteenth century reserves perversion largely for men. Women are rarely perverse and are defined as anything other than perverse—hysterical, frigid, narcissistic, melancholic, psychotic, and so forth.

5. Michel Foucault, *The History of Sexuality,* Vol. 1, *An Introduction,* trans. Robert Hurley (New York: Vintage/Random House, 1980). See also Robert A. Nye, "Medical Origins of Sexual Fetishism," in Emily Apter and William Pietz, eds., *Fetishism as Cultural Discourse* (Ithaca: Cornell University Press, 1993), 13–30, 19. Apter and Pietz's collection is still the most engaging edited volume on fetishism available.

6. In addition to Sobchack's essay, for other criticisms of this state of affairs see Rosemarie Garland-Thomson, *Extraordinary Bodies: Figuring Physical Disability in American Culture and Literature* (New York: Columbia University Press, 1997); Sarah S. Jain, "The Prosthetic Imagination: Enabling and Disabling the Prosthesis Trope," *Science, Technology, and Human Values* 24, no. 1 (1999): 31–54; David T. Mitchell and Sharon L. Snyder, "Introduction: Disability Studies and the Double Bind of Representation," in Mitchell and Snyder, eds., *The Body and Physical Difference: Discourses of Disability* (Ann Arbor: University of Michigan Press, 1997), 1–31, 7 n. 32. Mitchell and Snyder's introduction includes a useful overview of many of the issues that are at

stake in technofetishism, ranging from a critique of Paul Virilio's writing on the subject to an embrace of N. Katherine Hayles's thought.

7. The Latin *pervertere* means "to twist" or "to turn the wrong way." This nonsexual etymology will have a profound impact on my later engagement with the art of Matthew Barney and Aimee Mullins's place in it.

8. See Emily Apter, "Perversion," in Elizabeth Wright, ed., *Feminism and Psychoanalysis: A Critical Dictionary* (Blackwell: Oxford, 1992), 311–314. As Apter goes on to say: "The dismantled, disembodied body (Lacan's *corps morcelé*) is preferred to the integral or totalised corpus because it presents, as it were, a body composed of prosthetic parts (already split or symbolically castrated) rather than a body at risk of phallic loss. In each of these instances the choice of love-object is neither arbitrary nor convertible. Functioning as an ambient fetish or prosthesis, figured as an *idée fixe,* this object-type both motivates the fantasm and directs the questing of the subject of perversion" (312).

9. One needs to keep in mind the importance of the ideological differences between the discourses of reconstructive surgery (utility, rehabilitation, empowerment) and aesthetic/cosmetic surgery (beauty, passing).

10. Sander L. Gilman, *Making the Body Beautiful: A Cultural History of Aesthetic Surgery* (Princeton: Princeton University Press, 1999), esp. 21–42.

11. And of course, as Gilman makes clear, historically, there is a direct correlation between an individual's physical stigmatisation and their psychological unhappiness. As successful aesthetic surgery after successful aesthetic surgery has shown, the removal of said stigma brings about psychological happiness.

12. For Gilman, this dialectical (or rather binary) process of passing is inherently debilitating because it is premised on the fact that passing is a purely, *and need only be a purely* physical metamorphosis in which signs of physical difference, so called pathological signs, are disguised through modification. (This is of course why "passing" is so important an idea for Gilman, because the desire to "pass" is the very foundation upon which aesthetic surgery is built, is the way in which purely cosmetic [which is to say deeply ideological] aesthetic surgery is distinguished from the necessary, utilitarian practice of reconstructive surgery.)

13. Gilman, *Making the Body Beautiful,* 37.

14. This narrative is best exemplified in the "before and after" photographs that began (as an initiative, although not directly in relation to aesthetic surgery) in the 1840s and reached their point of saturation in the decades to come, notably, in the context of this volume, in images of the rebuilt faces of Civil War soldiers in the 1860s.

15. Gilman, *Making the Body Beautiful,* 39.

16. As Katherine Ott has said on these matters more generally, "Conventions of female modesty, as well as ignorance about and public reluctance to discuss female anatomy" account for the relative scarcity of disabled female bodies in medical text-

books at this time. See Katherine Ott, David Serlin, and Stephen Mihm, eds., *Artificial Parts, Practical Lives* (New York: New York University Press, 2002), 11. A need for modesty and anonymity may have something to do with why all of the figures of female amputees are turned away in these turn-of-the-century photographs while most of the figures of male amputees are not.

17. This phrase is used by Abigail Solomon-Godeau in "The Legs of the Countess," reprinted in Apter and Pietz, *Fetishism as Cultural Discourse,* 274, originally published in *October* 39 (1986): 65–108.

18. In continuing with this essay's interest in flirting, the phrase "Be a 'Creature Unlike Any Other'" is taken from a chapter heading of the sinister, widely read book by Ellen Fein and Sherrie Schneider, *The Rules: Time-Tested Secrets for Capturing the Heart of Mr. Right* (London: Thorsons, 1995). "Pretty legs" is a term of endearment that Mullins uses to describe her favorite prosthetic legs. See Susannah Frankel, "Able to Be Beautiful," *Weekly Mail and Guardian,* September 11, 1998.

19. The appearances on *The Oprah Winfrey Show* and *The Rosie O'Donnell Show* more than affirm the role of autobiography in Mullins's profile.

20. For an excellent explanation of how art historians have historically argued the fact of missing or absent limbs on sculptures back into existence, see Lennard J. Davis, "Nude Venus, Medusa's Body, and Phantom Limbs: Disability and Visuality," in Mitchell and Snyder, *The Body and Physical Difference,* 51–70.

21. On "enfreakment," see David Hevey, *The Creatures That Time Forgot,* 53, cited in Garland-Thomson, *Extraordinary Bodies,* 17. Mitchell and Snyder offer an argument (although this is part of their summation of the field of Disability Studies rather than one of their arguments per se) for exercising "the disruptive potential of the disabled body" (35–40, 36). They offer the category of "transgressive re-appropriation," a term with its roots in the appropriation of words such as *nigger* and *queer* by members of the black and gay communities and how such acts are taken up in the disabled community—witness the rebirth of terms such as "cripple" and "gimp." My sense though is that there is nothing intrinsically "disruptive" about any body per se, disabled or otherwise.

22. Kobena Mercer, "Reading Racial Fetishism: The Photographs of Robert Mapplethorpe," in Apter and Pietz, *Fetishism as Cultural Discourse,* 307–329, 316.

23. Nancy Spector, *Matthew Barney: The Cremaster Cycle* (New York: Guggenheim Museum Publications, 2002).

24. Ibid., 25.

25. Ibid., xii.

26. Ibid., 25.

27. Of working with Bartalos, Mullins says: "It was fascinating working with Gabe because his whole world is the aesthetic prosthetic realm and mine is the mechanics of prosthetics," in Spector, *Matthew Barney.*

28. Ibid., 53.

29. Earlier Spector says that *Maha byn* is "an untranslatable term that stands as a surrogate for the words of divine knowledge lost in Abiff's [the architect, played by Richard Serra] death, much as the Hebrew word *Jahweh* is a surrogate for the name of God" (ibid., 44).

30. Ibid., 57.

31. Ibid.

32. Mullins, "Personal Perspective," in Spector, *Matthew Barney,* 492–493.

33. Ibid., 493.

34. Ibid., 493.

35. At its most basic and most significant, the point here is that as a metaphor, prosthesis is simply a symbol of something else—whether castration, emasculation, nationhood, body-machine interfaces, and so on. The discourse of prosthesis as a metaphor (and this argument is made by Ott in her introduction to Ott, Serlin, and Mihm, *Artificial Parts, Practical Lives,* by Jain, and by Sobchack) misses the fact that prosthesis is something incredibly complex in itself.

36. This is not about the autonomy or independent life of the fetishistic object—something that is commented on by both Freud and Marx.

THE PHYSIOLOGY OF ART Alphonso Lingis

The Artist Drive in Bodies

An artist compulsion in evolution has produced the brilliant colors and fanciful designs of coral fish and butterflies, the iridescent colors and the fancifully shaped crests and tails of birds. Many mammals have highly decorative elaborations of head and rump—the antlers of elk, the coiled horns of mountain sheep, the manes of zebras and lions, the white tails of deer, the brilliantly colored rumps of baboons. The purely decorative hair of horses' manes grows to a certain length; the decorative hair of our heads, unlike the hair of our armpits and our pubic hair, keeps on growing.

This artist compulsion in nature is also in the individuals themselves, who clean, groom, and preen their plumage and furs. The peacocks who waltz before the hens and the birds of paradise who do gymnastic feats on branches know they are gorgeous.

We humans—along with antelopes, penguins, cranes, butterflies, and octopuses—dance. We—along with birds—sing. Since our closest brothers among the apes do not sing, paleoanthropologists suppose that we must have learned to sing from birds. The supreme form of art, Friedrich Nietzsche said, was that made of the most precious clay and oil—living flesh and blood. It is also the oldest. From earliest times, humans moved in the nonteleological, rhythmic, melodic movements of dance. From earliest times, humans modulated the inner rhythms of their bodies; clay seals depicting yogis were found in Mohenjodaro and Harappa, Pakistan, cities as old as Babylon.

An artist compulsion in evolution accompanies what living things make—the cocoons that caterpillars weave, the geometric patterns of spider webs, the hexagonic cells of honeybees, the intricately woven nests of weavebirds and of hummingbirds, the translucent cups woven of spider webs, the domed pavilions covered with living orchids built by Vogelkof bowerbirds and surrounded by carefully planted and maintained gardens of fine mosses and flowers. From earliest times, the chipped stone tools that humans made achieved perfection of form and refinement of detail. Insects, birds, and humans used the organs and limbs of their bodies to make art.

But are not all the plastic arts somehow derived from the artwork that the artist makes of his own body in song and in dance? Did not song and dance continually motivate humans to adorn themselves with the plumes and furs of other species whose songs and dances they took up? Jewelry, found early in the caves of the most ancient humans, soon added to the adornment of the sashaying and displaying humans. And like the stagemaker bowerbirds, humans began to fashion their habitats, their homes and gardens, as display areas for graceful and dramatic comings and goings. Mosaics, paintings, and sculptures eventually adorn them.

Elaborate and fantastic courtship behaviors have been much documented among jewelfish, whitefish, sticklebacks, cichlids, and guppies; among fruit flies, fireflies, cockroaches, and spiders; among crabs; among mountain sheep, antelopes, elk, lions, and sea lions; and among emperor penguins, ostriches, pheasants, and hummingbirds. Females are drawn to the most imposing and most glamorous males; females select their sexual partners. Through generations of sexual selection on the part of females, birds of paradise and hummingbirds have become ever more varied and ever more gorgeous.

Why does lust demand beauty? Whenever people tell you that they got laid last night, they at once tell you that she was gorgeous or that he was a hunk. Nobody ever tells you: "He or she was nothing to look at, but I just turned off the light and had a great fuck." Lust is accompanied by pleasure (indeed orgasm is, Sigmund Freud said, the supreme pleasure we can know), but evolutionary biologists say that evolution has produced pleasure to get us to go through with sex. For when you think about it, who would bother with copulating—that awkward thrashing about of bodies—if there were no pleasure in it? It is tedious enough

to have to spend twenty minutes a day on the stair machine in the gym. But the pleasure is not enough; lust also demands beauty. "The act of coition and the members employed are so ugly," Leonardo da Vinci opined, "that for the beauty of the faces, the adornments of their partners and the frantic urge, Nature would lose the human race." Sexual selection, by the females, has fixed the shimmering colors of birds and all those crests, wattles, ruffs, collars, tippets, trains, spurs, excrescences on wings and bills, tinted mouths, tails of weird or exquisite form, air bladders, highly colored patches of bare skin, elongated plumes, and brightly hued feet and legs.

Humans adorn their bodies and construct theaters and gardens in which to display them. But we also work on the very substance of the body. Artistry supplies for body parts cut off; artistry also cuts into and cuts off the substance of the body.

Apotemnein: Greek for "to cut off," "to amputate." Orgasm, according to Freud, is a state of built up tension, which is abruptly released. In the vagina, there are discharges and contractions—segments of tension that tighten, that push across duration, and that abruptly are cut off. The penis gets swollen and hard. Then abruptly it lets go a spurt of jism. The jet is cut off. The penis deflates, shrivels, hangs down.

Painting, composing songs, and writing poems or novels are also orgasmic: there is a flow of excess fluids. And there is cutting off, sectioning, segmenting. The artworks are cut off from the artists; like an ejaculation, or like a child delivered and wandering off on his own, the artists let them go. Paintings come in triptychs. Today artists do not paint masterpieces that stand all by themselves; they paint series and sequences. Galleries and museums put on retrospectives, in which we view an artist's itinerary or research all segmented in canvases that are each framed and cut off from the others. Poems and songs come in stanzas; novels come in chapters. They move along like the segments of a centipede or a segmented worm.

Prosthetic Body Parts and Art

John Wayne Bobbit was not an artist; he was a stud. He was a horny former marine who was married to a Latina woman from Equador. Lorena Bobbit cut off her husband's dick with a carving knife and threw it in the weeds.

They found it, though, and the doctor—an artist—sewed it back on. Skill that man had—artifice, from *ars* and *facere,* "to make art." It worked fine. John Wayne Bobbit now became an artist. He acted in a porn flick—*John Wayne Bobbit Uncut.* He became a star. Polls showed that he had greater name recognition, among Americans, than President Bill Clinton—until Bill Clinton also became a porn star.

Suppose they couldn't find it: the doctor might have cut a dick off a fresh corpse and sewn that onto Bobbit. Sex-change surgeons can build up a penis for a biological female using bits of flesh from here and there on her body and then insert a mechanical device to make it hard and erect.

A guy gets his dick cut off. It happens in war, in automobile accidents, in bedrooms. A guy or a gal gets a foot, a leg, a hand, an arm cut off; a woman gets a breast cut off. An artist cuts off his ear. Mechanical engineers contrive prostheses. They are works of artifice, of art. Every year they get more ingenious and beautiful. These craftsmen are Renaissance men, true descendants of Leonardo da Vinci.

Their art is a classical art, like that of Greek antiquity and the Renaissance. The whole art of prostheses is to restore the harmony and proportion of the natural body and the equilibrium and poise of its movements. Someone had a limb amputated off her or his body, and the body now looks whole. This art quests for perfection, for immortal beauty, for the beauty that looks immortal, without any inner disequilibrium that could bring about collapse.

Nietzsche explained that the whole of Apollonian art is prosthetic. That whole population of anthropomorphized deities in Homer and all the statues and friezes of the age of Pericles functioned to add on to humans' sense of themselves—the sense of their infirmities and debilities—so that they could see themselves as whole.

This drive for symmetry and equilibrium does not simply answer to an ideal of classical culture; it is a biological drive. Most of us never saw that the two sides of our face are not really symmetrical, until a photographer cut a photograph of our face in half, and doubled over each side. But it has been shown recently that across cultures, people find faces that are nearly symmetrical to be more beautiful than asymmetrical faces. In nature, very few species are really randomly mottled; virtually all color patterns and designs on birds, mammals, and fish are the same on both sides. Every zebra is striped differently, but the stripes on one side

are the same as those on the other. Does not the artist's celebration of harmony and proportion have its biological source in the very nature of an organism?

Supernumerary Body Parts

Because nothing demonstrates the demiurgic power of art more than the ingenuity and artifice that go into fabricating prostheses, the temptation inevitably arises to add more prosthetic parts—to add wings like Icarus, to add the powerful rear legs of a goat or a horse like satyrs and centaurs, to add a third arm like Stelarc. However, adding prosthetic body parts in excess of what the normal body has is done only in art and not in real life. And it is not done in classical art but in that somewhat dubious and marginal art of the horror movie.

Bodies with double penises or clitorises, three testicles, or several breasts seem not only ugly but abhorrent at first mention. The body of William Durks (who had two heads imperfectly separated so that he had a double nose, a split lip, and a third eye) and the bodies of persons who were born with incomplete parasitic bodies stuck to their own at first are too horrible for us to be able to gaze at their photographs for more than a moment. We cannot really endure imagining having to live with the body of Frank Letini, with his three legs and two penises; of Betty Lou Williams, with her four legs and three arms; of Myrtle Corbin, with her four legs and two vaginas; of Jean Baptista dos Santos, with his four legs and two functional penises; or of Lazarus Colloredo, with a second head grown out of his chest that had eyes that never opened and a mouth that never closed. Pasqual Pinos was born with an extra head growing out of his forehead; the head could move its eyes and see, and the mouth could open and shut. The excess of body parts initially provokes nothing but repugnance and horror.

But we do not find a child with a missing arm or foot repugnant. We feel instead a surge of tenderness and care. Nobody finds the sight of a three-legged dog running around the neighborhood repugnant.

Cloning brought to the forefront the possibility of producing, with every child born, a clone of that child with a vegetative brain. The clone would be raised to the age of fifteen, then its life terminated, and it would be quick-frozen and kept as a source of organs for any failing liver, kidney, heart, or indeed

amputated or crushed finger, hand, or penis in the child and adult. This procedure would replace the fine art of mechanical prostheses, yet when word of this possibility got out, it provoked alarm in the public and politicians. Animal biologists, however, viewed cloning with equanimity and enthusiasm as the key to producing top-quality flocks of sheep, cattle, and poultry. It was not simply the idea of terminating the life of the clone and then farming his body for organs that people found appalling. That would not be significantly different from using the body parts of stillborn or aborted fetuses. It was not simply a social uneasiness with such a procedure that would be available only to the rich. These issues can be rationalized away. But a nauseous horror subsists over all those extra body parts that would be waiting in the deep freeze—to be connected to our bodies and to begin gesticulating and flailing.

Apotemnophilia

How about cutting off not only the flows of body fluids but also body parts? How is that connected to sex—and to art?

In October 1999, the press carried the following item:

SAN DIEGO, CA—*An unlicensed doctor who amputated a healthy leg to satisfy his elderly patient's rare sexual fetish has been sentenced to 15 years in prison after the botched operation cost the man his life.*

John Ronald Brown, 77, had been a doctor for almost 30 years until his medical license was withdrawn in 1977 for negligence in performing numerous sex-change operations and other procedures.

Living in southern California, Brown continued to operate in secret just across the Mexican border—even after being jailed for three years for working without a license.

Brown received ten thousand dollars to perform the bizarre amputation on Philip Bondy, a 79-year-old New York man, who suffered from apotemnophilia, a fetish shared by only about 200 people around the world in which sexual gratification is derived from the removal of a limb.

Bondy's longtime friend, Gregg Furth, a Jungian psychoanalyst from New York, testified under a grant of immunity during the two-week trial in San Diego that he

*and Bondy had contacted Brown as a last resort to fulfill their lifelong desire to ampu-
tate their legs.*

*Mr. Furth himself paid Brown to amputate one of his legs last year but changed
his mind when he saw a Mexican doctor who was to assist in the surgery walk into the
clinic carrying a butcher's knife.*

*Bondy, however, was determined to go through with the operation because he felt
that his left leg did not belong to his body.*

*"When you're on the fringe yourself, you have to find someone in the medical
profession on the fringe," Mr. Furth explained.*

*According to the prosecutor, Brown "just chopped off" Bondy's left leg below the
knee in a crude operation in Mexico and buried the stump in the desert to hide the evi-
dence. Furth also testified that Bondy was "delighted" the night after his leg had been
cut off, although he was upset because he had fallen down several times in the San
Diego Holiday Inn hotel room where Brown had taken him after the surgery.*

Bondy died two days later of gangrene poisoning.

*In a court-ordered report, a probation officer wrote: "In retrospect Mr. Brown
stated that he made a poor decision in this instance. He feels that he is too old to be
performing surgery in the future."* [1]

How we understand Mr. Bondy! Hey, why bring in the shrinks and the cops? His
"perversion" is another victimless crime, doing no harm to anybody else. Is there
any of us, who at the age of seventy-nine won't think that we can do what we
want? Like anyone who goes into any kind of surgery, Bondy knew that there was
a risk of death. But he was already seventy-nine, after all. And how fortunate he
was to have a counselor in psychotherapist Gregg Furth, who so well understood
the problem—and who had the solution.

About the time I came on this news item, I was in a bus in Bangkok, and
looking out the window I was drawn to an amputee on crutches. He was stand-
ing in front of a department store and looked in no way pathetic. As Buddhists,
the Thais practice compassion in their daily lives, and everyone who passed him
some money shared a few words with him. I realized that I have often been drawn
to amputees in the street. I suppose that I imagined that I was intrigued by seeing
how they cope, despite their infirmity. Now I wonder if it was not rather envy of
them that drew me to them. If there is not a closeted apotemnophile in me.

So we understand apotemnophilia, although there is evidence that psychiatry does not.

Psychiatry

Since 1882, psychiatry has identified apotemnophilia as a paraphilic fixation of the stigmatic/eligibilic type in which sexuoerotic arousal and facilitation or attainment of orgasm are responsive to and contingent on being oneself an amputee. An apotemnophile becomes fixated on carrying out a self-contrived amputation or on obtaining one in a hospital. His fixation is accompanied by obsessional scheming to get one or more limbs amputated. Apotemnophiles say they are suffering from being "disabled persons trapped in nondisabled bodies."

The reciprocal paraphilic condition in which the partner is an amputee is acrotomophilia or acrotmetophilia (the liking of an amputated extremity). The condition of sexuoerotic arousal is contingent on having an amputee partner, on fantasizing about an amputee, or on fantasizing an nonamputated partner as an amputee to obtain erotic arousal and facilitate or achieve orgasm. An acrotomophile is erotically excited by the stump(s) of the amputee partner. Acrotomophilia is close to amelotasis—the condition of having an erotic inclination toward the stump of an extremity missing either congenitally or as a result of amputation. So around apotemnophiles there is a constellation of acrotomophiles and amelotatists.

Apotemnophilia is related to autoabasiophilia—a paraphilia of the eligibilic/stigmatic type in which sexuoerotic arousal and facilitation or attainment of orgasm are responsive to and contingent on the fantasy of being lame, with a limp, or crippled. The reciprocal paraphilic condition is abasiophilia, in which sexuoerotic arousal and facilitation or attainment of orgasm are responsive to and contingent on the partner being lame, with a limp, or crippled.

These terms were coined by and first used in the writings of sexologist and psychoendocrinologist John Money, professor emeritus in medical pediatrics at the Johns Hopkins School of Medicine and in the 1960s head of the Johns Hopkins Psychohormonal Research Unit. In the vernacular, apotemnophiles are called wannabes or pretenders, and acrotomophiles called devotees. Devotees speak of "the interest."

Pretenders want to "feel" disabled. One pretender asks online where he can buy long-leg braces on the black market—so that he can use his newly purchased crutches to crawl the mall. Another says, "My biggest hang-up is wanting to feel paralyzed. I can only experience it by using leg braces or a wheelchair in public." He admits to being frustrated by heavy doors and small bathroom stalls and isn't sure why he voluntarily puts up with the nuisance: "I don't know. I have a genuine visual handicap, and I know what it's like to live with that. You would think my actual disability would make a difference. Somehow it doesn't." Many pretenders have—since childhood—tied up one leg, fashioned crutches, and imitated amputees around the house. Some, however, tape up their ankle to their thigh and roam the streets on a pair of crutches.

Wannabes, in contrast, long for the real thing. Although the newspaper article said Mr. Bondy "suffered" from apotemnophilia, in fact apotemnophiles really suffer from frustration—from having a limb that they don't want and from not finding a surgeon who is willing to cut it off. The medical establishment abides by their slogan: if it ain't broke, don't fix it. Medical journals have described people who tried to cut or shoot their legs off. One woman who wanted both legs amputated above the knee used dry ice on her legs to cause gangrene. One person who is famous in apotemnophile circles and who suffered years of inner pain and unfulfilled sexual desire decided to lie down at a railway track and drink himself into unconsciousness. When he awoke, he was an amputee.

Devotees are erotically excited by the stump of an extremity that is missing either congenitally or as a result of amputation. Adolphus Frederick, who ruled Sweden in the eighteenth century, had seven mistresses: two were one-eyed, two were one-legged, and two were one-armed. The last one had no arms at all.[2]

One study found that 71 percent of devotees are also pretenders or wannabes, latent apotemnophiles. How many prosthetists, orthotists, and personal-care assistants are in fact closet apotemnophiles? All those people pushing wheelchairs in Hyde Park in London and the Jardin de Luxembourg in Paris: what percentage are moved by tender concern for someone disabled, and what percentage are wet with the physical closeness to a stump that they want to have?

That devotees are closet apotemnophiles, argues Richard L. Bruno, director of the Post-Polio Institute at the Englewood (New Jersey) Hospital and Medical

Center, is supported by the finding that only 13 percent of acrotomophiles have had a long-term relationship with an amputee. This statistic is reflected in G. C. Riddle's statement, "No amputee is the right amputee," a reference to acrotomophiles' obsessive but typically unsuccessful search for the "amputee of his or her dreams."[3] An actual relationship would cause the disabled individual to become a "real person," making projection of the devotees', pretenders', and wannabes' own needs into him difficult or even impossible.

"While devotees shouldn't be labeled as psychotic, we must ask how a real relationship can flourish with a person fixated on the one aspect of our bodies that may repel others and that we ourselves may like least," asked one amputee. A very tolerant woman amputee remarked, "I don't want to be a sex object or to be with a man obsessed with my breasts or my hair. Could a relationship be possible with a man obsessed with my stump?"[4]

Although the most common Internet bulletin boards, chat rooms, and Web sites are for male devotees of female amputees, others are for male and female, heterosexual and homosexual, plaster cast, crutch, leg, back and neck brace, and even orthodonture devotees, pretenders, and wannabes. An American Online bulletin board posting entitled "Bunion Love" requested "photos, videos, or correspondence dealing with gals [having] deformed/crippled feet, or toe/toes amputated . . . or who have severe bunions on their feet. The more severe, the better."

Attraction to disabled persons has been related—by P. L. Wakefield, A. Frank, and R. W. Meyers in the *Bulletin of the Menninger Clinic*—to homosexuality, sadism and bondage.[5] An amputee's stump, they suggest, resembles a penis, and provides a less threatening sexual stimulus for male "latent homosexuals." A stump's similarity to a penis has also raised the possibility that a desire for amputation is a "counterphobic" antidote for male acrotomophiles' fear of castration— although these psychiatrists admit that such fears have not been documented. More recent surveys find no increased prevalence of homosexuality, sadism, or interest in bondage among acrotomophiles. And "any similarity between a stump and one's own penis," remarks Richard L. Bruno, "would have little personal meaning for his patient Ms. D., not only because she is a woman but also because she was primarily attracted to men with braces and crutches and was herself interested in pretending to be a wheelchair user. Further, Ms. D. was exclusively heterosexual and had no interest in sadism or bondage."[6]

Bodies in Segments

The urge to create prostheses refers us to the most primal level of the formation of an organism, where we find a drive for bodily integrity, symmetry, equilibrium, and balance. Does not the orgasmic urge to cut off body parts also refer us to the deepest levels of the formation of organisms?

The original form of organism was the segmented worm. The primitive one-celled forms of life first expanded into forms where all functions were present in each segment: any segment that is severed from the organism can move, nourish itself, grow, and reproduce. The organism from which this piece was chopped off wriggles away. The original whole died without leaving a corpse.

Having segmented bodies—having members and joints—leads to dismemberments and disjoinings. Among other species, starfish and octopods readily drop a limb. Brittle starfish do this so readily that it is hard to pick up whole starfish. Some crabs do not wait for a predator otter to attack them but instead grab onto the otter's flesh with their powerful claws, clamp tight, and then disconnect the claws from the body. If a predator takes interest in them, many lizards disconnect and drop their tail. Insects have legs amputated almost routinely.

Anglerfish are deep-ocean fish that are found widely across the Pacific at depths of two and three thousand feet in some sixty species. The newborn male anglerfish has very large tubular eyes and an enlarged olfactory organ. His sexual development advances rapidly. He follows the scent of a female anglerfish avidly. When he has found a female, which can be as much as twenty-five times the size of the male, he uses his specialized small teeth to grip her anywhere on her body. His main task is to avoid being swallowed by her, as she tends to try to do. Once attached, his lips and mouth tissues fuse with the female's tissue, and his alimentary tract degenerates. In time, their bloodstreams intermingle, and he loses his now useless eyesight. Two small openings remain where the mouth used to be, and these allow water to enter for respiration. The male has become a parasite, but he apparently puts no strain on the female. Some have been known to support as many as three males.

Normal, Everyday Apotemnophilia

According to anthropologist Ruth Benedict, in a 1934 essay entitled "Anthropology and the Abnormal," character traits or impulses that are rejected as abnormal

in our psychiatry—such as the propensity to fall into trance, bellicose character, or suspicious character—have been documented to be positively valued in other cultures.[7] But it does seem that no culture has been able to value all of them positively. Apotemnophilia is designated a pathological fetish in our psychiatry. But the Japanese yakuza chop off a finger on initiation into the group. And Papuan women chop off a finger to mark each lover, spouse, or child they have lost. In both cases, the connection with sex is patent. In Italy, castration produced singers who had a vocal range and volume that was impossible for women. It is believed that in the seventeenth century there were four thousand *castrati* in Italy. They sang in the Vatican choirs until 1878. Male circumcision is widespread today in Jewish communities and routine for virtually all boys in the United States, and female circumcision is widespread in Africa.

Among the hip today, the sawing or chopping off of a piece of one's body seems boorish: low-rent. More sophisticated is drilling and boring. Thus cross-sections of tongue, nipple, and cartilage are taken out in body piercing, and cross-sections of bone are taken out of the now hip skull boring.

No doubt those two hundred apotemnophiles that medical science has identified are but the tip of an iceberg.

All this brought back a scene that I observed on Copacabana beach in Rio de Janeiro a few years ago. A dude with one arm amputated a few inches from the shoulder and the other arm amputated a few inches below the elbow sells knives. He pushes up against tables when tourists are eating. He gets a guffawing pleasure out of grossing them out. At the time, I thought that he had admirably turned his amputations into these powers and pleasures. But did he not first glimpse at the pleasure possibilities of his amputations in the pleasure of the amputations themselves? At the time, I envied his chutzpah. Now I wonder if I was not instead envying his amputations.

Freud laid out the continuity between experiencing orgasm and giving birth. Orgasm for a man or a woman is pleasure—*jouissance* in discharging some body fluids. For the woman, this pleasure leads to the pleasure, *jouissance,* in pushing out and disconnecting an infant and a placenta that have been part of her body. Thus all normal sex can be viewed under the heading of apotemnophilia. The release of endorphins during labor and delivery rejoins the purest apotemnophiliac pleasure.

Bulimia and anorexia are metonyms for apotemnophilia—parts for the whole or whole for the parts, depending on how you view them. Acts that are metaphoric apotemnophilia include the multitude of timid, miniaturized, disguised, symbolic, and hypocritical apotemnophiliac acts—getting a tooth pulled, shaving a face or a skull, plucking eyebrows, chewing on fingernails, picking at scabs, enjoying a bowel movement.

We human apes have lost most of the hair that must once have covered our bodies and protected them from cold and from sunburn. We have had to replace that hair with the hides of other animals or clothes made of plant fibers. When we aim to excite one another sexually, we first take pains to cover our bodies with glamorous garb, jewels, and perfumes. Then the climactic moment of excitement is when we drop our clothes. Georges Bataille saw in the removal of clothing the invitation and temptation to transgression.[8] But is not Bataille's conception of transgression too fundamentally constructed on an opposition between the human and the animal, between the sacred and the profane, and therefore ethnocentrically biased? Is the excitement that is aroused by disrobing an apotemnophiliac not excitement? To see this, let us think of the nudes that are revealed to be or are depicted in art to be integral, wholesome bodies. Then their nudity appears natural; we easily picture them strolling about nude in the Roman baths or reclining at some nineteenth-century open-air picnic. And they are precisely not erotically exciting. The gentlemen at *Le Dejeuner sur l'herbe* (1863) are not even inclined to take off their hats and jackets. The nudity that excites us when someone disrobes is the nudity of a body that needs those clothes to be self-sufficient. Such is the guy whose jeans, leather jacket, and sunglasses make his body that of a biker. Or the dancer who needs this skirt and these high heels to dance flamenco. When these people drop their clothes, they drop whole chunks of their body identity; they looked peeled or flayed. And the excitement it arouses is acrotomophiliac and, arousing a like urge, apotemnophiliac.

Dismemberment proceeds in the sexual act itself. The body collapses on the bed or on the grass, the postural axis that had splayed and sprung the limbs and body parts softens and dissolves. The legs lie on the bed or rock and roll about on their own. The arms expose themselves to manipulation and caresses, the hands lie disconnected from the rest of the body and its will, their positions determined by gravity. The breasts, the belly, the buttocks are animated with movements that

begin and end in them—shivers, shudders, spasms, contractions, giggles. The orgasmic body has lost its integrity; the body parts are disconnected and on their own.

We Artists

We artists.—When we love a woman, we easily conceive a hatred for nature on account of all the repulsive natural functions to which every woman is subject. We prefer not to think of all this; but when our soul touches on these matters for once, it shrugs as it were and looks contemptuously at nature: we feel insulted; nature seems to encroach on our possessions, and with the profanest hands at that. Then we refuse to pay any heed to physiology and decree secretly: "I want to hear nothing about the fact that a human being is something more than soul *and* form." *"The human being under the skin" is for all lovers a horror and unthinkable, a blasphemy against God and love.*[9]

"We artists," Nietzsche says. We leave out the kidneys, the pancreas, the liver—and we become artists. From the beginning, from the earliest rock carvings, we humans have been leaving things out in our pictures of each another. The artists at the Lascaux, Cosquer, and Chauvet caves depicted with the most painstaking anatomical accuracy the limbs and musculature of mastadons, aurochsen, and saber-toothed tigers, but when they depicted humans, they drew stick figures. The charm of a cartoon consists not only in how it whimsically emphasizes some facial feature or gesture but also in how much it leaves out. "Photographically realistic" can be a disdainful expression among artists.

At one time not long ago, those who could afford it, whether matrons of distinguished families or governors of states, had their portraits painted in oils. The painting was hung in the house even when the person was alive. What does the portrait add to the presence of the flesh-and-blood individual? Perhaps it does not add but subtracts. Nietzsche insisted that all plastic, Apollonian art is the construction of illusions. In an illusion, what is there seems complete and self-sufficient, even though much is lacking. In portraits by the old masters, which have the density of carnal reality depicted in perspective, do we admire the illusion of three dimensions on a two-dimensional canvas? Or do we admire the presence of the model, even when much is left out? Only one ear is visible; the portrait

will never turn to show the other ear. Sometimes only one side of the face is there. Often only one arm is in the painting; sometimes the legs and feet, not at all. Could it not be that seeing how much can be eliminated from a body and not be really missed is the secret of the pleasure? It is the excitement of feeling that we can do without the clothes dropped on the bedroom floor, we can do without the jet of jism cut off insouciantly, we can do without that other hand, those legs, that third dimension. Slicing off an ear in the heat of erotic passion is the sort of thing an artist would do to himself. As Nietzsche writes,

For seeing the ultimate beauties of a work, no knowledge or good will is sufficient; this requires the rarest of lucky accidents: The clouds that veil these peaks have to lift for once so that we see them glowing in the sun. Not only do we have to stand in precisely the right spot in order to see this, but the unveiling must have been accomplished by our own soul. . . . The world is overfull of beautiful things but nevertheless poor, very poor when it comes to beautiful moments and unveilings of these things.[10]

How can we make things beautiful, attractive, and desirable for us when they are not? . . . Here we could learn something from physicians, when for example they dilute what is bitter or add wine and sugar to a mixture—but even more from artists who are really continually trying to bring off such inventions and feats. Moving away from things until there is a good deal that one no longer sees and there is much that our eye has to add if we are still to see them at all; or seeing things around a corner and as cut out and framed; or to place them so that they partially conceal each other and grant us only glimpses of architectural perspectives; or looking at them through tinted glass or in the light of the sunset; or giving them a surface and skin that is not fully transparent—all this we should learn from artists while being wiser than they are in other matters. For with them this subtle power usually comes to an end where art ends and life begins; but we want to be the poets of our life—first of all in the smallest, most everyday matters.[11]

An artist is not a special kind of man, Eric Gill said, every man is a special kind of artist. But intermittently, by segmenting his life, by cutting one segment free from the rest.

Those crowds in the streets—all of us trudging up and down with leaden eyes and dour faces, stopping to greet each another and exchange mindless

banalities—how could we become poets of our lives? By trying to find the relationships between the segments, the meaning of each segment and of the whole? By trying to write some narrative that would try to connect all the segments of our lives together in a beautiful story that would have beginning, middle, and end? At our funerals, our pastors and our friends will sketch out such a story to show that all those segments added up to one of the good, decent, ordinary people or even to a child of God who is now being welcomed into heaven. Those of us in the church listen with leaden eyes and boorish faces, greet one another and exchange mindless banalities when the service is over, and trudge up and down the street to our homes.

But if we were to follow those people with a camera and tape recorder, perhaps we would find that each one, just once in the course of a day, or once every third day, comes out with a few words graceful and lilting as a song. Perhaps just once in the course of a day or once every third day, an intoxicated beam of spring sunlight or the reflected ray off a neon sign, lights up with glory our commonplace faces. To be able to see these small, everyday flash-fires of poetry in our lives, we have to stand precisely in the right spot and at a distance such that there is much that we no longer see. We have to frame those moments, section and segment them. These moments of poetry are disconnected from the prosaic continuity of a life, cut off and cast off: that outburst of laughter that broke from the throat of a stout middle-aged woman in the alley, that faint scent of perfume that lingered on the pillow after the stranger who made love with you for an hour has left, that sudden skid on the polished marble floor that shot the office manager across the room on his ass, that sudden sneeze that scattered into the lecture that the boss was starting to give.

And suppose we were to follow ourselves around all day, with camera and tape recorder, would we—if we found ourselves standing precisely in the right spot—not find moments when a beam breaks out of the turgid clouds of the sky to frame our faces in glory, moments when words comes tumbling out of our mouths like a song? The trick is to catch and disconnect these segments. It is true that it is accomplished by standing on the levels and supporting ourselves on the continuities in our everyday world, by thinking about practical world. But is it not by disconnecting, and letting go of the prosaic continuities, the cloying resentments, the practical worries, that we find segments of poetry in our lives?

Notes

1. *Bankok Post,* September 28, 1999, 3.

2. Daniel P. Mannix, *Freaks: We Who Are Not as Others* (San Francisco: Re/Search, 1976), 112.

3. G. C. Riddle, *Amputees and Devotees: Made for Each Other?* (New York: Irvington, 1988).

4. Ibid.

5. P. L. Wakefield, A. Frank, and R. W. Meyers, "The Hobbyist: A Euphemism for Self-Mutilation and Fetishism," *Bulletin of the Menninger Clinic* 41 (1977): 539–552.

6. Richard L. Bruno, "Devotees, Pretenders and Wannabes," *Journal of Sexuality and Disability* 15 (1977): 243–260.

7. Ruth Benedict, "Anthropology and the Abnormal," *Journal of General Psychology* 10 (2) (1934): 59–82.

8. Georges Bataille, *Eroticism,* trans. Mary Dalwood (San Francisco: City Lights, 1957).

9. Friedrich Nietzsche, *The Gay Science,* trans. Walter Kaufmann (New York: Vintage, 1974), para. 59.

10. Ibid., para. 339.

11. Ibid., para. 299.

STUMPED BY GENES: *LINGUA GATACA,* DNA, AND PROSTHESIS

Lennard J. Davis

A new field of thought is emerging that, for want of a better term, is being called *biocultures*—the study of the scientificized and medicalized body in history, culture, and politics. Biocultural approaches have been used to explore various kinds of phenomena from the out-of-boundary[1] disciplines of the humanities, social sciences, medical sciences, and so on. Biocultural analysis is to these discourses as theory has been to the humanistic discourses. In this essay, I take a biocultural approach to examining genetics and use this culture-based way of knowing to look at certain issues in the field of genetic and medical research.

One notion of prosthesis approaches genetics through a reconceptualization of the idea of prosthesis that is permeable to medical and technological ways of thinking and to linguistic and humanities-oriented ways of knowing. This type of analysis might begin with the observation that the original meaning of *prosthesis* in English is "addition," notably first used not in a physiological or technological sense but in a grammatical one as an element that is *added* to a sentence. This original grammatical meaning is transformed at the end of the eighteenth century into a medical meaning—something that is *added* in surgery. The comfortable continuation between science and the humanities was very much of a sign of those times; in today's science-self-segregated world, a jump between the two disciplines would be harder to make. The meaning of *prosthesis* as something that is added to the body becomes much more widely used in the middle and late nineteenth century, when it comes to mean, fairly exclusively, an artificial limb or part that supplements the original but missing body part.

According to the *Oxford English Dictionary, prosthesis* as a supplement to grammar or parts of speech is connected to *prosthesis* as a supplement to body parts. As Jacques Derrida's work on Jean-Jacques Rousseau and the supplement has shown, Rousseau's famous "Essay on the Origin of Language" took late eighteenth-century readers into an inquiry about the way that human language develops. In looking at Rousseau, Derrida develops a theory of the "supplement." He notices that Rousseau opposes nature and society and sees the latter as a supplement of nature. Rousseau, according to Derrida, privileges nature and fits it into a series of oppositions, including health and disease, purity and contamination, good and evil, and speech and writing.

By this privileging of nature, language can be thought about as a supplement—something prosthetic that is added to nature rather than being of nature itself. Spoken language, according to Rousseau, is closer to nature than written language, which is further away from the natural origin of words. Derrida's theory is in opposition, for example, to Noam Chomsky's notion of language as inherently part of human nature—as hard-wired into the brain and therefore not a prosthetic. So being human becomes an aspect of supplementarity. Humans are not natural because language, at least written language, is a supplement.

These oppositions can be seen as defining a new set of expectations about humanity and the biosphere—the world that is inhabited by and made habitable (or inhabitable) by humans. This ambiguity also can be found in the original disability-related notion of prosthetics in the word *stump,* a word that refers to both the body that is maimed and the prosthetic that replaces it. The stump of a limb is replaced by a wooden leg, also referred to as a stump. The cut-down root of a tree is a stump, and by analogy the limb that is removed from the body is also a stump. Ironically, the wooden leg participates in the original sin of the removal by being part of the metaphoric and metonymic tree so that the human gains a stump from the stump created in the tree. The analogies continue as one is foiled by tripping on a stump and then comes to be stumped by the difficulty of the tree and by the stomping sound made by the stump leg, which combines the fleshly stump with the wooden stump.

The prosthetics industry in the nineteenth century got its jump-start following the Civil War in the United States, a war in which more American soldiers died than in all other u.s. wars combined. Massive numbers of men perish,

and massive numbers survived—many of them maimed. Nascent industry saw that restoring the wholeness of the divided country was achievable, again through metaphor and metonym, by restoring the limbs of soldiers who had given part of their bodies so that their country's body would remain whole and undivided. The call to return all amputees to working citizens found its answer in the technology and cosmetic enhancement of the artificial limb. But why after the Civil War did prosthetics manufacturers begin making realistic-looking limbs rather than the wooden stumps that had been widely used before? Was this a result of a general eugenic push that promoted the normal and tried to exorcise the abnormal? Was there a sense that amputees had to appear distinctly normal—to fake normality (itself a contradictory state)?

This question has stumped researchers in the history of prosthetics. In a sense, its answer involves the supplementary notion of the prosthetic difference as both addition and removal. A new biocultural history of prosthetics might involve this ambiguity that is built into the idea of the prosthetic. The issues involve the metaphorics of limb replacement and the complex contradictions that are embodied in the removal of the body part and the replacement with the supplement. In Yeats's words,

nothing can be sole or whole
That has not been rent.

Another way of thinking about prosthesis considers the issue of a kind of bodily surplus value in which the work of replacement takes value from the worker, the manufacturer, and also the body that is being prosthesized. What loss comes from the gain? What value is added and in the same process diminished in the addition?

Rather than trace a material history of prosthetics in this manner, which would be a perfectly good endeavor, I want to shift the ground a bit for the purposes of this essay and consider the outcome of the prosthetic difference—the notion of supplementarity in the discussion around genetics and race. The word *prosthetics* is not used much in this context but seems to me to inform the discussion by providing a milieu of replacement and supplementarity to notions of being human.

The ambiguity around the notion of genetic in one sense comes from an active generation or genesis involved in human reproduction. Genetic is both an active notion and a passive one. The activeness of generating physical and physiological changes occurs through a genetic activity and a passive activity in the sense that the genetic is seen as fixed and written, like a written language. The opposition between spoken and written language plays out in the modern conception of genetics that contains both the vocalized natural (and thus subject to change and self-making) and the fixed, inscribed, written-in-stone sense of the genetic fate or destiny. In addition, the ambiguity between the real-looking but actually "fake" prosthetic limb is now eliminated in the genetic era with genes, totally "fake" looking and known by computer graphic representations (the double helix with colored bits representing the "building blocks"). Yet genes are presumed to be natural and "in" the body, part of the body, in a way that "real-looking" artificial limbs can never be.

The area in which some of these ideas of fixity and mutability played themselves out was in notions of race, degeneracy, and the human body. In the nineteenth century, race was as developed as a "scientific" concept—first, along phenotypic lines, as a measurable, quantifiable categorization of human populations. Brain size, hair color, type, skin color, and so on were measured and charted. In this sense, race was seen as inherently part of the human body—in no way as a prosthetic. Yet this quiddity of race, its fixity in the body, also contained notions of change. The human body over generations, and even within one single body, could change, improve, or degenerate. In fact, the mechanisms of race were poorly theorized. For example, it was believed that racial characteristics would diminish over several generations, yet it was also believed that race was strong enough to survive even if people had only one grandparent of a particular race.

The mode of transmission for race was conceived as occurring through some idea of transmission of racialized blood. Because notions of inheritance were poorly understood, perceived hereditary conditions, like race, were seen almost as disease entities passed along over generations by an improbable combination of mixing of blood, Lamarckian adaptation, and general influences. When Gregor Mendel made public his work on garden peas, the first steps were taken toward a more scientific explanation of inheritance. However, most people do not realize that Mendel's ideas were mathematical only and did not advance any

clear notion of what genes were or how they worked. Mendel merely told the world about the distribution of certain traits—how likely a specific trait was to appear in offspring. In fact, the idea of the gene is itself a kind of cobbling together of Mendel's notions of the distribution of traits with some kind of notion that there had to be a place that traits could call home—the gene. Based on the relatively flawed idea that a single factor is responsible for a single trait, Mendel's work was nevertheless influential. Although Mendel did not call that place a gene, he left open the idea that the gene, in this sense, is a prosthesis—a human-made artifact that stands in for, replaces, and thus becomes the location of inherited traits. In fact, the "realness" of the gene in current discourse is belied by the fact that there really is no locus—no "there" there—for genes. So the prosthetic gene is in fact an imaginary location that replaces the "realness" of physical features, hair color, and so on.

Aside from the strides that Mendel made in his mathematical formula, very little serious work followed on the actual way that traits were inherited. It was not until the 1950s, when James Watson and Francis Crick discovered the chemical structure of DNA, that an actual mechanism for inheritance was hypothesized on a chemical and molecular basis. Here again, it is necessary to have a prosthetic understanding of what it was that Watson and Crick "discovered." Their discovery was that DNA had the structure of the double helix (although recent work has led to some questioning of whether they did indeed "discover" this information or simply ended up explaining in detail what other scientists at the time had already discovered).

Indeed, Watson and Crick did not discover the gene, although we still use the term to describe the prosthetic space of inheritance. They discovered the mechanism by which DNA replicates itself. The gene remains in fact a fictional entity without an existence. There really is no gene as a locatable place or item, and science tends to use the term as a kind of prosthesis to mark the place where the location of the gene should be if there were a gene. The gene, like the prosthetic leg, marks the place of an absence and acts as a physical memorial to something lost. What was lost, in fact, was the certainty that race was real, had a location, was "there." The gene now acts as a kind of prosthetic *en abime,* an endlessly deferred location. In this sense, like grammatical usage and the "real-looking" fake limb, the gene has come to take the place of something else that in many ways

cannot be named. We can call it the place of the certainty of race. In the early years of genetic thinking, the gene essentially took the place of—was the prosthetic for—the idea of racialized phenotypes. Yoked to eugenic concepts and notions of inheritance, the gene came to do the work of race. If Negroid people had kinky hair and flat noses, then there had to be a gene for each trait. If Jews were labeled degenerate, then the gene was the location for their flat feet, nervousness, feeble-mindedness, and so on. That legacy of the gene as racial marker was not entirely abandoned. While the term *eugenics* was discarded by the 1930s, the replacement term for the same endeavor was *genetics.* Indeed, the now infamous center for eugenics at Cold Spring Harbor, New York, became by a simple name change the new national center for genetics. In London, the Eugenics Society changed its name to the more neutral Galton Institute, named after Sir Francis Galton.

In other words, the gene was the prosthetic location for traits that were presumed to be real and verifiable—but that location had never been seen or even ascertained by any other means. The gene was a virtual prosthetic—a location like heaven that had to exist if there were a Christian god, as the gene had to exist if there were inheritable traits. The human body, as a construct, could not have an entirety and an identity if there were no addition, now called genetic, that was the place of origin, the real place for being human, and for being a certain kind of human—whether Caucasian or Negroid or Semitic.

Because genetics is both a research area and an area of biotechnology with an elaborated and scientific discourse surrounding it, nonscientists tend to assume that all is well and well organized in this world. But a biocultural approach can provide various kinds of illuminations and insights that are not always available to a scientific one. To achieve these interventions, we need to inform ourselves about the science associated with genetics. Thus, common knowledge and journalistic explication posits a "gene" for language, depression, intelligence, breast cancer, even gayness or deafness. What needs to be made clear here is that complex human processes cannot be contained in a gene for several reasons. First, a gene is not an actual place or thing. Second, according to the central dogma of genetics, as postulated by Watson and Crick, one gene makes one protein. Complex human processes like intelligence can never be the result of the production or lack of production of a single protein. We can say that the idea of the gene for a complex trait is a prosthetic that posits the trait as an addition to being human.

Thus the default gene for humans is, say, heteronormative activity, and the prosthetic, added on to this, replacing the normative gene, is homosexuality. In this sense, the original is what is actually socially constructed as belonging to the body; the replacement part is seen as inferior, as a wooden leg would be considered "not as good" or "not as real-looking" as the original one of flesh.[2] We could construct a series of such prosthetics that are seen as "add-ons" to all the major categories of otherness in dominant, medicalized cultures. Thus blackness would be the prosthesis for whiteness, femininity for masculinity, and so on.

What I am getting at is that even though there may be good, even the best, science behind genetics, the level of science gets one only so far in a social, cultural context—the context in which we live. The next stage—the biocultural stage in which science melds with the biosphere, the mental, physical, ideological, architectural space made by and inhabited by humans—is always going to have to rely on human imaginings, which will lead to various ways of metaphorizing the explanatory system (in this case, genetics). Are genes in the body, of the body, or an addition to the body? This discussion of the prosthetic nature of the gene is made in this spirit. Science seems not to deal in meanings or significations and claims to present an unmediated reality, but the idea of the gene—the idea of the double helix, as we visualize it, the idea of the direct connection between allele, DNA, RNA, protein—is a complicated process that exists in a frame of meanings and significations. To fully imagine the facts requires a biocultural understanding that is currently lacking in both the sciences and the humanities. Thus, even on the levels of the greatest degrees of hypersignification, a kind of intellectual supplementation—indeed, prosthesis—is required to understand all the parameters in the play of meaning and fact that is inherent in the genetic gamble being undertaken at the present moment.

Another step toward defining genes is understanding the defining structures of genetics. From the most complex level (the functioning human, animal, or plant organism) to the most basic level (the chemical level), there is a continuum. If we think of these levels as the extremes, we can understand the conceptual structure that leads from one to the other. At the basic level, the building blocks of DNA are four nucleotides—adenine (A), guanine (G), thymine (T), and cytosine (C). These amino acids are always paired—adenine with thymine, guanine with cytosine. The "code" of the DNA molecule, which determines the

manufacture of a specific protein, is made by repetitions of these four amino acids in a long strand. Another strand that is made up of the matching pairs exists beside the strand in sequence. So a string of GATACA will have a coordinated strand next to it of CTATGT. These paired nucleotides will be held together by a weak bond that comes undone when the DNA molecule divides down the center of the double helix and then reforms into two virtually identical molecules. At various points along the DNA molecule are loci that we have called *genes*. In the same way that we divide up the spectrum and assign arbitrary names to wavelengths, so we divide up the DNA molecule. But the division of sequences of nucleotides is somewhat arbitrary, as is the majority of DNA, which is called junk. As weeds are plants that we don't use, so junk DNA can be DNA whose purpose, if any, is currently unknown in that it appears not to produce a specific protein. Likewise a gene can be made up of several groupings of nucleotides (called *alleles*) in very separated and diverse locations. On the next level of complexity from DNA, chromosomes are made up of bundles of DNA strands that can be seen by microscope within the nucleus of the cell. Because these can be stained and seen, chromosomes are not so obviously "prosthetic," although in popular imagination and vision the dramatic visualized division of the cell with the chromosomes performing their snake dance of duplication takes on an aura of genes by proxy. When we talk about the double helix and genes, most people probably visualize the choreography of cell division with the stunning optical view of chromosomes reproducing in a kind of visible/invisible primal scene.

I have said that the gene is the locus on the DNA molecule that codes for a specific protein. If you imagine the double strand of DNA involving hundreds of thousands of base pairs of nucleotides, the question is, "Where is the gene?" In a human being, there are 3.2 million nucleotides. Based on the number of proteins in the human body, it has been estimated that 100,000 genes would be necessary to produce that variety of proteins. At a functional level, it is possible to experiment, removing a sequence of base pairs and then seeing what protein is or is not manufactured. The sequencing of the human genome revealed only about 30,000 genes in the human genome, creating a bit of a puzzle about the efficacy of the model that was devised by Watson and Crick. Now the number appears to be significantly less than 30,000.[3] The neat way that genetics is laid out in textbooks

(and that I've attempted to relate) is now undergoing a major revision. Instead of a gene, scientists are now talking about "gene expression"—that is, the process by which the coded information gets translated into cellular matter and structure. Gene expression is to genetics what Einstein's constant is to physics: it is a fudge-factor word that allows the notion of gene to continue in the absence of a clear way of thinking about genes.

The point I am trying to make is that the gene, as such, is an amputated location, a place that is not there. In talking about genes and "junk" in the genome, scientists are dividing up what they think of as functional sequences of nucleotides from the seemingly random distribution of nucleotides that are just "there." The trick is how to divide up the 3.2 billion nucleotides that are endless repetitions of four nucleotides—GATC. The most common metaphor concerning the human genome, which is defined as the total of all genes and junk in human DNA, is that the genome is "the book of life." By that metaphor, the letters GATC are the basic units of the book, corresponding to letters, and the letters GATC spell out sentences that are essentially genes. But the book of life is less like a book and more like a large and very messy hard drive with disruptions, gaps, spaces, and meaningless bits of information mixed up with very meaningful bits of information. If there is a book of life, its cover is the human body, and its contents are a kind of endless babble with some sense every now and then. The body creates the illusion of a kind of prosthetic wholeness, the neat, seamless exterior held up like a *Playboy* pin-up while the fragmented and mysterious, even obscene, interior is no longer the blood and the guts but the impenetrable darkness, as Conrad might describe it, of the mysterious incantation of TACGATACTGG and so on into the abyss. The heart of darkness of being human is not the cannibalistic, sexualized moment suggested by Joseph Conrad's Marlowe but the monotonous voice of HAL in *2001: A Space Odyssey* reciting word-salad into infinity. Plucked from that racket is the prosthetic, the addition in grammar and language, the strand that can be "read" as the place where the protein is made. This prosthetic, the gene, both dominates and subordinates our sense of the body—its contours and lineaments. It rationalizes some darker matrix that is still securely unknown to us despite our efflorescing technology. The gene is a substitute for the confusion of biochemical processes still unknown.

Genetics is a new way of examining old problems. In this sense, genetics represents a breakthrough, as did the discovery of the gene, the atom, the molecule, and subcellular chemistry. But each of these areas of study, while yielding results, opened many questions that could not be answered. After all, a frontier means both an opening of something new and a boundary beyond which we have not yet gone. We have no reason to believe that the conclusions we have drawn at this early stage of examination will hold or even if genetics will actually prove to be the hopeful area that we are assuming it will be. Therefore, when we say *gene* or *genetics,* the word substitutes a hopeful sense of breakthrough for what also might be thought of as a bewildering confusion of information. We have learned that we can "read" DNA rather than see it is a babble of *lingua gataca.*

On a level of hypersignification, the genetic now becomes, anew, the racial. The primary reason given for the Human Genome Project and all genetic research is the promise of cures for genetic diseases and the development of genetic-specific drugs geared to particular human variations. Both of these reasons lead directly back to the genetics of race since human populations, for all practical purposes, tend to be seen as racial groups. Take for example a *New York Times* article from December 2002 reporting that "scientists studying the DNA of 52 human groups from around the world have concluded that people belong to five principal groups corresponding to the major geographical regions of the world: Africa, Europe, Asia, Melanesia and the Americas. . . . These regions broadly correspond with popular notions of race."[4] The same researchers attempting to find genetic similarities in racial groups find their work used by researchers who are trying to find diseases linked to specific groups. The litany is familiar—sickle-cell anemia for blacks, Tay-Sachs and breast cancer for Jews, thalassemia for southern Europeans. A recent *New York Times* story emphasized that Jews carry ten genetic diseases.[5] Compare this current assessment of Jews with nineteenth-century eugenicist evaluations that saw Jews as particularly prone to diseases like epilepsy, neurasthenia, hysteria, mental illness, and so on.[6] There are not uncoincidentally few specifically "white" or "European" diseases: those are called "chronic" or just thought of as universal.

With this arrangement, to be human is to be the norm, to be ethnic or racial is to have diseases that require prosthetics at a genetic level. Rather than saying, as did nineteenth-century eugenicists, that various racial groups were infe-

rior, defective, or degenerate, we can now say that various "populations" have "defective" genes that create birth "defects." The one-armed man or the eyeless woman in need of prosthetics now becomes the person born with a missing or erroneous allele or protein. The prosthetic level has become interior, intracellular, a grammatical mistake hidden within the *lingua gataca* that can be corrected by a supplementary addition. Of course, this lack is now no longer a permanent defect that can never be corrected. While now invisible, even without specific effects, the innermost notation of defect—that written in *lingua gataca* only readable by experts with complex machines of analysis—can be remediated, hypothetically in some hypothesized future, with an addition or correction on a genetic level. That invisible prosthetic addition will never be perceived visibly and so resides as a transcription, a rewrite that no one will ever read.

We have to ask whether we will be creating a prosthetic space in genetics as we did over the mechanical replacement of body parts in the nineteenth. For the nineteenth century, this space was defined by a kind of anaclitic confusion. Is the stump the missing limb, the tree, or the prosthetic? As Yeats wondered about trees, we might paraphrase, how can you know the stumper from the stump? The prosthetic limb creates a new kind of anxiety in personal space and stands in for the void that it is supposed to fill. The question of armlessness becomes metonymically now connected to the problem of the artificial limb that is trying to erase the void and so becomes the new void. The primitive horror of looking on at the severed limb shaded into the visual horror of looking at the "lifelike" wooden limb. Likewise, the group of people with the genetic "defect" now become writ large as the problem of the replacement or drug prosthetic therapy. Rather than being "cured" by genetic therapy (which has not proven even partially successful at this point), the human population with the genetic "defect" becomes racialized anew as that group known to be "missing" the proper gene for hemoglobin production, in sickle-cell anemia, or for membrane permeability in cystic fibrosis.

This transgressive existence as the mistake that is correctable becomes even more problematic when we consider that the way that genetic therapy works is that a virus is emptied of its genetic matter and that the "right" genetic material is inserted into it. The virus is then injected into a human or an animal, and its mechanism allows the cells to be invaded and their genetic material altered. This sci-fi scenario, which has not yet proved successful and has killed several people in the

process carries a weighty signification. The defective race must be infected, invaded, and altered by a disease to correct a disease. Thus the invisibility of the prosthesis becomes linked to an invasion/contamination scenario that we have seen before in countless sci-fi films—perhaps most notably Ridley Scott's *Alien*. This "cure" scenario also repeats on some fundamental level the racial purity fears of a hundred years earlier in which defective races were seen as "infecting" the purity of more advanced races. Now the infection scenario is reversed as the advanced races deliberately infect the defective races to correct their defects.

Further, the visual isolation and stigmatization of the wearer of the prosthetic limb now becomes the institutionalized visualization of the group under the lens of genetic scanning. Populations that are overresearched will tend to be those in which more genetic anomalies are found. In other words, the group "white" tends not to be studied as a social group, while the groups "African American," "Hispanic," and "Jewish" tend to be studied. In that case, it is no surprise that genetic differences in the studied group, as distinguished from the "normal" population, will be found. Thus, scrutiny will produce observations that will produce corrections. So a group that is studied will be found in need of prosthetic intervention. In this scenario, prosthesis is more about the observation than the conclusion. We can speak of a prosthetic process within a space of prosthesis.

In addition to specific groups entering into a prosthetic relation to a dominant group, a new development is well underway. Drugs that are tailored to specific ethnic or racial groups are being developed. There is a genetic component to this work since the notion is that certain populations will have diseases specific to those groups, probably because of hypothetical genetic differences. As we have indicated, the genetic cause will replace a far more likely complex of social causes and political consequences as individuals and races get blamed and exploited for "their" diseases. Indeed, several companies in the United States, including Alcon Laboratories, have already created pharmaceuticals that are tailored for African Americans: Travatan is marketed as "the first glaucoma drug to demonstrate greater effectiveness in black patients,"[7] and BiDil, a cardiac medication made by NitroMed, provisionally approved by the U.S. Food and Drug Administration, is being billed as "the first heart failure medication specifically for African American patients."[8]

The drug BiDil provides an excellent case in point. Jonathan D. Kahn has traced the history of this drug and shown how racializing medicine and using genetic explanations for medical conditions lead to bad science and abuse of the drug industry for profit.[9] The drug, which is a combination of two previously available generic drugs, failed on its first round through the FDA because of poor testing design and bad statistical work. But with statistical rearrangement of the initial test, NitroMed has been permitted to design a test using only black patients. The new application was based on a few articles, some written by the patent applicants themselves, that claim that blacks die from heart failure at a rate that is twice that of whites. Kahn shows that this statistic was used and published widely in scientific and medical journals, as well as in the public press, even though it is completely false. According to Kahn, the more accurate statistic, based on more recent numbers, is that the mortality rate difference between white and blacks is virtually nil.[10] Kahn concludes that, even without hard evidence, researchers will grab at the genetic racial explanation because it is easier to hypothesize an individual biological cause than to pay attention to the complexities of social, economic, and cultural factors. Race may factor in as racism rather than genetics, according to a recent report from the Institute of Medicine of the National Academies that found that racial and ethnic minorities tend to receive lower-quality health care than whites, even when researchers correct for income, age, and insurance status.[11] Another study indicates that people who perceive themselves the object of racism will have higher blood pressure.[12] The reality is that diseases, even if associated with genetic causes, will have a complex interaction between the genes and the environment. This Troy Duster refers to as "a complex interaction of social forces and biological feedback loops."[13]

Thus, with the advent of drugs that are tailored to racial groups, the prosthetic element is now doubled. What we get is eugenics squared: to be of a racialized group is to be in a prosthetic relation to the dominant group, as we have seen above. Now we add another element: to be of a racialized group requires additional therapies to cure that group of the diseases that are inherent to that group because it is racialized. So coursing through the bloodstream of all racialized groups will be the hidden prosthetic of drugs designed to make that group "human" and "normal." This is the truly biocultural moment in which humanity is

redefined in terms of medical interventions to correct the "defect" of race. Thus, to be human is to be normalized, which means that one must have the prosthetic corrective that is purchased from globalized pharmaceutical corporations whose existence is based on achieving this widespread consumption. At its best, the prosthetic is no longer lifelike but becomes life itself, inserting itself into the unseen biological processes. We are witnessing the ultimate moment of prosthetics in which the differences between the tree stump, the limb stump, and the prosthetic stump dissolve. The genetic model combined with the advent of gene therapy, genopharmacology, and segmented marketing gives us a prosthetic that resides within the living being sharing the very life processes that all living things share. This opportunistic, in all senses of the word, occupation inaugurates the biotechnological existence in a step that makes the cyborg obsolete. We see layers and cascades of prosthetic hypersignification from the prosthetic nature of the gene and DNA to the geneticizing of social categories like race and finally to the solution to the problem of race through biotechnological fixes inspired by the rapacity of global capitalism.

We can say that we are no longer stumped by genes, but we are more likely to find ourselves trumped by genes, particularly since this transition is happening at breakneck speed in the context of a largely uniformed public sphere. Although many of us are highly informed about the social and cultural issues that arise around race, we are in great need of a biocultural education that would allow us to confront the changes that are happening outside of the public's ken and inside the corridors of hospitals, research institutions, and biotech firms. If we allow a prosthetic space to develop regarding the corporate and institutional takeover of the human genome and the genomes of various indigenous and racialized groups, we will see a relation of power and substitution continuing from the social to the genetic. In the prosthetic space, meanings and biotechnical objects are put in the place of, added, and created as a supplement to existing definitions of being human. The relationship that we are describing—the politics of prosthesis—cedes that meaning-giving power, the power to add something as a correction, to corporate, institutional, and even personal entities without discussing the process. In the biocultural space, however, the substitution becomes a reservoir of meaning—a helping limb, as it were—to explain and decode the mystery of the hidden substitution. The prosthetic describes the lack and the biocultural suggests

the meaning of the lack and the congealed power that becomes embodied in the prosthesis itself.

Notes

1. In saying "out-of-boundary," I am committing a kind of heresy against biocultural analysis, which is premised on having nonspecialists and not medical scientists analyze researchers' data and findings. Specialists cannot or have not to any great extent engaged in a rigorous self-critique of their own basic systems.

2. An interesting question that has been raised by microtechnology is the possibility that prosthetic devices can be better than the original body parts. How will super hearing aids, infrared contact lenses, more nimble and durable limbs, and super genes alter our notions of the prosthetic?

3. A recent issue of *Science* offers a cash prize to anyone who guesses the correct number.

4. Nicholas Wade, "Gene Study Identifies Five Main Human Populations," *New York Times,* December 20, 2002, A37. This article was based on a study by Noah A. Rosenberg, Jonathan K. Pritchard, James L. Weber, Howard M. Cann, Kenneth K. Kidd, Lev A. Zhivotovsky, and Marcus W. Feldman, "Genetic Structure of Human Populations," *Science* 298 (2002): 2381–2385.

5. Gina Kolata, "Using Genetic Tests, Ashkenazi Jews Vanquish a Disease," *New York Times,* February 18, 2003, F1.

6. Charcot, for example, said that "nervous illness of all types are innumerably more frequent among Jews than among other groups." Quoted in Sander Gilman, *Difference and Pathology: Stereotypes of Sexuality, Race, and Madness* (Ithaca, NY: Cornell University Press, 1985), 155.

7. Alcon Laboratories, "New Prostaglandin Shows Significant Reductions in IOP and Greater Effectiveness in Black Patients," press release, March 20, 2001.

8. NitroMed's Web site indicates that, like the HIV vaccine, BiDil failed on a general population but was effective for the minority portion of the test. FDA approval is pending the results from a new test that is being conducted with an exclusively African American male population. <http://www.nitromed.com/bildil/DOCS/background.html>.

9. Jonathan D. Kahn, "How a Drug Becomes 'Ethnic': Law, Commerce, and the Production of Racial Categories in Medicine," *Yale Journal of Health Policy, Law and Ethics* 4 (2004): 1–46.

10. Ibid.

11. B. Smedley, A. Stith, and A. Nelson, eds., *Unequal Treatment: Confronting Racial and Ethnic Disparities in Health Care* (Washington, DC: National Academic Press, 2003).

12. N. Kriegere and S. Sidney, "Racial Discrimination and Blood Pressure: The CARDIA Study of Young Black and White Adults," *American Journal of Public Health* 86 (1996): 1370-1378.

13. Troy Duster, "Buried Alive: The Concept of Race in Science," *Chronicle of Higher Education,* September 14, 2001, retrieved from <http://chronicle.com/weekly/v48/i03/03b01101.htm>, accessed February 11, 2005.

THE BUG'S BODY: A DISAPPEARING ACT Gary Genosko

The bug's body is a disappearing act. Phantom limbs have the power to make their presence felt in their absence. But how can a phantom prosthesis be addressed—analyzed, criticized, have a light shone on it? A prosthesis (external, usually but not necessarily) can make its absence felt even in its presence. A prosthesis of *intelligence and behavior* can manifest itself according to hypotheses about its most viable modality (analog or digital) in waves of modeling (animat to roachbot) that develop the bug reference. A prosthesis can always be on the way—no matter how well it supports a hypothesis—to a timely demise. Demise is the timeliness of the bug's body. A simple urban experience is illustrative: stumble into your apartment's kitchen at 3:00 a.m., switch on the light, and watch (and hear) them scatter. Bugs: as soon as light is trained on them, they tend to disappear. Matters are no different with the micromechanical cybugs that are designed in university labs to test hypotheses about preferred modalities in modeling adaptation. Military-industrial research figures the cybug as being ultimately disposable when production becomes cost effective and massive—a plague of disposable prostheses.

Bugs can make their presence felt without having much of a positive existence. This is a common enough experience after each round of spraying that would have eradicated *them* once and for all. *Them*[1] is a keyword in the atomic monster movies of the 1950s and in the films shown at the University of Illinois's inaugural Insect Fear Film Festival in 1984. As an early invitation to the desert of the (ir)real, *Them!* has provoked fascinated disgust and academic contempt.[2]

The bug's body is an example of Jacques Lacan's *objet petit a* (an absence in the form of a secret that requires explanation; dubbed "the McGuffin" by Slavoj Žižek after Alfred Hitchcock as "a pure pretext whose role is to set the story in motion") give shape to loss and lack in the symbolic order.[3] The bug's body is a void—a lack that is filled out, a speck that causes the man with the spray gun (or the flame thrower, in the case of *Them!*) to spring into action. Roach motel. Off. Diatomaceous earth. Exoskeletal strafing. Impact. And they're gone. Were those little specks on the counter droppings or stray flakes of pepper? Drop or dropping? The *objet petit a* (*t'a* or *tas*—heap of dung) "symbol[izes] the lack . . . insofar as it is lacking."[4] The object manifests lack for the subject and displays for the subject his or her lack. Mind the gap.

The bug's body is an object of fascination (object cause of desire): the more that someone tries to kill it, grind it underfoot, spray it, and lay traps for it, the stronger it seems, the more ubiquitous, the more remarkable, the more fascinating. Is it ever safe *not* to spray? Even if a battered corpse turns up, you are never really sure that the toxic bomb you just dropped did its job.

Debugging

The history of hacker lore could be read as a cultural entomological masterpiece written for paranoiacs. All the way from Digital's landmark first computer, the PDP-I (1959) to the Y2K millennium bug predictions, the bug's body haunts cyberculture by embodying geek desire. Cyberculture has never given up on bugs. In 1961, Peter Samson called the PDP-I's debugging program DDT, for DEC Debugging Tape (now the Dynamic Debugging Technique).[5] Jack Dennis and Thomas Stockman later developed a debugging program for the TX-0 (the first transitorized computer) that they named FLIT (Flexible Interrogation Tape) after an insect spray.[6] One of the first small robots developed in what became Marvin Minsky's Artificial Intelligence Laboratory at MIT was called a "bug" by its young inventor David Silver,[7] others said that it looked like a piece of junk. The MIT Museum is perhaps the greatest repository of early insectoid robotic specimens, all beautifully preserved under glass or tucked into drawers like their pinned counterparts in entomology departments of natural history museums. The evo-

lution in this unnatural history from the glitch to the insectoid robot raises a fundamental problem of mimesis, to which I return below.

The "bugs" (glitches) were there to be debugged in hacker practices, in their original meaning of tinkering and improving on tools in an open environment. Such bugs were waiting to be rewritten or debugged toward the perfection of a piece of software, given not so much a name as a "remedy." Manuel De Landa[8] has emphasized the interactive movement of the hacker ethic such that debugging may be called an interactivity-enhancing engagement. The question here is whether the hacker ethic—the free flow of information to improve computers through open access to programs—necessarily presupposes bugs or perhaps less formally makes bugs a first principle: "Typically, a hacker would write a piece of software, maximizing interactivity, and then place it in a 'toolbox,' where it was available to anyone who wanted to use it or improve on it."[9] Debugging is both improvement and enhancement. Consider Neal Stephenson's version of this process in the case of UNIX operating-system hacking: "As of this writing [January 1999] something like 32,000 bugs have been reported to the Debian Linux bug database."[10] There is also a simple typology of bugs (critical, grave, and normal). And the BEOS lightweight operating system is pretty much the same: "some of the 'bugs' here are nothing more than hackers blowing off steam." The bug is a machinic principle of interactivity, whether it's there or not. Simply, the bug is the cause of geek desire.

And this is the end, for some. In her novel *The Bug,* Ellen Ullman reflects on debugging: "Debugging: what an odd word. As if 'bugging' were the job of putting in bugs and debugging the task of removing them."[11] A programmer's job is to find and fix the bugs attributed to particular lines of code. For every cute ASCII beetle balled up and tossed into the waste basket—bugs as mere mistakes and failures—a superbug exists, which leads Ullman to shift to describing specters and hobgoblins. In the process, her character Ethan Levin is driven to suicide as bugs and, specifically, his superbug reverberate in his head like munching earwigs.

It's a bit like Y2K—the millennium bug—as Slavoj Žižek explains in one of his doom reports: "The very term is tell-tale with regard to its three meanings: glitch/defect; an insect; a fanatic. This drift of meaning performs the most elementary ideological operation: a simple lack or glitch imperceptibly acquires

positive existence, it becomes a disturbing 'insect' endowed with a certain psychic attitude (zealotry)—and the malfunctioning has all of a sudden a cause, a zealot that should be exterminated as an insect. . . . We are already knee-deep in paranoia."[12] The insect manifests the lack in the big Other, the symbolic order, the Matrix; it signifies lack insofar as it is lacking—"an entity about which it is not clear even if it 'really exists' or not." It caused global distress and stirred wild scenarios. It had its promoters (making the absent bug present in the World Wide Wonderland) and detractors and made fortunes. Precautions were taken on a massive scale to prevent the collapse of the symbolic. And even when nothing happened, was this really evidence that it didn't exist?

Trivia(l) question: "What insect shorted out an early supercomputer and inspired the term *computer bug*—a fly, roach, moth, or Japanese beetle?" Answer: A moth. You're a millionaire. In the quiz-show culture,[13] knowledge doesn't require deliberation or analysis—just a little demonstrative grinding of the cerebral gears for visual effect and the uncoiling of an answer in response to a question on a screen. Millionairism. The search for origins is always a dangerously seductive undertaking. Ullman is bewitched: "Bug: supposedly named for an actual moth that found its way into an early computer, an insect invader attracted to the light of glowing vacuum tubes, a moth that flapped about in the circuitry and brought down a machine. But the term surely has an older, deeper origin. Fly in the ointment, shoo fly, bug infested, bug ridden, buggin' out, don't bug me. . . ."[14] Shuffling through vernaculars is another way of dematerializing and making ephemeral the bug's body.

For every moth, there is a *Mothra* (1961).[15] What happens to Mothra in a later film is of interest and seems to conform to an interdiction against monster movies, perhaps in fear of another Japanese military invasion. In *Godzilla vs. Mothra* (1964),[16] the giant moth hits U.S. theaters renamed as *Godzilla vs. The Thing*. How can I get my thing, my bugs, when one of them is renamed for the thing that I cannot have, the identity as thing being defined simultaneously by an academic and cultural interdiction (stop fooling around with monster movies, especially if they are Made in Japan)? And if I get it (get to continue working on it and theorizing the great chain of Lepidoptera), I must come to realize that it can't be It, anyway. The only way I can pull it off is to mothball the project and

Figure 6.1: *Mothra,* © 1961, renewed 1989, Columbia Pictures Industries, Inc. All rights reserved. Courtesy of Columbia Pictures

thus open it to symbolization. Get on it or with it, as scientist or novelist, but not both at once.

Bugaboo

A long journey from Canada's boreal forest to New Zealand's perfumed floral excess was smoothed on the day that I left my home in Thunder Bay, Ontario, for a conference in Auckland when I encountered a large metal grasshopper on display on the lunch counter of a local favorite haunt, the Hoito Restaurant. The daily newspaper featured a cover photograph of two young boys who were inspecting the creature while enjoying breakfast. The festivities of St. Urho's Day beckoned, and the grasshopper once again would enjoy pride of place on the lead parade float as it made its way along Bay Street. I was ready for a brush with paradise, but had I missed it? St. Urho's Day is celebrated each year on March 16 in certain northern Minnesotan and northwestern Ontario towns with significant Finnish populations. In Menahga, Minnesota, an enormous statue of the saint stands with a grasshopper speared on his trident. Since the mid-1950s, St. Urho's Day has parodied St. Patrick's Day, which is celebrated the following day. St. Urho's apocryphal feat was to have, like St. Patrick, rid his country of a certain kind of creature. Instead of snakes, St. Urho expelled the grasshoppers from Finland, thus saving the vineyards and wine production. In a reversal worthy of postmodern slippage, the Irish are said to have stolen the idea from the Finns.

This apocryphal history has given rise to annual rituals (parades) and exchangeable keepsakes (greeting cards) that help maintain locality and reproduce social life, especially in the Finnish community, against the external pressures that militate against its production (regimes of standardization emanating from the city, province, and beyond). St. Urho is a context generator. The fact that the saint is manufactured does not diminish its social significance in the production of locality.[17] The public presentation of the bug's body in the Hoito Restaurant and then in the St. Urho's Day parade builds with ephemeral tools the ephemeral and fragile experience of locality. The parading of the bug's body is a ritual occasion for the confirmation and renewal of the locale. That this simulated history has largely eclipsed representations of and knowledge about the actual history of Finnish immigration, illustrious Communist organizing, bush work, and so on

merely underlines the power of the imagination in shaping local life. Every year when the metal grasshopper is dusted off and put on display, it stands in stark and parodic contrast with other localities in a jumbled ethnoscape and against the extermination of national, normative inspiration, against the standards of commemoration (statues, plaques), against uniformity (linguistic), and against capitalistic one dimensionality. The bug's body makes *them* nervous. The bug's body challenges them (in the Heideggerian sense of *they*)[18] in their average everydayness (the "who" is "nobody" to which *Dasein* (Martin Heidegger's human being whose ability to question Being puts it at the center of Being's disclosure and elucidation) in its everydayness stands in subjection) but only insofar as those who would invoke it are already defined relationally in the first place. Yet they can clear this obscurity away and in the process modify the relation with the "they."

Subsidence

Roger Caillois[19] argues that mimesis erodes and undermines the distinction between an organism and its environment. This hypothesis regarding the subsidence of such a distinction is a key theoretical statement of the disappearance of the bug's body—what Denis Hollier has elegantly put as Caillois's elevation of "subjective detumescence" into a "cosmic, virtually metaphysical principle."[20] An investigation of the heterogeneity of materials at Caillois's disposal—animal (especially insect) mimesis, sympathetic magic (applied to insects), and psychasthenia—would take us far afield. Caillois's lesson for the purposes of this text is that the mimetic bug's body tends to disappear through assimilation to its surroundings.

Caillois first offers a typology of mimetic relations between organisms and their surroundings based on what he thought were "extreme" examples and the "unsatisfactory" character of existing explanations of them. Thus he considers offensive (surprise prey), defensive (escape from predators), and direct (taking on a disguise in a creature's interest) and indirect mimetic relations (resemblance and convergences between species that are divided into taking on forbidding features such as eyes and homomorphic adaptation, as with leaf insects and leaves). Caillois then rejects as insufficient any explanations that are based on principles of preadaptation (seeking out surroundings that match them or adjusting to what

they resemble), on chance (simple accumulation of details and features), and on defensive mechanisms (which incorrectly presuppose that carnivores hunt by sight and seek out motionless prey since immobility can be as defensively effective as mimesis). Indeed, Caillois noted that even those insects that push resemblance to the minutest of details are still found in the stomachs of predators. Caillois preferred a "sketchy hypothesis": "we are thus dealing with a *luxury.*"[21] The so-called luxury of mimesis is dangerous because neither gardeners wielding pruning shearers nor leaf insects browsing together can distinguish between leaves and other insects. Insects are pruned as if they were leaves, and other insects are consumed homophagously during "mutual browsing": "the simulation of the leaf being a *provocation* to cannibalism."[22] Mimesis poses a risk. Luxury bites: Y2K showed this in exotic detail.

To the extent that the bug's body becomes progressively indistinct, this assimilation to its surroundings may be said to complete mimetic morphology (especially in the case of butterflies, notably mayfly larvae). Whether this is sympathetic magic (like attracts like) or a "perceptual disturbance" (such as legendary psychathenia in which the living creature, as the origin of coordinates between object and ground, is "dispossessed of privilege" (perspective) and "no longer knows where to place itself")[23] is probably moot. The basic principle of subsidence of the organism in its repositioning as one coordinate among others—its absorption into what was hitherto its ground—is a disturbance of space. Space is a phagocytositic (cell-eating) machine that in Caillois's estimation erases distinctions at the expense of the bug's body. For Caillois, mimicry (biological and magical) and psychathenia have a common root in the blurring of the organism/environment distinction. In Caillois's hands, mimicry becomes an "instinct of renunciation" (32).

For all of Caillois's desire to combine disparate discourses and explanations, avoiding the obvious psychoanalytic hypothesis of the death drive and the ridiculous reductionism of adaptation,[24] his conception operates with internal constraints, two of which are salient—the unidirectionality of the phenomenon of mimicry (animal mimics plant) and the assimilation of the animate to the inanimate.[25] Has Caillois mapped out the destiny of the bug's body by directing his readers toward the postbug world against every expectation that such a world would be impossible no matter which extreme scenario is entertained? Perhaps

he simply isolated mimesis as an accelerated modality of disappearance and in so doing refocused attention on resemblance as a fundamental problem for thinking the bug's body.

Cybug

The autonomous-robot approach to artificial intelligence emerged in *From Animals to Animats: Proceedings of the First Conference on Simulation of Adaptive Behavior* (1991).[26] The papers in that volume present related research approaches, most undertaken during the second half of the 1980s, involving the use of simulated animals in the study of adaptive behavior and intelligence. First coined by Stewart Wilson in 1985, the term *animat* refers to simulated animals or autonomous robots. But more often than not the term simply means "bug" given the large number of artificial insectoids under study. I prefer the term *cybug*. Nonetheless, the study of an animal's adaptive behaviors (physiological, sensory, and learned) in selected artificial environments, the mutual influences of which are modeled on the postulates of ethology, biology as well as cognitive science, furthers a variety of artificial intelligence research agendas—such as making practical inroads into robot design and construction, improving computer modeling techniques, investigating the difficult question of emergent consciousness, and returning to ethology something of the insights gleaned. But the animat as cybug suggests an array of animated insects such as those used by naturalist documentary maker Wladyslaw Starewicz in his prerevolutionary Russian films featuring insect corpses dressed in human garb such as *Happy Scenes of Animal Life* (1912), *The Grasshopper and the Ant* (1913), and *The Lily of Belgium* (1915). These taxidermic simulations for the cinema are perhaps the precursors to the cybug. Indeed, Akira Lippit[27] alerts us to the fundamental historico-theoretical connection between animals and cinema (and photography) as a mimetic machine that embalms animals in animation just at the moment when, as early cinematographers such as Muybridge recognized, animals were disappearing from the urban environment (clearly, though, Lippit's thesis does not extend straightforwardly to the lower orders). But the cybug—cyberbug or robobug—carries us beyond simulation but not beyond mimesis in the combination of machine and insect body under the theoretical umbrella of *biomimesis*.

Animat was a buzzword in robotics in the 1990s. For the new millennium, a new buzzword appeared—*biomimesis.* The concept takes the biology of living creatures, often insects, as inspiration for robot design—roachbots like those designed at Case Western Reserve University, McGill University, and the University of Michigan.[28] Mimicry is less rigorous because it is not copying. Rather, it works by means of analogy, abstraction, and extrication of the most promising features of creatures from an engineering perspective. Sometimes this is taken quite literally in the redeployment of biology in synthetic form. Mark Tilden, for instance, refers to his Unibug 3.2 as a biomech or biomorphic bot, eschewing digital programming for analog adaptability to changing terrain conditions.[29]

Consider again Caillois's observation of the unidirectionality of mimicry in nature and the assimilation of the organic to the inorganic (bug being toward disappearance). Biomimesis is actually bidirectional when it is deploying biology by literal extrication. The late 1990s saw the development of a Japanese program of research (much at Tokyo University's biorobotics lab) in which the antenna of male giant silk moths were detached and connected to a tiny wheeled robot. Although the detached antennae had a limited lifespan of only a few hours, they were able to detect and respond to the pheromones emitted by a female silk moth. Another approach moved in the opposite direction. By surgically implanting microrobotics into modified, living roaches (with their wings and antennae removed), Japanese scientists were able to direct the bug's movement. Instead of receiving signals with its antennae, the modified roach received and responded to remote radio signals with its implanted electrodes. These examples show that biomimesis is bidirectional in the expanded sense that the assimilation of the organic to the inorganic is complemented by the assimilation of the inorganic to the organic. The lifespan of a roboroach is at best several months. Taken in either direction, this vein of research that focused on insect antennae leads to the unnatural demise of the research subjects.

Cybug research in the United States and United Kingdom (such as the University of California at Berkeley's micromechanical robotic fly, Vanderbilt University's battery-powered crawlers, or the University of Sussex's roboinsect research program) has many other fascinating veins, some of the most interesting of which involve the investigation of collective robotic behaviors (swarm dynamics and

cooperative problem solving). For the purposes of this text, however, I have emphasized only one because it is a continuation of the problem of mimesis by literal, bidirectional bioextrication/machinic implantation.[30] And the examples under consideration require living creatures. Enormous numbers of living creatures of all kinds are destroyed in the course of research programs (the destruction of insects for research purposes is regulated).

The question that interests me is the destiny of remote roboinsect control. One of the main concerns of this program is that biomimesis hypothesis is perfectly adapted to both mass production and military research programs. It is cheaper to mass (re)produce cybugs because such production lowers costs and distributes risk in field trials. Loss of some cybugs does not entail failure since a great deal of information may still be retrieved by those that complete the task—a basic reorientation since the Mars Exploration Rover failure. Still, the revolution in microrobotics and the focus on insects has led to interest in mass production for military purposes of large numbers of identical and expendable grunt-bots (*armyants* in the parlance of the u.s. Office of Naval Research). Expendability becomes a principle of the cybug's disappearance: simple, cheap, hence, disposable, homogeneous (deindividuated), and thus designed for collective tasks. We need to heed Donna Haraway's warning, written during the Reagan years, about the military origins of the cyborg: "modern war is a cyborg orgy."[31] It is no different with the cybug because entomology-inspired biomimesis is the latest solution to military problems. The disappearance of the cybug's body is contained in the thesis of its mass production for military tasks such as spying: disposable, expendable, sacrificeable. And it has been this way for some time.

The history of insects in military research may seem somewhat obscure, but it is not without its literature. It is perhaps not surprising that the Office of Naval Research has its hands in the UCal Berkeley spyfly project or that DARPA (Defense Advanced Research Projects Agency) funds the Vanderbilt elastodynamic crawlers. In the 1960s, especially the middle years of the decade, the u.s. Army Limited War Laboratory and Army Service Agency experimented with insects as reliable indicators of human presence for the purposes of ambush and intrusion detection in the jungle environments in which the u.s. military was operating in Vietnam. This is one origin of the remote-control cybug—a low-tech

handheld, air pump contraption that deployed cone-nose and bed bugs resting among wound piano wire across which air would be hand pumped by a mobile operator. Any human effluent would cause an increase in the activity of the bugs, and the wire, connected to a phonograph cartridge, would amplify the bugs' movements and transmit this information to the earphones of the operator.[32] Field tests were not particularly promising. But in another set of trials, a possible precursor of current cybug antenna-focused research may be seen. Using giant cone-nose bugs, the olfactory receptors of which are found near the ends of its antennae, a handheld intruder detector was developed:

For each preparation the insect was immobilized in modeling clay. One antenna was attached by small wire hooks to the clay. Using a minute tungsten electrode, 5 microns in diameter, efforts were made to record from individual neurons immediately under-neath olfactory receptors. Unfortunately, out of about every seventy bugs, only one suc-cessful preparation was obtained. This preparation lasted for ten days without exhibiting any degeneration. It was selectively sensitive to human breath.[33]

These failures—too many false alarms, spontaneous activities, operator influence, cyclical insect activity—demonstrated, however, that the bug's body might be operationalized for certain military purposes. But it would take a revo-lution in micromechanics to solve basic problems of research design. The disap-pearance of the bug's body in biomimetics was, in a sense, already played out in the disposability of insect specimens in the very spotty research of the 1960s.

Crushed

Science fiction has provided glimpses of another destiny for the bug's body, a future detoured from military operationalization toward the sphere of marketing. In this sphere, mass production is also vital. From Philip K. Dick to Jeff Noon, the science-fictionalized mediascape is populated by adbugs. The Nitz commercials of Dick's *The Simulacra*[34] are buzzing, fly-sized adverts that crawl through cracks around doorways and deliver their annoying blurbs (today, the little score clock dropped onto a screen during telecasts of sporting events is known as a bug and

is, for some, too intrusive). Moreover, even the cute Martian papoola is described as a stubby, six-legged, orange bug-shaped creature with a hat worn jauntily over one antenna. And it bites, too. Noon picks up this motif in *Nymphomation*[35] and fills the skies of Manchester with blurbflies, what he often calls blurbverts, for the lottery corporation, AnnoDomino Co. The blurbs—technically Bio-Logical-Ultra-Robotic-Broadcasting-Systems—saturate the city with sponsored messages. It is illegal to capture them.

In both novels, the bodies of these bugs are subdued. In Dick's novel, the Nitz commercials are shot, either with pellet guns or pistols, and then crushed in revulsion under foot (perhaps more properly one may say *crunched,* like biting into a deep-fried beetle or inhaling a number of aphids, the flying insects that once every ten years infest Toronto's SkyDome stadium and make baseball an entomologically interesting spectacle). Noon hacks his bugs, and a great swarm of them carry the novel's protagonist Jazir (whose hacked Masala blurbfly initiates the process) into the very heart of the AnnoDomino Co., where the secrets of the domino lottery are revealed, and the biggest score of all is made against a result that was never expected.

This futuristic vision of annoying, pestering cybugs that get in through the cracks in the service of marketing conjures visions of a smooth seamless exterior lines and componential assemblage that Roland Barthes[36] likened, in his analysis of the Citroën D.S., to a substance "more entomological than mineral." An impenetrable bug.

Conclusion: The Future of an Absence

There are many modes of disappearance of the bug's body: dispersal, poison, hacking, dusting off a model and invoking locality through ritual, object cause of geek desire and Y2K fears, mimesis toward subsidence, biomimesis toward disposability, gunshots, crushing under foot. This text has touched on only a few of the possible modalities of the bug's body disappearance. Georges Bataille[37] reveled in the formlessness of the crushed spider, the spray of fluids and lacerated sac, smearing and staining like splattered insects on a car's windshield, and thought that an encounter with it was liberating and quite against academic tendencies to give form, homogenize, and prevent the slippage toward nonknowledge that the

operation of the formless entails. The only way to know the bug's body is through its modes of disappearance *in* a mode of disappearance, in full retreat from form.

In the end, it is instructive to revert to the lesson of Caillois. In his writings on the cannibalistic female praying mantis who devours her mate during or after copulation, Denis Hollier has expertly surmised a double disappearance. Considering Caillois's autobiographical *The Necessity of Mind,* Hollier writes: "the text, between its writing and its publication [posthumously published but written many years earlier by a youthful Caillois], is in fact subjected to a fate that illustrates the defeat of the first person quite literally: both versions of the essay [on the praying mantis included therein, from 1934 and 1938] published by Caillois during his lifetime suppress all personal references from the exposition of their themes [for the sake of what Caillois believed was their objective lyricism]. It is as if the autobiography had been sapped, dissolved from within, then assimilated by the third-person voice of the scientific study on the praying mantis."[38] What was zapped like a bug in an Electroswat device? The troubling symmetry or continuity was "between nature and human consciousness," as Caillois specified, but not any consciousness. Hollier explains: "it was in 1928 (when Caillois was fifteen years old) that he saw his first mantis, while on vacation on a beach in the south of France. The same day a woman made advances to him, thus making two firsts in one day."[39] Both the writings and events are exercises in subjective detumescence, subsidence that reverberates in life and work.

The being toward disappearance, across the disciplines, of insectoid prostheses of intelligence and behavior imperils those who would pursue such knowledge. It is not only in my own transversal flitting that this is evident. It is not a question of conforming to Caillois's biographical experience. Rather, the dangerous luxury is in disposable prosthetics itself: it really succeeds through disappearance. Success is measured in eradication. This suggests that the destiny of the bug's body is a plague of prostheses, most of which are simply destined to be sacrificed. Is it possible to explain the fascination with the bug's body in military research and robotics labs, in geek subcultures in general (code writing, sci-fi), in terms of detumescence, or, more generally, through the production of absences, withdrawals, subsidences? Surely, this is the fictive fate of programmers who are obsessed by elusive bugs. Isn't the very notion counterintuitive? After all, bugs are supposed to be the postapocalyptic creatures par excellence. Bugs can survive

anything—the cold war, even the millennium. In the case of the millennium bug, didn't it exhaust huge resources for no or little reason? Didn't it zap or, rather, sap energy, virtual and otherwise?

The destiny of mimesis is a cautionary tale about the impairment of knowledge of the bug's body as its prosthetic realization in achievable forms of mass disposability (as external or internal prostheses illustrated in the cases of silk moths and roachbots). For such knowledge follows the destiny of its object toward disappearance. Yet there are different shades of disappearance: in one mode, the bug's body is crushed or crunched; in another mode, materials are reused within limited constraints, as Belgian artist Jan Fabre demonstrated in recycling the wing cases of Asian jewel beetles from restaurant waste in Indonesia, Malaysia, and Thailand and using them to cover the ceiling of the Hall of Mirrors in the Royal Palace in Brussels.[40] There are glimpses of the junking of artificial intelligence in the eradication rhapsodies of hackers wielding names like DDT and FLIT. Simulated intelligence is a bug obsessed with its own dissolution.

Notes

1. *Them!*, directed by Gordon M. Douglas, 1954, film.

2. See Jonathan Lake Crane, *Terror and Everyday Life: Singular Moments in the History of the Horror Film* (Thousand Oaks, CA: Sage, 1994).

3. Slavoj Žižek, "Introduction: Alfred Hitchcock, or, The Form and Its Historical Mediation," in *Everything You Always Wanted to Know about Lacan but Were Afraid to Ask Hitchcock* (London: Verso, 1992), 4; Jacques Lacan, *Four Fundamental Concepts of Psychoanalysis,* trans. Alan Sheridan (London: Hogarth, 1977).

4. Ibid., 103.

5. See Steven Levy, *Hackers* (New York: Penguin, 1984), 53.

6. Ibid., 33.

7. Ibid., 109.

8. Manuel De Landa, *War in the Age of Intelligent Machines* (New York: Swerve, 1991).

9. Ibid., 225.

10. Neal Stephenson, *In the Beginning Was the Command Line* (New York: Avon, 1991), 112.

11. Ellen Ullman, *The Bug* (New York: Doubleday, 2003), 71.

12. Slavoj Žižek, "Welcome to the Desert of the Real," *Mute* 17 (2000): 63.

13. See Jean Baudrillard, *The Consumer Society* (Thousand Oaks, CA: Sage, 1998), 103.

14. Ullman, *The Bug,* 71.

15. *Mothra,* directed by Ishiro Honda, 1961, film.

16. *Godzilla vs. Mothra,* directed by Ishiro Honda, 1964, film.

17. See Arjun Appadurai, *Modernity at Large: Cultural Dimension of Globalization* (Minneapolis: University of Minnesota Press, 1996).

18. Martin Heidegger, *Being and Time,* trans. John Macquarrie and Edward Robinson (New York: Harper & Row, 1962), 164–168.

19. Roger Caillois, "Mimicry and Legendary Psychasthenia," *October* 31 (1984): 17–32.

20. Denis Hollier, *Absent without Leave: French Literature under the Threat of War,* trans. Catherine Porter (Cambridge: Harvard University Press, 1997), 41.

21. Caillois, "Mimicry," 25.

22. Ibid., 25.

23. Ibid., 28.

24. Jacques Lacan, *Ecrits,* trans. Alan Sheridan (New York: Norton, 1973), 3.

25. Caillois, "Mimicry," 31–32.

26. Jean-Arcady Meyer and Stewart W. Wilson, eds., *From Animals to Animats: Proceedings of the First International Conference on Simulation of Adaptive Behavior* (Cambridge: MIT Press, 1991).

27. Akira Lippit, *Electric Animal* (Minneapolis: University of Minnesota Press, 2000), 185–197.

28. See Peter Menzel and Faith D'Aluisio, eds., *Robo Sapiens: Evolution of a New Species* (Napa, CA: Material Word, 2000), 96, 102ff.

29. Ibid., 177–121.

30. The research on cybugs on which I relied was gathered in 2002 from Internet sources by Nathan Radke, who was then a graduate student in sociology at Lakehead University. Most source materials were university or research lab press releases, specialty newsletters, or science and technology reports in the popular press. The sources are too numerous and disposable to notate. I am also grateful for the editing and comments of Jerry DePiero, a research assistant in my Technoculture Lab.

31. Donna Haraway, "A Manifesto for Cyborgs: Science Technology, and Socialist Feminism in the 1980s," in Linda J. Nicholson, eds., *Feminism/Postmodernism* (London: Routledge), 191.

32. Robert Lubow, *The War Animals* (Garden City, NY: Doubleday, 1977), 111.

33. Ibid., 113.

34. Philip K. Dick, *The Simulacra* (London: Methuen, 1987).

35. Jeff Noon, *Nymphomation* (London: Black Swan, 2002).

36. Roland Barthes, *Mythologies,* trans. A. Lavers (London: Paladin, 1973), 96.

37. Georges Bataille, ed., *Encyclopedia Acephalica,* trans. Iain White (London: Atlas Press, 1995), 50-51.

38. Denis Hollier, "Fear and Trembling in the Age of Surrealism," in Roger Caillois, *The Necessity of Mind* (Venice: Lapis Press, 1990), 157.

39. Ibid., 157.

40. Marlise Simons, "Bits of Bugs Glow, to Delight a Queen," *New York Times,* February 4, 2004, n.p.

ON THE SUBJECT OF NEURAL AND
SENSORY PROSTHESES

Lisa Cartwright and
Brian Goldfarb

*Is it really so sad and dangerous to be fed up with seeing with your eyes, breathing with
your lungs, swallowing with your mouth, talking with your tongue, thinking with your
brain . . . ? Why not walk on your head, sing with your sinuses, see through your
skin. . . . Where psychoanalysis says, stop, find your self again, we should say instead,
"Let's go further still. . . . Find your body without organs. Find out how to make it.
It's a question of life and death. . . ."*
 —*Gilles Deleuze and Félix Guattari,* A Thousand Plateaus: Capitalism
 and Schizophrenia[1]

In *A Thousand Plateaus: Capitalism and Schizophrenia,* Gilles Deleuze and Félix
Guattari thought about the psyche and challenged psychiatry and psychoanalysis,
fields that are based in neurology. But they considered only marginally the role of
the spinal cord and nervous system in the production of a body without organs.
During the 1990s, years that the American Psychiatric Association dubbed the
decade of the brain, neurology took seriously the production of its own material
versions of a body without organs, facilitated by evidence accruing since the 1950s
that the brain and nervous system were not rigid and hardwired but plastic and
malleable. By the 1980s, it was clear to neurologists that adult nerve fiber was ca-
pable of changing form and making new connections. This sea change in neu-
rology made it possible to imagine the willful redistribution of intrasubjective
relationships among organs, the nervous system, and sensory experience through

neural prosthetics designed for people with injuries or progressive diseases of the spinal cord.

The nervous system emerged with prosthesis as a scholarly trope in the 1990s.[2] These terms often appeared with the word *network,* a concept that emerged across computer science and biomedicine. Variously modified by the terms *neural* or *computer, network,* like *prosthesis,* signified enhanced connectivity between organisms and machines in the late-century frenzy over digital and organic systems[3] that was anticipated in the cybernetic theories of Norbert Wiener and figured in his postwar cybernetic prosthesis.[4] This chapter chronicles some neural and sensory prosthetic technologies that were introduced in the 1990s. We consider material and semiotic relationships among instruments, bodies, and subjects across these concepts.

In 1999, Brian Goldfarb chronicled the development of ocular prosthetics in *Ocular Convergence: Shared Subjectivity and Visual Prosthetics,*[5] a digital installation that constructed an imaginary global consortium of government, university, and private ocular prosthetic research and development. The research that this project documented was actual, but the federation was a fabrication that commented on the state of global science. In this essay, we mine that work to identify changes in concepts of sensory prostheses and the nervous system that were occurring at the century's end.

We also view prosthesis actively through the experience of spinal-cord injury sustained by Lisa Cartwright in the early 2000s and experienced by both of us as a condition that required collaborative research, accommodation, and medical management. Prosthesis, narrowly speaking, hasn't been part of that injury's management; orthotics and surgical hardware have. We propose, however, that prosthetics exist in a continuum with orthotic and surgical hardware and software that are designed to facilitate nerve function, sensory function, and motor ability. Experiencing life through the dynamic neural perspective that a spinal-cord injury and its accommodation in the early twenty-first century invites, we looked back on the critical writings about prosthesis that were published in the 1980s and 1990s.[6] That discourse inspired us to write an earlier review of the prosthesis trope and the meaning of disablement.[7] How, we ask now, do we reconceive the body and the subject when their organization is altered by changes in concepts of the nervous system introduced in the 1980s and 1990s? How do neural prostheses

reorganize the body as it is imagined across the discursive realms of biomedical research, medicine, rehabilitation, and patient discourse? What constitutes the object that is lost when nerves and not organs are the primary entities of interest in treatment and rehabilitation? And how do the very ideas of object, organ, and part change when the senses and the nervous system are recognized to be the entities replaced or supplemented in a prosthetic system?

The image of the adult nervous system early in the twentieth century was that of a hardwired system with limited potential for adaptation or regeneration after injury or degenerative illness. After World War II, discourses of neurology and machine computing became mutually constitutive. Descriptions of the nervous system as a model for machine intelligence were paralleled by characterizations of the nervous system as a conductive mediating network. By the early 1980s, there was clear evidence that nerves were capable of change and regeneration. By 1990, the image of the nervous system had become that of a dynamic, changeable network with potential for organic regeneration and reconfiguration.[8] The nervous system had come to life, conceptually and practically, as much more than the body's hardwired interface. At the same time, the brain and spinal cord emerged as previously untapped sites of potential medical management through prosthetic intervention. Instrumentation introduced late in the century included external and implanted elements (neural stimulators) and surgical manipulation (deep brain stimulation). We propose that neural and sensory prostheses that were introduced at the end of the century offered a set of meanings and relationships of body and technology that are different than those theorized on the basis of mechanical prostheses in late-century critical writings on the concept. We emphasize overlooked changes in intrasubjective relationships of experience and meaning produced across the sensory and nervous systems. The purpose of this essay is to introduce some thoughts about changes in intrasubjective experience with the new neural organization of the body and with the introduction of neural prostheses.[9]

Touch and Intersubjectivity: Myoelectrics and the Prosthetic Sense of Feel

Myoelectric refers to devices that use electrical systems to tap the body's nervous system. Katherine Ott, David Serlin, and Stephen Mihm propose that the myoelectric

limb, which had been in development since World War II, was not commercially viable by century's end.[10] Serlin notes that in the postwar United States, Norbert Wiener was commissioned to develop electronic prosthetic limbs but that the model he developed was first picked up as an industrial production device. The pricey models that were introduced to the prosthetics market beginning in the 1960s were never widely used.[11]

These early models offered their wearers greater control over limb movement but not limb sensation. Jack, "the mean-looking guy with the myoelectric arm" in William Gibson's 1986 short story "Burning Chrome," reflects some of the desires that drove researchers to introduce sensitivity to prosthetic and paralyzed limbs.[12] Jack describes his encounter with Rikki Wildside, a woman erotically drawn to his prosthesis. For readers of the 1980s and 1990s, Rikki and Jack embodied the erotic potential of technologies that might restore not only body parts but also sensations like touch reciprocally shared across bodies through virtual skin. Jack's prosthesis replaces his limb and also its enveloping organ—the skin—as a medium of sensual pleasure. Histories of prosthetics emphasize the regard of the hand as functional, cosmetic, and symbolic.[13] For centuries, designers of mechanical hands have attended to both form and appearance, crafting glovelike covers to simulate the appearance of skin or emphasizing the esthetics of functionality in, for example, sleek design features. The hand clearly serves a visually symbolic function that includes the hands and fingers as instruments of speech in sign language. Jack's prosthesis emphasizes the role of the hand as an instrument of sensual feeling. A sense that is strongly linked to sentiment, the emotions, and language, touch is a supplement of language that conveys emotion through what we might loosely call a semiotics of feeling. In all of that term's valences, *feeling* is the object facilitated via Jack's cyberarm. Through this skin prosthesis, the meaning of feeling slips from the sense of touch to affect, emotion, and communicated sentiment.

In 1980, following six years of development, researchers at the University of Utah released a nonsensory myoelectric limb that offered refined control over pressure and movement.[14] The robotic Utah Arm, produced by Motion Control, Inc., places electrodes in contact with nerve endings in the amputee's residual limb. The prosthetist picks a "control site" in the amputee's residual limb by testing for areas that provide good nerve conductivity. The wearer is taught to control the device's motorized movement through nerve impulses triggered in remnant

Figure 7.1: Utah Myoelectric arm from the Web site of Motion Control, Inc.

Figure 7.2: Utah Myoelectric arm from the Web site of Motion Control, Inc.

musculature. Existing nerve pathways in the body are essentially retrained to accommodate the prosthesis. The wearer of a myoelectric limb must engage in a process of reflexively retraining, incorporating, and being retrained and aggressively *hailed* by a device that stimulates nerve pathways.

Incorporation of a mechanical prosthesis also involves retraining remnant musculature to control the attached device. The wearer of the mechanical limb could also be said to be interpellated by and to incorporate the prosthesis.[15] However, the myoelectric device requires the wearer's body physically to redeploy nerve pathways. This process suggests a system in which the body is more radically and deeply reorganized. Myoelectric devices tap the body's nervous system, and the body reciprocally extends into the device, producing a system that is interconstitutive beyond the interface between body and prosthetic part or between prosthetist and amputee.[16]

Gibson's story "Burning Chrome" describes this prosthetic facilitation of sensual feeling by referring to the Sense-of-Feel (SOF) system that was developed by real-life second-generation prosthesis engineer John Sabolich. The surface of the SOF prosthesis is implanted with sensors that transmit information—about temperature, for example, from a prosthetic hand or about pressure from the base of a prosthetic foot. Sensory information passes into the flesh through thermopiles and electrodes that press against the base of the wearer's residual limb, triggering sensations elsewhere in the wearer. NovaCare's promotional materials posted to the Web in the late 1990s offered testimony from a client who had been fitted with an experimental Sense-of-Feel arm: "For the first time in a decade, I could reach out and touch my wife's hand and feel the warmth. That was a very emotional moment."[17] "For the first time in a decade" makes this scenario profoundly poignant and nostalgic. The Sense-of-Feel arm's hand, like Jack's in the story "Burning Chrome," approximates lost manual sensation in the body of the wearer and in so doing draws on memories of "warm feeling" (love) communicated through hand-to-hand contact. This system requires its wearer to engage in psychological training in how to incorporate and control a limb with electrical components that redeploy the nervous system and also in how to orient where and how "warmth" enters into and is experienced in and through the body. It is tempting to say that the client quoted above has gained virtual heat sensation *in his new hand*. But it is more accurate to say that he must be trained to recognize as "hand" sensations the stimuli that are felt in another, relatively arbitrary location in his body.

Abstraction is an important aspect of this process. Temperature sensation is delivered in isolation from other types or qualities of sensations that are conducted through touch—such as texture, tickle, itch, numbness, position sense, and pressure (pressure is delivered to the Sense-of-Feel prosthesis not by thermopiles but through electrodes). Sensations are parsed in this system. Touch in itself is reduced to the abstraction of one of its aspects, temperature, which is in return reduced to warmth as a synecdoche of the "feeling," a euphemism for love.[18] Warmth produces a different meaning than extreme heat, which invokes the experience and meanings of pain. Warmth is an important signifier of life and of arousal (of desire and pleasure). Warm flesh signifies the simple fact that a body is alive. Warmth is also an involuntary response to and signifier of arousal as blood flows to the

surface of the body in response to nerve stimulation by contact and in response to the psychical chemistry of desire.

Who would deny the value of technologies that facilitate such essential psychical pleasures as being able manually to touch and feel these involuntary signifiers of "life" and "love" in another's body? But these meanings are unstable and relative, even if they are strongly supported by memory and experience. In Gibson's story "Burning Chrome," Jack conveys to the reader the pleasure that he takes in the fact that this sensory prosthesis of desire is reciprocal, between himself and Rikki, but she is a "flame" and not someone with whom he shares a past experience of organic touch. Rikki, he lets us know, is exciting because she "feels" differently: she finds the cold metal of his prosthesis hot and prefers it to his warm flesh. We might ask, what does the Sense-of-Feel hand feel like to the wife of the Sabolich client? Had she learned to incorporate the mechanical prosthesis into their relationship as fetish? Is this new prosthesis a model that offers the surface texture of flesh to her hand, and will Sabolich design a model that can also communicate warmth back to her hand on contact? Might the simulation of warmth involve mechanisms for stimulating blood flow to the surface of the "skin" on stimulation so that the hand can radiate the meaning of warmth? We might also ask how important it is that this example relies on the beloved as the object that communicates "warmth" to the sensory hand. Can the client discern between different degrees of physical and semiotic intensity—say, between the warmth of love and the heat of anger or between the heat of a body and that of a burning flame?

Rather than pursuing these hypothetical questions about fleshing out what it means for a partner to be incorporated as a prosthetic of feeling, we stay with the Sense-of-Feel wearer's body and the problem of regulating intrasubjective communication of emotional feeling via sensation. We emphasize the extensive representational and psychical work—especially the work of spatial displacement, reorientation, and imagination of a new organization of "feeling"—that is required of the Sabolich client to make his arm a satisfactory instrument for communicating within himself "safe" degrees of feeling. There are limits to how far this prosthesis may go in providing access to feeling. The Sabolich Sense-of-Feel arm allows the wearer to use his virtual hand to feel the warmth of a loved one's body, but it does not afford him the experience of the cutaneous pain and nerve trauma of being burned when his prosthesis touches a flame. There are limits on

the degree of agency that the assistive technology allows its user. This is in contrast with standards that we set on the technologies that we produce for the able body, which push these limits all the time. A prime example is automotive technology.[19] The toddler learns to recoil from the heat of a fire and not to touch the invisibly hot stove burner. But the wearer of the prosthetic hand that restores the sensory capacity of skin does not have that potential to be burned. Understandably, companies producing sensory prostheses bypass sensory risks to avoid liability and to avoid the potential for nerve damage in the subject who has already experienced injury and loss. That subject will not get "burned" twice.

Prosthetic Stimulation

So far we have dwelled on the sensory prosthesis in cases where the limb is lost. Paul Schilder, the Austrian neurologist (1886–1940) is widely cited for his observations on body image in war amputees. He also studied and published significant work on the psychology and symptomatology of progressive paralysis.[20] Here we draw out the implications of progressive paralysis for body image and as impetus for neural prosthetic support. Paralysis can be sudden and traumatic (as in a stroke or an accident that damages the spinal cord), but loss of sensation and control can also be gradual and partial as a result of degenerative changes that follow injury or illness. Since the impaired spinal cord generally does not register localized pain, the location of impairment relative to the site of pain can be remote, its connection to the site of injury obscure—hence the need for protections from injury. In my (Lisa Cartwright's) experience, an injury to the cervical spine produced minimal immediate pain and no visible injury but triggered the slow progression of nerve damage and the formation of an undetected lesion in the cord that resulted in escalating chronic and dispersed pain and functional limb and organ impairment over the course of more than a year.

Vivian Sobchack notes that numbness is "not not-feeling, but the feeling of not-feeling."[21] The gradual loss of nerve supply to muscles in the body following injury or degenerative illness can be described in a more varied sort of detail than the language of absence and presence allows. In my (Cartwright's) experience, numbness was arbitrary and abstract. It was a momentary stop en route to other phases of sensation and was almost always partial, as in instances where

the sense of the limb's weight was exaggerated in the absence of an ability to control it or feel physical stimuli through it. Numbness was profoundly semiotic, serving an important material signifying function as an indicator of degenerative processes in action. Periods of limb numbness after my injury progressively became longer, and the regions, areas, and types of numbness multiplied and expanded over months, signaling progressive nerve and muscle degeneration. "Not feeling" my arms and legs sparked feelings of confusion and distress, triggering anxious hypervigilance of the limbs. The numb limb, like a phantom, demands attention precisely because it is not "there" on one sensory level alone. Its "absence" is thus abstract and partial. Inevitably, throughout sleep my numb hand, arm, or leg would rouse me to consciousness, sometimes a dozen times a night. Numbness disturbed my body image profoundly, requiring me to touch or to open my eyes and look at the "missing" limb, to use other sensory means to locate the sleeping appendage where I imagined it should be relative to my body schema. To be roused from an unconscious state with this negative signal of the body image gone awry is an uncanny feeling that invokes death. More than once, I responded with consternation at the ironic situation in which my senseless limbs would have the "nerve" to deny me much-needed sleep. The sleeping limb usually inspired me to lift and shake it with the intact hand, an attempt to awaken it. Over months, as I gradually lost nerve supply in various degrees, I recurrently experienced the disorienting "feeling of not-feeling" in appendages that would randomly come back to life with the unpredictable fireworks of fine internal twitching (neurons misfiring, muscle fasciculations) and radiating, cramping muscle pain, only to feel the limb periodically slip back into a *dead weight,* a term that accurately captures the sense of pressure that can so paradoxically exaggerate a limb's physical presence in its state of numbness and that belies the characterization of numbness as absence of feeling.

Elizabeth Grosz describes changes to the body and its organs as a result of disease as they are reflected in changes in body image. Her point is followed by reference to depersonalization, in which the subject loses interest in bodily zones or the whole of the body.[22] Disease typically is progressive, producing an unstable, changeable body that is always out of sync with prior schemas. A temporal mismatching of material conditions and schema is partly responsible for this depersonalization. Over the course of months, I was interested to find that although I did "lose in-

35. For a full account of the legal justifications for such atrocities, see Anthony Lewis, "Making Torture Legal," *New York Review of Books,* July 15, 2004, 4–8. For a brilliant analysis, see also Jasbir K. Puar, "On Torture: Abu Ghraib," *Radical History Review* 93 (Fall 2005): 13–38.

36. Susan Sontag, "Regarding the Torture of Others," *New York Times Magazine,* May 23, 2004, 24–29, 42.

37. Rush Limbaugh, "It's Not about Us; This Is War," transcribed by the author from Limbaugh's syndicated radio program, May 4, 2004.

38. Arundhati Roy, "Mesopotamia. Babylon. The Tigris and Euphrates," *The Guardian* (London), April 2, 2003.

39. Sergeant David Sterling, quoted in Michael Janofsky, "Redefining the Front Lines in Reversing War's Toll," *New York Times,* June 21, 2004, A1.

--

PART II
ASSEMBLING: INTERNALIZATION.
EXTERNALIZATION

NAKED Elizabeth Grosz

[The other's eyes] turn to me a liquid pool waiting for unforeseeable disturbances. They
are more naked than the flesh without pelt or hide, without clothing. . . . They are more
naked than things can be, than walls bared of their adornments and revolvers stripped of
their camouflage; they bare a substance susceptible and vulnerable. Their nudity exposes
them to whatever message I may want to impose, whatever offense I can contrive.
 —*Alphonso Lingis,* Foreign Bodies[1]

Mammalian Orchids

Human bodies—indeed, bodies of all kinds—are the product of a weird and sur-
prising intrication of a nature that must be regarded as considerably more com-
plex, convoluted, nonlinear, nondeterministic than we had once believed and of
a history that cannot be contained in culture alone. This history includes but is
not restricted to the social, economic, geographical, and representational prac-
tices that surround and sustain bodies. But such a history—the history of cul-
ture—cannot be conceived as wholly outside of or autonomous from nature, for
it is nature, a reconceived and open nature, an evolutionary nature that both pro-
duces all environments and all bodies that are sustained in and by those environ-
ments. In a certain sense, it is nature that requires and accomplishes culture, but
nature conceived as richly open in possibilities rather than rigidly determined in
its outcomes. It is a nature that is driven not by the forces and closures of the past

———— 187

but fundamentally directed to the future and thus is nonteleological or evolutionary nature. A history of culture is in a certain sense the ever-expanding history of nature. Friedrich Nietzsche called for a history of culture that would not simply include or focus on scientific, cultural, economic or military achievements but would explore the self-cultivation of minds and bodies, the human production of itself as a species. In this sense, his work is not entirely alien to that of Charles Darwin and the biological tradition that follows him. Every culture and social group, Nietzsche maintained, can be understood not only in terms of its social and cultural products but also in terms of the particularities of its corporeal arrangements and body ideals—its management, representation, and production of bodies and thus of nature.[2]

Nietzsche claimed that the first artists worked with the noblest of resources—the clay, canvas, and oil of flesh and blood. In a certain sense, they were the founders of culture. The first art is one developed from out of the core of one's own body and its products. This impulse to make something other of oneself, to make one's body other than what it is—the primordial moment of the artistic impulse—is the very explosion of culture itself and the input that such a reconceived nature gives to the human and the human-to-be. One can see in the products of culture—its technological, political, and scientific achievements—the exteriorization of this primitive artist's impulse, the directing outward of this primordial body art. A history of culture *could* be written as the history of the way that humans makes their bodies other and do so—indirectly, through the meandering feedback that action and production impose on and as the nature of bodies.

The paleoanthropologist André Leroi-Gourhan has argued that the technological history of humanity can be divided into four broad stages that coincide with the biological evolution of the species.[3] This history reveals the intertwining of biological-evolutionary and cultural techniques in the transformation of bodies. Bodies and technologies function in a self-feeding relation where transformations in the one produce transformations in the other, which in turn feed back on both. The histories of nature and of civilization coincide insofar as they are both a function of the bodily impulses that produce and are transformed by technological impulses:

1. This history "begins" with the most primitive use of tools, tools that in the first instance are parts, and then are extensions, of the body itself, and above all, of its privileged organs and functions: cutting, chopping and grinding—tools modeled, at the outset, on teeth, and prosthetic cutting. The baboon, the chimpanzee, and the ape forage and manipulate using their teeth, and baboon implements, which are forged by chipping stones or branches between the front legs, exteriorize this function of chewing and grinding. As the four-legged gait gives way to upright posture, the privilege of the teeth and nose give way to the primacy of the eyes and the hands. The mouth no longer encounters nature directly; rather, the legs propel the creature into the world, and its hands serve to mediate between the world that it samples and its mouth. It now reacts to a world that is manually mediated. Tools exteriorizing and supplementing the atrophying senses (nose, snout, mouth, teeth) emerge, tools that are part of the process of this very atrophy;

2. Technological history harnesses externally driven motor power—the power of water, winds and animals to power the tools thus devised. These devices—the plough, the windmill, the sail—enable a wider locus of control than what was available to either the individual's or the group's labor power. The power of vision is even further privileged insofar as the externally driven forces require regular and careful supervision. In addition, this transfer of energy and force from musculature to external energy sources helps participate in the supercession of muscular power, its reservation for tasks of nobility and bravery rather than mere survival. Moreover, as Freud hypothesized, with the privileging of visual and the repression of the sense of smell, sexuality becomes unseasonal, no longer confined to an estrus cycle, no longer inflamed by the enticements proffered by smell but excited by the now-upright ape's visually exposed genitalia;

3. Replacing the utilization of these rather unpredictable or erratic natural resources comes the invention of machines—nonhuman and nonorganic devices that are able to be regulated and used with increasing reliability and control. The key image of the controllable machine is the mechanical clock, which is not only a self-regulating mechanism, but also one into which other sorts of mechanical connections could be made, and other, more complex machines devised. Mechanism has the advantage over external motor power insofar as it requires everdiminishing surveillance, through perhaps a more minute vision of the mechanism

and its functioning. This is accompanied by the increasing atrophy of muscula-ture and an ever-escalating emphasis on capacities for conceptualization.

4. The internalization of the machine into the circuits of the human brain it-self, the augmentation and replacement of conceptual skills through information or data storage, processing and retrieval. This is an evolution into a pure specta-torial state and its correlative, display. Leroi-Gourhan describes it as an orchid ex-istence—the becoming of what might be understood as a mammalian orchid. We must recall that orchids are genetical monstrosities, plants with atrophied trunks and limbs, pure, spectacular sexual organs enticing bees for their frenzied cross-species union. As a species, he speculates that we are in the process of becoming huge eyes, feeding into massive brain, in the hope of engorged genital pleasures, Nietzsche's giant organs on tiny bodies, the drastically shrunken homunculus whose body shrinks as its brain expands, for whom the hand no longer links with the genitals, but give way to the primacy of the eyes. A huge brain linked to big eyes and dextrous hands, with a spindly body attached.

If there is some plausibility in Leroi-Gourhan's genealogy, it implies that history, or at least human history, is both an inward and an outward movement: outward, insofar as the species produces from its interior, from its body and its con-densed and compressed, projected rhythms to create cultural forms, its various arts (including dance, painting, poetry, and "architecture"), and inward, insofar as ex-ternal resources (natural forces, mechanical forces, electronic forces) are gradually incorporated into and become capable of replacing human organs and tissue.

There are at least two significant effects of the evolutionary tendency to-ward the obsolescence of musculature and the atrophy of sensory organs: the first is that the human body has tended to subordinate and render secondary all sense organs other than those of vision, to which it grants an extraordinary priority. The movement from mouth and nose, to hand, and eventually to the eyes is an in-creasing movement toward the spectacular, an ever-increasing orientation to the visual, and thus to the artistic, and the representational. The second is that there is at the same time a movement toward display—toward the rendering of the body as exhibition. In other words, correlative with the development of the organs for seeing is the heightened development of organs to be seen. The transformation from quadrapedal to bipedal locomotion, the movement from a crouched to an

upright posture, Freud argued, made the visual organs pivotal in both the mastery of nature and in the transformation of sexuality from a cyclical to an unseasonable form.[4] The privileging of the visual goes together with the repositioning of genital organs for frontal viewing. The protohuman creature becomes simultaneously a viewing object and a viewed object, its organs for viewing being closely identified and articulated with its organs to be viewed.

It is thus hardly surprising that art, and especially the visual arts—have become a primary medium for the socially sanctioned and culturally binding relations of sexual spectacle and sexual viewing. Art, the art of self-making, transformed bit by bit to the art of depiction, to functional art, and to experimental art—is crucial in the experimental processes of transforming both body and nature, a pivotal hinge that is midway between sexual and erotic practices and the practices of self-making that constitute culture. Art lies at the heart of culture as much as sexuality and sex lie at the heart of art.

Naked Vulnerability

I am interested in this text in exploring the interface between sexuality, bodies and art. While I certainly don't have the training, or perhaps the artistic sensibility, required for anything more than the most perfunctory discussion in artistic terms, I do want to discuss some of the political and theoretical issues that are at stake in highlighting and refiguring the role of the body in art. The body must be understood as both the object and the medium of art, and more particularly, as a means for transforming art and the ways that it is commonly understood. I reconsider here some of the terms that have become central to the ways in which art and representation more generally have been theorized and to problematise some prevailing intellectual models. In particular, I rethink notions like the gaze, voyeurism, and exhibitionism, in other words, the relations between representation and eroticism that have dominated visual theory in the last twenty years or so—not so much to provide a new theory of art and spectatorship but to refine these overwrought terms and concepts and bring some freshness to this significant nexus of bodies looking at bodies through and as art.

I begin with an initial hypothesis: we don't know what bodies are capable of. Whether in the realm of the biomedical (genetics, embryology, molecular

biology), or in the sphere of sports and bodily exertion (body building, exercise, records), or in the order of production and labour power we have a general understanding of bodily capacities but little understanding of the limits and boundaries—the threshold between what is bodily possible and impossible. This is not simply true because of the limitations of our current forms of knowledge, the lack of refinement in our instruments of knowledge, but more profoundly because the body has and is a history and under the procedures of testing, the body itself extends its limits, transforms its capacities, and enters a continuous process of becoming, becoming something other than itself. This capacity for becoming other, or simply becoming, is not something that culture simply imposes on an otherwise inert nature but is part of the nature of nature itself. Becoming is what suffuses bodies from both outside (through the imposition of increasingly difficult tasks) and from within (through the unfolding of a nature that never was fixed and through the self-overcoming that is inherent in the very being and ontology of bodies).

A body is produced from other bodies, and its cohesion and continuing existence and integrity as a body are contingent on its ability to glean energy from other bodies—the bodies that it ingests and gains energy from to not only continue its existence but to proliferate itself in its products, including its offspring. This was the physicist Erwin Schroedinger's response to the biological dilemma that physics poses to all studies of life. If all physical systems tend toward disorganization and disorder—maximum entropy or thermodynamic equilibrium—then how does the living organism avoid decay? His answer was as simple as it was profound: "The obvious answer is: By eating, drinking, breathing and (in the case of plants) assimilating."[5] We prevent ourselves from plunging into atomic simplicity, physical or systemic annihilation, through the assimilation—in effect, the annihilation—of other organic existences. These give us the energy to maintain cohesion and growth. Bodies thus live in debt to the life that they destroy—the organic supplementation that they require. They must give back something of themselves—of their own bodily cohesion—for anything more than mere existence to be possible. I have already suggested that culture can be understood as an extension, a protraction, and a projection of the interior of the body itself. This is what the body gives back to the life on which it feeds and which it must destroy, as Bataille recognized, a sacrificial excess that produces not only the most noble and elevated cultural achievements, but, even more richly, the surprising

and ever-productive possibility for the subversion of these achievements and their transformation into different, often equally prodigious achievements. This is what life is—the ever-transforming, ever-recontextualizing of what has been done so that it can be done differently.

A body reproduces itself not only biologically but through its self-representations and the rigors of its practice. At this point, art figures itself as a bodily practice. While much of art merely re-presents the body (depicts or pictures it) at its most provocative, art also contains the possibility of refiguring, transforming, and functioning at the very limit of the body's capacities—especially if (as Nietzsche outlines) the origin of art is the very exploration and use of the body. Good art, as much as good science, presents us with the possibilities of bodies that are barely conceivable, that challenge and problematize the very stability and givenness of bodies, that force us to rethink our presumptions and our understandings of what bodies are.

We can follow Alphonso Lingis, with whose words I began this chapter, in arguing that it is in part the ridiculousness of the human form—its simultaneous vulnerability and infinite productivity—that is the very motive and force for the history of art and the history of technology: "Is not the conviction that our anatomy, ridiculous by nature, has to serve as the material for art coextensive with all civilization? The civilization our species has launched and pursued to relay its evolution appears in nature as the exteriorization not only of the powers but also of the splendours in our organs."[6] Can art be seen as a way of forcing this anatomical ridiculousness into productivity—of both enforcing this status of the ridiculous while pleasurably and productively exploiting it? Perhaps this may be one of the more profound differences between erotic and esthetic attachment—that erotic attachment induces a voluntary reciprocity in vulnerability, it produces the overcoming, the normalization or naturalization of ridiculousness, while aesthetic practices serve to denaturalize and heighten it (while in their own ways renormalizing and renaturalizing it, at least in terms of artistic conventions).

Maybe another way of asking this question is: what is it about bodies, and particularly about bodily organs, what is it about *naked* bodies, that propels us to produce and to view art, and most especially, to produce and view the body as *nude*. What is the difference between naked and nude (an old theoretical question whose range is not yet exhausted and whose provocations we must still, on occasion,

address)? If (as Leonardo da Vinci claimed) human genitalia and nakedness are "of an irremediable unsightliness"; if (as Lingis suggests) humans have no bodily equivalent to the lure of the peacock, the inwardly coiling horns of mountain sheep, and the lasciviously scarlet buttocks of the baboon; if there is nothing inherent in the human to make it orchidlike—then does art (including the art of fabrics, the art of cosmetics, the art of car design, the art of prosthetics—indeed, art as prosthetic) serve as our sexual lure, the visual snag that rents our vision?[7]

A second hypothesis: we are not "allowed" or encouraged in our culture, nor indeed in other known cultures, to either exhibit ourselves or to observe the bodies of others, *except* in highly restricted and codified contexts. Although nakedness seems a necessity and a convenience in all cultures, almost all cultures cultivate some kind of clothing or covering, some sense of shame or modesty, some stretch or limitation on the reach of nakedness. We are discouraged from nakedness ourselves except on the condition that we are children; we are lovers or in some intimate sexual context; or we are mediated in a relationship to nudity through representations—in art, pornography, advertising, medicine, cinematic and fictional contexts, and so on. These three contexts seem to be the privileged spaces of bodily intimacy, not where nakedness takes place, but rather where nakedness is automatically coupled with the desire, possibly even the imperative, to look and with the pleasure of looking. It is in intimate and/or nurturing relations that we are encouraged not just to look, but also to show, not just to look, but also to induce a touching.

Nakedness is a lure to intimacy and proximity because it invites the other's care and solicitude.[8] Nakedness is a state of vulnerability, not simply because one is open to the elements, at the mercy of the environment, unprotected, but also because one is prone, more prone than usual, to the affect and the impact of the other. There is so little to mediate, only the most intimate surfaces of the skin. And mutual nakedness modulates this vulnerability by making it reciprocal: by making each vulnerable to the look, the touch, and the intimate judgment of the other. A singular nakedness—the kind of nakedness that is represented by, say, the nudes of photographer Helmut Newton—is the most naked, prone, the most vulnerable for the model, but also, in a sense, for the observer.[9] This is why the boundary of the frame, the mediation of the image, the protection afforded by the artistic representation of the naked body—the emergence of the nude from

the naked—makes that nakedness even more alluring in its representational form than it may be in the flesh. Nakedness is not the most alluring state: it is the veiling of nakedness—its suggestion or intimation, its promise or possibility that entices. This has long been recognized by both artists and pornographers, and the lure of eroticism—the props, veils, adornments, the half-dressed, the near-naked (that is, the naked in promise alone)—is the body adorned by representation:

Without the gearing-into the tool—or without bravery at grips with death—the unathletic male nudity is ridiculous. The female anatomy verges on the ridiculous too, as our advertising, our high art, and our pornography know; it has to be relayed with stage props—be they reduced to the minimum, as in Nô theater, to high-heeled shoes, a garter, atmosphere spread with vaseline on the camera lens, or, as Marilyn Monroe said, perfume.[10]

Jacques Lacan has already made it clear that the human infant is even more fascinated with the image or depiction of an object than it is with the object itself.[11] The image holds the promise of a richness and a controllability that is unavailable in life. This is the allure of the cinema, fiction, and art, the mediation of an object or objects so powerful as to entice one to identify with them, to desire to watch them, to be entertained and amused by them. The allure of the image, the evocation of nakedness, and the simultaneous containment of nakedness that the image affords are the perfect context and setting for the depiction of bodies, bodies in their rich openness and in their sexual provocation.

We augment our skin to entice and signal our openness, we do not do this through displaying our plumage, the magnificence of our horns or tusks, the beauty and luster of our markings, stripes, or spots, or through flashing our genital organs.[12] We do not do this through our organs directly, at least not usually, but rather through the supplementation that allows us to signify our organs without designating them—through sheer underwear, through provocative low-cut or tight clothing, pendants worn at breast level, and weapons and tools carried on the hip. We entice through insinuation rather than explication.

The naked becomes nude through equivocation, through the suffusing of the image of nakedness with a context, a purpose, and a possible signification, which in a sense form a covering for that nakedness, in other words, through

ladening the naked body with beauty, grace, form, and solidity, we create a frame that contains it (even the frame of the art gallery or museum itself in the case of a work not literally framed) the frame, in other words, that designates some thing or activity as a work of art. The frame thus functions just as pervasively in non-painterly and nontraditional modes of art—in performance, dance, video, installations—as it does in the traditions of academic painting. This containment of nakedness in the nude enhances the naked form—through the idealization that is performed by representation on the one hand, and, on the other, it authorizes a spectator to watch, to look, without the overwhelming obligation for intimacy that the naked or the erotic body poses. The spectator is insulated from the usual obligations of naked intimacy and can thus watch the spectacle in pleasure or in discomfort with a distance of the voluntary. Representation intercedes between nakedness and the spectator to enable the spectator to dwell on, savor, and enjoy—without erotic obligation.

Nudity Veils

Kenneth Clark has argued for a certain Platonic elevation of art over pornography: art represents the nude, the female nude in particular, as an object not for the senses but for the mind or reason.[13] It is elevated, "sublimated" from its bodily origins and set up for noble purposes. This nobility is secured through a kind of distancing that removes the depicted objects from their more sensory and base implications and possibilities and instead presents the naked body for intellectual and aesthetic contemplation. In other words, at a certain level, Clark is, in spite of himself, recognizing the power of the image to veil nakedness, to produce nakedness as nudity. The naked body has a force that can give rise to bodily impulses in a spectator. Art protects the spectator from the more mundane and venal of these impulses: art is a veil of modesty here—not for the model or object but for the spectator.

Instead of seeing how to veil this nakedness most aesthetically, to refine it into a moderate, consumable nudity, most provocative art since the time of Gustave Courbet has not striven to present the most beautiful and aesthetically appealing images. Quite the contrary, modern art has sought to problematize beauty, the assumed norms of the aesthetically appealing, and instead to bring back some-

thing of the visceral force of bodies through their representation, whether through the direct representation of bodily momentum in the work of Jackson Pollock, or through the intensified viscerality of depiction in the works of Francis Bacon. Art has become exploratory of how to view bodies differently—how to see them from angles and perspectives unthought of, to bring out latencies within them are may not be obvious in everyday life, and to make them speak with a directness that has been blunted through what is now the most stylized and ritualistic forms of sexual depiction, pornography. It is not that art and pornography differ in what they depict, or even necessarily how they depict nakedness; rather, pornography can only function as such in so far as it is ritualized, fundamentally repetitive, a series of infinite variations of a very small number of themes. Pornography refuses innovation in a way that (ideally, at least) art does not. Pornography relies on its formula, its theme, its script, to induce its desired effects through a more or less guaranteed pathway. Its eros resides in its insistence on infinite repetition. This makes it no "better" or "worse" than art, simply much less resourceful.

What pornography and art do share in common is this: whatever their quality, originality, framing and context, whatever their audience and cost, they consist of representational practices that both render what is historically private, that is, a relation between a very limited and select number of individuals, into a publicly and anonymously accessible form, and that veil naked bodies through a representational structure that makes their image, their diegetical content, as desirable or appealing as their materiality. Both pornography and art produce nudity as a form out of nakedness as a content. Theirs is not a project of dematerialization (from the real to representation) but a process of rematerialization—the transformation from one mode of materiality (flesh) to another (paint, canvas, photographic paper, choreographed movements). Both materialize bodies whose materiality is contained by, bordered by, and riven with and as representation. And in doing so, both license an audience to develop particular relations of seeing that are commonly not available in everyday life, at least not at will: one is authorized to look—not to gaze, but to look—in any way one chooses. One need not be captivated, but could also be bored, indifferent, disgusted. One is not implicated in the other's vulnerability, not simply because, as traditional feminist theories of the gaze suggest, the other cannot look back, but because one, as spectator, has free reign with the kind of look one can utilize. In intimate bodily

relations, one is already committed in some sense to a relation of positivity, a relation of non-indifference, non-disgust, a relation of desire. One is, in Levinasian terms, "called," called upon by the open giving up of a certain vulnerability that the other offers to us as naked. It is this that we are protected against, this vulnerability in observing the work of art. We are not called to protect or to bare ourselves to this other that we observe. Our observation is given free range. We are liberated from the impulse toward reciprocity.

If Clark is naïve about the distinctions between pornography or salacious representation and pure or high art (what shocks the sensibilities of one period becomes the high art of another; one century's pornography becomes the classical tradition of another's), he also seems to misunderstand the nature of perception itself and the role of looking. Looking is, of course, no more refined, no more cerebral, no more intellectual than any of the senses. And, more subtly, this kind of argument—that draws a clear-cut dividing line between pornography and art—reduces the kinds of looking to only two—an ennobled looking that illuminates the soul and a salacious, perverse looking that feeds only the body, and particularly the other organs.

Psychoanalytic discourse, too, reduces the various modalities of looking to only two—the look of the voyeur (reduced, in feminist discourse, to "the gaze") and the desire to be looked at of the exhibitionist. These are the active and passive variants of scopophilia. What is needed instead is a typology of looking, a mode of thinking of spectatorship that, instead of relying on the vast apparatus of projection, identification, fetishism, and unconscious processes—what psychoanalysis has offered to film theory and what theorists of the visual arts have borrowed as their primary model of spectatorship. Voyeurism is not the only modality of looking. Seeing has many particular forms that are well beyond the purview of the gaze, which is, in psychoanalytic terms, necessarily aligned with sadism—the desire for mastery and the masculine privileging of the phallus. Feminists have long recognized the gaze as an expression of male domination of psychical structuring in patriarchal cultures but more recently have also recognized that the apparatus that is generated through the structuring of the gaze leaves the female subject, or for that matter, the male subject, with no position other than a masterful phallic one. Instead of pushing this description further, regarding it as a fundamental political truth of the ways that patriarchy has structured seeing and has

limited the kinds of seeing that are available to women, I would suggest instead that seeing needs to be retrieved by feminists and that vision needs to be freed from the constrictions that have been imposed on it by the apparatus of the gaze.

In addition to the gaze, for example, there is the seductive fleeting glance, the glance that overviews without detailing; there is laborious observation, a slow, penetration inspection that seeks details without establishing a global whole, there is a sweeping survey, there is the wink and the blink, speeded up perceptions that foreclose part of the visual field to focus on elements within it, the squint which reduces the vertical to the horizontal, and many other modalities. Men, but also women look in many different ways, and it is this plurality of these possible visions—depending on one's interests, investments, commitments, and beliefs—that dictates how objects are seen and even which ones are seen.

We must see that bodies are not simply the loci of power but also of resistance, and particularly, resistance because of their excess. Bodies exceed whatever limits politics, representation, management, and desire may dictate: the bodies of women, even the depicted bodies of women, are no more passive, no more exhibitionistic, no more the objects of consumption, than male bodies, animal bodies or natural bodies. And the ways in which women, as well as men, look, the ways in which they engage with images and representations of bodies is not singular or monolithic either. One can inspect, survey, peer, glance, peek, scour, one can focus on or look through.[14] Art itself has in fact always elicited looks other than the gaze. This of course is not unknown by artists, whose work is commonly an attempt to engage with, and perhaps produce, other ways of looking that may move beyond the mundane and the habitual, and hopefully beyond the apparatus of the gaze. (This indeed is one of the founding assumptions of installation art, of conceptual art and most art of the twentieth century, the art of surprise, the art of re-looking, the art of the double-take.)

Looking Good

Given the limits of conventional art historical analysis and of feminist versions of psychoanalytic theory, which limit the look, reduce the body to the nude, and presume a fixed set of signification, it is important not just to celebrate the body as the universal object and medium of both culture in general and art in particular—

as has been the fashion over the last few years—but also to use its rich and un-contained complexity to problematise and rethink this conceptual edifice that surrounds art production (an edifice or frame, of course, as Derrida recognized, always suffuses the interior, parergonally).[15] To use conceptions and theories about the body to rethink the role of the body both in its representation and its reception.

Although the nude is of course not the only domain in which such a recon-ceptualizing or re-presentation of the body is possible, it is a place where these issues can be tackled most directly, for the human body—in its relation to other human bodies, animal bodies, props, and scenery—is its primary focus. As the vestigial structures of muscles, sense organs, hair, and tissue suggest an ever-more redundant human body and as enjoyment, pleasure, gratification, and display continue to focus on the body, art, especially erotic art, art that deals with bod-ies—whether with their depiction or their refiguration—has become an intense locus for the body's transformation. On the cusp of redundancy through the in-herent human capacities for excess production over and above survival or need, no longer bound only to survive (because of that excess production), we need to make the trajectory of the body's redundancy reach into the very condition of art itself. To make oneself into a work of art is in a sense the only response to an im-manent and ridiculous redundancy of the specific forms of the body; and to make oneself into a work of art (as Nietzsche and, following him, Michel Foucault sug-gest) is not simply to aestheticize life, to dandify it, or to make oneself into an ob-ject or spectacle for the artistic investigations of others. It requires living one's life and one's body in excess of what is required—in excess of discipline and even in excess of aesthetics.[16]

To live one's life as a work of art is, among other things, to once again re-turn to one's body as the site and source, the origin of pleasure and productivity and to utilize it differently, to move and act in ways other than those that have ha-bitually confined us. Acting differently also leads to being acted on differently—to sense differently, developing each sense beyond its usual biological reach and inquiring into the limits and transformability of biology itself. Developing alter-natives—synesthetically cross-mapping the senses onto each other, sensing differ-ently, using the senses in terms of the range and scope of the other senses, exploring how each sense functions or is capable of functioning quite differently from its as-sumed and normalized role. To develop these alternatives is inherently invested in

artistic activity. It is to render the body differently in representation, for representation is, as I have argued, almost a second skin, a diaphanous sheathing for bodies that transforms what the body is and does. It is looking good in both senses—looking at something well (outside the domain or order of the gaze) and being looked at, as well.

Notes

1. Alphonso Lingis, *Foreign Bodies* (New York: Routledge, 1994), 171.

2. Friedrich Nietzsche, *The Genealogy of Morals and Ecce Homo,* trans. Walter Kauffman and R.J. Hollingdale (New York: Vintage Books, 1969).

3. André Leroi-Gourhan, *Le geste et la parole. Technique et langage* (Paris: A. Michel, 1964).

4. Sigmund Freud, *The Standard Edition of the Complete Psychological Works of Sigmund Freud,* Vol. 21, *Civilization and Its Discontents,* trans. James Strachey (London: Hogarth Press, 1953–1974).

5. Erwin Schroedinger, *What Is Life?* (Cambridge: Cambridge University Press, 1994), 74.

6. Lingis, *Foreign Bodies,* 38.

7. "In some species of birds, females mate preferentially with long-tailed males. The shimmering iridescence and extension of the peacock's feathers exemplify traits that may have been selected not because they offer any survival advantage to the peacock, but because they please, sexually excite or otherwise charm the peahen." Lynn Margulis and Dorion Sagan, *Mystery Dance: On the Evolution of Human Sexuality* (New York: Summit Books, 1991), 100.

8. This naked vulnerability is an extension of the vulnerability of the face-to-face relation that Emmanuel Levinas poses as the foundation of all ethics. The other faces me, and his face, which is not a *sign* of vulnerability, is living, breathing vulnerability, a call to and on the subject. See Emmanuel Levinas, *Otherwise Than Being or beyond Essence* (The Hague: Martinus Nijhoff, 1981), 45–50, 85–94.

9. See, for a representative example, Helmut Newton, *Self-Portrait with Wife June and Models,* 1981, photograph.

10. Lingis, *Foreign Bodies,* 34.

11. Jacques Lacan, "The Mirror Stage as Formative of the Function of the I," trans. Alan Sheridan, *Écrits. A Selection* (London: Tavistock, 1977), 1–7.

12. Lynn Margulis and Dorion Sagan illustrate the strange proclivities of the squirrel monkey, which has an almost compulsive reflex of self-exhibition: "These

monkeys show off their erections not only to indicate sexual desire, but to greet and to threaten. In one species of squirrel monkeys, males invariably raise their erection to their own reflection when seen in a mirror. Apparently in doing this, squirrel monkeys are trying to frighten away what they see as rivals." Margulis and Sagan, *Mystery Dance,* 133.

13. Kenneth Clark, *The Nude: A Study of Ideal Art* (London: John Murray, 1956).

14. See for example, Edward Casey, "The Time of the Glance," in Elizabeth Grosz, ed., *Becomings: Time, Memory, Futures* (Ithaca: Cornell University Press, 1999).

15. Jacques Derrida, *The Truth in Painting,* trans. Geoffrey Bennington and Ian McLeod (Chicago: University of Chicago Press, 1987).

16. Michel Foucault, *The History of Sexuality,* Vol. 1, *An Introduction,* trans. Robert Hurley (London: Allen Lane, 1978).

VISUAL TECHNOLOGIES AS COGNITIVE PROSTHESES: A SHORT HISTORY OF THE EXTERNALIZATION OF THE MIND

Lev Manovich

1

Entering modern culture after the end of World War I when large numbers of amputees were outfitted with artificial arms and/or legs, *prosthesis* came to stand for an outside extension of the body. Prosthesis adds to the body what has been taken away or extends the body's natural organs (teleoperators).

More recently, a new kind of prosthesis has become possible—a device or machine that is enhancing or curing the body by invading it from the inside. A whole set of possible additions—from a plastic surgery implant to an artificial heart—are slowly becoming commonplace. And if early twentieth-century prostheses extended the body in visible and dramatic fashion ("thus making prosthesis into a topic of interest for painters, filmmakers and eventually cultural critics"), the new prostheses are increasingly small and invisible. For instance, in 2001, Tejal Desai, an assistant professor of bioengineering at the University of Illinois at Chicago, cured rats with diabetes using the insulin-secreting devices that are only 7 nanometers across.[1] Other biological microelectromechanical systems (bioMEMS) have been used in diagnostics and genetic sequencing.

In this essay, I sketch a history of yet different kinds of modern prostheses that are neither external mechanic (or electromechanical) extensions of the body nor intrusive devices, systems, or parts. In this history of *representation as prosthesis,* I discuss new kinds of representations that are enabled by modern visual technologies that were (or are) thought to help our cognition. Here no physical contact

between a body and prosthesis is necessary, since prosthesis is a separate entity that we are working with by looking at and interacting with.

This *cognitive prosthesis* belongs as much to the history of media as to the history of the body. I am thinking here of Marshall McLuhan, who in his founding and still most far-reaching 1964 study of media—*Understanding Media: The Extensions of Man*—conceptualized all key modern communication and transportation technologies, from roads and money to telephone and television, as prosthetic devices that extend the body.[2] I am also thinking of the influential 1960 article by J. C. R. Licklider—"Man-Computer Symbiosis"—which proposed that an interactive digital computer can act as a kind of metaprosthesis that augments our memory, perception, decision making, and other cognitive operations.[3] As we know, Licklider's notion of a computer as prosthesis for the mind (rather than the body), which was fully appropriate for the coming information society, was indeed realized in the subsequent decades. Today, practically all cognitive work—from architecture and finance to scientific research and design—involves the use of these new metaprostheses. The history sketched in this chapter involves new cognitive prostheses that are computer-based (visualization and virtual worlds), but it begins much earlier—in the nineteenth century.

2

In 1877, Sir Francis Galton—a statistician, a cousin of Charles Darwin, a founder of eugenics (a project of social betterment through planned breeding), and the author of highly influential psychological texts—pioneered a procedure for making composite photographs that proliferated widely in the final decades of the nineteenth century.[4] Fabricated by a process of successive registration and exposure of portraits onto a single plate, Galton's composites were thought to constitute true statistic averages that represented human types—a criminal, a prostitute, an Englishman, a Jew, and others. Galton wrote about his composite pictures that they are "much more than averages; they are rather the equivalents of those large statistical tables whose totals, divided by the number of classes and entered on the bottom line, are the averages. They are real generalizations, because they include the whole of the material under consideration."[5]

Galton not only claimed that "the ideal faces obtained by the method of composite portraiture appear to have a great deal in common with . . . so-called abstract ideas" but in fact he proposed to rename abstract ideas "cumulative ideas." In contrast to the human mind ("a most imperfect apparatus for the elaboration of general ideas") Galton championed his composite photographs, which, being mechanical and precise were much more reliable for arriving at abstract representations.[6]

With his photographs, Galton not only proposed that universals may be represented through generic images; he actually objectified and materialized them. Plato's *ideas* were given concrete form: they could now be touched, copied, fabricated, multiplied, and distributed.

Galton's belief that his composite photographs gave material tangible form to abstract ideas is just one example of a more general modern phenomenon. This phenomenon can be called *externalization* of the mind. It manifests itself in two ways. On the one hand, we witness recurrent claims by the users of new visual technologies (from Galton to Jaron Lanier) that these technologies externalize and objectify the mind. On the other hand, modern psychological theories of the mind (from Freud to cognitive psychology) also equate mental processes with external, technologically generated visual forms.

What can we make of this desire to externalize the mind? Although eventually this externalization is justified by the idea of cognitive prosthesis, I think that at first it is driven by a different agenda. We can relate it to the demand of modern mass society for standardization. The subjects have to be standardized, and the means by which they are standardized need to be standardized as well— hence the objectification of internal, private mental processes and their equation with external visual forms that can be easily manipulated, mass produced, and standardized on their own. The private and the individual are translated into the public and become regulated.

What before was a mental process, a uniquely individual state, now becomes part of a public sphere. Unobservable and interior processes and representations are taken out of individual heads and put outside—as drawings, photographs, and other visual forms. Now they can be discussed in public, employed in teaching and propaganda, standardized, and mass distributed. What was private becomes

public. What is unique becomes mass produced. What was hidden in an individual's mind becomes shared.

3

Francis Galton saw photography as a machine for the externalization of ideas. Even stronger claims were made about the next visual technology—film.

Indeed, the revolutionary new medium, the medium of mass society par excellence—film—was immediately proclaimed to be the machine for the externalization of private mental functions and states. In 1916, Hugo Münsterberg, a professor of psychology at Harvard University and one of the founders of the fields of industrial and applied psychology, published *The Photoplay: A Psychological Study,* which today is canonized as one of the earliest theoretical treatments of cinema.[7] According to Münsterberg, the essence of the new medium lies in its ability to reproduce or "objectify" various mental functions on the screen:"The photoplay obeys the laws of the mind rather than those of the outer world."[8] In contrast to the theater, where the action is constrained by the limitations of physical reality, film is free to shape arbitrarily its material, closely approximating flashes of memory, the flights of imagination, and other mental acts. In the theater, for instance, events have to follow each other corresponding to the progression of time; in film, the action can suddenly jump back and forth, just as in an act of imagination.

In addition to pointing out the analogy between film and mental life, in an astounding analysis Münsterberg correlates the main cinematic techniques to different mental functions, such as attention and memory, one to one. For example, in the close-up, "everything which our mind wants to disregard has been suddenly banished from our sight and has disappeared," analogous to how our attention selects a particular object from the environment. Similarly, the "cut-back" technique objectifies the mental function of memory.

"In both cases," Münsterberg writes, "the act which in the ordinary theater would go on in our mind alone is here in the photography projected into the pictures themselves."[9] The psychological laboratory became indistinguishable from the movie house, and the textbook of experimental psychology indistinguishable from the cinematographer's manual. The mind was projected on the screen; the inside became the outside.

ing abstract social constructions and are in fact powerful critical lenses through which we can peer into the ideological mechanisms that produce meaning in a particular cultural moment. Literary critic Eve Kosofsky Sedgwick, for example, invokes the disruptive potential of queerness—in both its positive and negative forms—as a queer Jewish woman who sees the entire edifice of normalcy neatly configured in the concept of Christmas. Mourning the dominant culture's suppression and cooptation of anything that does not fit the Christmas paradigm, Sedgwick observes that "they all—religion, state, capital, ideology, domesticity, the discourses of power and legitimacy—line up with each other so neatly once a year, and the monolith so created is a thing one can come to view with unhappy eyes."[7] Similarly, Henri-Jacques Stiker, a French historian of disability, makes a comparable claim when he establishes a relationship between the demands of social conformity and the demands of rehabilitation medicine: "Rehabilitation marks the appearance of a culture that attempts to complete the act of identification, of making identical. This act will cause the disabled to disappear and with them all that is lacking, in order to assimilate them, drown them, dissolve them in the greater and single social whole."[8] Disability studies and queer studies are, then, allies in their shared commitment to demystifying the cultural and political roots of terms like *normal* and *healthy* and *whole* at the same time that they seek to destigmatize the conceptual differences implied by those terms. Scholars in these fields recognize that our exaggerated commitments to physical and cultural wholeness, to bodily coherence, and to making order from disorder—the grandiose illusions of normalcy that are so deeply cherished by our culture, from the disciplining mechanisms of psychiatry to the latest episode of *Queer Eye for the Straight Guy*—are in and of themselves forms of oppression.

The Amputettes were undoubtedly a product of the mid-1940s, the era in which they appeared on the scene. But they also marked a historical change from earlier conceptions of what constituted ablebodiedness and normative masculinity. Prior to the twentieth century, definitions of what made a good soldier relied on fears of racial and ethnic differences and nonnormative body types for the military to maintain its own integrity as an American institution. The convalescence of veterans was understood as a sober task in which "broken" men who were physically and culturally emasculated were trained to join the ranks of the normal, productive, and whole. With the Amputettes, however, what might have

been expected to be the paradigmatic case of inappropriate military conduct—disabled veterans who performed in drag—instead affirmed the discourses of rehabilitation as well as the privileges of heterosexual masculinity. To use Sedgwick's language, the popular appeal of the drag performances "lined up" neatly with the patriotic fervor of rehabilitation culture during World War II, thereby allowing soldiers and rehabilitation therapists to diffuse their putatively queer content. To understand how this shift occurred over time—from the anxious pathologization of the queer disabled body to the unalloyed reverence for a particular kind of queer disabled body—requires an understanding of how the U.S. military has continuously refashioned its own definitions of queerness to position itself in relation to political, economic, and cultural expressions of ablebodiedness and heterosexual masculinity. Recent examples, such as the rehabilitation of U.S. veterans from the Iraq war and the treatment of prisoners who were held at the Abu Ghraib military prison, offer contemporary manifestations of this shift and are discussed at the end of this chapter.

During the late nineteenth century and throughout the first half of the twentieth century, the U.S. military developed an array of physical and analytical tools to measure the viability of potential recruits. These affected the recruitment, administration, and regulation of soldiers. During the draft for the Great War in 1917, for example, the army institutionalized examinations for the "patulous anus," during which a gloved physician tested a male recruit's sphincter muscle to see if it had lost the proper resistance due to unnatural activities. In slightly less invasive settings, trained examiners also began to apply the methods of physical anthropology to determine the fitness of potential soldiers. This marked a huge methodological shift from the ways that recruitment manuals and inspection officers had assumed that visible ablebodiedness—that is, what could be measured with the naked eye—was a prerequisite for serving in the military. In 1918, the U.S. War Department commissioned scientists Charles B. Davenport and Albert G. Love, both leaders in the American eugenics movement, to mobilize data about racial and ethnic groups for future use. By measuring and comparing the physical characteristics of recent immigrants against old-stock Americans, they produced such notable manifestos of institutional surveillance as *Defects Found in Drafted Men: Statistical Information* (1920) and *Army Anthropology: The Medical Department of the United States Army in the World War* (1921).[9]

Davenport and Love's anthropological approach to the study of soldiers to determine their fitness based on racial hierarchies had an enormous influence two decades later during the mobilization for war in Europe and Japan when it was translated into other types of physical fitness. *Fitness,* a term loaded with Darwinian implications, had been exploited by the eugenics movement in the early decades of the twentieth century to discourage and prohibit the so-called genetically unfit from reproducing. *Fitness* had a specifically gendered component in the context of the military.[10] Reflecting on the recent war in 1946, for example, prominent Washington, D.C., anthropologist T. D. Stewart contended that studies of physique among soldiers during World War II demonstrated that "types with somewhat of a feminine body build could not achieve a high level of physical fitness. This information was useful in the selection of men for different military roles and might be more generally applied."[11] Stewart's contention was based on two studies made of new recruits and military officers—William Woods and Carl C. Seltzer's *Selection of Officer Candidates* (1943) and Clark W. Heath's *What People Are: A Study of Normal Young Men* (1946).[12] These studies in turn relied heavily on formulations put forth by William Sheldon, a physical anthropologist at Harvard who introduced the concept of the *somatotype* in the 1930s. Somatotyping—the scientific system of measurement in which physique is used as an accurate gauge of temperament and social standing, a neoeugenic interpretation of biology as destiny—was created partly in response to fears that certain physical types (immigrants, for example, or the physically or mentally disabled) were polluting the human gene pool.

In his work, Sheldon described three different somatotypes with distinct physical characteristics: tall, thin, or wiry body types were identified by the term *ectomorph;* short, heavy, or stocky body types were called *endomorph;* and symmetrical, classically proportioned, muscular body types were identified as *mesomorph.*[13] These typologies complemented and effectively articulated the military's own conception of physical competence (and its implied antithesis) in a way that was not altogether different from the typologies used by contemporary psychiatrists and sexologists to determine the physical characteristics of the modern homosexual.[14] In T. D. Stewart's view, for example, the excessively "feminine body build" of the endomorph—known for his soft rounded hips, fleshy buttocks, gynecomastia (breast tissue deposits), and gestures that might be characterized as "girlish"—did not possess the requisite masculine character to serve in a

position of power. In fact, not only was the endomorph unfit to become an officer, but his lack of fitness—in all senses of the word—also threatened the homosocial sphere of military activity. While ectomorphs were simply too scrawny and undernourished, endomorphs with their obvious and excessive body types were menaces to be rooted out and discharged.

Like the test for the "patulous anus," the appearance of men who fit the endomorphic model suggested that military doctors believed that they could read accurately whether a man's body was linked physiologically to a nascent or overt homosexual identity.[15] Since the paradigm of military masculinity honored virile male beauty but stigmatized the allegedly visible characteristics of the male homosexual, the feminized endomorph embodied the image of a recruit who might be competent enough to fight for his country but was patently too queer to represent the public face of military life. Endomorphic bodies were akin to disabled ones in that their mobility within the military would need to be curtailed or they would have to be rejected outright. To crystallize the concept of military masculinity in the public imagination, both the military itself as well as the web of industrial and commercial interests that supported the war effort during World War II depended on widely disseminated images of the mesomorph, the idealized male body whose physical dimensions confirmed the links between mesomorphic ablebodiedness and heterosexual masculinity.

A 1943 advertisement for Cannon towels, for example, captures the idealized features of able-bodied masculinity (see figure 8.3), even though only a tiny percentage of American servicemen who went through the recruitment and training process could compete with such representations of soldiers—either in abstract iconographic terms or in material bodily statistics.[16] The patriotic spirit that flourished in a country at war required such an image to project a toned, unabashedly masculine, and uniformly white military body, as well as to sell consumer products like towels back on the home front. It may be worth noting that such an image undoubtedly horrified many public health officials who were grappling with stories of malaria, dysentery, and other water-borne infectious diseases that were being contracted by American soldiers in the Pacific. Although the playfully homoerotic qualities of this ad betray a fundamental ambiguity that could be pulled right out of an early twenty-first century Abercrombie & Fitch clothing catalogue, what remains intact is an explicit relationship between ablebodiedness

ARMY DAY — CROCODILES KEEP OUT!

Figure 8.3: This illustration, part of a series created by Young & Rubicam for the Fieldcrest Cannon Corporation and published in mainstream publications like *Life* in 1943, suggests how homoerotic play is not only one of the military's many tacit privileges but is in fact one of the principal components of able-bodied heterosexuality. Image reproduced from the on-line archives of the Commercial Closet (www.commercialcloset.org)

and masculinity. The mesomorphic soldier maintains his normative status—as a real man *and* as a real American man—by emphasizing some form of physical competence that gets treated as an element of masculine bravado.

Images like these, their lingering queer ambiguity notwithstanding, were powerful rhetorical tools for promoting patriotic attitudes toward soldiers and the war effort in general. Despite their exaggerated or hyperbolic qualities, such images conveyed the idea that the mesomorph was a "naturally" superior soldier in the same way that his body represented a "natural" category rooted in biological authenticity that, theoretically, might even trump race or class. If Sheldon's assumptions about physiological difference were correct, then a mesomorphic physique was proof of natural male superiority, independent of whether a man

became disabled in the line of duty. Indeed, a man's claim to normative American masculinity might depend, ultimately, on his relationship to combat-related injury that included the possibility of long-term physical and psychological trauma. By putting his body on the line, in other words, a soldier could simultaneously represent the mesomorphic ideal *and* be disabled. A disabled mesomorph was still a mesomorph, no matter how he was sliced, and despite or even because of his disability he could continue to be used as the masculine standard by which all military bodies might be judged.

Throughout the war and long afterward, when the popular media were saturated with representations of soldiers that expressed the soldiers' patriotic commitment to their nation as mesomorphs (as distinguished from feminized endomorphs or asexualized ectomorphs), many of these representations included men whose masculine integrity was not based exclusively on their ablebodiedness. In the summer of 1944, for example, American audiences were captivated by the story of Private Jimmy Wilson, a quadruple amputee who was the only survivor of a ten-person plane crash in the Pacific Ocean. When he was found forty-four hours later amid the plane's wreckage, army doctors were forced to amputate both arms and both legs. After Wilson returned to his hometown of Starke, Florida, surgeons outfitted him with new prosthetic arms and legs, and he became a poster boy for the plight of thousands of amputees who faced physical and psychological readjustment on their return to civilian life. In early 1945, the *Philadelphia Inquirer* initiated a national campaign to raise money for Wilson. By the end of the war in August, the *Inquirer* had raised over $50,000, collected from well-known philanthropists and ordinary citizens alike, such as a group of schoolchildren who raised $26 by selling scrap iron.[17] By the winter of 1945, Wilson's trust fund had grown to over $105,000, and he pledged to use the money to get married, buy a house, and study law under the newly signed GI Bill, which authorized education benefits for veterans.

At approximately the same time, the Coast Guard press corps captured a different kind of amputee, who in full military dress made explicit the needs of disabled veterans within the discourse of patriotism (see figure 8.4). The small body of Thomas Sortino of Chicago is framed deliberately against the Olympic-sized statue of Abraham Lincoln. The accompanying caption proclaims, "A fighting coastguardsman . . . poses for a Memorial Day tribute to the Great Emancipator

. . . So That 'Freedom Shall Not Perish From the Earth'

A fighting coastguardman, who lost his right arm in battle, poses for a Memorial Day tribute to the Great Emancipator at the Lincoln shrine here. The guardsman, who took part in the invasion of North Africa, is Thomas Sortino, of Chicago.

Figure 8.4: Coast Guardsman and veteran amputee Thomas Sortino of Chicago performs his patriotism at the Lincoln Memorial in Washington, D.C. Undated newspaper clipping ca. 1944 from the Donald Canham Collection, Otis Historical Archives, Armed Forces Institute of Pathology, Walter Reed Army Medical Center, Washington, D.C.

at the Lincoln shrine here." The photograph deploys Sortino's salute to endorse the democratic ethos of sacrifice, as if his amputation had been nothing less or more than what the government demanded of all its citizens during wartime— "pitching in," buying war bonds, tending victory gardens, and rationing consumer goods. Under Lincoln's attentive gaze, the visual and verbal cues here invoke nostalgia for the Civil War and reinforce the idea that those who were disabled during World War II fought and won the war to preserve democracy. Two articles published about the same time in a local Washington, D.C., newspaper confirm this theme. One, about the Quebec-born amputee Fernand Le Clare, declares in a headline, "Canadian GI Proud to Be an American," while the other,

about the Hawaiian-born disabled veteran Kenneth T. Otagaki, assures us that "This Jap Is Justly Proud That He Is an American."[18]

In spring 1946, the comic strip *Gasoline Alley* ran a four-part story at approximately the same moment when quadruple amputee Jimmy Wilson had ascended to iconic status in the popular media. The *Gasoline Alley* comic tells the story of Bix, a veteran of World War II who "lost both legs in the war and has two artificial ones," and the able-bodied men who are impressed and won over by the display of Bix's normalcy. In the brief narrative, Wilmer, a business owner, protests foreman Skeezix's decision to hire Bix as a new employee on the warehouse floor. Wilmer tells Skeezix, "It's nice to help those fellows, but we've got work to turn out—lots of it!" When Wilmer hires a former sailor for the position, he is amazed to discover that he is the same double amputee that Skeezix had hired the day before. The comic strip echoes the promotion of rehabilitation medicine as one of the perks of the postwar economy. Skeezix declares, "Modern medicine and surgery have been doing wonders for war casualties. . . . [Bix] tells me he was out dancing last night!" By the social standards of the mid-1940s, what evidence was more reasonable assurance of an American's normal status than Darwinian competition with other males on the dance floor? Apparently Bix was not alone: in a 1946 autobiography, the writer Louise Baker observed that a "great wave of slick stories has pounced [on] the public recently in which disabled soldiers bounce out of their beds, strap on artificial legs, and promptly dance off with pretty nurses. . . . [One nurse] not only affected a miraculous cure of the poor boy's complexes, she practically put blood and bones in his [prosthetic] leg."[19] Artifacts of popular culture like *Gasoline Alley* suggest that some sectors of the public were only too aware of the harsh standards that amputees were judged by. These were conventional versions of normal, heterosexual masculinity that few men, able-bodied or otherwise, could deviate from without fear of reprisal. That Bix is able to "pass" as an able-bodied, virile veteran—and is not immediately identified as a delicate or effeminate war casualty—seems to be the comic's principal message. While watching Bix carry an enormous carton across the shop, Wilmer declares, "You sure put one over on me. I didn't suspect [Bix] wasn't perfectly *normal*." Skeezix replies, "Practically he is. . . . He wants to show he's as good as anybody. That makes him better."

Such sentiments were not the exclusive purview of mass culture. A photograph taken in March 1952 at Walter Reed Army Medical Center, for example—the place where the Amputettes were a hit only seven years earlier—was undoubtedly meant to capture a veteran amputee in a familiar able-bodied activity: lighting and enjoying a cigarette (see figure 8.5). As usual, at issue was not simply the veteran's vocational or domestic rehabilitation but the crucial preservation of his masculinity as conveyed by the dramatic lighting and crisply graduated shapes of the amputee's body—conventions of celebrity iconography that descend directly from photographers such as Cecil Beaton and George Platt Lynes. The performative style with which the amputee lights his cigarette, however, also implies that the prosthesis will confirm his cultural fitness—that is, his natural fitness as a mesomorphic amputee that allows him to take care of himself. A similar photograph of an older veteran reading the newspaper, taken at Walter Reed in 1949, challenges the expectation that all amputees were young and stereotypically mesomorphic (see figure 8.6). The representation of this newspaper-reading veteran's manliness is explicitly naturalized as a function of his cultural fitness: difficult to discern in the photograph are the pinup girls painted on the amputee's legs, icons that are more characteristic of sailors' tattoos or the noses of airplanes than the allegedly fragile artificial limbs of the emasculated veteran amputee. Smoking, reading the sports section, and, in Bix's case, swing dancing, were typical able-bodied activities that conveyed the quotidian casualness with which these veterans seemed to embody normal, heterosexual male identity. In the case of this older man, perhaps painted pinup girls allowed him to identify with the blue-collar workers to which his trapped white-collar Organization Man psyche deeply aspired.

Yet the swaggering gesture and brazen though vulnerable gaze that are captured in figure 8.5 are also not unlike those of body builders or underwear models that were published in beefcake physique magazines in the 1950s and early 1960s and enjoyed by an almost exclusively gay male readership. Indeed, for many the image of a handsome veteran lighting a cigarette—despite or even because of his disability—may have invoked, as George Chauncey has described, the suggestive nature of the query "Got a light?" within gay urban culture during the early decades of the twentieth century.[20] Such knowing gestures and ambiguous poses,

Figure 8.5: Unknown above-the-elbow amputee, looking not unlike James Dean, lighting and enjoying a cigarette in a poignant distillation of the codes of military masculinity particular to the post-World War Two era. Photograph taken March 1952, from the collections of the Otis Historical Archives, Armed Forces Institute of Pathology, Walter Reed Army Medical Center, Washington, D.C.

Figure 8.6: By painting tattoo-like images of calendar girls on his prosthetic legs, this unknown above-the-knee double amputee challenged the popular reputation of veteran amputees as emasculated or socially maladjusted. Compare his prosthetic legs with that of Iraq war veteran Michael McNaughton in figure 8.8. Photograph ca. 1949, from the collections of the Otis Historical Archives, Armed Forces Institute of Pathology, Walter Reed Army Medical Center, Washington, D.C.

in the hands of filmmakers like Kenneth Anger and Andy Warhol, knowingly blurred (and sometimes erased outright) the lines between explicit heterosexual bravado and implicit gay iconography. To a large degree, nothing could completely prevent a growing gay constituency in the postwar era from drawing associations between the queer and the hypermasculine, as repeatedly mined by graphic artists like Tom of Finland, which are memorialized in the sartorial excesses of military fatigues, police uniforms, undershirts, jack boots, bomber jackets, Ray-Ban sunglasses, and other tight-fitting accoutrements of iconic male power.[21]

By the mid-twentieth century, then, two competing though overlapping ideologies, informed by the symbolic meanings that Americans attached to notions of disability, had emerged within u.s. military culture. Both preyed on the fear that normative versions of American masculinity were under attack. In the first, military culture affirmed the military male body as mesomorphic, competent, virile, and heterosexual. As the hostile attitude toward the endomorph made clear, the perceived feminization of the military was an especially potent anxiety among many in the armed forces. Although the professional focus on effeminate soldiers obviously predated the war, it consolidated in the public imagination after the 1948 publication of Alfred Kinsey's *Sexual Behavior in the Human Male.* But long before Kinsey's revelations hit the newsstands, army psychologists who feared that one bad apple could convert the whole barrel taunted new recruits with effeminate mannerisms and code words that were thought to be the performative gestures and underground lingo of a vast homosexual conspiracy in order to root out the problem. During and after the war, military physicians administered urine tests to determine which soldiers' bodies had appropriate levels of testosterone and rejected those with too much estrogen.[22]

A second and competing military ideology affirmed the disfigured male amputee as mesomorphic, competent, virile, and heterosexual. Patriotic stories about veterans convalescing or undergoing physical therapy treatments occupied a semipermanent place in news reports, feature films, radio broadcasts, and local and national newspapers. These popular images and narratives were directly influenced by the fiercely heterosexual culture of rehabilitation medicine, especially its orthodox zeal to preserve the masculine status of disabled veterans. Among military and university researchers, rehabilitating the amputee's masculinity along with his body was an implicit goal that exposed the military's discomfort with

physical weakness and vulnerability as well as its own homophobia. A rehabilitation manual published in 1957 at the University of California at Los Angeles, for example, explicitly correlated physical disability with the perceived heterosexual anxieties of the male amputee: "Will he be acceptable to wife or sweetheart? Can he live a normal sex-life? Will his children inherit anything as a result of his acquired physical defect? Can he hope to rejoin his social group? Must he give up having fun?"[23] Rehabilitation therapists at New York University wrote in 1953 that, "a good prosthesis, provided in an atmosphere of understanding and interest by people who are looking to him as a man, a human being, and as an important cog in an experimental program, fills two interwoven needs. He can feel a lessening of the threats against which he must continually arm himself and he can utilize the potentialities of the prosthesis to a much greater extent."[24]

Observations like these—like circulated stories of Jimmy Wilson, Bix from *Gasoline Alley,* and the image of the handsome amputee smoking a cigarette— were designed as positive propaganda to affirm veterans not simply as normal men but as those whom queer scholars like Michael Warner have identified as heteronormative men.[25] Indeed, well into the 1950s the widespread veneration of both real men like Wilson and imaginary characters like Bix encouraged many to endorse war mobilization (and its domestic concomitant in the cold war era— civil defense training) as a method of encouraging normative gender roles in the population at large. Writing in 1955, physician George W. Henry saw in the prosperity of civilian life the degradation of masculinity and advocated the salutary effects of military training as a way to tackle the problem of effeminacy among American men:

The hazard in a democratic country of being lulled by an apparent state of peace has been amply demonstrated in our lack of preparedness for the two world wars. . . . Lack of discipline, passivity, and a desire for comfort contribute to a state of lethargy in which the nation becomes virtually defenseless. Men are the chief victims of this slump; they are revived only under the stress of another national emergency—the need to fight in order to survive. [Only] then men again become virile, belligerent, and heroic.[26]

To what extent does national security or, better yet, the maintenance of core American values depend on the Darwinian mechanisms of virility, belligerence,

and heroism? Does that mean that any opposing concepts—such as femininity, passivity, and cowardice—should be assumed to be threats to national security and to core American values? Apparently not. In another advertisement from the 1943 Cannon towel campaign (which might demonstrate what Henry saw as "passivity" and a "lack of discipline" among American men), the playful burlesque performed by the nude soldier on the right is not meant to express his effeminacy (see figure 8.7). Instead, it is meant to convey the solidity of American values as marked by heterosexual male privilege (and, it might be added, the solidity of imperialistic arrogance among soldiers overseas, implied by the artist's racist caricatures of Australian natives watching from the sidelines). Under the exigencies of military preparedness, unit cohesion, and individual sacrifice for the national good, the privileges of ablebodiedness and heterosexual masculinity have

Figure 8.7: This illustration, part of a series created by Young & Rubicam for the Fieldcrest Cannon Corporation and published in mainstream publications like *Life* in 1943, suggests that unconventional or gender-transgressive behavior—in this case, soldiers doing a playful burlesque—is not only one of the military's many tacit privileges but is in fact one of the principal components of able-bodied heterosexuality. Image reproduced from the on-line archives of the Commercial Closet (www.commercialcloset.org)

TRUE TOWEL TALES: No. 6 . . . AS TOLD US BY A SOLDIER

Illustration as described by the sold

the capacity to absorb what in another context would be perceived as dangerous gender-transgressive behavior.

At the intersections of disability and queerness in military culture, the physical stigma that is attached to disability in the military can be seen to cover much of the same ideological ground as the physical stigma that homosexuality covers. But the two stigmas have important conceptual differences that lead the state to scrutinize and define disability and homosexuality within very different rhetorical structures. The legal protections that are afforded by the Americans with Disabilities Act of 1990, the constitutional protections that are afforded to consensual sexual partners following the u.s. Supreme Court's ruling in *Lawrence and Garner v. Texas* (2003), and the (unresolved) debates around same-sex marriage that were exploited to partisan ends during the 2004 presidential campaign all suggest that we have only begun to understand the transition of queerness and disability from being categories of shame and alienation to being fully formed public and political identities, especially in relation to questions of civil rights and meaningful definitions of citizenship.

Sixty years ago, being queer and being disabled were equivalent concerns for military administrators and officers. But queerness and disability began to diverge once the military sought to bestow on war veterans the privileges of patriotic citizenship and, in a moment that was perceived as one of crisis, the privileges of normative masculinity. The military's continued emphasis on mesomorphic bodies—as evident in the images of the amputee smoking at Walter Reed in figure 8.5, that of Iraq war veteran Michael McNaughton using a high-tech prosthetic leg developed at Walter Reed and jogging with President George W. Bush on the South Lawn of the White House in April 2004—could be argued to be the only way that the u.s. government can accept its role in facilitating death and disability among its citizenry (see figure 8.8). Admiration for the ideal patriot and his physical body can go hand in hand, until death do they part.

Yet when the reverence for death or disability is combined with evidence or even perceived evidence of queer *sexuality*, then the sentimental appeal or rhetorical potential of this homoeroticism is quickly diffused, and the true meaning of national defense quickly comes to the fore. In the short time since the Clinton administration launched its "Don't ask, don't tell" policy in 1994, the military-judicial infrastructure has disavowed any evidence of homosexuality and has also

disavowed the normalization process that constantly takes place within military culture.[27] This normalization process is necessary to diffuse queerness and to maintain the military's public face as an institution of normative bodies and values. But when this process is unmasked, the shifting status of queerness and disability within a military context becomes a poignant barometer for measuring social progress or lack thereof. It allows us to measure and designate the kinds of bodies that are needed to constitute and materialize the ideal citizen both in military culture and in civilian society.[28]

Men like the Amputettes were torchbearers for the rituals of heterosexuality and ablebodiedness in the mid-twentieth century. They entered into a visible male homosocial community that enjoyed public drag performances and solidly normalized cross-dressing within the patriotic parameters of rehabilitation culture. In this environment, to express queerness was to express allegiance to the patriotic program of the state. Think how different this expression of civic utility is from the openly gay, lesbian, bisexual, or transgender soldier who encounters a hostile response when she or he attempts to link gender identity or sexual orientation to normative citizenship under the rubric of equal rights. This is why the scales of justice tip heavily against openly gay or lesbian soldiers. When queerness takes a form that is socially and ideologically productive, as in the case of the Amputettes, all's well with the world. But when queerness is perceived to serve its own promiscuous agenda that challenges or otherwise runs counter to the needs of the state and productive citizenship, the state and the popular media retrieve their most familiar distillations of heteronormativity—the mesomorphic soldier (like Michael McNaughton) who is virile and independent, or (as depicted in domestic portraits of Iraq war veteran and their wives and girlfriends) the disabled veteran who is virile but in need of protection by the state and his loving female partner.[29]

It could be argued that the Amputettes' performances embodied a sublimated sexual insecurity or inferiority that their amputations made visible to the naked eye. In the images of the Amputettes, the appearance of their prostheses beneath their skirts exposed the soldier's tenuous relationship to the heterosexual masculinity that defines such drag. Yet in the rehabilitation culture of the era, failed attempts at able-bodied activity were far more potent markers of queerness than the desire or willingness to dress up and perform in drag. Whereas being queer was usually marked by dressing in women's clothes, *not* dressing in women's clothes marked

Figure 8.8: Iraq war veteran Staff Sergeant Michael McNaughton of Denham Springs, Louisiana, performs a ceremonial jog in a photo op with President George W. Bush on the South Lawn of the White House. Despite the photograph's attempt to depict their male bonding as natural and effortless, the correlation between physical activity and patriotic iconography—from the embroidered signature decorating the presidential jogging suit to the American flag decorating McNaughton's prosthetic leg—suggests some of the methods through which able-bodied masculinity is culturally produced as a rhetorical necessity during wartime. Compare McNaughton's prosthetic leg with those of World War II veteran amputee in figure 8.6. Photograph taken April 14, 2004, © ZUMA/Corbis

them as potentially unable to fulfill the social roles expected of them as soldiers, employees, boyfriends, husbands, fathers, and citizens. The prosthetic legs with which the Amputettes performed were not simply artifacts of military or medical ideologies of normalization and ablebodiedness but were in effect cultural tools that produced ideologies of normalization and ablebodiedness and made them both physically tenable and socially meaningful.

However we finally interpret the Amputettes, we must not forget the larger historical context in which their first appearances took place. As David K. Johnson has meticulously documented in *The Lavender Scare: The Cold War Persecution of Gays and Lesbians in the Federal Government,* only a few years after the Amputettes' successful engagements in military hospitals and convalescent centers in Washington, D.C., and suburban Maryland, a Senate subcommittee was commissioned to study the alleged infiltration of subversive elements into the federal government and the armed forces.[30] Following its investigations, the U.S. Congress published in 1950 the notorious *Senate Report on the Employment of Homosexuals and Other Sex Perverts in Government.*[31] Popular books like Jack Lait and Lee Mortimer's salacious *Washington Confidential* (1951) began to identify public and commercial sites of queer depravity, such as bars, restaurants, tearooms, and other secret meeting places of known homosexuals in the District of Columbia.[32] Such gossipy innuendo helped fuel reactionary theories about the potential Communist backing of early homosexual rights organizations like the Mattachine Society, a point that was not lost on the House Committee on Un-American Activities in the early 1950s or during the Senate's 1959 investigation into Senator Joseph McCarthy's attacks on various U.S. Army members.[33]

Yet the activities of the Amputettes, which were detectable on any semiconscious queer's radar screen, were utterly unremarkable. Their performances, protected within the fold of military culture, were equated with asexual male frivolity and also with the sober and necessary task of social acclimation and physical rehabilitation. It might be possible to see the campy antics of the Amputettes as a subversive expression of resistance to gender roles or social conformity. The greater likelihood, however, is that the Amputettes participated in drag vignettes for the same reasons that their able-bodied counterparts danced and sang in drag for them. They did it because the compulsory systems of heterosexuality and ablebodiedness demanded it.

Americans had a visceral reintroduction to some of these themes in the spring of 2004 when incidents at Abu Ghraib prison in Iraq, first reported publicly by journalist Seymour M. Hersh in *The New Yorker,* made visible the disturbing practices of physical torture and sexual humiliation of Iraqi prisoners by U.S. military personnel that were documented in a series of now-infamous photographs.[34] Some saw the photographs as sadistic but also undeniably homoerotic— images of American soldiers forcing Iraqi prisoners to strip and form piles of naked bodies, making them simulate oral sex with each another, keeping them prostrate on dog leashes, attaching electrodes to their genitals, and requiring them to do jumping exercises while singing "The Star-Spangled Banner."[35] For writers like the late Susan Sontag, such images followed the familiar contours of the pornographic and seemed to expose a queer crack in the military's claims to cultural and political normalcy.[36] But the acts depicted in the Abu Ghraib photographs also provide material evidence for the conflation of excessive force and arrogant privilege that protects the military from such accusations. In May 2004, radio host Rush Limbaugh—eager to neutralize the political and psychological effects of the torture photographs on popular opinion of the Iraq war and of George W. Bush's credibility as commander-in-chief—compared such practices to those of hazing rituals within elite secret organizations like Yale University's Skull and Bones Society, the fraternal organization to which Bush once belonged:

[What happened at Abu Ghraib] is no different than what happens at the Skull and Bones initiation. And we're going to ruin people's lives over it, and we're going to hamper our military effort, and then we are going to really hammer them—because they had a good time? You know, these people are being fired at every day. I'm talking about people having a good time, these people. You ever heard of emotional release?[37]

Given the ways through which the privileges of heterosexuality are normalized in our culture—the reckless and impulsive acts that are indulged and interpreted as "having a good time," from the earliest playground traumas to the latest video of *Girls Gone Wild*—Limbaugh's defense of the American soldiers at Abu Ghraib should not be surprising. Indeed, the pronounced appearance of Private First Class Lynndie England—the reservist who posed in many of the more offensive images at Abu Ghraib and who was later domesticated through clothing,

makeup, and the sudden announcement of her pregnancy—demonstrates how the mutually constitutive codes of military and heterosexual normativity remain reliable mechanisms for exercising political power and containing the specter of difference. In early April 2003, during the first few weeks of Operation Iraqi Freedom, the Indian author Arundhati Roy tried to distinguish the U.S. government's military campaign in Iraq from earlier (and allegedly more controlled) models of American military activity.[38] Roy assumed that past U.S. governments were much better at concealing their brute tendencies toward economic and cultural imperialism. In promoting the Bush administration's plan to rebuild Iraq, Roy argued that the president "has achieved what writers, activists, and scholars have striven to achieve for decades. He has exposed the ducts. He has placed on full public view the working parts, the nuts and bolts of the apocalyptic apparatus of the American empire." Perhaps we underestimate the ability of power to uncoil itself slowly under conditions of its own choosing to make the "apocalyptic apparatus" of empire visible for the whole world to see. In the benign camp of the Amputettes or in Abu Ghraib prison, we see soldiers offering parodic performances, both literally and figuratively, of the heterosexual normalcy that is cherished by institutional culture. We also see the military's compulsive focus on bodily norms (and on its counterparts in civilian society) and the particular ways in which American culture consistently valorizes normative gender roles and ablebodiedness at the deliberate exclusion of other possibilities of human experience.

In June 2004, Sergeant David Sterling, an American soldier who was disabled in Iraq, was featured in a front-page article in the *New York Times,* where he described his kit of snap-on attachments, each of which cost $800, for his $85,000 myoelectric prosthetic forearm. The arm and its attachments are currently not available to civilians but are part of the multibillion-dollar rehabilitation technologies that are being furnished exclusively to Sterling and other war veterans by prosthetists and engineers at Walter Reed Army Medical Center. "I've got a hundred of [these attachments]," claimed Sterling, reassuring readers that he could write, play golf, shoot pool, and even go fishing without any compromises to his lifestyle or reputation: "If I wanted, I could have a hundred more. Anything I want. There's no limit to the rehabilitation."[39]

In the end, American soldiers using prosthetic limbs—whether they are playing a game of golf or performing in Carmen Miranda drag—physically embody the same political and technological privileges that soldiers have always had

access to and have been accustomed to throughout their military service. To be a normal American soldier means constantly having to perform what a normal body looks like as well as what a normal gender role looks like. And playing by the rules of heterosexuality and ablebodiedness means never having to apologize, show humility, or admit to physical limitations. Such performances are, inevitably, socially and historically contingent practices, caught up in the vanities and insecurities of the era in which they are performed. In the mid-twentieth century, to be a normal man in the military meant possessing the ability to perform the accepted gestures (especially the coy, campy ones) of heterosexual masculinity as well as the gestures of the normal American body—whether by dancing, smoking, or (as the culture decreed) performing in drag. To be a normal man in the military in the early twenty-first century will be long remembered for exposing how the familiar performative rituals of normalcy for American war veterans include not only leisure pursuits such as golfing and fishing but also the physical and psychic humiliation of war prisoners. The privileges accorded to American ablebodied masculinity are thus essential components of a political power that, in its most seething incarnations, facilitates the shamelessness with which an empire flexes its prosthetic muscle.

Notes

1. An early version of this essay was published in GLQ: *A Journal of Lesbian and Gay Studies* 9, no. 1/2 (2003). Research support was provided by a fellowship from the Center for the Study of Sexual Minorities in the Military at the University of California at Santa Barbara. Thanks to Aaron Belkin, Lisa Cartwright, Steven Mazie, and Marquard Smith for their collegial support and valuable insights.

2. All references to the Amputettes are from undated newspaper sources, probably published in February or March 1945, from scrapbooks in the Donald Canham Collection, Otis Historical Archives, Armed Forces Institute of Pathology, Walter Reed Army Medical Center, Washington, D.C.

3. See, for example, David A. Gerber, *Disabled Veterans in History* (Ann Arbor: University of Michigan Press, 2000); Gerber, "Heroes and Misfits: The Troubled Social Reintegration of Disabled Veterans in *The Best Years of Our Lives*," *American Quarterly* 46, no. 4 (1994): 545–574. See also Glenn Gritzer and Arnold Arluke, *The Making of Rehabilitation: A Political Economy of Medical Specialization, 1890–1980* (Berkeley: University of California Press, 1985).

4. See, for example, Christina Jarvis, *The Male Body at War: American Masculinity during World War II* (DeKalb: Northern Illinois University Press, 2004); David Serlin, *Replaceable You: Engineering the Body in Postwar America* (Chicago: University of Chicago Press, 2004), esp. 21–56. See also Susan Bordo, *The Male Body: A New Look at Men in Public and Private* (New York: Farrar, Strauss, and Giroux, 2000), esp. 105–152, 229–264; Harry Brod and Michael Kaufman, eds., *Theorizing Masculinities* (Thousand Oaks, CA: Sage, 1994); Michael Kimmel, *Manhood in America: A Cultural History* (New York: Free Press, 1997).

5. Annie Woodhouse, *Fantastic Women: Sex, Gender, and Transvestism* (New Brunswick, NJ: Rutgers University Press, 1989), 6.

6. For some influential examples of these scholars' works, see Douglas Baynton, *Forbidden Signs: American Culture and the Campaign against Sign Language* (Chicago: University of Chicago Press, 1996); Lennard Davis, *Enforcing Normalcy: Disability, Deafness, and the Body* (New York: Verso, 1995); Simi Linton, *Claiming Disability: Knowledge and Identity* (New York: New York University Press, 1998); Rosemarie Garland Thomson, *Extraordinary Bodies: Figuring Physical Disability in American Culture and Literature* (New York: Columbia University Press, 1997).

7. Eve Kosofsky Sedgwick, "Queer and Now," *Tendencies* (Durham, NC: Duke University Press, 1993), 5–6.

8. Henri-Jacques Stiker, *A History of Disability,* trans. William Sayers (Ann Arbor: University of Michigan Press, 2000), 128.

9. Charles B. Davenport and Albert G. Love, *Defects Found in Drafted Men: Statistical Information* (Washington, DC: U.S. Government Printing Office, 1920); Davenport and Love, *Army Anthropology: The Medical Department of the United States Army in the World War* (Washington, DC: U.S. Government Printing Office, 1921).

10. For a thorough exploration of the gendered aspects of military approaches to recruitment, see Jarvis, *The Male Body at War.*

11. T.D. Stewart, "Anthropology and the Melting Pot," *Annual Report of the Board of Regents of the Smithsonian Institution* (1947): 338–339.

12. William Woods and Carl C. Seltzer, *Selection of Officer Candidates* (Cambridge: Harvard University Press, 1943); Clark W. Heath, *What People Are: A Study of Normal Young Men* (Cambridge: Harvard University Press, 1946).

13. See William Sheldon's two influential books that bookend the era of the Amputettes—the prewar *The Varieties of Human Physique: An Introduction to Constitutional Psychology* (New York: Harper, 1940) and the postwar *Atlas of Men: A Guide for Somatotyping the Adult Male at All Ages* (New York: Harper, 1954). For a contemporary example of the resilience of somatotyping in the social sciences, see J.E. Lindsay Carter and Barbara Honeyman Heath, *Somatotyping: Development and Applications* (New York: Cambridge University Press, 1990).

14. For more about the historical development of diagnosing homosexuality, see Vernon Rosario, ed., *Science and Homosexualities* (New York: Routledge, 1997), and Jennifer Terry, *An American Obsession: Science, Medicine, and Homosexuality in Modern Society* (Chicago: University of Chicago Press, 2000).

15. See Terry, *An American Obsession*. For a concise discussion, see Terry's "Anxious Slippages between 'Us' and 'Them': A Brief History of the Scientific Search for Homosexual Bodies," in Jennifer Terry and Jacqueline Urla, eds., *Deviant Bodies: Critical Perspectives on Difference in Science and Popular Culture* (Bloomington: Indiana University Press, 1995), 129–169.

16. For revealing statistics on military recruits that demonstrate the enormous divide between actual soldiers and those depicted in such advertisements, see Jarvis, *The Male Body at War*. For a comparative perspective, see also Allan Bérubé, *Coming Out under Fire: The History of Gay Men and Women in World War II* (New York: Free Press, 1990).

17. "Fifty Thousand Mark Passed in Drive to Aid Army Multiple Amputee," *Washington Evening Star*, August 30, 1945.

18. Newspaper clippings from the *Washington Evening Star*, probably 1945 or 1946, from the scrapbooks of the Donald Canham Collection, Otis Historical Archives, Armed Forces Institute of Pathology, Walter Reed Army Medical Center, Washington, DC.

19. Louise Maxwell Baker, *Out on a Limb* (New York: McGraw-Hill, 1946), 37.

20. See George Chauncey, *Gay New York: Gender, Urban Culture, and the Making of the Gay Male World, 1890–1940* (New York: Basic Books, 1995), esp. chapters 1–3. Thanks to Robert McRuer for making this excellent observation about the photograph.

21. For an informed discussion of some of these themes, see Micha Ramakers, *Dirty Pictures: Tom of Finland, Masculinity, and Homosexuality* (New York: St. Martin's Press, 2000).

22. For a contemporary account of this, see "Homosexuals in Uniform," *Newsweek*, June 9, 1947, reprinted in Larry Gross and James Woods, eds., *The Lesbian and Gay Reader in Media, Society, and Politics* (New York: Columbia University Press, 1999), 78.

23. Miles Anderson and Raymond Sollars, *Manual of Above-Knee Prosthesis for Physicians and Therapists* (Los Angeles: University of California School of Medicine Program, 1957), 40.

24. New York University College of Engineering Research Division, *The Function and Psychological Suitability of an Experimental Hydraulic Prosthesis for Above-the-Knee Amputees,* National Research Council Report 115.15 (New York: New York University/Advisory Committee on Artificial Limbs, 1953), 48.

25. See Michael Warner's discussion of the heteronormative in *The Trouble with Normal: Sex, Politics, and the Ethics of Queer Life* (Cambridge: Harvard University Press, 2000).

26. George W. Henry, *Society and the Sex Variant* (New York: Macmillan, 1965 [1955]), 118.

27. For a powerful discussion of the discursive limits of "Don't ask, don't tell" in relation to the construction of gay political identity, see Janet Halley, *Don't: A Reader's Guide to the Military's Anti-Gay Policy* (Durham, NC: Duke University Press, 1999).

28. For some recent influential studies that examine sexual subjectivities within the concept of citizenship, see Laurent Berlant, *The Queen of America Goes to Washington City: Essays on Sex and Citizenship* (Durham, NC: Duke University Press, 1998); Eric O. Clarke, *Virtuous Vice: Homoeroticism and the Public Sphere* (Durham, NC: Duke University Press, 2000); Jose Esteban Muñoz, *Disidentifications: Queers of Color and the Politics of Performance* (Minneapolis: University of Minnesota Press, 1999); Warner, *The Trouble with Normal.*

29. See, for just two examples, portraits of Robert Shrode and his wife, Debra, on the cover of the *New York Times Magazine,* February 15, 2004, and that of Michael Cain and his fiancée, Leslie Lantz, in Dan Baum, "The Casualty," *The New Yorker,* March 8, 2004, 64–73.

30. See David K. Johnson, *The Lavender Scare: The Cold War Persecution of Gays and Lesbians in the Federal Government* (Chicago: University of Chicago Press, 2004). For more about the homophobic backlash during the cold war era, see Robert Corber, *Homosexuality in Cold War America: Resistance and the Crisis of Masculinity* (Durham, NC: Duke University Press, 1997); John D'Emilio, *Sexual Politics, Sexual Communities: The Making of a Homosexual Minority in the United States, 1940–1970* (Chicago: University of Chicago Press, 1983); Jonathan Ned Katz, *Gay American History* (New York: Meridian, 1992 [1976]); Stuart Timmons, *The Trouble with Harry Hay* (Boston: Alyson, 1990).

31. *Senate Report on the Employment of Homosexuals and Other Sex Perverts in Government* (Washington, DC: U.S. Office of Government Printing, 1950). See also William B. White, "Inquiry by Senate on Perverts Asked," *New York Times,* May 20, 1950, 6.

32. For further exploration of Washington, D.C., during the 1950s, see Johnson, *The Lavender Scare.* See also Brett Beemyn, "A Queer Capital: Race, Class, Gender, and the Changing Social Landscapes of Washington's Gay Communities, 1940-1955," in Beemyn, ed., *Creating a Place for Ourselves: Lesbian, Gay, and Bisexual Community Histories* (New York: Routledge, 1997), 183–209.

33. See Lee Edelman, "Tearooms and Sympathy: or, The Epistemology of the Water Closet," in Henry Abelove, Michele Barale, and David Halperin, eds., *The Lesbian and Gay Studies Reader* (New York: Routledge, 1993), 553-575.

34. Seymour Hersch, "Torture at Abu Ghraib," *The New Yorker,* May 10, 2004, 43-49.

35. For a full account of the legal justifications for such atrocities, see Anthony Lewis, "Making Torture Legal," *New York Review of Books,* July 15, 2004, 4–8. For a brilliant analysis, see also Jasbir K. Puar, "On Torture: Abu Ghraib," *Radical History Review* 93 (Fall 2005): 13–38.

36. Susan Sontag, "Regarding the Torture of Others," *New York Times Magazine,* May 23, 2004, 24–29, 42.

37. Rush Limbaugh, "It's Not about Us; This Is War," transcribed by the author from Limbaugh's syndicated radio program, May 4, 2004.

38. Arundhati Roy, "Mesopotamia. Babylon. The Tigris and Euphrates," *The Guardian* (London), April 2, 2003.

39. Sergeant David Sterling, quoted in Michael Janofsky, "Redefining the Front Lines in Reversing War's Toll," *New York Times,* June 21, 2004, A1.

--

PART II
ASSEMBLING: INTERNALIZATION.
EXTERNALIZATION

NAKED Elizabeth Grosz

[The other's eyes] turn to me a liquid pool waiting for unforeseeable disturbances. They are more naked than the flesh without pelt or hide, without clothing. . . . They are more naked than things can be, than walls bared of their adornments and revolvers stripped of their camouflage; they bare a substance susceptible and vulnerable. Their nudity exposes them to whatever message I may want to impose, whatever offense I can contrive.
 —*Alphonso Lingis,* Foreign Bodies[1]

Mammalian Orchids

Human bodies—indeed, bodies of all kinds—are the product of a weird and surprising intrication of a nature that must be regarded as considerably more complex, convoluted, nonlinear, nondeterministic than we had once believed and of a history that cannot be contained in culture alone. This history includes but is not restricted to the social, economic, geographical, and representational practices that surround and sustain bodies. But such a history—the history of culture—cannot be conceived as wholly outside of or autonomous from nature, for it is nature, a reconceived and open nature, an evolutionary nature that both produces all environments and all bodies that are sustained in and by those environments. In a certain sense, it is nature that requires and accomplishes culture, but nature conceived as richly open in possibilities rather than rigidly determined in its outcomes. It is a nature that is driven not by the forces and closures of the past

but fundamentally directed to the future and thus is nonteleological or evolutionary nature. A history of culture is in a certain sense the ever-expanding history of nature. Friedrich Nietzsche called for a history of culture that would not simply include or focus on scientific, cultural, economic or military achievements but would explore the self-cultivation of minds and bodies, the human production of itself as a species. In this sense, his work is not entirely alien to that of Charles Darwin and the biological tradition that follows him. Every culture and social group, Nietzsche maintained, can be understood not only in terms of its social and cultural products but also in terms of the particularities of its corporeal arrangements and body ideals—its management, representation, and production of bodies and thus of nature.[2]

Nietzsche claimed that the first artists worked with the noblest of resources—the clay, canvas, and oil of flesh and blood. In a certain sense, they were the founders of culture. The first art is one developed from out of the core of one's own body and its products. This impulse to make something other of oneself, to make one's body other than what it is—the primordial moment of the artistic impulse—is the very explosion of culture itself and the input that such a reconceived nature gives to the human and the human-to-be. One can see in the products of culture—its technological, political, and scientific achievements—the exteriorization of this primitive artist's impulse, the directing outward of this primordial body art. A history of culture *could* be written as the history of the way that humans makes their bodies other and do so—indirectly, through the meandering feedback that action and production impose on and as the nature of bodies.

The paleoanthropologist André Leroi-Gourhan has argued that the technological history of humanity can be divided into four broad stages that coincide with the biological evolution of the species.[3] This history reveals the intertwining of biological-evolutionary and cultural techniques in the transformation of bodies. Bodies and technologies function in a self-feeding relation where transformations in the one produce transformations in the other, which in turn feed back on both. The histories of nature and of civilization coincide insofar as they are both a function of the bodily impulses that produce and are transformed by technological impulses:

1. This history "begins" with the most primitive use of tools, tools that in the first instance are parts, and then are extensions, of the body itself, and above all, of its privileged organs and functions: cutting, chopping and grinding—tools modeled, at the outset, on teeth, and prosthetic cutting. The baboon, the chimpanzee, and the ape forage and manipulate using their teeth, and baboon implements, which are forged by chipping stones or branches between the front legs, exteriorize this function of chewing and grinding. As the four-legged gait gives way to upright posture, the privilege of the teeth and nose give way to the primacy of the eyes and the hands. The mouth no longer encounters nature directly; rather, the legs propel the creature into the world, and its hands serve to mediate between the world that it samples and its mouth. It now reacts to a world that is manually mediated. Tools exteriorizing and supplementing the atrophying senses (nose, snout, mouth, teeth) emerge, tools that are part of the process of this very atrophy;

2. Technological history harnesses externally driven motor power—the power of water, winds and animals to power the tools thus devised. These devices—the plough, the windmill, the sail—enable a wider locus of control than what was available to either the individual's or the group's labor power. The power of vision is even further privileged insofar as the externally driven forces require regular and careful supervision. In addition, this transfer of energy and force from musculature to external energy sources helps participate in the supercession of muscular power, its reservation for tasks of nobility and bravery rather than mere survival. Moreover, as Freud hypothesized, with the privileging of visual and the repression of the sense of smell, sexuality becomes unseasonal, no longer confined to an estrus cycle, no longer inflamed by the enticements proffered by smell but excited by the now-upright ape's visually exposed genitalia;

3. Replacing the utilization of these rather unpredictable or erratic natural resources comes the invention of machines—nonhuman and nonorganic devices that are able to be regulated and used with increasing reliability and control. The key image of the controllable machine is the mechanical clock, which is not only a self-regulating mechanism, but also one into which other sorts of mechanical connections could be made, and other, more complex machines devised. Mechanism has the advantage over external motor power insofar as it requires ever-diminishing surveillance, through perhaps a more minute vision of the mechanism

and its functioning. This is accompanied by the increasing atrophy of muscula-
ture and an ever-escalating emphasis on capacities for conceptualization.

4. The internalization of the machine into the circuits of the human brain it-
self, the augmentation and replacement of conceptual skills through information
or data storage, processing and retrieval. This is an evolution into a pure specta-
torial state and its correlative, display. Leroi-Gourhan describes it as an orchid ex-
istence—the becoming of what might be understood as a mammalian orchid. We
must recall that orchids are genetical monstrosities, plants with atrophied trunks
and limbs, pure, spectacular sexual organs enticing bees for their frenzied cross-
species union. As a species, he speculates that we are in the process of becoming
huge eyes, feeding into massive brain, in the hope of engorged genital pleasures,
Nietzsche's giant organs on tiny bodies, the drastically shrunken homunculus
whose body shrinks as its brain expands, for whom the hand no longer links with
the genitals, but give way to the primacy of the eyes. A huge brain linked to big
eyes and dextrous hands, with a spindly body attached.

If there is some plausibility in Leroi-Gourhan's genealogy, it implies that
history, or at least human history, is both an inward and an outward movement:
outward, insofar as the species produces from its interior, from its body and its con-
densed and compressed, projected rhythms to create cultural forms, its various arts
(including dance, painting, poetry, and "architecture"), and inward, insofar as ex-
ternal resources (natural forces, mechanical forces, electronic forces) are gradually
incorporated into and become capable of replacing human organs and tissue.

There are at least two significant effects of the evolutionary tendency to-
ward the obsolescence of musculature and the atrophy of sensory organs: the first
is that the human body has tended to subordinate and render secondary all sense
organs other than those of vision, to which it grants an extraordinary priority. The
movement from mouth and nose, to hand, and eventually to the eyes is an in-
creasing movement toward the spectacular, an ever-increasing orientation to the
visual, and thus to the artistic, and the representational. The second is that there is
at the same time a movement toward display—toward the rendering of the body
as exhibition. In other words, correlative with the development of the organs for
seeing is the heightened development of organs to be seen. The transformation
from quadrapedal to bipedal locomotion, the movement from a crouched to an

upright posture, Freud argued, made the visual organs pivotal in both the mastery of nature and in the transformation of sexuality from a cyclical to an unseasonable form.[4] The privileging of the visual goes together with the repositioning of genital organs for frontal viewing. The protohuman creature becomes simultaneously a viewing object and a viewed object, its organs for viewing being closely identified and articulated with its organs to be viewed.

It is thus hardly surprising that art, and especially the visual arts—have become a primary medium for the socially sanctioned and culturally binding relations of sexual spectacle and sexual viewing. Art, the art of self-making, transformed bit by bit to the art of depiction, to functional art, and to experimental art—is crucial in the experimental processes of transforming both body and nature, a pivotal hinge that is midway between sexual and erotic practices and the practices of self-making that constitute culture. Art lies at the heart of culture as much as sexuality and sex lie at the heart of art.

Naked Vulnerability

I am interested in this text in exploring the interface between sexuality, bodies and art. While I certainly don't have the training, or perhaps the artistic sensibility, required for anything more than the most perfunctory discussion in artistic terms, I do want to discuss some of the political and theoretical issues that are at stake in highlighting and refiguring the role of the body in art. The body must be understood as both the object and the medium of art, and more particularly, as a means for transforming art and the ways that it is commonly understood. I reconsider here some of the terms that have become central to the ways in which art and representation more generally have been theorized and to problematise some prevailing intellectual models. In particular, I rethink notions like the gaze, voyeurism, and exhibitionism, in other words, the relations between representation and eroticism that have dominated visual theory in the last twenty years or so—not so much to provide a new theory of art and spectatorship but to refine these overwrought terms and concepts and bring some freshness to this significant nexus of bodies looking at bodies through and as art.

I begin with an initial hypothesis: we don't know what bodies are capable of. Whether in the realm of the biomedical (genetics, embryology, molecular

biology), or in the sphere of sports and bodily exertion (body building, exercise, records), or in the order of production and labour power we have a general understanding of bodily capacities but little understanding of the limits and boundaries—the threshold between what is bodily possible and impossible. This is not simply true because of the limitations of our current forms of knowledge, the lack of refinement in our instruments of knowledge, but more profoundly because the body has and is a history and under the procedures of testing, the body itself extends its limits, transforms its capacities, and enters a continuous process of becoming, becoming something other than itself. This capacity for becoming other, or simply becoming, is not something that culture simply imposes on an otherwise inert nature but is part of the nature of nature itself. Becoming is what suffuses bodies from both outside (through the imposition of increasingly difficult tasks) and from within (through the unfolding of a nature that never was fixed and through the self-overcoming that is inherent in the very being and ontology of bodies).

A body is produced from other bodies, and its cohesion and continuing existence and integrity as a body are contingent on its ability to glean energy from other bodies—the bodies that it ingests and gains energy from to not only continue its existence but to proliferate itself in its products, including its offspring. This was the physicist Erwin Schroedinger's response to the biological dilemma that physics poses to all studies of life. If all physical systems tend toward disorganization and disorder—maximum entropy or thermodynamic equilibrium— then how does the living organism avoid decay? His answer was as simple as it was profound: "The obvious answer is: By eating, drinking, breathing and (in the case of plants) assimilating."[5] We prevent ourselves from plunging into atomic simplicity, physical or systemic annihilation, through the assimilation—in effect, the annihilation—of other organic existences. These give us the energy to maintain cohesion and growth. Bodies thus live in debt to the life that they destroy—the organic supplementation that they require. They must give back something of themselves—of their own bodily cohesion—for anything more than mere existence to be possible. I have already suggested that culture can be understood as an extension, a protraction, and a projection of the interior of the body itself. This is what the body gives back to the life on which it feeds and which it must destroy, as Bataille recognized, a sacrificial excess that produces not only the most noble and elevated cultural achievements, but, even more richly, the surprising

and ever-productive possibility for the subversion of these achievements and their transformation into different, often equally prodigious achievements. This is what life is—the ever-transforming, ever-recontextualizing of what has been done so that it can be done differently.

A body reproduces itself not only biologically but through its self-representations and the rigors of its practice. At this point, art figures itself as a bodily practice. While much of art merely re-presents the body (depicts or pictures it) at its most provocative, art also contains the possibility of refiguring, transforming, and functioning at the very limit of the body's capacities—especially if (as Nietzsche outlines) the origin of art is the very exploration and use of the body. Good art, as much as good science, presents us with the possibilities of bodies that are barely conceivable, that challenge and problematize the very stability and givenness of bodies, that force us to rethink our presumptions and our understandings of what bodies are.

We can follow Alphonso Lingis, with whose words I began this chapter, in arguing that it is in part the ridiculousness of the human form—its simultaneous vulnerability and infinite productivity—that is the very motive and force for the history of art and the history of technology: "Is not the conviction that our anatomy, ridiculous by nature, has to serve as the material for art coextensive with all civilization? The civilization our species has launched and pursued to relay its evolution appears in nature as the exteriorization not only of the powers but also of the splendours in our organs."[6] Can art be seen as a way of forcing this anatomical ridiculousness into productivity—of both enforcing this status of the ridiculous while pleasurably and productively exploiting it? Perhaps this may be one of the more profound differences between erotic and esthetic attachment—that erotic attachment induces a voluntary reciprocity in vulnerability, it produces the overcoming, the normalization or naturalization of ridiculousness, while aesthetic practices serve to denaturalize and heighten it (while in their own ways renormalizing and renaturalizing it, at least in terms of artistic conventions).

Maybe another way of asking this question is: what is it about bodies, and particularly about bodily organs, what is it about *naked* bodies, that propels us to produce and to view art, and most especially, to produce and view the body as *nude*. What is the difference between naked and nude (an old theoretical question whose range is not yet exhausted and whose provocations we must still, on occasion,

address)? If (as Leonardo da Vinci claimed) human genitalia and nakedness are "of an irremediable unsightliness"; if (as Lingis suggests) humans have no bodily equivalent to the lure of the peacock, the inwardly coiling horns of mountain sheep, and the lasciviously scarlet buttocks of the baboon; if there is nothing inherent in the human to make it orchidlike—then does art (including the art of fabrics, the art of cosmetics, the art of car design, the art of prosthetics—indeed, art as prosthetic) serve as our sexual lure, the visual snag that rents our vision?[7]

A second hypothesis: we are not "allowed" or encouraged in our culture, nor indeed in other known cultures, to either exhibit ourselves or to observe the bodies of others, *except* in highly restricted and codified contexts. Although nakedness seems a necessity and a convenience in all cultures, almost all cultures cultivate some kind of clothing or covering, some sense of shame or modesty, some stretch or limitation on the reach of nakedness. We are discouraged from nakedness ourselves except on the condition that we are children; we are lovers or in some intimate sexual context; or we are mediated in a relationship to nudity through representations—in art, pornography, advertising, medicine, cinematic and fictional contexts, and so on. These three contexts seem to be the privileged spaces of bodily intimacy, not where nakedness takes place, but rather where nakedness is automatically coupled with the desire, possibly even the imperative, to look and with the pleasure of looking. It is in intimate and/or nurturing relations that we are encouraged not just to look, but also to show, not just to look, but also to induce a touching.

Nakedness is a lure to intimacy and proximity because it invites the other's care and solicitude.[8] Nakedness is a state of vulnerability, not simply because one is open to the elements, at the mercy of the environment, unprotected, but also because one is prone, more prone than usual, to the affect and the impact of the other. There is so little to mediate, only the most intimate surfaces of the skin. And mutual nakedness modulates this vulnerability by making it reciprocal: by making each vulnerable to the look, the touch, and the intimate judgment of the other. A singular nakedness—the kind of nakedness that is represented by, say, the nudes of photographer Helmut Newton—is the most naked, prone, the most vulnerable for the model, but also, in a sense, for the observer.[9] This is why the boundary of the frame, the mediation of the image, the protection afforded by the artistic representation of the naked body—the emergence of the nude from

the naked—makes that nakedness even more alluring in its representational form than it may be in the flesh. Nakedness is not the most alluring state: it is the veiling of nakedness—its suggestion or intimation, its promise or possibility that entices. This has long been recognized by both artists and pornographers, and the lure of eroticism—the props, veils, adornments, the half-dressed, the near-naked (that is, the naked in promise alone)—is the body adorned by representation:

Without the gearing-into the tool—or without bravery at grips with death—the unathletic male nudity is ridiculous. The female anatomy verges on the ridiculous too, as our advertising, our high art, and our pornography know; it has to be relayed with stage props—be they reduced to the minimum, as in Nô theater, to high-heeled shoes, a garter, atmosphere spread with vaseline on the camera lens, or, as Marilyn Monroe said, perfume.[10]

Jacques Lacan has already made it clear that the human infant is even more fascinated with the image or depiction of an object than it is with the object itself.[11] The image holds the promise of a richness and a controllability that is unavailable in life. This is the allure of the cinema, fiction, and art, the mediation of an object or objects so powerful as to entice one to identify with them, to desire to watch them, to be entertained and amused by them. The allure of the image, the evocation of nakedness, and the simultaneous containment of nakedness that the image affords are the perfect context and setting for the depiction of bodies, bodies in their rich openness and in their sexual provocation.

We augment our skin to entice and signal our openness, we do not do this through displaying our plumage, the magnificence of our horns or tusks, the beauty and luster of our markings, stripes, or spots, or through flashing our genital organs.[12] We do not do this through our organs directly, at least not usually, but rather through the supplementation that allows us to signify our organs without designating them— through sheer underwear, through provocative low-cut or tight clothing, pendants worn at breast level, and weapons and tools carried on the hip. We entice through insinuation rather than explication.

The naked becomes nude through equivocation, through the suffusing of the image of nakedness with a context, a purpose, and a possible signification, which in a sense form a covering for that nakedness, in other words, through

ladening the naked body with beauty, grace, form, and solidity, we create a frame that contains it (even the frame of the art gallery or museum itself in the case of a work not literally framed) the frame, in other words, that designates some thing or activity as a work of art. The frame thus functions just as pervasively in non-painterly and nontraditional modes of art—in performance, dance, video, instal-lations—as it does in the traditions of academic painting. This containment of nakedness in the nude enhances the naked form—through the idealization that is performed by representation on the one hand, and, on the other, it authorizes a spectator to watch, to look, without the overwhelming obligation for intimacy that the naked or the erotic body poses. The spectator is insulated from the usual obligations of naked intimacy and can thus watch the spectacle in pleasure or in discomfort with a distance of the voluntary. Representation intercedes between nakedness and the spectator to enable the spectator to dwell on, savor, and en-joy—without erotic obligation.

Nudity Veils

Kenneth Clark has argued for a certain Platonic elevation of art over pornogra-phy: art represents the nude, the female nude in particular, as an object not for the senses but for the mind or reason.[13] It is elevated, "sublimated" from its bodily ori-gins and set up for noble purposes. This nobility is secured through a kind of dis-tancing that removes the depicted objects from their more sensory and base implications and possibilities and instead presents the naked body for intellectual and aesthetic contemplation. In other words, at a certain level, Clark is, in spite of himself, recognizing the power of the image to veil nakedness, to produce nakedness as nudity. The naked body has a force that can give rise to bodily im-pulses in a spectator. Art protects the spectator from the more mundane and ve-nal of these impulses: art is a veil of modesty here—not for the model or object but for the spectator.

Instead of seeing how to veil this nakedness most aesthetically, to refine it into a moderate, consumable nudity, most provocative art since the time of Gus-tave Courbet has not striven to present the most beautiful and aesthetically ap-pealing images. Quite the contrary, modern art has sought to problematize beauty, the assumed norms of the aesthetically appealing, and instead to bring back some-

thing of the visceral force of bodies through their representation, whether through the direct representation of bodily momentum in the work of Jackson Pollock, or through the intensified viscerality of depiction in the works of Francis Bacon. Art has become exploratory of how to view bodies differently—how to see them from angles and perspectives unthought of, to bring out latencies within them are may not be obvious in everyday life, and to make them speak with a directness that has been blunted through what is now the most stylized and ritualistic forms of sexual depiction, pornography. It is not that art and pornography differ in what they depict, or even necessarily how they depict nakedness; rather, pornography can only function as such in so far as it is ritualized, fundamentally repetitive, a series of infinite variations of a very small number of themes. Pornography refuses innovation in a way that (ideally, at least) art does not. Pornography relies on its formula, its theme, its script, to induce its desired effects through a more or less guaranteed pathway. Its eros resides in its insistence on infinite repetition. This makes it no "better" or "worse" than art, simply much less resourceful.

What pornography and art do share in common is this: whatever their quality, originality, framing and context, whatever their audience and cost, they consist of representational practices that both render what is historically private, that is, a relation between a very limited and select number of individuals, into a publicly and anonymously accessible form, and that veil naked bodies through a representational structure that makes their image, their diegetical content, as desirable or appealing as their materiality. Both pornography and art produce nudity as a form out of nakedness as a content. Theirs is not a project of dematerialization (from the real to representation) but a process of rematerialization—the transformation from one mode of materiality (flesh) to another (paint, canvas, photographic paper, choreographed movements). Both materialize bodies whose materiality is contained by, bordered by, and riven with and as representation. And in doing so, both license an audience to develop particular relations of seeing that are commonly not available in everyday life, at least not at will: one is authorized to look—not to gaze, but to look—in any way one chooses. One need not be captivated, but could also be bored, indifferent, disgusted. One is not implicated in the other's vulnerability, not simply because, as traditional feminist theories of the gaze suggest, the other cannot look back, but because one, as spectator, has free reign with the kind of look one can utilize. In intimate bodily

relations, one is already committed in some sense to a relation of positivity, a relation of non-indifference, non-disgust, a relation of desire. One is, in Levinasian terms, "called," called upon by the open giving up of a certain vulnerability that the other offers to us as naked. It is this that we are protected against, this vulnerability in observing the work of art. We are not called to protect or to bare ourselves to this other that we observe. Our observation is given free range. We are liberated from the impulse toward reciprocity.

If Clark is naïve about the distinctions between pornography or salacious representation and pure or high art (what shocks the sensibilities of one period becomes the high art of another; one century's pornography becomes the classical tradition of another's), he also seems to misunderstand the nature of perception itself and the role of looking. Looking is, of course, no more refined, no more cerebral, no more intellectual than any of the senses. And, more subtly, this kind of argument—that draws a clear-cut dividing line between pornography and art—reduces the kinds of looking to only two—an ennobled looking that illuminates the soul and a salacious, perverse looking that feeds only the body, and particularly the other organs.

Psychoanalytic discourse, too, reduces the various modalities of looking to only two—the look of the voyeur (reduced, in feminist discourse, to "the gaze") and the desire to be looked at of the exhibitionist. These are the active and passive variants of scopophilia. What is needed instead is a typology of looking, a mode of thinking of spectatorship that, instead of relying on the vast apparatus of projection, identification, fetishism, and unconscious processes—what psychoanalysis has offered to film theory and what theorists of the visual arts have borrowed as their primary model of spectatorship. Voyeurism is not the only modality of looking. Seeing has many particular forms that are well beyond the purview of the gaze, which is, in psychoanalytic terms, necessarily aligned with sadism—the desire for mastery and the masculine privileging of the phallus. Feminists have long recognized the gaze as an expression of male domination of psychical structuring in patriarchal cultures but more recently have also recognized that the apparatus that is generated through the structuring of the gaze leaves the female subject, or for that matter, the male subject, with no position other than a masterful phallic one. Instead of pushing this description further, regarding it as a fundamental political truth of the ways that patriarchy has structured seeing and has

limited the kinds of seeing that are available to women, I would suggest instead that seeing needs to be retrieved by feminists and that vision needs to be freed from the constrictions that have been imposed on it by the apparatus of the gaze.

In addition to the gaze, for example, there is the seductive fleeting glance, the glance that overviews without detailing; there is laborious observation, a slow, penetration inspection that seeks details without establishing a global whole, there is a sweeping survey, there is the wink and the blink, speeded up perceptions that foreclose part of the visual field to focus on elements within it, the squint which reduces the vertical to the horizontal, and many other modalities. Men, but also women look in many different ways, and it is this plurality of these possible visions—depending on one's interests, investments, commitments, and beliefs—that dictates how objects are seen and even which ones are seen.

We must see that bodies are not simply the loci of power but also of resistance, and particularly, resistance because of their excess. Bodies exceed whatever limits politics, representation, management, and desire may dictate: the bodies of women, even the depicted bodies of women, are no more passive, no more exhibitionistic, no more the objects of consumption, than male bodies, animal bodies or natural bodies. And the ways in which women, as well as men, look, the ways in which they engage with images and representations of bodies is not singular or monolithic either. One can inspect, survey, peer, glance, peek, scour, one can focus on or look through.[14] Art itself has in fact always elicited looks other than the gaze. This of course is not unknown by artists, whose work is commonly an attempt to engage with, and perhaps produce, other ways of looking that may move beyond the mundane and the habitual, and hopefully beyond the apparatus of the gaze. (This indeed is one of the founding assumptions of installation art, of conceptual art and most art of the twentieth century, the art of surprise, the art of re-looking, the art of the double-take.)

Looking Good

Given the limits of conventional art historical analysis and of feminist versions of psychoanalytic theory, which limit the look, reduce the body to the nude, and presume a fixed set of signification, it is important not just to celebrate the body as the universal object and medium of both culture in general and art in particular—

as has been the fashion over the last few years—but also to use its rich and un-contained complexity to problematise and rethink this conceptual edifice that surrounds art production (an edifice or frame, of course, as Derrida recognized, always suffuses the interior, parergonally).[15] To use conceptions and theories about the body to rethink the role of the body both in its representation and its reception.

Although the nude is of course not the only domain in which such a recon-ceptualizing or re-presentation of the body is possible, it is a place where these issues can be tackled most directly, for the human body—in its relation to other human bodies, animal bodies, props, and scenery—is its primary focus. As the vestigial structures of muscles, sense organs, hair, and tissue suggest an ever-more redundant human body and as enjoyment, pleasure, gratification, and display continue to focus on the body, art, especially erotic art, art that deals with bod-ies—whether with their depiction or their refiguration—has become an intense locus for the body's transformation. On the cusp of redundancy through the in-herent human capacities for excess production over and above survival or need, no longer bound only to survive (because of that excess production), we need to make the trajectory of the body's redundancy reach into the very condition of art itself. To make oneself into a work of art is in a sense the only response to an im-manent and ridiculous redundancy of the specific forms of the body; and to make oneself into a work of art (as Nietzsche and, following him, Michel Foucault sug-gest) is not simply to aestheticize life, to dandify it, or to make oneself into an ob-ject or spectacle for the artistic investigations of others. It requires living one's life and one's body in excess of what is required—in excess of discipline and even in excess of aesthetics.[16]

To live one's life as a work of art is, among other things, to once again re-turn to one's body as the site and source, the origin of pleasure and productivity and to utilize it differently, to move and act in ways other than those that have ha-bitually confined us. Acting differently also leads to being acted on differently—to sense differently, developing each sense beyond its usual biological reach and inquiring into the limits and transformability of biology itself. Developing alter-natives—synesthetically cross-mapping the senses onto each other, sensing differ-ently, using the senses in terms of the range and scope of the other senses, exploring how each sense functions or is capable of functioning quite differently from its as-sumed and normalized role. To develop these alternatives is inherently invested in

artistic activity. It is to render the body differently in representation, for representation is, as I have argued, almost a second skin, a diaphanous sheathing for bodies that transforms what the body is and does. It is looking good in both senses—looking at something well (outside the domain or order of the gaze) and being looked at, as well.

Notes

1. Alphonso Lingis, *Foreign Bodies* (New York: Routledge, 1994), 171.

2. Friedrich Nietzsche, *The Genealogy of Morals and Ecce Homo,* trans. Walter Kauffman and R.J. Hollingdale (New York: Vintage Books, 1969).

3. André Leroi-Gourhan, *Le geste et la parole. Technique et langage* (Paris: A. Michel, 1964).

4. Sigmund Freud, *The Standard Edition of the Complete Psychological Works of Sigmund Freud,* Vol. 21, *Civilization and Its Discontents,* trans. James Strachey (London: Hogarth Press, 1953-1974).

5. Erwin Schroedinger, *What Is Life?* (Cambridge: Cambridge University Press, 1994), 74.

6. Lingis, *Foreign Bodies,* 38.

7. "In some species of birds, females mate preferentially with long-tailed males. The shimmering iridescence and extension of the peacock's feathers exemplify traits that may have been selected not because they offer any survival advantage to the peacock, but because they please, sexually excite or otherwise charm the peahen." Lynn Margulis and Dorion Sagan, *Mystery Dance: On the Evolution of Human Sexuality* (New York: Summit Books, 1991), 100.

8. This naked vulnerability is an extension of the vulnerability of the face-to-face relation that Emmanuel Levinas poses as the foundation of all ethics. The other faces me, and his face, which is not a *sign* of vulnerability, is living, breathing vulnerability, a call to and on the subject. See Emmanuel Levinas, *Otherwise Than Being or beyond Essence* (The Hague: Martinus Nijhoff, 1981), 45-50, 85-94.

9. See, for a representative example, Helmut Newton, *Self-Portrait with Wife June and Models,* 1981, photograph.

10. Lingis, *Foreign Bodies,* 34.

11. Jacques Lacan, "The Mirror Stage as Formative of the Function of the I," trans. Alan Sheridan, *Écrits. A Selection* (London: Tavistock, 1977), 1-7.

12. Lynn Margulis and Dorion Sagan illustrate the strange proclivities of the squirrel monkey, which has an almost compulsive reflex of self-exhibition: "These

monkeys show off their erections not only to indicate sexual desire, but to greet and to threaten. In one species of squirrel monkeys, males invariably raise their erection to their own reflection when seen in a mirror. Apparently in doing this, squirrel monkeys are trying to frighten away what they see as rivals." Margulis and Sagan, *Mystery Dance,* 133.

13. Kenneth Clark, *The Nude: A Study of Ideal Art* (London: John Murray, 1956).

14. See for example, Edward Casey, "The Time of the Glance," in Elizabeth Grosz, ed., *Becomings: Time, Memory, Futures* (Ithaca: Cornell University Press, 1999).

15. Jacques Derrida, *The Truth in Painting,* trans. Geoffrey Bennington and Ian McLeod (Chicago: University of Chicago Press, 1987).

16. Michel Foucault, *The History of Sexuality,* Vol. 1, *An Introduction,* trans. Robert Hurley (London: Allen Lane, 1978).

VISUAL TECHNOLOGIES AS COGNITIVE PROSTHESES: A SHORT HISTORY OF THE EXTERNALIZATION OF THE MIND

Lev Manovich

1

Entering modern culture after the end of World War I when large numbers of amputees were outfitted with artificial arms and/or legs, *prosthesis* came to stand for an outside extension of the body. Prosthesis adds to the body what has been taken away or extends the body's natural organs (teleoperators).

More recently, a new kind of prosthesis has become possible—a device or machine that is enhancing or curing the body by invading it from the inside. A whole set of possible additions—from a plastic surgery implant to an artificial heart—are slowly becoming commonplace. And if early twentieth-century prostheses extended the body in visible and dramatic fashion ("thus making prosthesis into a topic of interest for painters, filmmakers and eventually cultural critics"), the new prostheses are increasingly small and invisible. For instance, in 2001, Tejal Desai, an assistant professor of bioengineering at the University of Illinois at Chicago, cured rats with diabetes using the insulin-secreting devices that are only 7 nanometers across.[1] Other biological microelectromechanical systems (bioMEMS) have been used in diagnostics and genetic sequencing.

In this essay, I sketch a history of yet different kinds of modern prostheses that are neither external mechanic (or electromechanical) extensions of the body nor intrusive devices, systems, or parts. In this history of *representation as prosthesis,* I discuss new kinds of representations that are enabled by modern visual technologies that were (or are) thought to help our cognition. Here no physical contact

between a body and prosthesis is necessary, since prosthesis is a separate entity that we are working with by looking at and interacting with.

This *cognitive prosthesis* belongs as much to the history of media as to the history of the body. I am thinking here of Marshall McLuhan, who in his founding and still most far-reaching 1964 study of media—*Understanding Media: The Extensions of Man*—conceptualized all key modern communication and transportation technologies, from roads and money to telephone and television, as prosthetic devices that extend the body.[2] I am also thinking of the influential 1960 article by J. C. R. Licklider—"Man-Computer Symbiosis"—which proposed that an interactive digital computer can act as a kind of metaprosthesis that augments our memory, perception, decision making, and other cognitive operations.[3] As we know, Licklider's notion of a computer as prosthesis for the mind (rather than the body), which was fully appropriate for the coming information society, was indeed realized in the subsequent decades. Today, practically all cognitive work—from architecture and finance to scientific research and design—involves the use of these new metaprostheses. The history sketched in this chapter involves new cognitive prostheses that are computer-based (visualization and virtual worlds), but it begins much earlier—in the nineteenth century.

2

In 1877, Sir Francis Galton—a statistician, a cousin of Charles Darwin, a founder of eugenics (a project of social betterment through planned breeding), and the author of highly influential psychological texts—pioneered a procedure for making composite photographs that proliferated widely in the final decades of the nineteenth century.[4] Fabricated by a process of successive registration and exposure of portraits onto a single plate, Galton's composites were thought to constitute true statistic averages that represented human types—a criminal, a prostitute, an Englishman, a Jew, and others. Galton wrote about his composite pictures that they are "much more than averages; they are rather the equivalents of those large statistical tables whose totals, divided by the number of classes and entered on the bottom line, are the averages. They are real generalizations, because they include the whole of the material under consideration."[5]

Galton not only claimed that "the ideal faces obtained by the method of composite portraiture appear to have a great deal in common with . . . so-called abstract ideas" but in fact he proposed to rename abstract ideas "cumulative ideas." In contrast to the human mind ("a most imperfect apparatus for the elaboration of general ideas") Galton championed his composite photographs, which, being mechanical and precise were much more reliable for arriving at abstract representations.[6]

With his photographs, Galton not only proposed that universals may be represented through generic images; he actually objectified and materialized them. Plato's *ideas* were given concrete form: they could now be touched, copied, fabricated, multiplied, and distributed.

Galton's belief that his composite photographs gave material tangible form to abstract ideas is just one example of a more general modern phenomenon. This phenomenon can be called *externalization* of the mind. It manifests itself in two ways. On the one hand, we witness recurrent claims by the users of new visual technologies (from Galton to Jaron Lanier) that these technologies externalize and objectify the mind. On the other hand, modern psychological theories of the mind (from Freud to cognitive psychology) also equate mental processes with external, technologically generated visual forms.

What can we make of this desire to externalize the mind? Although eventually this externalization is justified by the idea of cognitive prosthesis, I think that at first it is driven by a different agenda. We can relate it to the demand of modern mass society for standardization. The subjects have to be standardized, and the means by which they are standardized need to be standardized as well—hence the objectification of internal, private mental processes and their equation with external visual forms that can be easily manipulated, mass produced, and standardized on their own. The private and the individual are translated into the public and become regulated.

What before was a mental process, a uniquely individual state, now becomes part of a public sphere. Unobservable and interior processes and representations are taken out of individual heads and put outside—as drawings, photographs, and other visual forms. Now they can be discussed in public, employed in teaching and propaganda, standardized, and mass distributed. What was private becomes

public. What is unique becomes mass produced. What was hidden in an individual's mind becomes shared.

3

Francis Galton saw photography as a machine for the externalization of ideas. Even stronger claims were made about the next visual technology—film.

Indeed, the revolutionary new medium, the medium of mass society par excellence—film—was immediately proclaimed to be the machine for the externalization of private mental functions and states. In 1916, Hugo Münsterberg, a professor of psychology at Harvard University and one of the founders of the fields of industrial and applied psychology, published *The Photoplay: A Psychological Study*, which today is canonized as one of the earliest theoretical treatments of cinema.[7] According to Münsterberg, the essence of the new medium lies in its ability to reproduce or "objectify" various mental functions on the screen: "The photoplay obeys the laws of the mind rather than those of the outer world."[8] In contrast to the theater, where the action is constrained by the limitations of physical reality, film is free to shape arbitrarily its material, closely approximating flashes of memory, the flights of imagination, and other mental acts. In the theater, for instance, events have to follow each other corresponding to the progression of time; in film, the action can suddenly jump back and forth, just as in an act of imagination.

In addition to pointing out the analogy between film and mental life, in an astounding analysis Münsterberg correlates the main cinematic techniques to different mental functions, such as attention and memory, one to one. For example, in the close-up, "everything which our mind wants to disregard has been suddenly banished from our sight and has disappeared," analogous to how our attention selects a particular object from the environment. Similarly, the "cut-back" technique objectifies the mental function of memory.

"In both cases," Münsterberg writes, "the act which in the ordinary theater would go on in our mind alone is here in the photography projected into the pictures themselves."[9] The psychological laboratory became indistinguishable from the movie house, and the textbook of experimental psychology indistinguishable from the cinematographer's manual. The mind was projected on the screen; the inside became the outside.

Münsterberg admired the power of film to externalize the functions of consciousness. The next logical step was taken by a German psychologist, Kurt Levin, who in 1924 and 1925 was the first to use film in his experiments. He wrote that "fiction film attempts to objectify certain psychological processes for the viewer. Psychological (scientific) film studies to what extent these psychological processes can be objectified."[10] Soviet psychologist A. P. Luria, who planned to establish a psychological laboratory in Moscow in cooperation with the State Film Academy, acquainted Levin with Sergei Eisenstein, who attended the shooting of one of Levin's films and advised him.[11]

The figure of Eisenstein is particularly important because it reveals the historical connection between the desire to externalize the mind and the rise of mass communication, of which film was a major vehicle. The emergence of new mass societies in the early part of the twentieth century dictated the need to communicate ideological concepts to mass populations who were often illiterate.[12] In the 1920s, Eisenstein boldly conceived a screen adaptation of Karl Marx's *Capital* as a way to efficiently bring about the political enlightenment of Russian audiences, especially peasants who would not sit through a political lecture but, attracted by the "novelty" of a movie projector, would come to see movies, regardless of what was shown.[13] Unprecedented as his project was, its radicalism lay in both the decision to visualize the abstract notions and logic of *Capital* and the method employed, which according to Eisenstein would directly provoke dialectical thinking in audiences.[14] Jacques Aumont concludes that for Eisenstein, "the object privileged in Marx's work is not a theoretical one, like any of the key concepts from *Capital*. It is at another level entirely that Eisenstein selects his true object—the Marxist method itself."[15] Thus it was not simply a matter of the modern redeployment of the directions of the 1492 sermon: "Images of the Virgin and the Saints were introduced . . . on account of the ignorance of simple people, so that those who are not able to read the scriptures can yet learn by seeing the sacraments of our salvation and faith in pictures."[16] The viewers of *Capital* were to learn not only the scriptures of the new atheistic religion but also the process of reasoning.

It is significant that the most categorical statement by Eisenstein on the possibility of "filmic reasoning" (reasoning through images) appears in the context of his discussion of the sequence known as "For God and Country" from *October* (1929):

Maintaining the denotation of "God," the images increasingly disagree with our concept of God, inevitably leading to individual conclusions about the nature of all deities . . . a chain of images attempted to achieve a purely intellectual resolution, resulting from a conflict between a preconception and a gradual discrediting of its purposeful steps.

Step by step . . . power is accumulated behind a process that can be formally identified with that of a logical deduction. . . . The conventional descriptive form for film leads to the formal possibility of a kind of filmic reasoning. While conventional film directs emotions, this suggests an opportunity to encourage and direct the whole thought process as well.[17]

Far from simply representing God or deities, as they did for centuries, here images serve a totally new function, which is to provoke and direct reasoning of a particular kind—"Marxist dialectics." In accordance with its principles and as canonized by the official Soviet philosophy, Eisenstein wants to present the viewer with the visual equivalents of thesis and antithesis so that the viewer can then proceed to arrive at synthesis—the correct conclusion as preprogrammed by Eisenstein.

"The content of CAPITAL (its aim) is now formulated: to teach the worker to think dialectically," Eisenstein writes enthusiastically in April 1928.[18] Schooled by the film, viewers would become self-sufficient thinkers and learn the skill of "Communist decoding of the world." Each would be a walking camera, snapping pictures of visual thesis and antithesis, and the brain would automatically execute cognitive operations of montage, thinking through images efficiently and effectively.

Eisenstein claims the radical novelty of his concept of "filmic reasoning":

The proclamation that I'm going to make a movie of Marx's Das Kapital *is not a publicity stunt. I believe that the films of the future will be found going in this direction (or else they'll be filming things like* The Idea of Christianity *from the bourgeois point of view!). In any case, they will have to do with philosophy. . . . the field is absolutely untouched. Tabula rasa.*[19]

Yet Einstein's theory was not an isolated development. Many in the artistic left of the 1920s shared a similar belief in the cognitive power of new visual forms such as montage. In the late 1920s, Alexander Rodchenko promoted the use of montage sequences in graphic design, and like Eisenstein he saw montage as being equivalent to "dialectical" reasoning. In this formulation, an individual image

corresponds to a single concept, and thinking is provoked when a number of images are juxtaposed in a series.[20]

Galton, Münsterberg, Eisenstein. Composite photographs, cinematic devices of close-up, cut-back, and montage. These developments are symptoms of a single social imaginary at work—to make the mind more controllable by externalizing it and rendering it visible.

What before was a mental process, a uniquely individual state, now becomes part of a public sphere. Unobservable and interior processes and representations are taken out of individual heads and put outside—as photographs, films, and other visual forms. Now they can be discussed in public, employed in teaching and propaganda, standardized, and mass distributed. What was private becomes public. What was unique becomes mass produced. What was hidden in an individual's mind becomes shared.

4

The recurrent claims that new visual technologies externalize and objectify reasoning and that they can be used to control or augment reasoning (that is, acting as prostheses) are based on the assumption of the isomorphism of mental representations and operations with external visual effects—such as dissolves, composite images, and edited sequences. This assumption (which I so far have not questioned) on closer examination appears to be highly problematic. Whatever mental representations and operations really are, the mind surely does not contain pictures, photographs, or film clips that some mental homunculus looks at. The external images that are presented to the mind are not magically transplanted inside it as ready-made ideas and arguments. Regardless of what visual forms can be presented before the eye (diagrams, photographs, film images), they are subjected to complicated processing by the nervous system, which constructs its own internal representations.

Yet the assumption of such an isomorphism continues to persist in modern thinking about vision, ignited by every new round of visualization technology—photography, film, computer animation, and virtual-reality worlds. Consider the claims that surround the new field of scientific visualization—visualization of data sets, their relationships, and their dynamic behavior using computer graphics. Richard Mark Friedhoff and William Benson proclaim that computer visualization

techniques constitute the second computer revolution because they act as the direct "extension of preconscious visual processes."[21] They assume that the images on a computer screen do not simply function as an aid for reasoning but that they are equivalent to the mental representations that the mind may construct while thinking—and this is the source of their power.

Or consider another recently developed visual technology that even more so than scientific visualization is seen as capable of completely objectifying, better yet, transparently merging with mental processes—virtual-reality (VR) worlds. Again, the descriptions of its capabilities often do not distinguish between internal mental functions, events and processes, and externally presented images. According to one of the 1980s VR pioneers, Jaron Lanier, this is how VR can take over human memory: "You can play back your memory through time and classify your memories in various ways. You'd be able to run back through the experiential places you've been in order to be able to find people, tools."[22] Lanier also claims that VR will lead to the age of "post-symbolic communication" without language or any other symbols. Indeed, why should there be any need for linguistic symbols if everybody is not locked into a "prison-house of language" (Jameson) but lives happily in the ultimate nightmare of democracy—the single mental space that is shared by everybody and that results in communicative acts that always are ideal (Habermas). This is Lanier's example of how postsymbolic communication will function: "you can make a cup that someone else can pick when there wasn't a cup before, without having to use a picture of the word *cup*."[23] Here, as with the earlier technology of film, the fantasy of objectifying and augmenting consciousness, extending the powers of reason, goes hand in hand with the desire to see in technology a return to the primitive happy age of prelanguage, premisunderstanding. Locked in virtual-reality caves with language taken away, we will communicate through gestures, body movements, and grimaces, like our primitive ancestors.[24]

What can be made of this apparently unsound yet irresistible assumption of isomorphism—between the mental process of reasoning and external, technologically generated visual forms—that has haunted us at least since the end of the nineteenth century? The conflation of outside and inside is, of course, symptomatic of the desire to project the inside onto the outside—to make it objective and public. But is this all? To really understand the persistence of this assumption, we turn to the history of ideas about the nature of mental processes.

It is well known that technologies have historically provided and continue to provide the models according to which people imagine the mind. In the seventeenth century, it was the clock; in the nineteenth, the motor; in the second half of the twentieth, digital computers. More precisely, paradigms were provided not by the technologies themselves but by theories that made them possible. To take the third paradigm as an example, cognitive psychology (born in the 1950s and gaining prominence ever since) approaches the mind as an information-processing system, as software that runs on the hardware of the brain. But what gave cognitive psychology its epistemological basis was not the new technology itself (computers) but the information theory that accompanied it. This paradigm substituted the discussions of mind and brain with the notion of "human information processing." And before information theory, theories of the mind were influenced by thermodynamics (as in Freud) and mechanics (Hobbes).[25]

It can be also claimed, however, that human imagination about the mind's operations is limited by the current *visual technologies.* Consider current views about the nature of mental processes. The linguist George Lakoff asserted that "natural reasoning makes use of at least some unconscious and automatic image-based processes such as superimposing images, scanning them, focusing on part of them"[26] while the psychologist Philip Johnson-Laird proposed that logical reasoning is a matter of scanning visual models.[27] Such notions would have been impossible before the emergence of television and computer graphics. These visual technologies made operations on images such as scanning, focusing, and superimposition seem natural. Even more telling are the models of cognitive psychologists who, in the last two decades, have systematically scrutinized the role that is played by mental images in reasoning. These models—which define mental images in terms of such characteristics as spatial resolution, speed of access, and basic graphic operations (rotation, translation, copy)—seem to be describing first of all computer imaging systems. Psychologists argue among themselves which imaging systems better resemble mental processes, but they do not doubt the basic metaphor. As Paul Virilio notes, "Now the virtual images of the computer screen seem to confirm not only the existence of certain forms of representation but, more immediately, the objective presence of mental images."[28]

Similarly, in the earlier period, when Freud (in *The Interpretation of Dreams*) described the mechanisms by which dream-thoughts and the logical relations between them are represented in dreams, he and his fellow psychologists relied on

available visual technology for their understanding of the mind. Not surprisingly, Galton's composites—the earliest form of image processing before digital computers—provided a particularly attractive model. Freud compared the process of condensation with one of Francis Galton's procedures that became especially famous—making family portraits by overlaying a different negative image for each member of the family and then making a single print.[29] Writing in the same decade, the American psychologist Edward Bradford Titchener opened the discussion of the nature of abstract ideas in his textbook of psychology by noting that "the suggestion has been made that an abstract idea is a sort of composite photograph, a mental picture which results from the superimposition of many particular perceptions or ideas, and which therefore shows the common elements distinct and the individual elements blurred."[30] He then proceeds to consider the pros and cons of this view. We should not wonder why Titchener, Freud, and other psychologists take the comparison for granted rather than presenting it as a simple metaphor. Contemporary cognitive psychologists also do not question why their models of the mind are so similar to the computer workstations on which they are constructed.

5

As psychologists begin to furiously take on the questions that philosophers only wondered about, subjecting mental processes to controlled, scientific, laboratory study, their models begin to reflect, more and more, the external visual forms that are made possible by whatever visual technology dominates the period. Given the reliance of psychological theories of the mind on contemporary visual technologies, has there been any "progress" made between the turn of the century and today (other than dependence of the imagination of contemporary psychologists on the more sophisticated visual technologies of computer graphics? In fact, during this century, the assumption of an isomorphism between the mental and the objective became even more prominent), and externalization of reasoning has been taken much further, both technologically and theoretically.

On the one hand, the refinement of various medical imaging techniques in the 1980s made possible an increasingly precise imaging of brain activity, including the visualization of reasoning—in a literal sense. It is now possible to ask

the experimental subject to concentrate on solving a problem and to see which parts of the cerebral cortex are active. The question of whether reasoning in fact depends on the operations that are normally involved in perception becomes more and more a question that (according to a number of researchers) can be answered through experimentation. It is enough to show that the part of a cortex that normally is dedicated to the processing of visual information is activated in the process of reasoning.[31]

More important, in their theories, many cognitive psychologists have accepted as given the equivalence between internal mental processes and operations that can be done with external, objectively existing visual representations and objects. Consider the debates about the nature and role of mental imagery, which have constituted one of the most active areas of research in cognitive psychology over the last two decades.[32] Some researchers (such as Zenon Pylyshyn) argue that mental imagery consists simply of the use of general thought processes to simulate physical perceptual events. According to this view, if subjects report the presence of mental imagery during reasoning and problem solving, this imagery is simply a side effect—a by-product of real mental computations that do not involve visual representations.

Other psychologists and neurophysiologists (such as Alan Pavio, Roger Shepard, Stephen Kosslyn, and Martha Farah) use experiments and direct imaging of brain activity to try to prove that reasoning takes place through the construction and manipulation of mental images. One of the best-known experiments in defense of this view was done by Roger Shepard and Jacqueline Metzler of Harvard Univeristy.[33] They presented experiment participants with pairs of perspective line drawings of three-dimensional forms that were constructed from small cubes. The participants' task was to determine whether the forms were identical in shape, despite differences in orientation that were shown in the drawings. Shepard and Metzler found that reaction time for responses was proportional to the degree of rotation that was required to imagine the two drawings showing a similar position. These results were taken as proof that participants mentally rotated representations of three-dimensional objects to solve the problem and that imagined rotations corresponded to actual physical rotations of objects: "Imagined rotations and physical transformations exhibit corresponding dynamic characteristics and are governed by the same laws of motion."[34] Thus, a mental process

was equated with an operation that would be performed with real, objectively existing objects.

Other experiments in defense of the position that many kinds of reasoning involve manipulation of mental imagery entail the comparison of abstract qualities. When participants were asked to recall two animals and to judge which one was larger, their reaction time decreased proportionally to the difference in the estimated size of the animals. In another experiment, one group of participants was asked to rate animals in intelligence on a scale from one to ten, and another group had to compare the intelligence of pairs of animals. Again, reaction time decreased as the distance in rated intelligence increased. It was concluded that when participants tried to discriminate between two objects, their reaction time was shorter when the difference between two objects was greater—*regardless* of whether the objects were really presented (for instance, two lines of different length) or were imagined (size of animals) or whether the qualities to be compared were abstract (intelligence of animals).[35]

Psychologists are continuing the debate about whether these and numerous related experiments indeed prove that internal mental processes involve the manipulation of pictures that are similar in their qualities to real images. But for my purposes, it is significant that in imagining what mental processes are like, contemporary psychologists have assumed, without any reservations, an equivalence between the internal and the external, between the mental objects and the real ones.

Modernization, visualization, externalization. To externalize the internal, the invisible, it was first equated with the visual. Once this was accomplished, it was simple and only logical to equate the visual inside with the visual outside—the objectivity and standardization of images that are drawn on a classroom blackboard, on the screen of a movie theater, or, most recently, on the computer terminal.

6

I have traced different ways in which the mind was externalized in the last century and a half. Abstract ideas and the process of condensation were equated with composite photographs (Francis Galton and Sigmund Freud, respectively); mental functions such as attention and memory were equated with cinematic devices

of close-up and cut-back (Hugo Münsterberg); the process of thinking was equated with montage (Sergei Eisenstein). More recently, Jaron Lanier, Richard Mark Friedhoff, and William Benson similarly have linked mental processes with virtual-reality and scientific visualization techniques. And finally, cognitive scientists have described mental processes and functions in terms of operations that are possible only with computer-imaging systems.

The overall trajectory that I have followed is from the inside to the outside, from private and inaccessible mental states to public, external, technologically generated visual forms or the latest imaging technologies themselves. To a large extent, this very desire to objectify the psyche gave birth to modern imaging technologies such as photography, cinema, and virtual worlds. Indeed, is not the whole idea of photography to objectify private memories and private mental images?

This trajectory continues. In fact, the advances in electronics, computers, and neuroscience now allow us to externalize mental process *in real time*. Examples include medical imaging of brain activity and controlling computers by *thinking* commands. The 1993 special issue of a computer journal begins with the following report:

NTT *researchers in Japan have created methods to use brainwaves to determine which direction a person will move a joystick; University of Illinois psychologists developed a system that types when words are spelled out mentally; and the New York State Health Department devised a system that lets users take a cursor up-and-down or side-to-side by visualizing the moves.*[36]

However, the same technological advances (as well as work in nanotechnology and neural networks) also make it possible to take the next step, mentioned in the beginning of this essay—to go from the outside to inside, to internalize external technologies by putting the machines back into the brain. We are now witnessing the birth of neurotechnology—complete computers that will be the size of neurons and that potentially one day can be implanted under the scull or into tiny neural network circuits that merge with real neural networks.

We can only guess about how far such research has already advanced in military labs. (Is it possible that much twenty-century science fiction was not about the future but simply an accurate description of contemporary military

research?) For now, futuristic movies provide us with the best examples of how such implants could function. Two such movies are Hollywood's *Terminator 2: Judgment Day* (1991) and *RoboCop* (1987). In both films, the main character's vision is enhanced by a sophisticated computer-imaging circuitry. The circuitry functions as combination of a video camera and a robotic vision system. It allows both heroes to zoom in on distant objects, to see in the dark, to record and play back what they see, to bring up stored images that can be compared with what they presently see, and so on.

Instead of augmenting the body by extending it outside, prosthesis now invades inside with nano precision. The body and the outside universe have exchanged places; the new adventure is not to discover new lands or planets but to see and map the inside of the body. The M2A camera that was approved by the U.S. Food and Drug Administration in 2001 is one inch long and is swallowed as a pill. It takes two color pictures per second; as it travels from mouth to anus in about eight hours, it collects over 55,000 images. As Beatriz Colomina writes, "The M2A transforms the body into an occupiable interior. The body is turned inside out, making the skin irrelevant. All that remains is the endless interior, bathed in the light from the capsule video camera."[37]

We used to dream of flying carpets and magic castles. Now we dream of tiny video recorders that will be implanted in our retinas and computer random access memory (RAM) inside our sculls to supplement our own short-term memory. In short, we dream of becoming neurocyborgs.

We used to flock to movie houses where our mental mechanisms were projected on a huge screen. Soon each of us will be able to put this screen inside her or his head.

Carriage return. End of file.

Notes

1. Kristen Philipkoski, "Tiny Capsules Float Downstream," *Wired News,* retrieved from <http://www.wired.com/news>, October 29, 2001.

2. Marshall McLuhan, *Understanding Media: The Extensions of Man* (New York: McGraw Hill, 1964).

3. J.C.R. Licklider, "Man-Computer Symbiosis," *IRE Transactions on Human Factors in Electronics* 1 (1960): 4–11.

4. Allan Sekula, "The Body and the Archive," *October* 39 (1987): 40.

5. Quoted in ibid., 47.

6. Quoted in ibid., 51.

7. Hugo Münsterberg, *The Photoplay: A Psychological Study* (New York: Appleton, 1916).

8. Ibid., 41.

9. Ibid., 41.

10. Quoted in Olga Bulgakova, "Sergei Eisenshtein i ego 'psikhologicheskiy Berlin'—mezhdu psikhoanalizom i strukturnoy psikhologiey" ("Sergei Eisenstein and his 'psychological Berlin': Between psychoanalysis and structural psychology"), *Kinovedcheskie Zapiski* 2 (1988): 187.

11. Ibid., 177.

12. For instance, according to the 1926 census, out of every 1,000 citizens of the Soviet Union, only 445 were literate. Peter Kenez, *The Birth of the Propaganda State: Soviet Methods of Mass Mobilization, 1917–1929* (Cambridge: Cambridge University Press, 1985), 157.

13. Ibid., 220.

14. The pioneering work of Annette Michelson helped bring my attention to Eisenstein's *Capital* project. Annette Michelson, "Reading Eisenstein Reading *Capital*," *October* 2 (1976): 27–38, *October* 3 (1977): 82–88.

15. Jacques Aumont, *Montage Eisenstein* (London: BFI Publishing and Indiana University Press, 1987), 163.

16. Quoted in Michael Baxandall, *Painting and Experience in Fifteenth-Century Italy* (Oxford: Oxford University Press, 1972), 41.

17. Sergei Eisenstein, "A Dialectical Approach to Film Form," in Jay Leyda, ed., *Film Form: Essays in Film Theory* (New York: Harcourt Brace and World, 1949), 62.

18. Sergei Eisenstein, "Notes for a Film of *Capital*," trans. Maciej Sliwowski, Jay Leuda, and Annette Michelson, *October* 2 (1976): 10.

19. Quoted in Michelson, "Reading Eisenstein," 28.

20. At first, Rodchenko practiced juxtaposition of many separate photographs and fragments within the space of a single image. At the end of the 1920s, his photomontages became multipage layouts that were composed of a number of more "traditional" photographs, more like a film montage sequence.

21. Richard Mark Friedhoff and William Benson, *The Second Computer Revolution: Visualization* (New York: Freeman, 1991), 13.

22. Timothy Druckrey, "Revenge of the Nerds: An Interview with Jaron Lanier," *Afterimage* (May 1991): 9.

23. Ibid., 6.

24. At the Association for Computing Machinery's ACM SIGGRAPH 1992—the Nineteenth Annual Conference of the Special Interest Group on Computer Graphics and Interactive Techniques—which was attended by nearly 30,000 people, about a dozen virtual-reality exhibits had long lines of visitors. However, the lines at two of these exhibits—Dome and Virtual Reality Cave—were especially long. In both cases, visitors had to go inside cavelike structures. One exhibit featured a scientific visualization display that was of interest only to specialists. Seeing the spectacle required visitors to go inside a dark, cavelike space that was different from normal space and that requirement attracted visitors, even at the end of the century (as it did at its beginning, when millions flocked into the dark caves of movie theaters).

25. This theory is well known and widely accepted, but other facts suggest that sometimes influence runs in the opposite direction: biological and psychological theories of body and mind provide paradigms for theories of mechanisms. For instance, it appears that Norbert Wiener's cybernetics was inspired by the concept of homeostasis developed in biology: "Physiologist Walter B. Cannon viewed the animal body as a self-regulating machine. Building on the work done by Claude Bernard in the nineteenth century, Cannon developed the concept of 'homeostasis'—the process by which the body maintains itself in a state of internal equilibrium. Cannon's ideas were well known to Norbert Wiener. In fact, Cannon's *Wisdom of the Body* (1932) may be read as sort of an introduction to Wiener's *Cybernetics* (1948)." Charles Eames and Ray Eames, *A Computer Perspective: Background to the Computer Age* (Cambridge: Harvard University Press, 1990), 99. Another example is provided by the turn of artificial intelligence (AI) in the 1980s from trying to simulate the disembodied mind to simulating a collective of primitive organisms that had the functionality of insects. Drawing directly on research in biology, the researchers in AI hope that intelligence will emerge as a product of the collective behavior of machines that are simulating simple biological organisms.

26. George Lakoff, "Cognitive Linguistics," *Versus* 44-45 (1986): 149.

27. Philip Johnson-Laird, *Mental Models: Towards a Cognitive Science of Language, Inference, and Consciousness* (Cambridge: Cambridge University Press, 1983).

28. Paul Virilio, *Lost Dimension* (New York: Semiotext(e), 1991), 114.

29. Sigmund Freud, *The Standard Edition of the Complete Psychological Works of Sigmund Freud*, Vol. 4, *The Interpretation of Dreams*, trans. James Strachey (London: Hogarth Press, 1953-1974), 293.

30. Edward Bradford Titchener, *A Beginner's Psychology* (New York: Macmillan, 1915), 114.

31. Martha Farah, "Is Visual Imagery Really Visual? Overlooked Evidence from Neuropsychology," *Psychological Review* 95, no. 3 (1988): 307-317.

32. For a summary of different positions, see Ronald A. Finke, *Principles of Mental Imagery* (Cambridge: MIT Press, 1989).

33. Roger Shepard and Jacqueline Metzler, "Mental Rotations of Three-Dimensional Objects," *Science* 171 (1971): 701–703.

34. Finke, *Principles of Mental Imagery,* 93.

35. John Robert Anderson, "Mental Imagery," in *Cognitive Psychology and Its Implications* (New York: Freeman, 1980).

36. *Communications of the ACM* 36, no. 5 (May 1993): 11.

37. Beatriz Colomina, "Skinless Architecture," in Bernard Tschumi and Irene Cheng, eds., *The State of Architecture at the Beginning of the Twenty-first Century* (New York: Monacelli Press, 2003), 69.

PROSTHETISTS AT 33⅓ Raiford Guins and
 Omayra Zaragoza Cruz

The turntable's needle in Dj culture acts as a mediator between self and fictions of the external world.
 —*Paul D. Miller, aka Dj Spooky That Subliminal Kid,* Rhythm Science[1]

In 1877, Thomas Alva Edison shouted "Mary Had a Little Lamb" into the mouth-piece of his experimental phonograph. "Edison understood," writes Friedrich A. Kittler that "mechanical sound recording had been invented."[2] In 1988, the Mary of Edison's tin-foil-etched rhyme and the Monkees' song "Mary, Mary" became a memorable scratch: "'Mary, Mary,' why ya buggin?" Like Edison, the late Jam Master Jay of Run-DMC fame understood too, if somewhat differently. In the in-terim between these two forms of understanding—the phonograph as a playback medium and the turntable as an instrument for the continuous reconstruction of sound—dwells Marshall McLuhan. Working within the hyperbolic logic of his well-known probe that "All media are extensions of some human faculty—psy-chic or physical,"[3] McLuhan pronounces the phonograph to be "an extension and amplification of the voice."[4] Where does this leave turntablism, a fundamentally multisensory technology that has been known to exhibit a certain irreverence for the integrity of the voice in favor of the scratch? In posing such a question, this chapter aspires not toward a conclusive answer but toward an exploration of the paradigm shift that is occasioned when the question is posed. In other words, how

should the prosthetic function of technologies that are configured in terms of urban youth culture as well as place and identity be characterized?

Extending from Whom?

Recent writings on electronic music, on the sound assemblages of hip-hop, techno, illbient, house, and electro that emanate from the hands of DJs and turntablists regularly resound with the sentiment that drives McLuhan's famous probe. Recent books like Kodwo Eshun's *More Brilliant Than the Sun: Adventures in Sonic Fiction* and Paul D. Miller's *Rhythm Science*[5] quote McLuhan directly, even though his characterization of the phonograph clearly falls short of turntablism's multisensorial range of action. The same McLuhan probe *also* structures numerous explorations of new technologies as prosthetic devices. N. Katherine Hayles, for example, adopts the term "prosthetic extension" in *How We Became Posthuman: Virtual Bodies in Cybernetics, Literature, and Informatics,* a leading study of technocultural embodiment.[6] Donna Haraway's *Simians, Cyborgs, and Women: The Reinvention of Nature*[7] and Mark Dery's *Escape Velocity: Cyberculture at the End of the Century*[8] question the social and political implications of media as extension of human faculties.

How can the same axiom underwrite discourses that by all indices should overlap significantly but rarely actually do? This question becomes even more perplexing when framed by McLuhan's invocation of "the Negro, the teenager, and some other groups" in *Understanding Media*. These figures are meant to reveal just how radically electronic media extend human faculties, minimizing the distance between an unnamed though absolutely obvious "we" and "they": "They can no longer be *contained,* in the political sense of limited association. They are now *involved* in our lives, as we in theirs, thanks to the electric media."[9] Although McLuhan assumes a universal subject, his isolation of "the Negro, the teenager, and some other groups" shows that the subject at the center of his meditations is not so universal after all.

The "Negro" resurfaces in McLuhan's collaboration with graphic designer Quentin Fiore, *The Medium Is the Massage*. As the horizon of possibility for what media realize, this "Negro" figures in two ways: as a preliterate orator who addresses the tribe of the global village and (in the post-Gutenberg present of the Civil Rights era) as a criminal who is *contained* by armed enforcers for deigning

to become (politically) *involved* in the global village. How to make an indifferent "we" sit up and take notice of the profound effects brought about by electronic technology? Bring the "Negro" closer.

Blackness, in short, is clearly present in McLuhan's work. Unfortunately, it is a reified blackness shot through with primitivism, marginalization, and essentialism. Black people are naively positioned as technophobes.[10] Take, for example, the infamous *Playboy* interview of 1969:

MCLUHAN: *The future, I fear, is not too bright for either [the Negro or the Indian]— but particularly for the Negro.*
PLAYBOY: *What, specifically, do you think will happen to him?*
MCLUHAN: *. . .At worst he will be exterminated.*
PLAYBOY: *Exterminated?*
MCLUHAN: *I seriously fear the possibility, though God knows I hope I'm proved wrong. . . .*
PLAYBOY: *What can we do to prevent this from happening to America's Negro Population?*
MCLUHAN: *I think a valuable first step will be to alert the Negro.*[11]

This declaration, which appears to suggest that African Americans were oblivious to the world around them, hardly reflects the onslaught of activity within black communities at the time of the interview. White terrorism did claim the lives of four girls at the Sixteenth Street Baptist Church in 1963, thirty black homes and churches were burned in Mississippi in the summer of 1964, Malcolm X was assassinated in 1965, and Martin Luther King, Jr. was assassinated in 1968. "What can we do to prevent this . . . ?" queried *Playboy*.

"They" did not require patronizing concern. "They" had already mounted complex and vigorous responses. Robert F. Williams published *Negroes with Guns* in 1962; the people of Watts rebelled in 1965; the Black Panther Party Platform and Program was drafted in 1966; and the first issue of *The Black Panther* newspaper appeared in 1967. In 1969, the year of McLuhan's pronouncement, Sam Greenlee's *The Spook Who Sat by the Door* and H. Rap Brown's *Die Nigger Die!* were published. Only a short time earlier, coincident with the 1964 appearance of McLuhan's *Understanding Media,* Williams divined a very different future: "This

year, 1964, is going to be a violent one, the storm will reach hurricane propor-
tions by 1965 and the eye of the hurricane will hover over America by 1966.
America is a house on fire—FREEDOM NOW!—or let it burn, let it burn. Praise
the Lord and the pass the ammunition!"[12] By this account, McLuhan would seem
to make a poor meteorologist. Forgive us for being wry, but despite a strong
affinity for McLuhan's work that both of us share, he was truly off the mark on
this one. The period that he references did witness a struggle for survival, but not
for the reasons that he alludes to in the remainder of the interview—white jeal-
ousy over black people's tribal connections and black people's incapacity to rec-
ognize how the inequalities to which "they" have been subjected are the result of
an underdeveloped appraisal of electronic media.

What then were the stakes at hand? According to Manning Marable in
Race, Reform, and Rebellion: The Second Reconstruction in Black America, 1945–1990,
there are "two brief moments in history" during which the United States "expe-
rienced major social movements . . . [that] expressed a powerful vision of multi-
cultural democracy and human equality."[13] These are the Reconstruction that
followed the Civil War and a Second Reconstruction during the post–World War
II era. The latter, running concurrent with McLuhan's work, encompasses both
the Civil Rights era as well as its aftermath.[14] Like the first Reconstruction, the
gains of which were systematically overturned and culminated in the "separate
but equal" racism of the U.S. Supreme Court's decision in *Plessy v. Ferguson* (1892),
the Second Reconstruction witnessed a range of devastating reactionary efforts.

For George Lipsitz, the new and renewed institutionalizations of racism
that color the postwar period are an effect of the profit reaped by the United
States' systematic allegiance to the normative function of whiteness—or in his
words, a "possessive investment in whiteness." Though this possessive investment
in whiteness is "the residue of conquest and colonialism, of slavery and segrega-
tion, of immigrant exclusion and 'Indian' extermination," they do not exhaust its
influence.[15] In the twentieth century, whiteness was used to undermine the life
chances of aggrieved racial minorities through a range of inequalities. Discrimi-
natory labor practices, housing policies, and economic programs were designed
to be indiscernibly racist, and ideological and physical attacks on individuals and
their communities converged to create debilitating environments for racial mi-
norities during the post–Civil Rights era. Clearly, the repercussions of this back-

lash affected the prospects of urban communities more directly than an alleged detachment from the latest technological developments.

There is an additional parallel to consider. The modern development of prosthetics has been traced with frequency to the challenges presented by casualties of war. The Civil War, for example, ushered in a new era for prosthetics because of the enormous scale of human damage that was inflicted by new technologies. Writing about World War I, Elspeth Brown suggests that approaches to prosthetics reflected the culture of work that characterized the United States in general: "The visible hand of managerial reform . . . made the 'hand,' itself synechdoche for the industrialized worker, increasingly invisible under scientific management, as the worker became abstracted as 'the labor process' in the late nineteenth and early twentieth centuries."[16] By World War II, David Serlin argues, the relationship between citizenship, masculinity, and the "normal" body becomes conflated: "Many disabled veterans who returned home after wartime service were amputees and, in many cases, prostheses wearers who worked hard to integrate these new artificial body parts into their civilian lives. One of the foremost concerns of the era was the effect trauma and disability would have on veterans' sense of self worth, especially in the competitive economy defined by able-bodied men."[17] In keeping with this line of thinking, one which explores the kinds of prosthetics designed to re-create life possibilities in the wake of massive conflict, what prosthetics ameliorated the equally violent human damage inflicted during the post–Vietnam, post–Civil Rights Era?[18]

Here the media as extension probe regains the potential to elucidate the mediation of minoritarian selves. This potential lies in the less cited though fascinating précis to McLuhan's probe: "Any understanding of social and cultural change is impossible without a knowledge of the way media work as environments. *All media are extensions.*"[19] Media—as technological prosthetics that extend human capacities (eye, skin, foot, hand, central nervous system, or consciousness)—work as environments. Does this suggest that specific experiences of embodiment demand alternative environments or extend themselves through different media?

Turntablism represents just such an instance of media as technological extension/prosthetic—a repetition with a difference that places recognition of racialization at the center rather than at the limit. Tricia Rose and Alexander G. Weheliye have already initiated this in relation to their own work on sound-reproduction technologies.[20] The turntable provides an opportunity to focus on

connections between technology, identity, and environment. Spearheading this effort is the belief that folding media as prosthetic into media as environment enables an expanded analysis of the material and conceptual membranes that configure the social and political meanings of extension in contemporary critical and cultural practice.

Environmental Prosthetic

The relevance of disability theory to a study of prosthetics is paradoxically predictable and surprising. It is predictable because remarks on technologies that are commonly conceived of as prosthetic—artificial limbs and organs ranging from wheelchairs and hearing aids to respirators and contact lenses—frequently cohere around present or potential conditions of disability. It is surprising because disability theory shows that the problem of disability rests less on particularities of disabled persons' bodies than on the tacit understanding of what constitutes a whole or normative body—a body that is privileged by design. For example, *Enforcing Normalcy: Disability, Deafness, and the Body* by Lennard J. Davis begins by addressing what he considers to be the sine qua non of disability—the normal body. "To understand the disabled body," writes Davis, "one must return to the concept of the norm, the normal body. So much of writing about disability has focused on the disabled person as the object of study, just as the study of race has focused on the person of color. But as with recent scholarship on race, which has turned its attention to whiteness, I would like to focus not so much on the construction of disability as on the construction of normalcy."[21] Davis reasons that the "problem" of disability is not about persons who have a disability. It is instead the normal, itself a delicate construct, that renders the disabled person a "problem."[22] Lipsitz references a powerful observation by Richard Wright to similar ends at the outset of *The Possessive Investment in Whiteness.* Lipsitz points out that when asked to comment on the "Negro problem" in America by a French reporter, Wright proclaimed: "There isn't any Negro problem; there is only a white problem."[23] In both cases, the problem is an effect not of the identities with which it is associated but with the crafting of a norm that presupposes their exclusion and pathologization.

If disability, like race, is the result of historical processes rather than a quality of specific bodies, then a question forms: what contributes to its creation? One answer is that environments design much of what is experienced or perceived as disability, and it is an answer for which Rosemarie Garland Thomson makes a compelling case.

> *Stairs . . . create a functional "impairment" for wheelchair uses that ramps do not. Printed information accommodates the sighted but "limits" blind persons. Deafness is not a disabling condition in a community that communicates by signing as well as speaking. People who cannot lift three hundred pounds are "able-bodied," whereas those who cannot lift fifty pounds are "disabled." Moreover, such culturally generated and perpetuated standards as "beauty," "independence," "fitness," "competence," and "normalcy" exclude and disable many human bodies while validating and affirming others.*[24]

Both Davis and Thomson connect their insights to those that are generated in studies of racialization and, in other contexts, gender and sexual identity. Although David T. Mitchell and Sharon L. Snyder note that concerns have been raised over these connections, failing to do so would elide the important and complex histories that have resulted in the archetypal normal person against which so many forms of embodiment are deemed deficient—if not functionally disabled in the environments they are pressed to inhabit.[25]

More is gained than is lost by adopting an inclusive, intersectional vision of identity in another sense. Debates between humanist and posthumanist elaborations of the cyborg in contemporary culture shape numerous conceptualizations of the prosthetic. As Mitchell and Snyder indicate in their introduction to *The Body and Physical Difference,* postmodern science and culture are examined by N. Katherine Hayles, Avital Ronell, and Donna Haraway, who "deploy disabled bodies as proof of our fascination with 'cyborg-like' prosthetic enhancement" although their work reflects no "serious effort to specify the nature of this usage within disabled communities."[26] Katherine Ott also expresses reservations about the cyborg's capacity to explicate prosthetic relations. Concentration on the cyborg, she argues, leads to "a bland critique of contemporary culture" that leaves "history to an occasional footnote."[27] Yet the blandness and marginality of history that Ott

perceives as damaging to the study of prosthetics can perhaps be blamed less on fascination with cyborgs than on *whose* body materializes under its auspices.

Although Hayles is careful not to drown the posthuman in discourses of prosthetics—she is much more invested in rearticulating the human as an information-processing machine—Alexander G. Weheliye argues that Hayles's dismantling of the liberal humanist subject, an effort to which he is sympathetic, "appears as little more than the white liberal subject in techno-informational disguise."[28] To illustrate, when Hayles identifies two archetypes of the posthuman—RoboCop and the Six Million Dollar Man—Weheliye charges her with falling "back on white masculinist constructions" of the posthuman. To counteract the normative human resurrected by Hayles's posthuman, Weheliye broadens the informational media that are currently considered in cybertheory and cybernetics debates on embodiment and subjectivity to allow for the impact of sound technologies—specifically, the use of the vocoder in R&B.[29]

As Weheliye demonstrates, critical engagement with sound technologies also offsets the privileging of the historical over the popular that organizes Ott's approach to the prosthetic. Where Hayles's posthuman citizens are selected from popular culture and science fiction, Ott's collection absents "essays on popular culture spinoffs such as Inspector Gadget, Go-Bots, comic book characters, televisions' enthusiastic expansion of the realm of prosthetics with lip syncing rock stars, and the *Knightrider* adventures of Kit the car."[30] This decision is alarming for two reasons. First, it suggests that the recent past is somehow outside the purview of the historical. Second, it clearly replicates the kind of selective memory that characterizes Hayles's privileging of the Bionic Man over the Bionic Woman. Had Ott looked to the Transformers rather than the smaller Go-Bots, she would have noticed the black-coded voice of Blaster, who transforms into a boombox.[31] Even keeping with the early to mid-1980s examples that Ott foregrounds, the entrenchment of a prosthetic relation could still be located within popular culture. A case in point is hip-hop. Excision of the popular from a historical perspective on prosthetics—like the delineation of disability against the backdrop of normativity—can make recognition of relevance unduly difficult.

The popular discourse of Afrofuturism is full of science/sonic fiction characters who challenge Hayles's reliance on hegemonic subjects and who, given their subjection to liberal humanist history, understand the posthuman condition

in radically different terms. Consider RZA's alter ego, Bobby Digital, "the b-boy hero of our times"; the global recuperation mission of Drexciya's champions, "water-breathing, aquatically mutated descendants of those unfortunate victims of human greed"; or Public Enemy's reincarnation of the classical trickster in the person of Flavor Flav. As Eshun highlights in his discussion of Grandmaster Flash's *The Amazing Adventures of Grandmaster Flash on the Wheels of Steel*, "The 'Flash' points to the Supersonic Science of skratchadelia, the dj as DC Comics hero, the term 'Grandmaster' to levels of skills and depth induction into the martial artform of dj-ing. The name Grandmaster Flash brings together comics and kung-fu movies, superhero and Shaolin 'in a mythical battle.'"[32] This "mythical battle" enlarges the posthuman paradigm. The intersection of urban environments and electronic technologies birthed a new body capable of making a new sound—the third arm scratched.

The Third Arm

Turntablists' reconfiguration of the "phonograph" registers as a far cry from Charles Cros's blueprint essay "Procedure for the Recording and Reproduction of Phenomena of Acoustic Perception" (1877), the barely audible "Hello" of Edison's single-cylinder prototype, and even Emile Berliner's ancestral disk-based gramophone (1888). As Jonathan Sterne argues in *The Audible Past: Cultural Origins of Sound Reproduction,* the phonograph like any medium was determined by its changing range of social uses: "since a medium is a configuration of a variety of social forces, we would expect that, as the social field changes, the possibilities for the medium change as well."[33] Change appears evident in the name for the circulating horizontal rotating platform known as the "turntable" and its social network. "Placing before," as the Greek origins of the term *prosthesis* implies, turns the tables on the ontological status of the phonograph as an auditory writing machine.

The DJ's hand enters into a prosthetic as well as historical discourse when it is placed before the needle of a turntable's arm. This placement is so significant that Eshun goes as far as to claim that the "dj is a tactilist who goes on a journey of the hands, opening up a new field of objectile thought: fingertip perception."[34] Vibrations continue to reach the middle ear while the third arm—the sensorial

symbiotic relationship between DJ and turntable—physically reworks how they vibrate. Prerecorded sounds become heard through the hand. The DJ's hand massages the throat to vibrate the vocal trac(k)t. The hand also becomes a motor, twitching inertia in reverse, manually moving, pushing wax up hill. The turntable plays records, yes, but in turntablism the body becomes an engine for the turntable while arms work together to mine beats from the black pits of the groove with a diamond drill.

The needle functions as an instrument that returns, repairs, and reanimates. (A needle is also a gauge and pointed steel for sewing and as a verb connotes provocation.) Scratching—the technique that is most associated with turntablism and fundamentally dependent on the needle—is an act of labor carried out on and across the voice and rhythm. This act of labor correlates with McLuhan's analogy between the phonograph and automation in *Understanding Media:* "As the automation of human voice and gesture had approached perfection, so the human work force approached automation. Now in the electric age the assembly line with its human hands disappears, and electric automation brings about a withdrawal of the work force from industry."[35] McLuhan's "others" resurface here to find themselves configured by the social forces that converged in the South Bronx. The "withdrawl" that McLuhan speaks of may have witnessed hands disappear from the industrial factory, though they were far from idle in cultural production. As critics have insisted, the urban space of a nascent hip-hop culture in the late 1970s demonstrated innovative attempts to reshape and rework the surfaces of the immediate environment through the very products and technologies that were seemingly divorced from a U.S. human workforce.[36]

For Jean-Marie Guyau (1880), vibrations "turn back into a voice, into words, sounds, and melodies."[37] Mechanical artifice restores something that is etched into the naked surface of time. Yet the labor of scratching, the extension of urban youth, exceeds mere retrieval. The voice, as McLuhan indicates, may be extended. With mixing, however, the captured temporal and timbral element known as the "breakbeat" actually strips down the voice and instrumentation to capture rhythm (as well as to grasp elusive fragments of noise). In this instance, the voice is neither simply amplified nor extended.[38] If it is not removed altogether, the amplification of the voice falls to the mercy of the DJ's backspinning abilities.

Edison's clever party trick, turning the handle to speed up playback, may have been performed to entertain the ears of late nineteenth-century New York-

ers, but this work of the hand demonstrates that the phonograph was defined by the hand as much as it has been overdetermined by the ear. Scratching, also an action of the hand, implies an irritation, that pesky voice layered over rhythm that must be scratched away. Manually reversing the spin of the record runs the needle over what resides in the groove. Scratching's union between the sensory activities of touching, listening, and seeing reveals that the turntable (as well as the time-storage medium of vinyl) is less an external addition to the throat, optimization for the voice, than it is an instrumental arrangement between the hand, arm, eye, ear, stylus, mixer, decks, samplers, and vinyl that collectively and synchronically *plays with* the groove. As Jackie Orr announces in her contribution to *Prosthetic Territories: Politics and Hypertechnologies:* "It doesn't take a manufacturing process to groove a record so that the needle can read and amplify music, it takes a musician with a different intelligence in the fingers to scratch new grooves across the old."[39]

This "different intelligence in the fingers," also invoked by turntablist Prince Paul, illustrates the intimacy between media as extension and media as environment: "You have to be pretty smart, you know. You have to be pretty smart and pretty swift to know what breaks to play—when. And how people are gonna react cuz you're controlling their emotions. People don't really realize that the DJ's that deep. They think he's some knucklehead up there spinning records. You've got to know what's going on around you, or therefore you just fail as a DJ."[40] Where McLuhan asserts that "all media are an extension of some human faculty—psychic or physical," turntablism, its combination of arms and intelligence, marks the prosthetic relation as something more. Seeing through fingertips and addressing with the arms, the environments enabled through hip-hop technicians refuse the tired split between mind (psychic) *or* body (physical). Here is a radical intelligence that sees the change media effect on the present—one that is not defined by virtue of its distance *from* "the Negro, the teenager, and some others" but *by* them.

McLuhan suggests "alert[ing] the Negro" in 1969. During the Second Reconstruction, cultural producers explode the myth of urban youth's detachment from technology with such force that by 1990 Public Enemy upend the point with a rhetorical question: "War at 33⅓ / Haven't you heard." In this switch—which is rapped over yells, samples, scratches, and loops—the establishment is alerted. Urban youth—the "Negro, the teenager, and some other groups"—occupied environments that were designed in opposition to or at best in ignorance of them. Yet

the same urban youth extended through media to fashion less ill-fitting environments.[41] They became prosthetists at 33⅓. Among their instruments were hands, markers, spray paint, subway trains, walls, cardboard, linoleum, sneakers, portable cassette players, car stereos (the extension of the foot as well as ear), the body imitative of assembly-line automation in the form of the "robot," "moonwalk," or "freeze," electric lights or power from buildings used to supply sound-system parties, and, of course, turntables. If any extension of human beings constitutes new environments, if Edison's phonograph could transport the voice in the late nineteenth century, then so too did the subway car transport an inscribed voice spray-painted on its surface in the late twentieth. An authored voice in the form of a "tag" extends beyond the physical confines of a tenement building: the medium is the message in its vivid illustration of how disenfranchised human bodies accommodate themselves to a postindustrial landscape by reworking exactly how the medium "shapes and controls the scale and form of human association and action."[42]

While the fictive gang of Walter Hill's film *The Warriors* (1979) run across the cinema screen, run across the Hollywood façade of postindustrial urban environment as war zone, DJs Grandmaster Flash, Kool Herc, and Afrika Bambaataa materialize off-screen. They scratch and toast for sonic territories in the city imagined by Hill. Working with Grandmixer D.ST, jazz-funk fusionist Herbie Hancock produced his *Future Shock* album. In the 1983 music video for the album's hit song "Rockit," automata whose mechanical parts pulse to the aural signatures of the turntable and synthesizer replace human dancers. Darren "Buffy" Robinson becomes the "human beat box," the human vocal tract as percussion instrument—his lips a snare, his throat a bass drum, the tongue a bass pedal, the oral cavity a studio space. On his debut album, *Radio* (1985), L. L. Cool J. raps about his portable cassette player as pacemaker: "I Can't Live with out My Radio." Where Ladies Love Cool James, no love is shown to Radio Raheem by pizza shop owner Sal and New York City police officers when he is beaten to death over his radio's defiant amplification in Spike Lee's *Do the Right Thing* (1989). DJ Terminator X of Public Enemy becomes "the assault technician." Technics become technique and tactic in the fallout of the Second Reconstruction. These moments capture histories of hip-hop and sound-reproduction technologies, urban experience, labor, the post–Civil Rights Era, the black public sphere, cultural production, sensory experimentation, machines, and bodies. Environments, iden-

tities, and technologies converge to realize an urban prosthetic—media as extensions of specific rather than supposedly universal bodies in time and place.

Notes

1. Paul D. Miller, aka Dj Spooky That Subliminal Kid, *Rhythm Science* (Cambridge: MIT Press, 2004), 36.

2. Friedrich A. Kittler, *Gramophone, Film, Typewriter,* trans. Geoffrey Winthrop-Young and Michael Wutz (Stanford: Stanford UP, 1999), 21.

3. Marshall McLuhan and Quentin Fiore, *The Medium Is the Message: An Inventory of Effects* (New York: Bantam, 1967), 26.

4. Marshall McLuhan, *Understanding Media: the Extensions of Man* (New York: Signet, 1964), 241.

5. Kodwo Eshun, *More Brilliant Than the Sun: Adventures in Sonic Fiction* (London: Quartet, 1998); Miller, *Rhythm Science.*

6. N. Katherine Hayles, *How We Became Posthuman: Virtual Bodies in Cybernetics, Literature, and Informatics* (Chicago: Chicago University Press, 1999).

7. Donna Haraway, *Symians, Cyborgs and Women: The Reinvention of Nature* (London: Free Association, 1991).

8. Mark Dery, *Escape Velocity: Cyberculture at the End of the Century* (London: Hodder & Stoughton, 1996).

9. McLuhan, *Understanding Media,* 20.

10. The association between racial minorities and technophobia has been contested in publications such as Afrofuturism (Special Issue) *Social Text* (2002); Mark Dery, ed., *Flame Wars: The Discourse of Cyberculture* (Durham, NC: Duke University Press, 1994); Beth E. Kolko, Lisa Nakamura, and Gilber B. Rodman, eds., *Race in Cyberspace* (London: Routledge, 2000); Alondra Nelson, Thuy Lnih N. Tu, and Alicia Headlam Hines, eds., *Technicolor: Race, Tec, and Everyday Life* (New York: New York University Press, 2001). The theme has also been explored in at least three key conferences: the University of Southern California and Massachusetts Institute of Technology's "Race in Digital Space: A National Conference on Race and New Media Technologies," MIT: Cambridge, Mass., pp. 127-29, 2001 USC, MIT, and the University of California–Santa Barbara, "Race in Digital Space 2.0," Museum of Modern Art, Los Angeles, October 10-12, 2002; UCSB's "AfroGEEKS From Technophobia to Technophilia: A Race and Technology Conference," UCSB, Santa Barbara, Calif., May 7-8, 2004.

11. "The *Playboy* Interview: Marshall McLuhan—A Candid Conversation with the High Priest of Popcult and Metaphysician of Media," in Eric McLuhan and Frank Zingrone, eds., *Essential McLuhan* (New York: Routledge, 1995), 255-256.

RAIFORD GUINS AND OMAYRA ZARAGOZA CRUZ

12. Cited in Robin D. G. Kelley, *Freedom Dreams: The Black Radical Imagination* (Boston: Beacon, 2002), 78, originally published as Robert F. Williams, "USA: The Potential of a Minority Revolution," *Crusader* 9, no. 2 (1967).

13. Manning Marable, *Race, Reform, and Rebellion: The Second Reconstruction in Black America, 1945–1990,* 2nd ed. (Jackson: University Press of Mississippi, 1991), 1.

14. For Marable, both reconstructions involved "massive confrontations concerning the status of the African American and other national minorities (e.g., Indians, Chicanos, Puerto Ricans, Asians) in the nation's economic, social and political institutions" (ibid., 1). Other similarities included the diminishment of racial and caste structures, the emergence of new black leaders, strong activity in the South, and important effects in the northern and western states. Marable also notes that the government was viewed as a "reluctant ally" in both instances, federal courts and Congress were pressured to legislate on behalf of racial equality, and both Reconstruction periods "succumbed to internal contradictions, the loss of northern white support, and the re-emergence of the South's tradition of inequality and racial prejudice as the dominant theme of U.S. public policies *vis à vis* blacks" (ibid., 4).

15. George Lipsitz, *The Possessive Investment in Whiteness: How White People Profit from Identity Politics* (Philadelphia: Temple University Press, 1998), 1.

16. Elspeth Brown, "The Prosthetic Management: Motion Study, Photography, and the Industrialized Body in World War I America," in Katherine Ott, David Serlin, and Stephen Mihm, eds., *Artificial Parts, Practical Lives: Modern Histories of Prosthetics* (New York: New York University Press, 2002), 249.

17. David Serlin, "Engendering Masculinity: Veterans and Prosthetics after World War II," in Ott, Serlin, and Mihm, *Artificial Parts,* 46.

18. The technologies of war that the United States developed in Southeast Asia were applied to urban communities through the militarization of police forces. This has been documented in Sanyika Shakur, *Monster: The Autobiography of an L. A. Gang Member* (New York: Penguin, 1993), and Mike Davis, *City of Quartz: Excavating the Future in Los Angeles* (New York: Vintage, 1990).

19. McLuhan and Fiore, *The Medium Is the Massage,* 26 (emphasis in the original).

20. Cultural theory follows in the footsteps of practitioners like Miles Davis, Sun Ra, Herbie Hancock, George Clinton, Bootsy Collins, Bernie Worrell, Lee "Scratch" Perry, Grandmaster Flash, Afrika Bambaataa, DJ Spooky, Derrick May, Juan Atkins, Kevin Saunderson, and RZA.

21. Lennard J. Davis, *Enforcing Normalcy: Disability, Deafness, and the Body* (New York: Verso, 1995), 23.

22. Following this line of thinking, disabled persons may not be *the* problem, but a problem is nevertheless pressing. Because the parameters of normativity are

highly exclusive, its uniformity generally escapes the scope of even a single person's experience. At some point in the average lifespan, everyone is likely to be disabled either through illness, accident, or simply the indiscriminate process of aging.

23. Lipsitz, *The Possessive Investment*, 1, originally from Raphael Tardon, "Richard Wright Tells Us: The White Problem in the United States," *Action* 24 (1946).

24. Rosemarie Garland Thomson, *Extraordinary Bodies: Figuring Physical Disability in American Culture and Literature* (New York: Columbia University Press, 1997), 7.

25. David T. Mitchell and Sharon L. Snyder explore this point in both *Narrative Prosthesis: Disability and the Dependencies of Discourse* (Ann Arbor: University of Michigan, 2001) and *The Body and Physical Difference: Discourses of Disability* (Ann Arbor: University of Michigan Press, 1997). In the former, they write: "As feminist, race and sexuality studies sought to unmoor their identities from debilitating physical and cognitive associations, they inevitably positioned disability as the 'real' limitation from which they must escape" (2); while the latter draws attention to examples of disability's omission from explorations of academic discourses on the body.

26. Mitchell and Snyder, "Introduction: Disability Studies and the Double Bind of Representation," in *The Body and Physical Difference*, 8. Hayles, in particular, is singled out for criticism. Though she endeavors to establish a "level . . . cyborgian playing field" by adopting an expansive definition of prosthetically altered bodies, Mitchell and Snyder imply that it is debatable "whether or not 'difficulty [in] detaching parts' adequately describes the psychic/sensory impact of living one's life on a respirator, with an artificial limb, or in a wheelchair" in contrast to "chosen" prosthetics like computers (8).

27. Katherine Ott, "Introduction," in Ott, Serlin, and Mihm, *Artificial Parts*, 5.

28. Alexander G. Weheliye, "'Feenin': Posthuman Voices in Contemporary Black Popular Music," *Social Text* 71 (2002): 23.

29. Weheliye's emphasis on the virtual voice demands that he attest not only to the whiteness of Hayles's examples but to the masculinity that they embody. In his article, Weheliye asks why Hayles chose not to consider Lindsay Wagner's performance in *The Bionic Woman* (1976–1978, television series) with her discussion of Colonel Steve Austin, who starred in *The Six Million Dollar Man* (1974–1978, television series). When Weheliye turns to the virtual voice, he draws from black popular music, where the recorded voice historically is often female.

30. Ott, "Introduction," in Ott, Serlin, and Mihm, *Artificial Parts*, 7.

31. See Heather Hendershot, *Saturday Morning Censors: Television Regulation before the V-Chip* (Durham, NC: Duke University Press, 1999).

32. Eshun, *More Brilliant Than the Sun*, 14.

33. Jonathan Sterne, *The Audible Past: Cultural Origins of Sound Reproduction* (Durham, NC: Duke University Press, 2003), 202.

34. Eshun, *More Brilliant Than the Sun,* 18.

35. McLuhan, *Understanding Media,* 244.

36. This is a point that Tricia Rose's landmark book *Black Noise: Rap Music and Black Culture in Contemporary America* (Middletown, CT: Wesleyan University Press, 1994) makes abundantly clear. Arguing that hip-hop is urban renewal, Rose characterizes the phenomenon as "as a source for youth of alternative identity formation and social status in a community whose older local support institutions had been all but demolished along with large sectors of its built environment" (34). Relatedly, George Lipsitz's "The Hip Hop Hearings: Censorship, Social Memory, and Intergenerational Tensions Among African Americans," in Joe Austin and Michael Nevin Willard, eds., *Generations of Youth* (New York: New York University Press, 1998), points out that hip-hop created a variety of jobs for urban youth while Nelson George's *Hip Hop America* (New York: Viking Books, 1998) illustrates this trend through memoir and commentary on the development of the subculture.

37. Kittler, *Gramophone,* 31.

38. Rose explains in *Black Noise:* "Playing the turntables like instruments, these DJs extended the most rhythmically compelling elements in a song, creating a new line composed only of the most climactic point in the 'original'" (74). It is doubtful that Rose included the word *extended* as a subtle nod to McLuhan in her discussion of breakbeats. Her usage probably speaks more to the manipulation of duration by the third arm of the DJ turntable than it does to the "extension of the central nervous system."

39. Jackie Orr, "Re/Sounding Race, Re/Signifying Ethnography: Sampling Oaktown Rap," in Gabriel Brahm and Mark Driscoll, eds., *Prosthetic Territories: Politics and Hypertechnologies* (Boulder, CO: Westview, 1995), 181.

40. Prince Paul, selections from *Battle Sounds* documentary, *Scratch,* produced by Brad Blondheim and Ernest Meza, directed by Doug Pray, 255 min., Firewalk, 2001, DVD.

41. Grand Wizard Theodore is credited with being the first to scratch within the context of late 1970s hip-hop. We are less interested in entering into a discussion of the history of experimentation with turntables that would forces us to line up the unusual suspects (Edgard Varèse, John Cage, Pierre Schaeffer, Laszlo Moholy-Nagy, Grand Wizard Theodore, Grandmaster Flash, Christian Marclay, DJ Olive, MixMasterMike, DJ Spooky, DJ Qbert) than we are interested in the technique of scratching within the urban context.

42. McLuhan, *Understanding Media,* 24.

TECHN*E*OLOGY OR THE DISCOURSE OF SPEED David Wills

Between the moment when I agreed to contribute to this collection and the moment I began to write my chapter, things happened uncannily fast. And by means of an acceleration resembling Moore's law, which decrees an eighteen monthly doubling of the speed and capacity of a microchip, the time between the moment when I first opened a new wordprocessing file and the moment of reckoning that goes by the name of a deadline passed at an exponentially frightening velocity. Hence, what follows will have been invented—like some sort of premature Caesarean section out of Mother Necessity—very, very recently. Words and phrases never seen or heard before just emerging into the light of day, perhaps familiar enough but certainly deformed in this delivery. Such are the sorry perversions or felicitous caprices of our age, not entirely foreign to the whole question of technology that is the focus of this discussion.

All that is my fault—or that of time or of technology.

Technology is generally related to either reduced labor, increased speed, or both. Lighting a fire beats running around to keep warm; it reduces mandibular action and speeds up the digestion required to consume raw food. As we enter the second decade of a period of extraordinary electronico-digital technological innovation, it seems more and more clear that the desire to reduce labor has been sacrificed at the altar of speed, giving birth to an increasingly universal class of Web or e-mail slaves more laboriously time-constrained than ever and whose state of mechanical prosthetic stricture is structurally no different—though economic and ergonomic differences increase exponentially—from that of our ancestors who

tilled the fields or our third-world neighbors who sew our clothes in a sweatshop. In one way or another, we are all tethered to a timetable and to a machine.

Speed gives rise to the distance that motivates and configures every anti-technological nostalgia—what might be called, in the context of this discussion, every Promethean melancholy. "If there had been no railway to conquer distances, my child would never have left his native town and I should need no telephone to hear his voice; if travelling across the ocean by ship had not been introduced, my friend would not have embarked upon his sea-voyage and I should not need a cable to relieve my anxiety about him," laments Sigmund Freud in *Civilization and Its Discontents*.[1] Closer to us, Paul Virilio intones: "When one invents a technical object, for example the lift, one loses the stairs; when one inaugurates transatlantic flight, one loses the steamship."[2] Distanciation, alienation, *Verfremdung, ostranenie:* all imply a too rapid movement into otherness, a displacement fast enough to reveal a rupture, and this displacement has been the dominating theme of discussions of technology at least since the advent of the industrial revolution. There are of course converse effects: "live" images of war and famine are received directly in our living rooms, each one more intolerable than the last, but their utterly horrible otherness comes to be reduced to the banality of their new surroundings and touches only in the most suspect way the inured armchair viewer. If speed kills, it is sometimes because it bores us to death. Either way, speed will have always implied a displacement that is also a perversion. As Shakespeare has it, in the lines from *Hamlet* that I return to or that return to me without fail every time I reflect on this matter: "O most wicked speed, to post with such dexterity to incestuous sheets."[3]

In what follows, I wish to measure the speed of the technological question as it is developed in the work of Bernard Stiegler, notably the two first volumes of *La technique et le temps*,[4] and on the basis of that to posit a type of discursivity of speed and of technology that I relate to neologism, a neologistic effect that, I argue, is perhaps the only means by which we can articulate the mutations of digital technology and await, as we seem to more and more, the monstrous birth of some future mutation, the artificial intelligences or biotechnologies of our most fascinating and awful science fictive imaginings. For in fact, I maintain, in spite of the extraordinarily incisive analysis and inventive thinking of Stiegler's discussion of technology, haunted as it is and must be by the matter of speed, he falters

in his elucidation of it—as if there were something in it that resisted linguistic utterance; as if it were somehow a linguistic question and a linguistic problem; as if that originary fault which, as he demonstrates from every angle, is the difference that is time and technology, were also a breakdown in the essence of language.

A quotation that occurs about halfway through *La faute d'Epiméthée* will serve as the epigraph for everything I develop here: "L'homme est cet accident d'automobilité que provoque une panne d'essence."[5] In English, this sentence is translated, and glossed, as follows: "Man is this accident of automobility caused by a default of essence [*une panne d'essence,* a 'lack of fuel,' an 'empty tank']."[6] The same formulation returns twice in the middle of *La désorientation.*[7] With or without a gloss, a striking effect of bathos occurs once the expression *panne d'essence* falls into English (and many other languages) without the double sense of *essence,* a word that English preserves for certain distillations such as perfume but not for the hydrocarbonic crassness of gasoline. My point is that when throughout a confidently constative and sometimes declamatory discourse Stiegler resorts—as he does more than rarely and with rare adeptness—to what can perhaps still be called poetic effect, he manages to *perform* a technological truth that he repeatedly *affirms* yet also sometimes seems to *forget.* For in such moments, language itself mutates at the speed of light by means of a whole range of displacement effects whose paradigm is this *essential* logic that is perhaps no longer simply that of the *technê* in the strict sense, no longer *techno–logical* in the purest sense. It is a logic that I call resorting to shorthand, the logic of neologism, the *tech–neo–logism* that is perhaps the only speed that we can in effect speak of.

The presumption concerning speed is explicit from the beginning of *La technique et le temps* ("the specificity of modern technics resides, in essential part, in the *speed* of its evolution, which has led us to conjoin the question of technics with the question of time")[8] and is repeatedly emphasized: "*our most profound question is that of the technological basis of all relation to time,* something that once more comes into play in a singular manner against the horizon of technology that is ours: *speed.*"[9] For Stiegler, the horizon of technology is speed because its "origin" is time—"the originary relation between the human and the technical [as] *a phenomenon of temporality.*"[10] That phenomenon of temporality functions throughout the four historical analyses of Stiegler's first volume as well as in the contemporary moments of real-time computing, direct televisual transmission, and genetic

engineering. And it is in each case, related to questions of memory and forgetting—of an artificialized and exteriorized memory on the basis of which (in terms close to those I have developed at length elsewhere) the human is conceived of in its essential prostheticity.[11]

The temporality of technology requires us to think, as impossible as it is necessary, the structure of a coincidence that is also a disjunction—a time that in coming to be falls out of joint. This is the challenge to conceptual thinking that Derrida attempts to account for—as Stiegler readily acknowledges—by means of his *arche-writing* or *différance.* If the strength of Stiegler's work derives from his analysis of a structure that relies on both paleontological and ontological perspectives, in a sense (as Geoff Bennington has objected) he sometimes speaks of that disjunctive coincidence or coincidental disjunction as having arrived or as having been located and thereby reverts to a type of positivism. Although I share the tenor and some details of Bennington's critique more than its verdict, we might speak of a desire in Stiegler to think through (in the sense of *beyond*) that structure of coincidence with some sort of empirical certainty, whence his category of "inorganic organized beings" for technical objects whence the defining anthropological moments that are in *La faute d'Epiméthée* corticalization, in *La désorientation* alphabetic writing, and in *Le Temps du cinéma,* cinema.[12] As I attempt to show, Stiegler skirts but ignores a particularly linguistic configuration of that structure of coincidence and that is our most eloquent if not our most obvious technological moment and commentary, or rather *mise en scène* of the speed that is technics as it coincides disjunctively or disjointedly with time.

Space does not permit me to repeat in detail the four major, indeed monumental analyses that constitute *Technics and Time,* volume 1, *The Fault of Epimetheus.* Some summarizing nevertheless allows me to underline the questions relating to my own argument. The first analysis concerns Epimetheus himself, Prometheus's often forgotten brother, who distributed qualities to the animals but forgot to keep anything in reserve for humans. As a result, Prometheus has to steal fire so that humans will have at least something to fall back on, incurs the wrath of Zeus, and ends up being chained in the Caucasus and having his liver pecked out once a day (thereby becoming, as Stiegler astutely notes, the Titans' clock). Absentminded *Epi*metheus represents after-thought, in opposition to *Pro*metheus, who represents forethought. In rehabilitating this figure who has been forgotten in the

shadow of his more spectacularly *techie* brother, Stiegler emphasizes a first function of technology in its mythological origins—namely, its compensating for a forgetting, a fault or default.

The second strand of Stiegler's analysis comes via the work of André Leroi-Gourhan, particularly the two volumes translated as *Gesture and Speech*.[13] Leroi-Gourhan defines the human in terms of technological competence—the ability to use tools—by relating the production of knapped flint (in French, *silex*) to the development of the cortex, arguing for such a close structural link between "the two respective trends of the nervous system and of mechanical adaptation"[14] that human technicity will be so fundamental as to be almost "zoological," an almost automatic technological outgrowth of the body.[15] Leroi-Gourhan's other important insistence is that the same mutation to upright stance that freed the hands and rebalanced the skull also opened up the face for language. Thus the hominid's foreign relations that will come to constitute socialization appear as the end product of a process of exteriorization whose first gestures were the manipulations of tools and the earliest forms of language. What began, within Leroi-Gourhan's schema and in Stiegler's interpretation, as a porousness of flesh and stone whereby each helped the other to evolve, is now more explicitly a negotiation by the human of its technical outside, and an investment in forms of exterior memory that will continue all the way to the computer revolution of the end of the twentieth century. The upright hominid stance inscribes a definition of the human that is utterly determined by the idea of exteriorisation, the hand reaching outside the body to enter into a prosthetic relation with a tool, the mouth producing or adopting the prosthetic device that is language. As a result, the archive is born, the human species begins to develop a memory bank, and its relation to time begins to be catalogued by means of the traces of an artificial memory—the artefact, the narrative.

The articulating function of language in the relation of technics to time is henceforth unavoidable. For Stiegler, "if paleontology thus ends up with the statement that the hand frees speech, language becomes indissociable from technicity and prostheticity: *it must be thought with them, like them, in them, or from the same origin as theirs: from within their mutual essence.*"[16] An indissoluble nexus thus relates corticalization, verticality, mobility, technology, time, and language. Yet whereas the first five terms of that nexus continue to converge in the successive technological revolutions up to and including the present and even the future, converging

more and more around the function of speed (faster brains, more complicated manipulations of the machine, accelerated automobility, more rapid machines, less time), Stiegler does not discuss language as an evolving technology of self-acceleration.

Of course, language as an instrument benefits from the list of accelerations just referred to. It can be automatized and processed as never before, but the development of technologies that handle language is not the same as the development and acceleration of language as a technology. Instead, we imagine language as being a more or less static form since the arrival of writing; we don't conceive of its technological functioning as radically different now from what it was then. Diachronic linguistic mutations—whether from one language to another within the history of human civilizations or within a single language as in the evolution of its literatures—are impossible to compare with the rhythm of technological innovations even though language cohabits with technology within a structure of possibility. Would that be only because, as is no doubt the case, each technology—cortex, verticality, mobility—evolves according to rhythms whose relativity makes comparisons practically meaningless? After all, what meaningful comparison could be drawn between the hundreds of thousands of years separating the *Australopithecus* and *Homo sapiens* and the couple of centuries separating the steam engine from the computer? On the other hand, perhaps language has not yet begun to be analyzed as a technology in the terms that Stiegler's work invites. Is it possible that he ignores a properly technological conception of language in his otherwise comprehensive analysis of technology, in spite of repeated references to it and in spite of his frequent recourse to its unrevealed technological resources? This is the question that the present reading seeks to have emerge.

Stiegler's third main analysis is of Jean-Jacques Rousseau's state of nature before and without prosthesis: "Prosthesis is the origin of inequality. The man of pure nature has everything about himself, carries himself whole and entire about himself: his body is 'the only instrument he understands.'"[17] Humans begin to acculturate themselves by accident, putting on the clothes that they previously had no need of and heading down the path to civilization. Yet this accident is already a question of technology—an accident in nature, a sign of the machine in nature, the breakdown in natural essence that would distinguish the human from the animal. Here Stiegler first falls into or upon the wordplay of my epigraph: "*l'homme est cet accident d'au-*

tomobilité que provoque une panne d'essence."[18] But more important than Rousseau's nostalgia for pure *physis* is a certain exteriorization of time that takes place in terms of the anticipation of death. Replacing the natural sentiment that they share with animals (namely, pity), humans graduate from simple pain and suffering to conceptual knowledge and anticipation of death itself: "compassion is immediacy, whereas the feeling of death is anticipation, mediacy, preoccupation, projection of a singular and particularizable future, differentiation, and inequality in the fall, in(to) time."[19] Humans indeed fall into time once they mark out their days in the anticipation of their end, and this time operates beyond them and without them, obeying some strange automatism that is already there before them, although it also remains their time—the rhythm of their existence, the cadence of an approach to their own death. The human is chained to an event that is the inexorable clockwork degeneration of its own liver, a mortal Prometheus henceforth forever in technology.

The possibility of an authentic relation to time and memory is the focus of Stiegler's reading of Martin Heidegger. *Technics and Time* (whose title, as Bennington notes, "does not have an entirely modest relationship with *Being and Time*")[20] pays homage to Heidegger's monumental work yet seems to remind the philosopher of something that he appears to have forgotten in his discussion of the forgetting of Being—namely, a properly dynamic sense of technics that would come from remembering both Epimetheus and his brother Prometheus. By comparing the positions of Heidegger's *Being and Time* (1927), "The Question Concerning Technology" (1953), and "Time and Being" (1962), Stiegler mounts a critique of a later Heidegger who retreats from the technological perspective of his first great work (compared in turn with formulations in an earlier text, *The Concept of Time*). In developing a conception of being that is based on temporality, Heidegger is necessarily (as Stiegler sees it) very much *in* technology. The existential analytic of time (of the temporal being that Heidegger calls the Dasein), he argues, should be "an analytic of the *prostheticity* whereby he exists and becomes embodied—of prostheticity as being his *already-there* or of his *already-there* as being *essentially* prosthetic."[21] Though Stiegler concludes that Heidegger's work does not live up to that promise, he argues extensively, with and in spite of Heidegger, on behalf of such an interpretation.

Temporality is technological inasmuch as it is a or *the* fundamental form of exteriorization of the human memory: "the temporality of the human, which

marks it off among other living beings, presupposes exteriorisation and prostheticity: there is time only because memory is 'artificial.'"[22] Time is the original archival trace by means of which the human is able to define, differentiate, and individuate its existence. But as Heidegger emphasizes, in accepting to be thrown into time in order to understand how it exists, the Dasein is necessarily involved in its own articulation with otherness, a necessarily technological otherness: "as a 'process of exteriorization,'" Stiegler insists, "technics is the pursuit of life by means other than life."[23] Yet this process of exteriorization cannot be understood in simple teleological terms; it makes no sense to speak of life that continues in a form other than life or by means other than life. Everything that has been developed so far argues for the technological relation as originary, as a complex and differential, indeed differential relation. The *Pro*methean moment (proactive forethought that gave us fire) was first of all or was also *Epi*methean (supplementary afterthought). The corticalization that coincided with knapping of flints was precisely this undecidability of exteriority: "interior and exterior are . . . constituted in a movement that invents both one and the other: a moment in which they invent each other respectively, as if there were a technological maieutic of what is called humanity."[24] And Rousseau's pity was the contradiction of a natural interiority that was nevertheless expressed in relation to another.

This *différance,* particularly as it relates to the body, is the originary and, as it were, internal or exappropriating articulation that I have attempted to account for as prosthesis. Though Stiegler comes to the matter from a different perspective, his analysis is overwhelmingly oriented by a thinking of the prosthetic, of the human as originary prosthesis:

The evolution of the "prosthesis," not itself living, by which the human is nonetheless defined as a living being, constitutes the reality of the human's evolution, as if, with it, the history of life were to continue by means other than life.[25]

And

The prosthesis is not a mere extension of the human body; it is the constitution of this body qua *"human."*[26]

If the notion of the human constituted as always already *in prosthesis* allows a thinking of technology to develop, then I shall now begin to argue, it is the idea of prosthesis that will bring us back to thinking the technology of language, especially as it relates to the question of speed.

Prosthesis suggests that speed is less a matter of acceleration than one of transformation. Speed is a differential process, an articulation of time and space. Speed reinforces the effect of a displacement in space that takes place in time: the faster it occurs, the shorter the time and the greater the displacement. Speed therefore threatens a rapid displacement into otherness, a *fast-becoming-foreign*. Just such a transmutation haunts the texts of Paul Virilio and makes his work less an analysis of speed, less the *dromology* that it purports to be than a simple eschatology. Tellingly, a dislocation with respect to space in general (the loss of our sense of the extent of space that speed provokes) and with respect to the land in particular (an "abandoning of the soil")[27] is recast as an expropriation of the body.

First, predictably, the body loses its soul: "The body without soul is . . . a body assisted by technical prostheses."[28] But increasingly, the body itself is threatened with loss:

[In L'horizon négatif,*] I wrote: "It is difficult to imagine a society that would deny the body, after having progressively denied the soul; however, that is what we are heading towards."*

*Today that difficulty seems to have been overcome in part by the new technologies of instant interactivity. Closer to what is found far away than to our immediate neighbors, we are progressively detaching ourselves from ourselves. . . . If vehicular technologies (balloon, plane, missile) had us progressively taking leave of the integral body [*le corps plein*] of the earth . . . until we finally lost it at the time of the lunar landing twenty years ago, the* extra–vehicular *technologies of instant interactivity have exiled us from ourselves and made us lose our ultimate physiological reference, that of the weighty mass of the locomotive body, axis, or rather seat of behavioral mobility and of identity.*[29]

A body that is lost to itself is thus described on the one hand as traveling too fast over too great a distance and losing its "contact" with the points of reference that define its behavior and its identity—with other bodies in a restricted community or with

identifiable and familiar places within its earthly home. But, on the other hand, the body that is capable of losing its soul as a prelude to losing itself is divided by itself within itself—between natural and (unavowed) inanimate or mechanical functions. Hence the almost Platonic lament that can characterize Virilio's discourse:

There is no technological advance without some loss on the level of the living or vital. . . . Additional memories are developed, dead memories that come to complement [compléter] but also to replace living memory, the memory of mankind. Biotechnology is the next aspect of the technological revolution. After the revolution in transmission, the putting into operation of absolute speed whereby the world is reduced to nothing, we head towards the final menace, namely the reduction of the living to nothing. That is to say the artificial introduction of technical micro-objects into the body, prefigured by the pacemaker. . . . Today the animal body is threatened with colonization by micromachines.[30]

Within this perspective of a technological speed—a technology that is conceived of as speed, that not only destroys the relation between the animate body and the world, but, more insidiously for Virilio, transforms the body with respect to itself, and denaturalizes it by prosthetizing it—the outside paradigm for speed comes to be understood as instant change, metamorphosis, mutation. I would argue that speed always operates within the perspective of prosthesis to the extent that it is haunted by that sense of the monstrous and the mutant, never simply the threat of displacement to another place without also being the threat of displacement to another state—what can perhaps be called "warp speed."

Absolute speed—its outside limit, the breaking of the "light" barrier by means of "real time"—thus constitutes Virilio's apocalypse:

Now history, our history, has just run into the wall of real time. Everything I have said in my books concerning the relation between politics and speed reaches its limit. Henceforth we can accelerate no further. Henceforth history will have reached top speed [sa vitesse limite] . . . this general accident, our crashing against the wall of time, is an event that is going to make us slow down, regress, go in reverse.[31]

In the context of a speed that disjoins the body, we must interpret this accident as a crash out of the human and into technology. Stiegler's contention that the

"accident" in essence that is technology constitutes the human admittedly argues from the opposite direction. Yet he also refers to a shock induced by breaking the time barrier and that gives rise to a "disorientation"—whose possibility he evokes in the general introduction to his work and to which he returns in detail, giving it the value of a title in the second volume. Because technology evolves faster than culture, it is necessarily experienced as a particularly alienating form of disorientation. Writing that "it is as if time has leapt outside itself," Stiegler goes on to draw an analogy with the shock produced when a plane breaks the sound barrier: "to break the time barrier would be to go faster than time. . . . What shock would be provoked by a device going quicker than its 'own time?'"[32]

That shock is precisely the prosthetic mutation I just referred to—a speed that has the body crashing through into its own unrecognizable or catastrophic otherness. Thus the outside threat to the whole tradition of technological advance that has us talking so much about it these days and most often not knowing what to say, would be represented more by biotechnology than anything else, by the technological possibility of genetic manipulation, of mutation or metamorphosis, of rapid and as it were imperceptible transformation to a corporeal and mental human other. Biotechnology raises the specter of an invisible and internal prostheticity far more insidious than the animal body's "colonization by micromachines" that is feared by Virilio, for by means of it the animate itself comes to be artificially produced. The machine is henceforth irrevocably in the flesh, indistinguishable from it. The possibility that the human genetic process can be altered by artificial means therefore renders explicit what human history has consistently repressed—namely, the constitution of the human as other than simply human, as structurally inhabited by the artificial, as originarily prosthetic. Finding ourselves on the threshold of a possible reengineering of the human should not obscure the fact that, as Stiegler writes, "the laws of the living were effectively abandoned four million years ago. . . . the 'laws of evolution' have been suspended at least since the invention of man—that is to say, of technics."[33]

Displacement into a radical otherness such as genetic mutation therefore occurs with the instantaneity of an absolute speed that usurps the role of evolution. As Stiegler notes, "if . . . genetic manipulations constitute the possibility of a radical acceleration of the differenciation of life forms, but also and especially of indifferenciation, then we meet again the question of speed."[34] What he calls

indifferenciation is what I call *mutation*—species transmutation that is the techno-logical nightmare haunting us all. In that context, speed is imagined as the accel-erating haunting of such a transformation or metamorphosis that is nevertheless also that of invention.

The general terms of such a problematic orient *La désorientation*. The gam-bit there turns on a technological moment that is closer to us—the moment of pho-tography, a moment that by the end of the book and through Edmund Husserl's notion of the temporal object—will bring to light what Stiegler calls "the essen-tially cinemato-graphic structure of consciousness in general."[35] Such a formula-tion is recast in Stiegler's collaborative volume with Jacques Derrida, *Echographies of Television: Filmed Interviews,* where the cinematic structure of consciousness—a life that is always already cinema—assumes the general terms of a comparison with a Derridean speech that is always already writing.[36] In that context, the cul-minating point of the current technological configuration, moment of haunting and anxiety, is again marked by a transformation that is represented by the digi-talization of the image. The moment is charged with high political stakes com-parable to those in play in the postindustrial revolution campaigns in favor of universal literacy. For Stiegler, we stand poised to emancipate ourselves from a certain cinematization and Americanization of the flux of life, but only if by a concerted political effort we are able to take advantage of what now appears as the potential "delinearisation of the flux of images."[37] But the digitalization of the image is also the possibility of its emancipation from the real, its synthetization—which for me represents the defining moment in the history of the temporal ob-ject and calls into question the theory that Stiegler has developed around that object. In transferring the tenor of Husserl's model for the temporal object from melody to film, Stiegler risks anchoring that model in a type of realism in which the analogical relation between flux of film and flux of consciousness comes to rely on the presumption of a "first-level" analogical relation between the image and the real that it would represent—a presumption that is explicitly called into question by the digitalization of the image. In my view, this realist risk gets in-scribed in more than one configuration.

By emphasizing the exteriorization of memory as originary technological possibility, Stiegler's analysis of technology (whether mythological, paleontolog-ical, anthropological or ontological) falls within a Derridean schema of arche-

writing. In the limited historical perspective of that schema, beginning with orthographical inscription (written language itself) and leading up to current technologies of the image, the uniform operating structure is held to be one of accuracy or exactness: "The essential phenomenon of the orthographic writing called phonographic writing is the *exactness* of its recording of the voice. . . . Similarly, photography is an exact recording."[38] If exactness is a constant structure between writing and photograph, what has improved is less the form of realism than the speed of the recording process, which now occurs with the "instantaneity" of the speed of light (just as the phonograph will later record at the lesser instantaneity of the speed of sound). But in spite of the exactness and enhanced speed of the photographic record, there comes with it and with the current technological regime the heightened disorientation of a sense of contrivance; the *ortho*graphic is also an *ortho*thesis, an accurate or faithful inscription that nevertheless functions as a pose. This interpretation comes from Barthes's work on photography, from the paradox the latter draws, in *Camera Lucida,* between the affirmation that the object in the image "has been there" before the camera lens and the disjunction that comes with that affirmation since we also know that that moment has past. Consequently, what we see and receive as real in the image we nevertheless see as a specter; the photographed object or person necessarily has the structure of a dead thing.

The disjunction of memory that therefore occurs with the photograph by virtue of its very "instantaneity" (a disjunction that is already reminiscent of the time of technology in all the variants discussed up to this point) becomes more complicated, according to Stiegler, in the case of cinema. Films, like melodies, are temporal objects, which is to say according to Husserl's definition in the *Lessons on the Phenomenology of the Consciousness of Internal Time,* "objects that are not only unities in time but that also contain temporal extensions in themselves."[39] As we listen to a melody or watch a film, the flow of our consciousness of it coincides with the flow of the sounds or images that constitute it. In the same context, Husserl develops distinctions among three types of memory—the primary memory of each successive moment of a melody as it retains the moments that preceded it; the secondary memory that brings a melody back to mind once it is no longer being perceived; and the tertiary memory that is the recording. Given the capacity to record temporal objects, successive perceptions of them will set up a

complicated relation between primary and secondary memories. As a result, "this coincidence of the mechanical flux with the flux of the temporal object produces for the flux of consciousness of this object and its recording that superimposition of the past and the real that Barthes had associated with photography."[40] Consciousness is henceforth cinematographic: "like cinema in life I revise the rushes, I view, I edit everything that has been repressed-archived: shots, sound and odor recordings, touch, contact, and caress recordings, I take it all up again and I undo and redo, I abbreviate."[41] But inasmuch as I have no metacinematic knowledge, I do it without reflection, according to the rhythms and reductions that a Hollywood-dominated cinema and a fortiori, a massively repetitive experience of television have conditioned me for. As Stiegler sees it, with the digital image, the Internet and so on comes an accessible means of obtaining a metacritical approach to these operations of my technological consciousness. Potentially, I can gain the means to comprehend the workings of temporal objects in their relation to consciousness and attain a critical technological literacy. But if the current economic and cultural regime is able to preserve its emphasis on the same rhythms, reductions, and repetitions just referred to in the service of commercial gain, then I won't achieve anything. Those are the political stakes, according to Stiegler, of this juncture in our technological history.

Since the advent of writing and by virtue of every conception of technology up to the recording of sound and image, there has always been discontinuity. Technology is for Stiegler the disjointedness of time, its exteriorization as memory. Repeatedly traced through the mythological moment of fore- and afterthought, through a memory that occurs as a forgetting, through the prosthesis of cortex and *silex,* through the relation between pity and the anticipation of death, through the thrownness of the Dasein, or through the "it has been there" that gets displaced in the photograph—technology is consistently described as a differential arche-writing that is also a disjunction. From that point of view, it is somewhat incongruous to concede the seamlessness of a double coincidence between past and reality in the photograph and the flux of film and consciousness that leads to life as cinema that Stiegler now seems to find in the contemporary experience of technology and from which he hopes to be delivered, thanks to the digital image, by the reinsertion of delinearization and "discretization," however

fearful he be that what will in fact take place will amount to a reinforcement of the current regime.

Such a seamlessness presumes that cinema is less a disjunctive medium than, say, writing or photography, but we could say the same thing about time or the tool. Three or four decades of analysis of the image have demonstrated rather convincingly that the massive effects of camera movement, of montage, of the time distortions of sequences, of spectator interpellation, and so on can be repressed in favor of an impression of continuity only within a consistent ideology of realism. Many years before he wrote *Camera Lucida,* Barthes used a semiological analysis of the realist effects of the photographic image to argue that the image's denotative and connotative meanings are compounded by the prior denotative force of the ideology of analogical reproduction.[42] One would therefore have to presume that it is the same ideology of realism that allows consciousness to be cinematographic. The images flowing by in the form of a tertiary memory would have to be received by consciousness in the form of a realism—that is, a continuity rather than a series of disjunctions—for a coincidence to be perceived between their time and that of consciousness itself. One would have to be *in the flow* in that sense for the flow to be perceived as such. It might similarly be argued that the melody of Husserl's original temporal object was derived from a particular type of music that did not privilege either dissonance or conflicting rhythms and which, by presuming melodic continuity, repressed the rhythmic discontinuity without which a melody cannot function. To be in the flow, one has, in the final analysis, not to be aware of time—to experience, by means of primary retention, the successive moments of a film as progressing according to the cumulative seamless effect of one image as it gives way to another. For that coincidence to operate, there would have to be minimal dislocation of the type that might encourage a forgetting rather than a remembering of an image in the context of the one that preceded it.

But all that changes, potentially, in the light of the digitalized or synthesized image. Once the image (and the moving image, in particular) is no longer bound by the physics and chemistry of photography, once an "it" no longer needs to have been there in front of the lens at any point for an image to be produced, once the image is the result of a program rather than a revelation of light—then the disjunctive time of the image can no longer be capable of the same structuring

force that we currently presume it to possess. There will still be an ideology or a metaphysics of realism, but any relation to technology that functions by means of the patent instantaneity of the photograph will necessarily get displaced.

In films like *The Mask* (1994) and *Terminator 2: Judgment Day* (1991), a transmutation occurs before our very eyes—the transmutation that in cinema parlance has come to be known by the neologism *morphing*. The human or animal form *morphs* on the screen in "real" or "reel" time. By means of a continuity whose switch to radical alterity is presented as seamless, it becomes—*continuously evolves into*—that monstrous other. Still obeying a logic and a metaphysic of analogy, it suddenly depends on a technology of the synthesized digital image that can represent anything that it can imagine without necessarily referring to a reality that would have preceded it. As a result and by extension, the special effect becomes the rule rather than the exception of cinematic production. According to Stiegler's logic, we would have therefore to imagine a concomitant morphing of cinematographic consciousness from the *orthothesis* of an exact reproduction (the photograph) to the *prosthesis* of the synthesized image. Similarly, the disjunctive time of the orthothetic will be both reinforced and compounded by the rapid shift to otherness of the prosthetic. In ignoring the extent to which any cinematic consciousness must be that of a prosthetic consciousness that is structured by forms of otherness that no impression of the flow and no analogical compounding of that impression can reduce, Stiegler risks a type of realism that seems radically out of kilter with the whole thesis of a technical time that is related to originary breakdown and disorientation.

Although I am arguing that Stiegler's hypothesis of the cinematographic consciousness relies on a representation of flow that privileges an almost realist continuity, this is not to forget what I have already detailed in terms of an originary technological disjunctiveness. Nor is it to neglect two other things he emphasizes: cinematographic consciousness's editing and montage processes and the decomposition of the analog that is offered by digital analysis, its capacity to "delinearise, decompose, instrumentally and systematically break up the flux, to bracket the phenomena of belief."[43] Because of those emphases, it is all the more surprising to find disjunction again giving way to continuity and coincidence, to coincidence as continuity, to a return of the real that appears in terms of a particular function of cinematographic technology in its relation to speed. I refer to the

phenomenon of televisual technology that Stiegler calls "real time." Here, he maintains, there is a coincidence of not two but four factors, all regulated by the speed of light: the "original" videotaping, the "immediate" retransmission of the videotaped images, the viewing of that retransmitted temporal object, and the consciousness of the viewer. This produces "hundreds of millions of consciousnesses" that are simultaneously "consciousnesses of the same temporal objects," the "live diffusion and production of mass temporal objects constitutive of a flux of mass consciousness."[44]

That speed is differential seems not to be in dispute: *Technics and Time* makes explicit that we should not conceive of speed as the conjunction of space and time but rather should understand space and time as speed's "decompositions." Indeed, *différance,* "as a conjunction of space and time more originary than their separation," would perhaps have to be rethought in terms of speed.[45] In the case of real time, however, speed appears more direct and continuous—indeed, absolute:

Time cannot be *unless it be* deferred. *However,* there is *what is called "real time"* . . . *perhaps the fundamental trait of contemporary technology. . . .We include in this expression all phenomena of "direct" transmission of information.What we call "real time" is not therefore time; it is perhaps the detemporalisation of time or the occultation of time.*[46]

Direct transmission in real time thus sounds like the shock of a technology going faster than time, faster than the speed of light, through Virilio's wall, a flip into warp speed and black holes. Later, Stiegler employs the expression *light-time,* also used by Virilio: "The truth of computer technology (information) is *light time.* By means of this expression we wish, *in the first place,* to designate the *transmission* of information at the speed of light, that is to say without delay."[47] But there is an indecision on Stiegler's part between the absolute speed of light-time and the rapid yet deferred speed of contemporary technology. Three pages after the quote just given, light-time is referred to as a "speed *approaching* that of light."[48] Nine pages later we return to the formula of "what arrives *really, that is to say without delay,*" of "electronic transmission in real time [that] produces a confusion in that *what arrives* and *arrival itself* are destroyed in their *coincidence.*"[49] On the next page, digital performativity is said to be constituted by a "coincidence" similar to that of the photograph, yet within the space of a few lines that coincidence is modulated

("*coïncide pratiquement*") and reinforced ("*sans retard*"), before we read: "It is not only the transmission and recording of data that is accomplished in "light-time": the *processing* of information takes place in the form of a *calculus* operating in real time."[50] That last sentence has a significant footnote, one that, in this rhetorical rush, has been a long time coming: "We must, however, specify that *real time is but infinitesimally deferred time,* taking place at a speed such that differenciation passes below the level of perception."[51] And indeed on the next page, Stiegler reverts to the idea of information processing that takes place at a speed "*approaching* that of light,"[52] information that is itself repeated ten pages after that in terms of "the *proximity* of absolute speed" (my italics). By the end of that page, however, we again hear of computer technology as "undeferred" or "undifferentiated" [*l'information indifférante*] "dedicated to 'real time.'"[53]

There is no real real time. Stiegler's apparent lapses in critical rigor in favor of an undifferentiated real time that punctuate his otherwise cogent logic thus read like a return to the seamless continuity of a *realism* that is in sharp distinction to the principle of disjunction that has impelled his argument from the beginning. The rush of modern technological advance thus risks occluding the differential that must define speed and that must define it as a fundamentally disjunctive temporal function. Derrida appears almost at pains to emphasize this in *Echographies,* starting in his introductory "Artifactualities" (extracted from another interview):

How can we avoid denying ourselves these new resources of live or direct recording (the videocamera, etc.), while continuing to be critical of their mystifications? And above all, while continuing to recall and demonstrate *that the "live [direct]" and "real time" are never pure, that they do not deliver to us intuition or transparency, a perception stripped of interpretation or technical intervention.*[54]

In a later exchange, Stiegler wants to relate the flux of televisual media to real time and suggest that viewers' perception of that flux—their limited capacity to slow it down or go back over it (in contrast to reading a book)—functions in opposition to the iterability defining technology. Derrida interrupts him more than once, noting finally that "When we watch television, we have the impression that something is happening *only once* . . . [that] it is 'living,' live [*direct*], real time,

whereas we also know, on the other hand, [that] it is being produced by the strongest, the most sophisticated repetition machines."[55]

Echographies is a media event that was produced in the shadow of Derrida's *Specters of Marx.*[56] Stiegler wants to focus on the possibility of a politics of the new media, and what I have called his lapse is all the more paradoxical in view of that. He seems to forget that resistance to the four-factored reality effect of cinematic or rather "televisual" consciousness is posited on the critical viewer's capacity to "discretize" that continuity. Although he wants to say that the continuity of real time is in fact a discrete time that needs to be understood as such, his desire to construct a theory based on Husserl and to respond empirically to new technological and mediatic forms seems to lead him in the above examples to accept that continuity rather more uncritically. Yet it is precisely within that paradox (or what might better be called, as Richard Beardsworth emphasizes after Derrida, a certain "aporia" of time) that the political can be said to reside.[57] Only by preserving the irreducibility of that aporia will we be able to develop the political responses to the media that Derrida argues for in *Echographies*—the right to take one's time, to change the "rhythm" of "actuality" for if speed and acceleration are not homogeneous, different rates can be practiced;[58] the refusal of the forms of passivity that new technologies reinforce;[59] the need to develop a resistance or politics of "exception" that does not rely on a reductive nationalism.[60]

Technology is undoubtedly *unheimlich* (uncanny). This is its prosthetizing effect, which, as we have seen, dislodges and disjoins the subject. And the benefits of technological and therefore economic advance are inequitably distributed in the extreme. Derrida and Stiegler are clear in stating that a response is required to this uncanniness and to this inequity. In *La désorientation,* Stiegler speaks of "decommunitisation"[61] and of the "disappearance of idiomatic difference."[62] In *Echographies,* Derrida states that "the global and dominant effect of television, the telephone, the fax machine, satellites, the accelerated circulation of images, discourses, etc., is that the *here-and-now* becomes uncertain, without guarantee: anchoredness, rootedness, the *at-home* [*le chez-soi*] are radically contested."[63] Yet a response that is "aporetically" political will have to avoid the powerful will to return home, the "earthbound" reactivity that we have seen in Virilio, and that is often Heidegger's recourse.[64] As Derrida states:

The more powerful and violent the technological expropriation, the delocalization, the more powerful, naturally, the recourse to the at-home, the return towards home . . . there can be no question, it seems to me, of choosing between the two, or of saying: What matters is the acceleration of the technological process at the expense of the desire for idiom or for national singularity. Between these two poles one must find, through negotiation, a way precisely not to put the brakes on knowledge, technics, science, or research, and to accede—if possible, inasmuch as it is possible—to another experience of singularity, of idiom, one that is other, that is not bound up with these old phantasmatics called nationalism or with a certain nationalist relationship to language, to singularity, to territory, to blood.[65]

In the final analysis, therefore, a reference to a real time that does not systematically disjoin it—that does not emphasize that time is always already disjointed by the technological and that every effect of the technological is always already disjointed by time, progressive acceleration notwithstanding—will be haunted by the risk of a continuity as reality effect that has as its extreme poles the apocalyptic crash on the one hand and the nativist retreat on the other.

The spatiotemporal disjunction—the becoming-space of time and the becoming-time of space—has for a long time now been called, among other things, *différance*. If technology is the exteriorization of memory, a certain "de/respatialization" of a disjunctive time, it could well be served by the same term. Stiegler is right to call for *différance* to be rethought in terms of speed, something that Derrida reinforces: far from favoring "delay, neutralization, suspension," far from attenuating the political and ethical urgency of the present, *différance* refers to what cannot be anticipated, "precipitation itself."[66] Hence, if there were to be such a thing as real time, absolute speed, or light time, it would have to be performed within that precipitation itself, as a practice of *différance*. Indeed, if that time were to be performed anywhere, it might well be by means of a fall into the word itself, *in différance*—in the spatiotemporal disjunction that is the palimpsestic or paleonymic erasure and reinscription of the "same" word (*difference* within *différance* or vice versa), with that aporetically coincidental disjunction occurring *en direct*, live or real, by means of the play between written alteration and phonic imperceptibility. Within such a disjunctive coincidence, technology plays as language—as ancient and contemporary as any innovative memory machine.

In the end, therefore, the sort of rhetorical speed that Stiegler seems, in discussing real time, to inadvertently revert to as something other than a slip can be read as a fault or a breakdown in his normally impeccably forceful analysis. Yet it is in a section entitled "Speed, Urgency, Risk," which commences following the pages parsed above, that we read that "Urgency, paradox of speed, is a double-bind:—go ever faster to reduce the risks;—by means of that acceleration, *displace* the risks by taking them, to their limit."[67] This, Stiegler continues, is "a para-dox of techno-logical automobility, of autonomy and of mobility, of accident and breakdown in essence/lack of fuel [*un paradoxe de l'automobilité techno-logique, de l'autonomie et de la mobilité, de l'accident et de la panne d'essence*] . . . the question of an autonomisation of the *techne,* of its auto-mobility whose law could only be the accident as *panne* [*comme défaut*] *d'essence, d'être—de temps.*"[68] Saving time, we will find that time is short; going faster, we can never go fast enough. The better it performs, the more often technology runs out of gas, the more it stumbles over the fact of its essence as a time that skips a beat, like a motor that misses, putters, and fails. Uttered this way, in the breakdown of its essence, Stiegler's thesis somehow goes faster, processing more information than in all its other formulations, as if there were a technology of language that he mobilized or that mobilized him to speak truly through a coincidence of real time.

Although language's relation to technology is emphasized throughout *La technique et le temps,* there is a sense in which it thereafter drops out of the techno-logical essence, neglects to (re)fuel the argument, becomes instead instrumental to technology, simply words that are processed by that technology. Yet technology also depends on language, on discourse, as does every cultural practice imaginable. Language is technology's *mode d'emploi,* the medium of philosophical and other discourses on it, the remobilization of terms and the invention of neologisms (*warp* and *morph*) that name it, and so on. Language can be seen thus both to serve and be served by technology but still be within an instrumentalist perspective.

Language—like the body, like time—is one of the technologies with which humans are most familiar. It is familiar enough not even to be experienced as technology. When the more obviously instrumental technologies—everything from the simplest tool to today's high technologies—interfere with language, it is experienced as a threat almost as menacing as the biotechnological engineering

of the human itself. For Heidegger, as Stiegler notes, the most serious thing that can happen is the technicization of language,[69] its reduction to information. Indeed, a whole politics of "cultural exception" that is related to language and to strategies of resistance to the technological instrumentalization of language remains to be developed. Stiegler has suggested as much in referring to the question of idiom. For much more than Heidegger could ever have imagined, there is now raised the possibility of a radical exteriorization and mechanization of certain linguistic functions, comparable to that of certain arithmetical functions that occurred with the invention of electronic calculators—the notion that apprenticeship in language will take on quite different forms. That is already underway thanks to spell- and grammar-checks and the automatic correction, formatting and so on that word processors perform without asking (for example, persistently changing *différance* to *difference* at the speed of light). Just as we are rapidly forgetting penmanship, we can easily imagine future generations that will not need to learn how to spell, form plurals, conjugate verbs, obey the sequence of tenses, and so on. And of course, a literacy that relies on digital technologies and is trained by icons and a mechanized language production may well not want to or know how to read a Joyce, a Proust, a *Beowulf,* and so on. Such considerations make for critical challenges for philosophers of technology and again call for responses that neither rush forward to the impending catastrophe of a language changing so quickly that it is about to crash nor fall back on the myth of a language that was once safely at home with itself—on the presumption that it "began" as something other than a technique, as something other than an anamnestic practice and a form of shorthand, a memory—and time—saver, a prosthesis.

So the place of resistance that I would like, finally, to mark here relates to the properly technological function of language itself that I have just referred to—its speed of light, its warp and its morph, or its trace-effect. Its *différance.* Its "organic" and originary self-division into otherness. Its prosthetic mutability. To call language "prosthetic" here does not just refer to the adoption by the human organism of the inorganic otherness language represents; nor does it simply involve an analogy between a word divided in itself and a body divided in itself. Prosthesis might borrow the figure of the body but does not originate in the body. It is rather that trace or *différance*—or in Stiegler's terms, that technology that permits the idea of the body as "entity" capable of articulating with its "outside" to

be constituted. And if the articulations that are defined by prosthesis are repeated from relation to relation, that repetition and those relations are each time disjoined in their articulation by the "fundamental" sense of incongruity and irreconcilability without which prosthesis would have no sense, such that analogy comes irremediably undone.[70]

In a word, then, at warp speed, morphing as it is uttered, language mutates and so invents. It *techneologizes.* Its invention is not just the invention of a word that follows a technological innovation but instead a *techneologistics* that is a language traveling at the speed of light or even "faster" as every trace does in its disjunctive displacement, irrespective of whether it takes a written material form, irrespective of any visuality. Language, as series of traces, morphs into warp speed as it comes into being by virtue of its *différance;* always already projected, it "arrives" ahead of itself; always already in prosthesis, it is its own displacement into an otherness whose contextual bounds it cannot itself foresee or control; always already in translation, it is a displacement out of the therefore never intact originary moment of its production, *en route* at lightning speed toward the outside limit of comprehensibility. But that is not all: the trace that instantly departs also doesn't arrive; it never obeys the teleology of a simple hermeneutic operation, the electronic certainty of a digital impulse. Or else, if you wish, it diverges as it departs; it departs in two directions at once, like the precipitate *différance* of Stiegler's *panne d'essence,* two radically different directions that may be as far apart as a hydrocarbon and a philosophical *eidos* but whose relations never really diverge. This physical impossibility, an impossibility of physics, makes language at once the oldest and the newest—as if beyond the newest—technology.

Yet language is technology. The *différance* of language cannot, as I have suggested and as Derrida affirms, be limited to the forms that we recognize as linguistic. What I have just outlined is also a structural fact of every trace or message, including the electronic digital impulse. To function, it must obey both the teleological necessity of the laws of physics *and* the equally necessary possibility of a law of invention, that of a *techneologistics.* Otherwise, nothing happens: no future and certainly no technology. This is not to say that the law of physics no longer holds. But if in the moment of technological certainty, indeed inevitability, that is ours, there is to be something new, then it can begin to be found only in a thinking of the impossible that returns us to and stops us in the very essence of

technology, where language and technology are encountered in their essential fault and *faute d'essence,* a moment of newness and otherness that is the techneologism wherein it all began.

Notes

1. Sigmund Freud, *The Standard Edition of the Complete Psychological Works of Sigmund Freud,* Vol. 21, *Civilization and Its Discontents,* trans. James Strachey (London: Hogarth Press, 1953–1974), 88.

2. Paul Virilio, *Cybermonde, la politique du pire* (Paris: Les éditions Textuel, 1996), 34. This and all translations from French texts by Virilio are mine.

3. See "JD-ROM" in my *Matchbook: Essays in Deconstruction* (Stanford: Stanford University Press, 2005).

4. Bernard Stiegler, *La technique et le temps,* Vol. 1, *La faute d'Epiméthée,* Vol. 2, *La désorientation,* Vol. 3, *Le Temps du cinéma et la question du mal-être* (Paris: Editions Galilée, 1994, 1996, 2001). This chapter was written before the appearance of Stiegler's third volume, whose preface explains that it in fact replaces what he had envisaged as the third volume, the still unpublished *Le défaut qu'il faut.* A translated extract from volume 3, *Le Temps du cinéma,* appears as Stiegler, "Transcendental Imagination in a Thousand Points," trans. George Collins, from Joanne Morra and Marquard Smith, eds., *The Prosthetic Aesthetic, New Formations,* 46 (2002): 7–22. See also "Le temps du cinema"/ "The Time of Cinema," trans. George Collins, *Tekhnema,* 4 (1998), 62–113. Volume 1 is translated as *Technics and Time,* Vol. 1, *The Fault of Epimetheus,* trans. Richard Beardsworth and George Collins (Stanford: Stanford University Press, 1998). All translations from volume 2, *La désorientation,* are my own.

5. Stiegler, *La faute d'Epiméthée,* 132.

6. Stiegler, *Technics and Time,* 121.

7. Stiegler, *La désorientation,* 164, 165.

8. Stiegler, *Technics and Time,* 23, translation modified.

9. Ibid., 135, translation modified.

10. Ibid., 43.

11. See my *Prosthesis* (Stanford: Stanford University Press, 1995) and "Thinking Back, towards Technology via Dorsality," *Parallax* 32 (2004), where certain ideas from this discussion are taken up again in the context of a book in preparation.

12. See Geoff Bennington, "Emergencies," *Oxford Literary Review* 18, no. 1–2 (1996): 182–191. Although he agrees that Stiegler avoids a "*simple* positivist transcen-

dentalism" (184), Bennington finds that Stiegler is nevertheless committed "to a certain positivism *about* difference, and this leads to his confident identification of 'technics' as *the* name for a problem which he *also* recognises goes far beyond any traditional determination of that concept. . . . Stiegler's book [is] perhaps the most refined example to date of the confusion of the *quasi-transcendental* (originary technicity) and *transcendental contraband* (technics)" (190). Although I do not find Stiegler's reading of Derrida's *différance* to diverge from Derrida's as much as either he or Bennington maintains, Stiegler is anxious to find in it a "hesitation" to which he will be able to give a name and something of a periodization that stems from the paleontological orientation that his argument is at that point developing (cf. Stiegler, *Technics and Time,* 135–142). Something of this urgency or anxiety returns in a recent essay, "Derrida and Technology: Fidelity at the Limits of Deconstruction and the Prosthesis of Faith," in Tom Cohen, ed., *Jacques Derrida and the Humanities: A Critical Reader* (Cambridge: Cambridge University Press, 2001). For the work involving cinema, see my discussion below (and, more recently, Stiegler's third volume, *Le Temps du cinéma*).

13. André Leroi-Gourhan, *Gesture and Speech,* trans. Anna Bostock Berger (Cambridge: MIT Press, 1993); originally published as *Le Geste et la Parole* (Paris: Albin Michel, 1964, 1965).

14. Ibid., 60.

15. Stiegler's figuration of this structural technicity is to a great extent conveyed by a linguistic operation—the rhyming of *silex* and *cortex* in French: "There would be a double emergence of cortex and flint [*silex*], a convention of the two, an archidetermination that would surpass them and that would be the double work of a double difference abysmally mirrored" (*Technics and Time,* 155) and earlier, "One must first ask what mirage of the cortex is experienced as pathbreaking, in the hardness of flint; what plasticity of grey matter corresponds to the flaking of mineral matter" (*Technics and Time,* 135, translation modified).

16. Stiegler, *Technics and Time,* 145.

17. Ibid., 116.

18. Stiegler, *La faute d'Epiméthée,* 132.

19. Stiegler, *Technics and Time,* 130, translation modified.

20. Bennington, "Emergencies," 181.

21. Stiegler, *Technics and Time,* 179, translation modified.

22. Ibid., 172.

23. Ibid., 17.

24. Ibid., 142.

25. Ibid., 50.

26. Ibid., 152–153.

27. Virilio, *Cybermonde,* 19.

28. Paul Virilio, *Speed and Politics,* trans. Mark Polizzotti (New York: Foreign Agent Series, 1986), 110.

29. Paul Virilio, *L'inertie polaire* (Paris: Christian Bourgois Éditeur, 1994), 160-161.

30. Virilio, *Cybermonde,* 54-55. In mounting a critique of Virilio in terms of his logocentric presumption of an originary naturality, I do not wish to occlude the political importance of his positions, starting with the centrality of speed to military and state apparatuses of repression (*Speed and Politics*) and leading up to more recent arguments in favor of a politics of the new urban landscape and of the media. Once again, though, his references to "pollution" and "accident" risk falling back on the same reductive eschatology referred to above (see also his *Open Sky,* trans. Julie Rose [London: Verso, 1997]). Later in this discussion I return to questions of speed and time in relation to politics and the media.

31. Virilio, *Cybermonde,* 52.

32. Stiegler, *Technics and Time,* 15.

33. Stiegler, *La désorientation,* 177.

34. Stiegler, *Technics and Time,* 16.

35. Stiegler, "Le temps du cinema"/ "The Time of Cinema," 68.

36. Jacques Derrida and Bernard Stiegler, *Echographies of Television: Filmed Interviews,* trans. Jennifer Bajorek (Cambridge: Polity Press, 2002), 162.

37. Stiegler, *Le temps du cinéma,* 102.

38. Stiegler, *La désorientation,* 24.

39. Edmund Husserl, *Lessons on the Phenomenology of the Consciousness of Internal Time,* trans. John B. Brough (The Hague: Nijhoff, 1991), 24.

40. Stiegler, *Le temps du cinéma,* 76.

41. Ibid., 90.

42. See Roland Barthes, "Rhetoric of the Image," in *Image-Music-Text,* trans. Stephen Heath (New York: Hill and Wang, 1977).

43. Stiegler, *Le temps du cinéma,* 104.

44. Ibid., 100, 108.

45. Stiegler, *Technics and Time,* 146.

46. Stiegler, *La désorientation,* 77-78.

47. Ibid., 136.

48. Ibid., 139 (my italics).

49. Ibid., 148.

50. Ibid., 149.

51. Ibid. (my italics).

52. Ibid., 150 (my italics).

53. Ibid., 161–162.

54. Derrida, "Artifactualities," in Derrida and Stiegler, *Echographies,* 5, translation modified.

55. Ibid., p. 89.

56. Framed at beginning and end by Derrida's "Artifactualities" and Stiegler's "The Discrete Image," respectively, the book *Echographies of Television: Filmed Interviews* otherwise consists of a series of interviews with Derrida conducted by Stiegler and filmed for the Institut National de l'Audiovisuel in December 1993. Cf. Jacques Derrida, *Specters of Marx,* trans. Peggy Kamuf (New York: Routledge, 1994).

57. Richard Beardsworth, *Derrida and the Political* (New York: Routledge, 1996), especially xiii–xvi, 32–40, 91–95, 101–105, 147–151. Beardsworth concurs that "the real time of the teletechnologies risks reducing the *différance* of time, or the aporia of time, to an experience of time that *forgets* time" (148) and "despite real time's reduction of the human experience of the passage of time, the passage of time . . . *cannot be technicized,* it cannot be absolutely reduced" (149). Yet he also raises a number of questions (as it were, on Stiegler's behalf) concerning Derrida's thinking of technics (95–97, 151–153) that require analysis exceeding the space of my discussion here. Bennington discusses those questions, as well as a reductiveness inherent in Beardsworth's singular emphasis on time, in some detail in "Emergencies."

58. Derrida and Stiegler, *Echographies,* 6–7, 70, 77.

59. Ibid., 70.

60. Ibid., 45.

61. Stiegler, *La désorientation,* 93, 155.

62. Ibid., 168.

63. Derrida and Stiegler, *Echographies,* 79.

64. Ibid., cf. 133–134.

65. Ibid., 80.

66. Ibid., 10.

67. Stiegler, *La désorientation,* 164.

68. Ibid., 165.

69. Cf. ibid., 206–207.

70. See Wills, *Prosthesis,* 18–19, 26–27, 44–45, 134–143.

DRAWING MACHINE: WORKING THROUGH THE MATERIALITY OF RAUSCHENBERG'S DANTE AND DERRIDA'S FREUD[1]

Joanne Morra

All material has history. All material has its own history built into it. There's no such thing as "better" material. . . . An artist manufactures his material out of his own existence—his own ignorance, familiarity or confidence.
 —*Robert Rauschenberg,* Rauschenberg: An Interview with Robert Rauschenberg[2]

Drawing is a graphic language.
 —*Howard Warshaw,* Drawings on Drawing: A Graphic Reflexion of the Language of Drawing[3]

What is intolerable and fascinating is indeed the intimacy intertwining image and thing, graph. . . .
 —*Jacques Derrida,* Of Grammatology[4]

This text grows out of my interest in Robert Rauschenberg's early artistic practice from the 1950s and my developing concerns with the question of drawing. It combines a rigorous attention to the materiality of the work of art, artistic process, and their theoretical possibilities. A basic premise is the reciprocity or dialectic that is at play between the material and the theoretical. This has much in common with recent discussions on prosthesis within contemporary theory, cultural and

disability studies, which have considered prosthesis as both a literal, material and phenomenological concern and a metaphorical, theoretical, and philosophical one.[5] Both literal and abstract understandings of prosthesis have enabled a fruitful debate on the questions of subjectivity, epistemology, and ontology.

Within the discourses of prosthesis as theoretical concept, Bernard Stiegler has posited that the work of art is an "ex-pression" of interiority[6]—a prosthesis of the human body. Although my essay begins from this position that the work of art is a prosthesis, it attempts to problematise this by bridging the material and metaphorical polarities within the recent debates on prosthesis.[7] As such, I consider the materiality of the work of art, and at the same time, it becomes my theoretical tool. By working within a dual structure, the material and the philosophical, I can critically examine the way that Jacques Derrida's philosophical discourse on the graphic trace aims to repress the question of materiality. To reiterate this thesis differently, the materiality of the work of art makes it possible to disclose an elision of the material concerns within his philosophical discourse. This critique functions within the limited framework of a single work of art—Robert Rauschenberg's *Drawings for Dante's Inferno* (1958-1960)[8]—and of a single text—Jacques Derrida's "Freud and the Scene of Writing" (1966).[9] By deploying Rauschenberg's *Drawings* as a material and critical practice, I take to task the repression of the visual within Derrida's text and recover the materiality of the psychic trace from metaphorical obfuscation. In effect, then, I am positing an analogy between debates within prosthesis (material versus philosophical) and the way in which a work of art (as a prosthesis) and its process of making (as both material and theoretical) can enable a new way of considering this contested arena within debates on prosthesis.

At the same time, I aim to make a specific incursion into the question of prosthesis and its relationship to writing, subjectivity, and the psyche. Prosthesis as a means of understanding the construction of subjectivity—as corporeal and psychic—has been theorized in relation to speech and writing by many noted thinkers such as Derrida, Stiegler, and David Wills.[10] In this important scholarship, speech becomes a means of exteriorizing the subject's interiority—and this is similar to, as I have mentioned, the work of art.[11] Writing, as "graphic trace," is also posited as the subject's supplement—its prosthesis. However, for the written word to be privileged, a repression has taken place. And once again, with the assistance of Rauschenberg's *Drawings,* I recuperate this elided aspect of the graphic

and posit its supplemental and prosthetic nature to writing and the constitution of subjectivity.[12]

———

In 1958, Rauschenberg began his *Drawings for Dante's Inferno* using a transfer technique that he invented in 1952 while traveling in Cuba. The American artist's *Inferno* is singular in the confluence of its mode of production, its imagery, and the historical context of its emergence. Taking over two and a half years to make, the thirty-four cantos form a collective archive of American life between 1958 and 1960. The interpretation of Dante's *Inferno* that is envisioned in these drawings is a collaborative venture between Rauschenberg, Michael Sonnabend (a Dante scholar and friend of the artist who assisted him with the allegorical dimension of the poem), and John Ciardi's popular American translation of *The Inferno.*[13] Written in the *vulgari*—the vernacular spoken language of fourteenth-century Florence—the poem tells the tale of Dante, who is guided by the Roman poet-philosopher Virgil as they descend through the nine circles of hell and encounter political, cultural, and historical persons who are bound there by their wicked and self-destructive actions on earth. As Ciardi says, "The poem was conceived as a preachment, as an exhortation to godliness. The reader who does not care to read for its religious point is free to read for psychological insights."[14]

Perhaps the medieval poem is best known for the analogy it figures between delving into the depths of hell and a journey of self-discovery. Rauschenberg represents this secularized journey through images of contemporary American life. Sifting through issues of *Sports Illustrated, Life, Time,* and *Newsweek,* for example, he clipped out popular imagery for his own vernacular narrative. Dante's *Inferno* becomes a fifties American *Inferno*. The drawings delve into the ideological formation of the American psyche and disclose its underbelly, its unconscious, while at the same time referencing the subjectivity of a Dante, an everyman who is the product of his milieu. In *Canto II* (figure 13.1), Dante is represented by the semi-nude male figure in the upper right corner of the drawing. Beneath him we find a classical female statue that has been substituted for Beatrice—who is the woman that Dante loves—and an arrow is used to direct an athlete further into hell. In *Canto IX* (figure 13.2), blinded eyes cannot but see anonymous black faces, the

Figure 13.1: Robert Rauschenberg, *Drawings of Dante's Inferno, Canto II*, 1958–60, Museum of Modern Art, New York, copyright DACS, London

Figure 13.2: Robert Rauschenberg, *Drawings of Dante's Inferno, Canto IX,* 1958–60, Museum of Modern Art, New York, copyright DACS, London

White House, and astronauts, referencing desegregation, the arms race, and the cold war. In *Canto XII* (figure 13.3), the political situation is further connoted in the guise of John F. Kennedy, Adlai Stevenson, and Richard M. Nixon. The latter is plunged down into the bowels of a red and painful hell. And in the end, *Canto XXXIV* (figure 13.4) solidifies a reading that the emergence through hell is a cultural and historical battle fought by everyman's alter ego—as Dante is represented doubled and upside down.

Rauschenberg worked on one drawing and one canto at a time. He found the relevant images for each before moving on to the next. In the first stage of the transfer process, an image from the popular press is substituted for a moment in the poem, and a metaphorical relationship is established. This aspect of the process is based (as is metaphor) on the practice of difference. Within this metaphorical structure, the process represents two moments of historical and cultural difference: (1) the difference between the clipping and that which it now represents in relation to Dante's text, for example, Dante is often depicted as a seminude male figure taken from an advert for golf clubs; and (2) the difference between the two—at least two—contexts that are figured in the clipping's movement from the popular press to a work of art and their political, historical, and cultural contexts.

After finding the relevant images for a single canto, Rauschenberg transferred them onto paper. His transfer drawings were produced by soaking clippings in lighter fluid, placing them face down onto paper, and stroking the back of each with an empty ball point pen,[15] which transfers the image of the clipping onto the drawing paper.[16] The deteriorating clippings transfer as traces of an original image, in reverse. The process of production remains visible in the strokes and hatchings that veil the transferred image. This physical and material transfer of the clipping image's trace can be understood as a metonymic deferral, whereby the image is shifted from the newsprint onto the drawing paper. This stage of the process is based (as is metonymy) on the practice of deferral. This practice occurs without the artist's being able to either see the image (since the clipping is faced down) or the process of its manifestation (whether, for example, the image has been fully transferred). The process of transfer drawing as a material practice, then, provokes a theoretical conceptualization of it based on the structure and practice of metaphor and metonymy—on difference and deferral.

Figure 13.4: Robert Rauschenberg, *Drawings of Dante's Inferno, Canto XXXIV*, 1958–60, Museum of Modern Art, New York, copyright DACS, London

In the final stage of making, Rauschenberg washed over many parts of the drawings with goauche or watercolor and sometimes added pencil drawings and diegetic signs such as arrows—to create an overall illusive and allusive ambience and a narrative strategy for his *Inferno.*

The duality of the dreamlike and allegorical qualities of the transfer drawings has led several critics to compare them to the unconscious: both are a reservoir of inscriptions—personal, historical, cultural—that are imprinted on a ground.[17] Blurred, veiled, partially unknowable, partially reconfigured, or known through metaphoric substitution, the drawings as inscriptions have characteristics that are familiar to us from the language of psychoanalysis. In fact, the associations bring to mind Freud's writings on dreams, his early work on the breaching of the psyche in *Project for a Scientific Psychology,* and the paper on the *Wunderbloch* or Mystic Writing-Pad.[18]

———————

A light bulb in the dark cannot show itself without showing you something else too.
 —Robert Rauschenberg, "Random Order"[19]

What is intolerable and fascinating is indeed the intimacy intertwining image and thing, graph. . . . There are things like reflecting pools, and images, an infinite reference from one to the other, but no longer a source, a spring. There is no simple origin. For what is reflected is split in itself. . . . The reflection, the image, the double, splits what it doubles. The origin of the speculation becomes a difference. What can look at itself is not one; and the law of the addition of the origin to its representation, of the thing to its image, is that one plus one makes at least three.
 —Jacques Derrida, Of Grammatology[20]

In "Freud and the Scene of Writing," Derrida explores the *content* and *structure* of psychoanalysis by reading both the way in which the psychic trace is constituted *and* the apparatus that Freud posits as a means of representing the formation of the psyche as a system. Thus, the philosopher explores issues around representation as they relate to the unconscious graphic trace, dreamwork, and the structuring metaphors of psychoanalysis.

Derrida begins by laying down his text's "limited" task—to uncover certain crucial moments in the analyst's thought wherein the metaphorical models that are used for understanding the psyche are borrowed from script rather than the spoken word. By choosing to discuss the formation of the psyche through the graphic trace, Derrida posits that Freud "makes what we believe we know under the name of writing enigmatic . . . and opens up a new kind of question about metaphor, writing, and spacing in general."[21] As I have mentioned, for the philosopher the analyst employs the graphic metaphor in relation to two areas of representation—content and structure: "Psychical *content* will be *represented* by a text whose essence is irreducibly graphic. The *structure* of the psychical apparatus will be *represented* by a writing machine."[22] This acknowledgment of the necessary "externalization" of the content and structure of representation within Freudian psychoanalysis as graphic and a writing machine is closely connected to some of the philosophical debates on prosthesis. For instance, the work of Stiegler and Wills has taken this concern with "externalization" as a starting point, and in a different manner, Friedrich A. Kittler's work has focused on this concept of the "writing machine."[23] Having said that, my main interest here is to follow Derrida's path in this specific text. Derrida is concerned with the way in which Freud deploys the graphic when he discusses the inscription of traces on the unconscious (the subject as representation) and also when he represents a metastructure for the functionings of the psyche as a machine (discourse as representation). If Freud is representing psychic writing through the graphic metaphor and thereby is instigating a notion of the psyche as text, then Derrida asks, "What is a text, and what must the psyche be if it can be represented by a text?"[24]

And at this point, my critique of Derrida through the materiality and process of Rauschenberg's transfer drawings begins. Through a close reading of "Freud and the Scene of Writing" and *Canto xx* of Rauschenberg's *Inferno,* I explore the associations and elisions raised by Derrida's interests and my own concerns with materiality and drawing (see figure 13.5).

In Dante's "Canto *xx*," he arrives at the Fourth Bolgia of hell's Eighth Circle. Standing on a bridge and looking into the fourth moat, Dante sees the wretched distorted figures of those whose heads have been reversed on their necks. Unable to see in front of them, the damned stare backward, looking toward what is behind them. Pitifully crying for themselves, the tears run down

Figure 13.5: Robert Rauschenberg, *Drawings of Dante's Inferno, Canto XX,* 1958–60, Museum of Modern Art, New York, copyright DACS, London

their buttocks. Dante is overcome by grief and bursts into tears. At the sight of his companion's emotional outburst, Virgil chastises him for feeling pity for the arrogant souls beneath them. Collecting himself, Dante looks down and sees Amphiareus—one of the seven champions who joined Oedipus's son Polyneices to fight against Thebes. Foreseeing his own death during battle, Amphiareus attempts to run away from his post but is swallowed by an earthquake during his flight. As the punishment fits the crime, Dante is asked to "observe how he has made a breast of his back. / In life he wished to see too far before him, / and now he must crab backwards round this track."[25] While Dante looks on, Amphiareus "fell headlong through the gaping earth / to the feet of Minos, where all sin must yield."[26] Sifting through the crowd, the Florentine also recognizes Manto—the founder of Mantua—"whose unbound hair flows back to hide / her breasts—which you cannot see—and who also wears / all of her hairy parts on that other side."[27] After pointing out many other diviners cast into hell's Eighth Circle, Virgil takes heed that the moon is full and that they must travel on.

Rauschenberg's *Canto XX* (figure 13.5) begins with Dante's arrival onto the next level of the bridge. Having been carried onto it by Virgil—referenced by an astronaut's head with an arrow pointing to a representation of the towel-robed man (Dante)—Dante appears for a second time settled on the bridge at the top of the drawing. After seeing the disfigured forms of the Diviners below, the horrified Dante begins to sob. Rauschenberg represents this in the open-mouthed and ghastly face in the upper right corner. Unified by two vertical pencil lines, this part of the image functions as a separate frame within the drawing. Below are the sinners. Filled to the brim with layers upon layers of figures whose heads have been reversed, Rauschenberg includes Manto (the woman is represented in the upper right corner above the rest of the sinners, and her unbound hair flows back to hide her breasts), a barely discernible representation of Minos the bull in the center of the crying mass, and a representation of Freud in the upper left region of this moat full of diviners and soothsayers. Condemned to hell for his desire to see into the future through the past, Rauschenberg includes the analyst in the twentieth Canto of his *Inferno.*[28] As the moon is represented full in the bottom corner of the drawing, Dante and Virgil must move on.

Derrida begins his chronological reading of Freud by noting that in the *Project for a Scientific Psychology* of 1895 the analyst begins to use the concept of the

trace to examine the content and structure of the psyche.[29] The trace enables Freud to, in his own words, "'represent psychical processes as quantitatively determined states of specifiable *material* particles.'"[30] The formation and function of the trace also gives Freud the opportunity of gesturing toward a *metadiscursive* apparatus for understanding memory. The analyst is specifically interested in the way in which material particles are inscribed on the psyche—the psyche being at the same time both a blank and a marked surface—and are called on by memory to consciousness. Thirty years later, he uses the structural metaphor and the material object of the Mystic Writing-Pad[31] to posit a structure for memory and the unconscious. However, in 1895, Freud concentrates on developing a theory concerning the way in which material inscriptions are represented through *Bahnung* or breaching (facilitation) in and on the psyche.

Freud posits that there are two types of neurones—those that do not offer any type of resistance to inscription and therefore leave no trace of contact and those that do offer resistance and thereby produce a trace. For Derrida, "Breaching, the tracing of a trail, opens up a conducting path. Which presupposes a certain violence and a certain resistance to effraction. The path is broken, cracked, *fracta,* breached."[32] The two kinds of breaches "'thus afford [Freud] a possibility of representing [*darzustellen*] memory,'" wherein memory is represented by the differences between breaches.[33] As Derrida summarizes, "Trace as memory is not a pure breaching that might be reappropriated at any time as simple presence; it is rather the ungraspable and invisible difference between breaches."[34] The difference between breaches may be altered through repetition, wherein the repeated inscription of the nontraceable mark may eventually lead to an inscription *with* trace. However, an originary breach does not exist since all breaches always take place in relation to something else—resistance: this Derrida calls "the contact between two forces."[35] Thus, breaching is always already a repetition, a doubling, since it is always produced in relation to an other and is therefore without origin. To balance the expenditure that is used in making the inscription through breaching and repetition, the trace maintains a remainder. This remainder displaces or defers an excessive expenditure. The mitigation of excess delays death and at the same time instigates desire—the pleasure principle.[36]

As breaching "'serves the primary function'" for Freud,[37] Derrida is not surprised when five years later in *The Interpretation of Dreams* the analyst defines

primariness as a "'theoretical fiction'" in relation to the "'delaying'" of the secondary process of psychic formation.[38] The theoretical fiction of primariness allows Derrida to posit that the foundational moment of the Freudian psyche is *différance,* wherein the psychic trace is the nonoriginary origin of nonpresence.

In this way, for Derrida, the psychic trace or breach as *différance* is thus constituted through difference and deferral, and through the erasure of the myth of the origin as presence. (This is one of Derrida's continued affirmations in *Monolingualism of the Other, or The Prosthesis of Origin.*) It is also figured through the qualitative difference in the space and place of the inscription—its context. For Freud, the qualities between inscriptions are due to "'*sensations* which are *different* [*anders*] and whose difference [*Anders,* lit. otherness] is distinguished [*unterschieden wird,* lit. is differentiated] according to its relations with the external world.'"[39] Therefore, qualitative differences in and between breaches have to do with the external world—with language, culture, society, and so on. Derrida rereads qualitative difference as "pure differences, differences of situation, of connection, of localization, of structural relations more important than their supporting terms; and they are differences for which the relativity of outside and inside is always to be determined."[40] (And here we hear the echo of both Stiegler's and Wills's work on prosthesis as a dialectic of interiorization and exteriorization.) However, these sensations cannot be quantifiable in the external or internal world. They are qualities that are a part of the quantitative inscription of the trace. For Freud, these qualitative differences are temporal in nature. They form the temporal moment— the contextual time—within which the space of the trace is breached. Thus, Derrida proposes that the psychic trace as nonoriginary origin is constituted through the time and space of *différance* as difference and deferral.

Is it possible to consider the formation of the psychic trace as analogous to the time and material practice of transfer drawing—the *metaphoric difference* and *metonymic deferral* of this practice's material inscription? And what are the consequences of such a comparison?

Metaphors have been theorized as violent because in the act of substitution, metaphors privilege similarity and elide difference.[41] That is, a metaphor works only if the two objects that are conjoined are believed to be more similar than different. In the case of Rauschenberg's drawings, viewers must believe that the similarities between Dante and a seminude man wrapped in a towel and standing

in front of a medical chart are enough that their differences and Dante's unique-
ness fall by the wayside. As a result, in Rauschenberg's drawings, the substitution
that takes place puts the primary object, Dante's *Inferno,* under erasure, in order to
privilege the fifties imagery. However, it is difficult to substitute images for words
since the irreducible gap between them is impossible to overcome. Rauschen-
berg's *Drawings* give themselves away as impossible translations of the verbal to the
visual. The art historian and critic Doré Ashton, writing on the *Dante Drawings,*
points out many of the artist's attempts to translate the verbal, aural, and visceral
into the visual. But the gaps remain.[42] The metaphor fails in its task.

As I have mentioned, metonymy (or deferral) is also an aspect of how the
drawings were produced. In transferring the image, the artist has caused connec-
tion, contingency, displacement, and reversal to take place. The clipping, text,
and drawing paper are contingently connected through a mediated practice of the
external world of everyday life, politics, and culture and the internal world of the
artist as subject. The process of transferring a clipping onto drawing paper is a
spatialized and temporal practice of deferral of the contact between image and
paper and of the time of drawing. The clippings, the cultural archive, and its his-
torical moment are deformed. They are used up; they deteriorate in the process
of rubbing during the act of transference. The clippings become traces of their
former selves—imprints. They follow the logic of the unconscious and become
reversals, distortions. But something is forgotten. What about the discarded clip-
pings (the piece of newsprint with Freud's head on it, for instance)—the "re-
mainder"? The used-up clippings are deformed through this practice and are
literally used up. The images actually deteriorate and fall apart in the process of
rubbing. However, traces of their materiality remain and form the representa-
tional basis of the drawings. According to the logic of the unconscious, the clip-
pings constitute the materiality of the historical, cultural, and economic traces
that are inscribed on the unconscious. This is similar to what Rauschenberg refers
to as the "complex interlocking disparate visual facts" of the media image that
form the stuff of the "subconscious," wherein a connection is produced by the
conjunction of "disparate" things—"visual facts."[43]

Like the originary trace, for Derrida (and then later Freud) the psychic in-
scription is a fiction because it is constituted through the other of resistance. In
Rauschenberg's *Drawings,* the breaching is produced by the pressure of the pen,

and the resistance by its contact with the clipping and the paper onto which it is inscribed—between the pen strokes that form the astronaut's head and the drawing paper. The contact is between two forces. The violence enacted by the process of inscription uses up and distorts both the clipping and the image, while producing a remainder—the material (the ink, the astronaut's portrait) that is displaced onto the paper.

I have suggested that this metonymic function is the difference and deferral of the drawings, and now I align it with the difference and deferral of the psychic trace. In Rauschenberg's *Inferno,* for instance, the inscription of Freud's head, the pressure of the pen against the resistant paper, the color of the trace, its placement on the paper, and the traces that it overlaps or fails to, overlaps all constitute differences within and between the image itself. In addition, the differences between Freud's head and the astronaut's head, the pressure that was used to inscribe them, the color of the traces, their place on the paper, and the presence or absence of a watercolor wash all constitute differences between the images. These are the temporal and spatial differences within and between the traces (breaches) that constitute the image and its transferral. Each of the breachings (each transfer) differs from the next by the image that is represented, the force of the pen, the resistance of the clipping, and the repetition of the transfer onto another image. But unlike Derrida's difference (which is always already the written trace), *the difference that is proposed by the drawings is constituted by the difference within the graphic itself:* the difference is *between* the written and the drawn. As both writing and drawing and yet neither, Rauschenberg's *Inferno* functions as a graphic undecidable. Freud does not need to be reminded of the graphic's dual structure; his work on the psychic trace is replete with pictographic metaphors. But Derrida represses the pictorial element within the graphic,[44] and Rauschenberg's *Drawings* interrogate Derrida's thinking. In the duality that can be found within the full meaning of the term *graphic,* the graphic is both writing *and* drawing. By repressing the visual—the drawn aspect of the graphic trace—this philosophical genealogy has been able to privilege the written word. In effect, Rauschenberg's *Drawings for Dante's Inferno,* as image and practice, enable us to rethink Derrida's "writing machine"[45] and posit it as a *drawing machine.*[46]

Why repress the pictorial? Why subsume the visual into the textual? This disavowal can be used to initiate an answer for Derrida's own question: what must

the psyche be if it can be represented by a text? If the psyche is constituted by the graphic trace, then it is both the textual *and* the pictorial.

This aspect of Derrida's elision and Freud's explicitness in relation to the pictographic becomes more pressing when the philosopher turns to his second main task—the analysis of the graphic within Freud's discussions of the apparatus through which the system of psychic traces, dreamwork, and interpretation can be understood. Freud maintains the momentum and movement of the psyche by employing a number of visual metaphors for describing the psychic structure as a *mise en scène*. For example, the microscope and the photographic apparatus are utilized to give a sense of the graphic trace as given in a place that is not a tangible component of the apparatus itself. The machines also represent both the spatial and temporal factors that are involved in the production of psychic traces. (Here Kittler's work resonates strongly.) The apparatus must also be able to retain inscriptions while at the same time capturing changes within them. "We should not be surprised," Derrida suggests, by Freud's turn to visual apparatus "to suggest the strangeness of the logico-temporal relations in dreams, [since Freud] constantly adduces writing, and the spatial synopses of pictograms, rebuses, hieroglyphics and nonphonetic writing in general."[47] And one of these visual metaphorics is Freud's Mystic Writing-Pad.

Almost thirty years after publishing *Project for a Scientific Psychology* (1895) and after many discarded pictorial metaphors, Freud chanced on the Mystic Writing-Pad—an apparatus that metaphorically represents the psyche in its entirety. In "A Note upon the 'Mystic Writing-Pad'" (1925), Freud posits a technological prosthesis.[48] In Freud's time, the Mystic Writing-Pad was a children's toy consisting of a slab of wax resin, at the top of which were secured two sheets, the lower edges unattached. The protective covering sheet was made up of celluloid, and the bottom one was wax paper. By pressing upon the celluloid sheet with a stylus or a fingernail, an inscription, or dark trace, was made by the wax paper attaching itself to the wax resin below. In order to erase the mark, one needed only to lift up both sheets and the inscription seemingly disappeared, except that a trace of its former self remained on the resin. This apparatus represents for Freud an almost perfect material, machinic, and prosthetic metaphor for the function of memory and graphic traces. The Mystic Writing-Pad allows the trace to be inscribed on the unconscious (the wax slab), and for it to acquire visibility

as a conscious memory trace (the dark trace), and then to fall back into the re-cesses of the unconscious when the sheets are lifted (the clean sheets and the faint indentation on the wax). For Freud, history and the external world also affect the unconscious and conscious mind in this process. In addition, the gap between the sheets and the waxed slab represents a theory of discontinuous time within the formation of subjectivity. The process also presupposes a subject whose labor al-lows the graphic mark to be inscribed, to be erased, and yet to remain present as trace. But Freud was clear to articulate the fact that, unlike memory, the Mystic Writing-Pad was unable to reproduce memories from within itself.

Following Derrida and Freud, I propose that the Mystic Writing-Pad is another layer of the critical relationship being formed between psychoanalysis and Rauschenberg's *Drawings for Dante's Inferno*. For example, it is possible to con-sider Freud's waxed slab as the drawing paper that Rauschenberg employs. The fine celluloid sheet is the clipping that protects the drawing paper and the trans-ferred image while at the same time ensuring that a trace is produced. The writ-ing or transfer seems to vanish, but a material inscription remains. However, in "A Note upon the Mystic Writing-Pad," Freud reconsiders the necessity of the material particles with which he began *Project for a Scientific Psychology*. He suggests that with the Mystic Writing-Pad, material trace is an unnecessary consideration. And yet, it seems to me that the materiality of the trace is essential to a reading of the Mystic Writing-Pad as a prosthetic apparatus. The material trace of the *Draw-ings* insists on it. Isn't the production of an inscription between the wax paper seal-ing itself on the waxed slab based on material contact and material trace? Isn't the trace an imprint that is demarcated through material difference: the different pres-sures and resistances that are placed on the sheets and the waxed slab, for instance, produce various types of grooves and depths of color. Like the transferred mate-rials that constitute Rauschenberg's drawings, the inscriptions made on the Mys-tic Writing-Pad are also material formations. Rauschenberg's *Inferno* points to the existence and necessity of a materiality that inscribes and gives form and sub-stance to the graphic mark and its trace.[49]

In the end, as Derrida suggests, "The subject of writing [and now also of drawing] is [for Freud] a system of relations between strata: the Mystic Pad, the psyche, society, the world."[50] The graphic as text *and* drawing is certainly consti-tuted through and by these relations of representation. And yet what of the *sub-

ject of writing? The Mystic Writing-Pad must be controlled by two hands—the labor of the subject of psychoanalysis and the subject's relation to the external world. Like the labor involved in Rauschenberg's *Drawings for Dante's Inferno,* one hand must draw and gesture, while the other holds the clipping and drawing paper in place.[51] When the process is complete, and the clipping is removed, the trace—materiality, history, and subjectivity—remains as a prosthesis of drawing as supplement.

Notes

1. I would like to thank Omayra Cruz, Harry Gilonis, Raiford Guins, Fred Orton, and especially Marq Smith for their longstanding advice, support, and encouragement. I would also like to thank Central Saint Martins College of Art and Design for its continued generosity, and the Leverhulme Trust for awarding me a fellowship that has given me much-needed time for my work.

2. Robert Rauschenberg and Barbara Rose, *Rauschenberg: An Interview with Robert Rauschenberg* (New York: Avedon, 1987), 58.

3. Howard Warshaw, *Drawings on Drawing: A Graphic Reflexion of the Language of Drawing* (Santa Barbara, CA: Ross-Erikson, 1981), 20.

4. Jacques Derrida, *Of Grammatology,* trans. Gayatri Chakravorty Spivak (Baltimore: Johns Hopkins University Press, 1974, 1976), 36.

5. See, for example, N. Katherine Hayles, *How We Became Posthuman: Virtual Bodies in Cybernetics, Literature, and Informatics* (Chicago: Chicago University Press, 1999); Sarah S. Jain, "The Prosthetic Imagination: Enabling and Disabling the Prosthesis Trope," *Science, Technology, and Human Values* 24, no. 1 (1999): 31–54; Celia Lury, *Prosthetic Culture: Photography, Memory and Identity* (London: Routledge, 1998); David T. Mitchell and Sharon L. Snyder, "Introduction: Disability Studies and the Double Bind of Representation," in *The Body and Physical Difference: Discourses of Disability* (Ann Arbor: University of Michigan Press, 1997); Katherine Ott, "Introduction," in Katherine Ott, David Serlin and Stephen Mihm, eds., *Artificial Parts, Practical Lives: Modern Histories of Prosthetics* (New York: New York University Press, 2002); Vivian Sobchack, "A Leg to Stand on: Prosthesis, Metaphor, and Materiality," chapter 2 in this volume; Bernard Stiegler, *Technics and Time,* Vol. 1, *The Fault of Epimetheus,* trans. Richard Beardsworth and George Collins (Stanford: Stanford University Press, 1998); Stiegler, "Transcendental Imagination in a Thousand Points," trans. George Collins, in Joanne Morra and Marquard Smith, eds., *The Prosthetic Aesthetic* (Special issue),

New Formations 46 (2002): 7-23; David Wills, *Prosthesis* (Stanford, CA: Stanford University Press, 1995).

6. Stiegler, *Technics and Time;* Alphonso Lingis, "The Physiology of Art," chapter 4 in this volume; David Wills, "Techneology or the Discourse of Speed," chapter 12 in this volume.

7. For a sharp critique of the philosophical uses and abuses of prosthesis, see Sobchack, "A Leg to Stand On," chapter 2 in this volume.

8. For various readings of Rauschenberg's *Drawings for Dante's Inferno,* see, for instance, Doré Ashton, "Rauschenberg's Thirty-four Illustrations for Dante's *Inferno,*" *Metro* 2 (May 1961): 53-62; Laura Auricchio, "Lifting the Veil: Robert Rauschenberg's *Thirty-four Drawings for Dante's Inferno* and the Commercial Homoerotic Imagery of 1950s America," in Thomas Foster, Carol Siegel, and Ellen E. Berry, eds., *The Gay '90s; Disciplinary and Interdisciplinary Formations in Queer Studies* (New York: New York University Press, 1997); John Cage, "On Robert Rauschenberg, Artist, and His Work," *Metro* 2 (1961): 36-51; Andrew Forge, *Rauschenberg* (New York: Abrams, 1969, 1972); Brandon W. Joseph, "'A Duplication Containing Duplications': Robert Rauschenberg's Split Screens," *October* 95 (2001): 3-27; Joseph, *Random Order: Robert Rauschenberg and the Neo-Avant-Garde* (Cambridge: MIT Press, 2003); Rosalind Krauss, "Perpetual Inventory," in *Robert Rauschenberg: A Retrospective,* exhibit catalogue, curated by Walter Hopps and Susan Davidson (New York: Guggenheim Museum and Abrams, 1997), 206-223; Krauss, "Rauschenberg and the Materialized Image," *Artforum* 13 (1974): 36-43.

9. Jacques Derrida, "Freud and the Scene of Writing," in *Writing and Difference,* trans., intro., and notes Alan Bass (London: Routledge, 1990), 196-231.

10. On the question of language and prosthesis, see, for instance, Jacques Derrida, *Monolinguism of the Other, or The Prosthesis of Origin,* trans. Patrick Mensah (Stanford: Stanford University Press, 1998); Stiegler, *Technics and Time;* Stiegler, "Transcendental Imagination"; and Wills, *Prosthesis.* Wills's work quite securely connects language to the body (see, for example, 137).

11. A prosthetic exteriorization also becomes an interiorization, and a dialectic is set into place between inside and outside. See Derrida, *Monolingualism;* Stiegler, *Technics and Time;* Wills, *Prosthesis.* This dialectic is also at play within Rauschenberg's practice, which takes on the overdetermination of the relationship between art and life and which, in effect, takes on that "and." See, for instance, my "Rauschenberg's Skin: Autobiography, Indexicality, Auto-Eroticism," in Joanne Morra and Marquard Smith, eds., *The Prosthetic Aesthetic* (Special issue), *New Formations* 46 (2002): 48-63.

12. My essay is attempting something similar to the work of Yve-Alain Bois in his text "Matisse and 'Arche-drawing,'" in *Painting as Model* (Cambridge: MIT Press, 1990), 3-64. Rather than unpacking the arche-drawing of Derrida's arche-

writing, however as Bois does through an analysis of Matisse's art practice), I am interested in the *elision* of drawing within Derrida's conceptualization of the graphic as revealed to us through Rauschenberg's *Thirty-four Drawings for Dante's Inferno*. For various perspectives on drawing, see, for instance, Karen Edis Barzman, "Perception, Knowledge, and The Theory of *Disegno* in Sixteenth-Century Florence," in *From Studio to Studiolo: Florentine Draftsmanship under the First Medici Grand Dukes,* exhibit catalog, ed. Larry J. Feinberg (Seattle: Allen Memorial Art Museum Oberlin College and University of Washington Press, 1991), 37–48; Bois, "Matisse"; Sabine Breitwieser, ed., *Reorganizing Structure by Drawing through It* (Vienna: Generali Foundation, 1997); Cornelia H. Butler, *Afterimage: Drawing through Process,* exhibit catalog (Los Angeles: Museum of Contemporary Art and MIT Press, 1999); Pamela Lee and Christine Mehring, *Drawing Is Another Kind of Language: Recent American Drawings from a New York Private Collection,* exhibit catalog (Cambridge: Harvard University Art Museums, 1997); Martine Reid, ed., "Boundaries: Writing and Drawing," *Yale French Studies* 84 (1994); Bernice Rose, "A View of Drawing Today," in Jean Leymarie, Geneviève Monnier, and Bernice Rose, eds., *History of an Art: Drawing* (Geneva: Skira, 1979), 200–253; Richard Serra and Lizzie Borden, "About Drawing: An Interview," in *Richard Serra: Writings, Interviews* (Chicago: Chicago University Press, 1994), 51–60. There is much to say about Rauschenberg's Dante drawings in relation to this literature, specifically around issues of painting and drawing, line and color, figure and ground, and found and invented objects and around questions of immediacy, sight, blindness, and residue. Some of this I discuss in this chapter.

13. Dante Alighieri, *The Inferno,* trans. and intro. John Ciardi (New York: New American Library, Norton, repr. 1970 [1954]).

14. Ibid., "Translator's Preface," x.

15. On tools and prosthesis, see Stiegler, *Technics and Time.* On visibility and touch within the discourse of screen studies, see, for instance, Heidi Ray Cooley, "It's All about the Fit: The Hand, the Mobile Screenic Device and Tactile Vision," in Anne Friedberg and Raiford Guins, eds., *Televisual Space* (Special issue), *Journal of Visual Culture* 3, no. 2 (2004): 133–156.

16. This is one version of how Rauschenberg's transfer drawings were made. The other version has the drawing paper moistened with lighter fluid, and the dry clippings rubbed onto it and transferred. However, the differences between these practices do not affect my reading of them in this text.

17. See, for instance, Ashton, "Rauschenberg's Thirty-four Illustrations"; Forge, *Rauschenberg;* Krauss, "Perpetual Inventory." On allegory and psychoanalysis, see, for example, Joel Fineman, "The Structure of Allegorical Desire," *October* 12 (1980): 47–66; Craig Owens, "The Allegorical Impulse: Towards a Theory of Postmodernism, Part I," *October* 12 (1980): 67–86.

18. Sigmund Freud, *The Standard Edition of the Complete Psychological Works of Sigmund Freud,* Vol. 1, *Project for a Scientific Psychology,* trans. James Strachey (London: Hogarth Press, 1953–1974), 283–397; Freud, "A Note upon the 'Mystic Writing-Pad'" (1924), in Angela Richards, ed., *On Metapsychology: The Theory of Psychoanalysis,* trans. James Strachey (London: Penguin, 1955/1984), 427–435.

19. Robert Rauschenberg, "Random Order," *Location* 1, no. 1 (1963): 29.

20. Derrida, *Of Grammatology,* 36.

21. Derrida, "Freud and the Scene of Writing," 199.

22. Ibid.

23. Friedrich A. Kittler, *Discourse Networks, 1800/1900,* trans. Michael Metteen with Chris Cullens (Stanford: Stanford University Press, 1990); Kittler, *Gramophone, Film, Typewriter,* trans. and intro. Geoffrey Winthrop-Young and Michael Wutz (Stanford: Stanford University Press, 1999).

24. Derrida, "Freud and the Scene of Writing," 199.

25. Dante, *The Inferno,* 105.

26. Ibid.

27. Ibid.

28. I have chosen to consider Dante's "Canto XX" because Rauschenberg includes Freud in his drawing. Any of the other drawings in the series would also evoke the same theoretical questions that concern me here. But several drawings with collaged elements in them and these would require me to ask alternative questions around materiality, drawing, and prosthetics, and this would take me too far afield for the context of this chapter.

29. Freud, *Project.*

30. Freud, *Project,* 295, quoted in Derrida, "Freud and the Scene of Writing," 200.

31. Freud, "A Note."

32. Derrida, "Freud and the Scene of Writing," 200.

33. Freud, *Project,* 299, as quoted in Derrida, "Freud and the Scene of Writing," 201.

34. Derrida, "Freud and the Scene of Writing," 201.

35. Ibid., 202.

36. On prosthesis and death, see, for instance, Stiegler, *Technics and Time.*

37. Freud, *Project,* 301, quoted in Derrida, "Freud and the Scene of Writing," 203.

38. Derrida, "Freud and the Scene of Writing," 203.

39. Freud, *Project,* 308, quoted in Derrida, "Freud and the Scene of Writing," 204.

40. Derrida, "Freud and the Scene of Writing," 204.

41. See, for instance, Paul de Man, "The Epistemology of Metaphor," *Critical Inquiry* 5, no. 1 (1978): 13–30; Jacques Derrida, "White Mythology: Metaphor in the Text of Philosophy," in *Margins of Philosophy,* trans., intro., and notes Alan Bass (New York: Harvester Wheatsheaf, 1982), 207–272; Gayatri Chakravorty Spivak, "Displacement and the Discourse of Woman," in Mark Krupnick, ed., *Displacement: Derrida and After* (Bloomington: Indiana University Press, 1982), 169–195. On the construction of these and other rhetorical figures, see Paul Ricoeur, *The Rule of Metaphor: Multidisciplinary Studies of the Creation of Meaning in Language,* trans. Robert Czerny, with Kathleen McLaughlin and John Costello (London: Routledge and Kegan Paul, 1978).

42. Ashton, "Rauschenberg's Thirty-four Illustrations," 62.

43. Rauschenberg, "Random Order," 29.

44. For Derrida on the image, see, for instance, *Of Grammatology,* 36. Here the question of the image is subsumed under the auspices of writing, and the pictographic is, once again, sublimated within writing. I am interested in excavating this elision by which drawing—substantive a priori of the graphic—is repressed within this same discourse.

45. Derrida, "Freud and the Scene of Writing."

46. In a different context, a similar move is made by Bois, "Matisse" (see note 12).

47. Derrida, "Freud and the Scene of Writing," 217.

48. Within the context of film and specifically the work of Martin Arnold, Akira Lippit provides an interesting analysis of the Mystic Writing-Pad and the questions of interiority, exteriority, memory, and in passing, prosthesis. See Akira M. Lippit, "Martin Arnold's Memory Machine," *Afterimage: The Journal of Media Arts and Cultural Criticism* 24, no. 6 (1997): 8–10.

49. On the materiality of the letter, see, for instance, Paul de Man, *Aesthetic Ideology,* ed. and intro Andrzej Warminski (Minneapolis: University of Minnesota Press, 1996).

50. Derrida, "Freud and the Scene of Writing," 227.

51. On touching and Rauschenberg's *Thirty-four Drawings for Dante's Inferno,* see, for example, Morra, "Rauschenberg's Skin."

LIST OF CONTRIBUTORS

Lisa Cartwright is an associate professor in the department of communication and the graduate science studies program at the University of California at San Diego. She is coauthor of *Practices of Looking* (Oxford University Press, 2001) and author of *Screening the Body: Tracing Medicine's Visual Culture* (University of Minnesota Press, 1995) and *Moral Spectatorship* (Duke University Press, forthcoming) a book on children, disability, and technologies of communication.

Omayra Zaragoza Cruz is lecturer in the department of American and Canadian studies at Nottingham University. She is a columnist for *PopMatters,* is an editor of the *Journal of Visual Culture,* and is coauthor of two books—*Popular Culture: A Reader* (Sage, 2005) and *Popular Across Culture* (Sage, forthcoming).

Lennard J. Davis is professor of English, disability studies, and medical education, as well as director of Project Biocultures at the University of Illinois at Chicago. His recent publications include *Enforcing Normalcy: Disability, Deafness, and the Body* (Verso, 1995, reprinted 2000), *Disability Studies Reader* (Routledge, 1997), *My Sense of Silence* (University of Illinois Press, 2000), and *Bending over Backwards: Essays on Disability and Disability Culture* (NYU Press, 2001).

Gary Genosko is Canada research chair in technoculture studies and director of the technoculture laboratory in the department of sociology at Lakehead University, Canada. His publications include *Baudrillard and Signs* (Routledge, 1994), *The Guattari Reader* (Blackwell, 1996), *Undisciplined Theory* (Sage, 1998), *McLuhan and Baudrillard* (Routledge, 1999), and *Deleuze and Guattari* (Routledge, 2001, 3 volumes). He recently published two books on Félix Guattari. He is editor of the *Semiotic Review of Books.*

Elizabeth Grosz is professor of women's and gender studies at Rutgers University. She is the author of *Sexual Subversions: Three French Feminists* (Allen and Unwin, 1989), *Jacques Lacan: A Feminist Introduction* (Routledge, 1990), *Volatile Bodies: Toward a Corporeal Feminism* (Indiana, 1994), *Space, Time and Perversion: Essays on the Politics of Bodies* (Routledge, 1995), and *Architecture from the Outside: Essays on Virtual and Real Space* (MIT 2001). She has also edited nine anthologies on feminist theory, politics, and European philosophy.

Brian Goldfarb is an associate professor in the department of communication at the University of California at San Diego. He is author of *Visual Pedagogy* (Duke University Press, 2002) and is a new media artist whose recent projects include *Ocular Convergence* (2001) and *Love Your Symptom: Playing on the Tourette-OCD Spectrum* (2004).

Raiford Guins is the principal editor of the Americas for the *Journal of Visual Culture* and is a senior lecturer in contemporary screen media at the University of the West of England. His work has appeared in *West Coast Line, Television and New Media, New Formations,* and *The Visual Culture Reader* (2nd ed., Routledge, 2002). He is coauthor of two books—*Popular Culture: A Reader* (Sage, 2005) and *Popular Across Culture* (Sage, forthcoming)—and is working on a book manuscript entitled "Edited Clean Version: The Aesthetics of Censorial Procedures in the Age of Digital Effects" (University of Minnesota Press, forthcoming).

Until recently **Alphonso Lingis** was a professor of philosophy at Penn State University. He is the author of numerous books, including *Trust* (University of Minnesota Press, 2004), *Dangerous Emotions* (University of California Press, 2000), *Foreign Bodies* (Routledge, 1994), *Abuses* (University of California Press, 1994), *Sade My Neighbour* (Northwestern University Press, 1994), and *Excesses* (SUNY Press, 1984).

Lev Manovich is an associate professor in the visual arts department at the University of California, San Diego, where he teaches courses in new media art and theory. He is the author of *The Language of New Media* (MIT Press, 2001), *Tekstura: Russian Essays on Visual Culture* (Chicago University Press, 1993), and over sixty articles that have been published in over thirty countries. Currently he is working on a book manuscript entitled "Info-aesthetics" and a digital film project (*Soft Cinema*).

Joanne Morra is a senior lecturer in historical and theoretical studies at Central Saint Martins College of Art and Design, University of the Arts, London. She has published writings on modern and contemporary art and critical theory and is completing a monograph entitled "The Sensibilities of Translation: Studies in Art History." Founder of the cultural theory journal *Parallax,* she is the principal editor of the *Journal of Visual Culture.* With Marquard Smith, she edited a themed issue of *New Formations* entitled *The Prosthetic Aesthetic* (Summer 2002).

David Serlin is an assistant professor in the department of communication at the University of California, San Diego. He is the author of *Replaceable You: Engineering the Body in Postwar America* (University of Chicago Press, 2004) and the coeditor of *Artificial Parts, Practical Lives: Modern Histories of Prosthetics* (NYU Press, 2002). He is

currently at work on a book project about disability and experience in twentieth-century architecture.

Marquard Smith is the course director of the masters program in art history and senior lecturer in visual culture at the School of Art and Design History, Kingston University, London, and is editor in chief of the *Journal of Visual Culture.* An honorary research fellow of the Science Museum, he is editor of *Stelarc: The Monograph* (MIT Press, 2005) and is completing a book manuscript entitled "Moving Bodies: Perverse Visions of Prosthetic Culture."

Vivian Sobchack is an associate dean at the School of Theater, Film and Television at the University of California, Los Angeles, and a professor in the UCLA Department of Film, Television, and Digital Media. She is the author of *The Address of the Eye: A Phenomenology of Film Experience* (Princeton University Press, 1992), *Screening Space: The American Science Fiction Film* (Ungar, 1987; reprint, Rutgers University Press, 1997), and *Carnal Thoughts: Embodiment and Moving Image Culture* (University of California Press, 2004); coauthor of *An Introduction to Film* (Little, Brown, 1980, 2nd ed., 1987); and editor of *The Persistence of History: Cinema, Television and the Modern Event* (Routledge, 1996) and *Meta-Morphing: Visual Transformation and the Culture of the Quick-Change* (University of Minnesota Press, 2000).

David Wills is a professor of French and English at the State University of New York, Albany. A translator of various titles by Derrida, most recently *Counterpath* (Stanford University Press, 2004), he has published collaborative or edited work on Thomas Pynchon, film history, and visual arts theory, including *Deconstruction and the Visual Arts: Art, Media, Architecture* (Cambridge University Press, 1994), and *Jean-Luc Godard's* Pierrot le fou (Cambridge University Press, 2000). Authored titles include *Prosthesis* (Stanford University Press, 1995) and *Matchbook: Essays in Deconstruction* (Stanford University Press, 2005). He is completing a follow-up to *Prosthesis* on the dorsality—the technology of the back.

INDEX

Note: Page numbers in *italics* indicate illustrations.